THE
SECRET GARDENERS

TO ALL SECRET GARDENERS EVERYWHERE —
THE LEGIONS OF VOLUNTEERS; THE SKILLED PROFESSIONAL
GARDENERS; THE NURSERY OWNERS — WHOSE WORK IS
UNRECOGNISED AND RARELY PRAISED. VS

THE
SECRET GARDENERS

BRITAIN'S CREATIVES REVEAL THEIR PRIVATE SANCTUARIES

VICTORIA SUMMERLEY
PHOTOGRAPHS BY HUGO RITTSON THOMAS

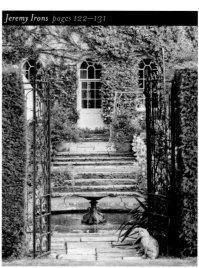
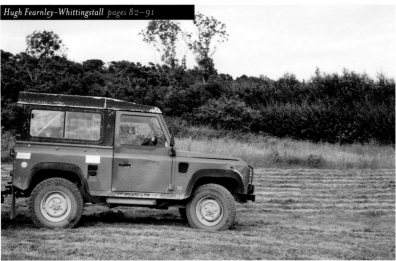
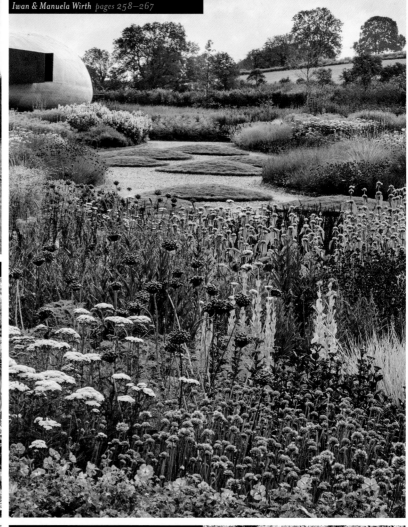
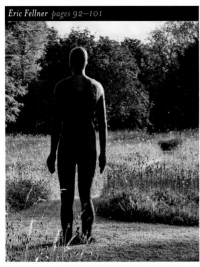
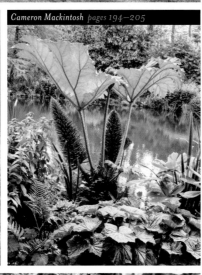
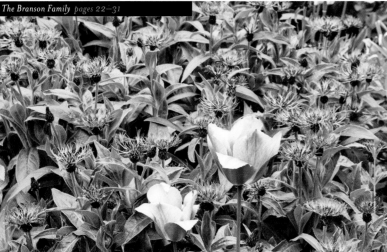
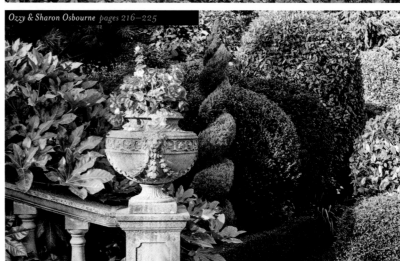

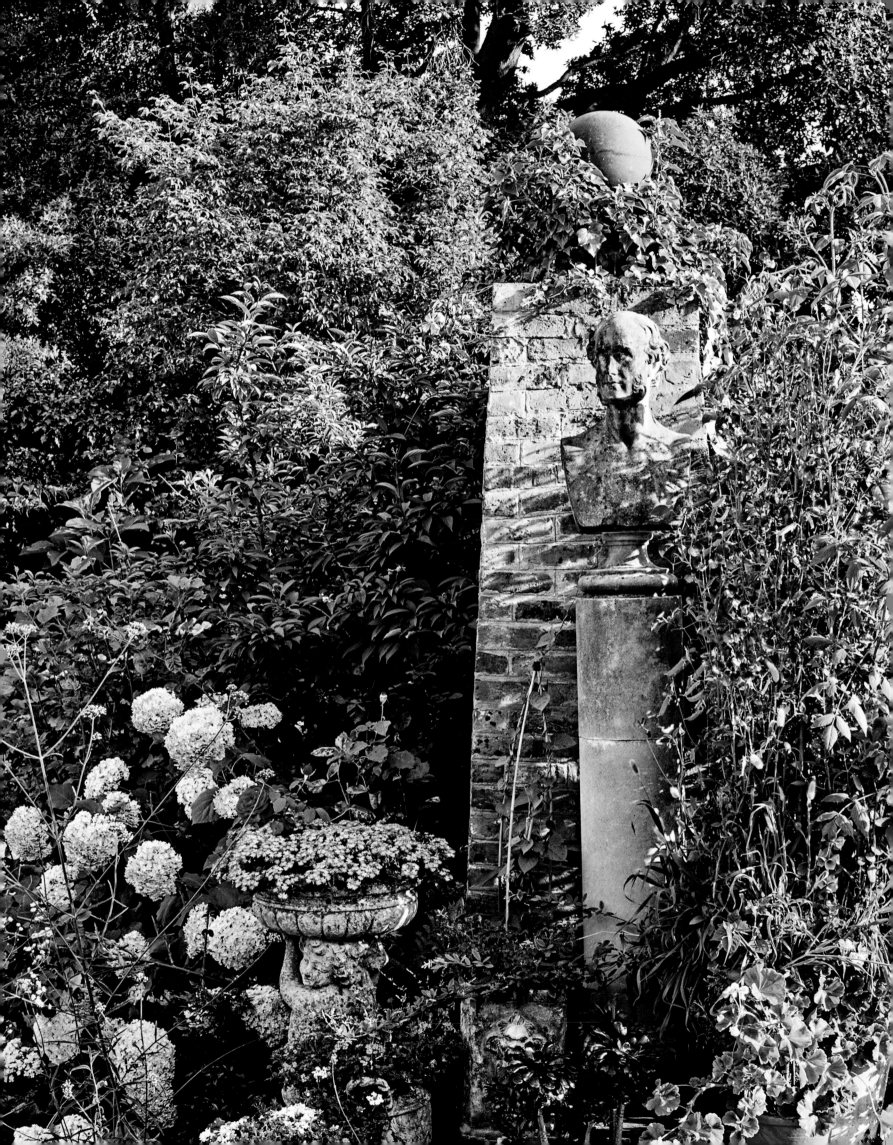

INTRODUCTION

Whenever I tell people that I write books about gardens, the usual response is something along the lines of "nice work if you can get it" or jokes about how arduous my life must be. I have to admit that I do have a very enjoyable job, but it is not without its tricky moments.

Confronted with a beautiful garden on a lovely sunny day, it is very easy to slip into relaxation mode and wander round in a daydream, enjoying the scent of the flowers and the sound of birdsong. I often have to remind myself to stop and concentrate on what is there, and analyse why it works.

At Stavordale Priory, for example, the home of Cameron Mackintosh and his partner Michael Le Poer Trench, I had to walk round the garden twice — the first time simply to enjoy it, and the second time to take notes on what I was seeing. Luckily, Michael was my guide on the second tour and since he is one of the most passionate and methodical gardeners I have ever met, I came away with the details I needed.

Meeting people's dogs is always a bit of a distraction too. The conversation usually starts with me asking: "Oh, is this a miniature dachshund (Christopher Evans)/wheaten terrier (Cameron and Michael)/ Irish wolfhound (Trudie and Sting)/border collie (Julian and Emma Fellowes)/ border terrier (Kirstie Allsopp)?" It then continues with a description of the breed's good points, their dog's mischievous habits, and its general lovableness (usually rated by its fond owner as 11/10).

When planning this book, Hugo Rittson Thomas and I did not set out to feature famous people who had lovely gardens. Our original concept was a book on artists' gardens, looking at how those who had some training or background in the visual arts organised their outdoor spaces.

We came up with the idea over lunch at Hugo's house in Oxfordshire. Hugo studied fine art at Central St Martins and Goldsmiths in London, and his wife, Silka, is a curator and contemporary art consultant, so we were looking for a project that combined art and gardens. We were all very enthusiastic about the idea, but realised that it might have a broader appeal if we included people who were involved in the performance arts as well.

I'm often asked how I choose the gardens for my books. The answer is that I don't — Hugo does. I have a power of veto if I feel strongly that a garden shouldn't be included for some reason (perhaps because it's too well known), but Hugo is the one who persuades people to open their gates and let us in.

How he does this, I have no idea. I am firmly of the belief that Hugo could persuade St Peter to open the gates of heaven if Frances Lincoln, our publishers,

decided to commission a book on the Garden of Eden. I suspect that bucketloads of charm comes into it, plus a lot of dogged persistence, because most people – even if they are household names – are a little bit nervous about having their gardens photographed and discussed in print.

Indeed, some of the gardens Hugo photographed didn't make it into the book because the owners decided they wanted to remain anonymous. Others were more relaxed about the photographs, but horrified when I pitched up, because they thought I would expect them to have a degree in horticulture. "But I don't know any Latin names!" was a constant refrain, along with the classic garden owner's lament: "You should have been here last week, it looked wonderful then."

The individuals in this book may have names that are familiar to most of us, but they are just like any other garden owners. They wage daily battles with slugs or rabbits or deer; they can't remember the name of the rose that takes pride of place on the pergola; they have weeds in the vegetable patch; they plant something that doesn't do well and have to replace it with something else. But above all, they love their gardens.

When I talked to Trudie Styler, a film producer and Sting's wife, she called me from New York, and we spent over an hour and a half on the phone chatting about her garden in Wiltshire. I apologised for taking up so much of her time, but she told me it was wonderful to talk about the garden with someone who had visited it and knew what she was referring to.

Cath Kidston sat me down in her kitchen and made me a cup of tea while we discussed her garden, and then insisted that I went upstairs to her bedroom – "no, don't worry about taking off your shoes" – to see how the central axis that runs through it works.

Talking of kitchens, the one belonging to Prue Leith – chef, restaurateur, novelist and *Great British Bake Off* judge – was almost as much of an attraction as her garden, filled as it was with delicious-looking food. I visited just after Christmas, and the whole time we were talking about the garden, I was dying to ask how she had used up the turkey leftovers.

People often ask me which are my favourite gardens. It's a very easy question to answer: my favourites are those where the owners give me tea, or a glass of wine, or even (if I'm very lucky) lunch. This may sound like a joke, but I have found that people who offer hospitality tend to be more forthcoming about their gardens too, and that gives me a greater insight into what they are trying to achieve.

For many of us, gardens are a haven, where we can get away from the demands of work. Sting and Sharon Osbourne use theirs for spiritual refreshment, while

Below: The entrance to the Courtyard Garden at the Cotswold home of scientist Christopher Evans and his wife Anne. The late Rosemary Verey had helped with the garden's restoration prior to the couple moving in, and they then commissioned Stephen Woodhams to redesign some areas of the historic garden. The Courtyard Garden is Anne's own design project.

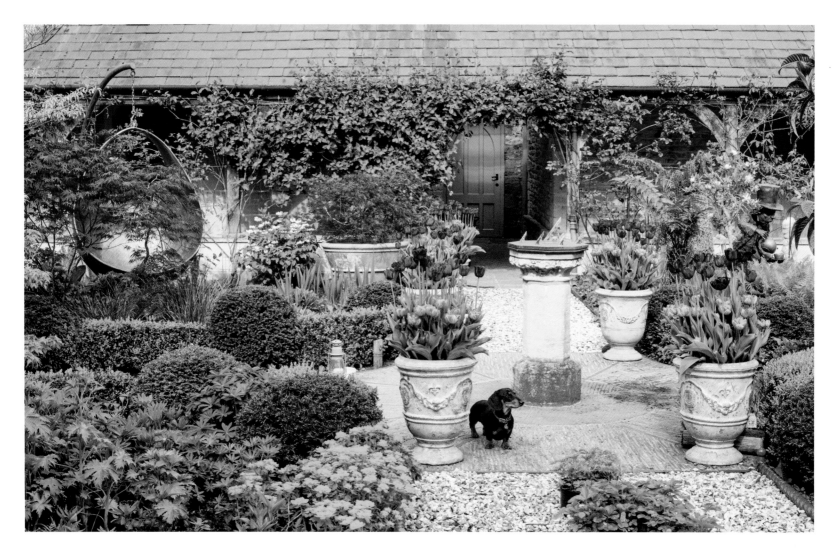

Griff Rhys Jones and Paul Weiland enjoy the creative outlet that their outdoor spaces provide. Indeed, Paul – true to his profession as a film and television director – said that if he didn't achieve the effect he was after in the garden, he would redo it again and again, like film "takes", until he was happy.

Admittedly, the gardeners in this book may have a bit more cash than the rest of us, and yes, they might also be able to afford a bigger garden – thanks to decades of hard work, it should be pointed out – but it's all relative. If you walk down any road, anywhere in the UK, whether it is on a council estate, or in an affluent suburb, a remote village or a bustling city, you will see gardens that are well tended and you will see gardens that have been a bit neglected. Of the gardens that are cared for, some will look wonderful while others will look all right, but nothing special.

You soon realise that creating a good garden has nothing to do with money. It's about having a vision and, more importantly, the determination and skill to bring that vision to fruition. Nick Foot, head gardener for film producer Eric Fellner at Pyrton Manor in Oxfordshire, made an interesting observation when I was talking to him about what a wonderful atmosphere the garden had.

"It doesn't matter how good the head gardener is, the spirit of the place comes from the owner," he explained. "If the owner is not passionate about the garden, it will never have that, no matter how well it is maintained. The great thing about Eric is that he is used to working with visuals. He might not know the names of all the plants in the garden, but he has a very clear idea about the effect he wants to achieve."

If gardens were simply collections of plants, they would not have the same impact on us as human beings. Even the best garden can fail to move us if we are not familiar with the design "language" in which it is framed. Some of the gardens in this book are exquisitely manicured, while others, such as sculptor Daniel Chadwick's estate in Gloucestershire, have a wilder, untamed beauty, but they are equally effective in their own way.

The designs often mirror the owners' professions or personalities, too. Terry Gilliam's garden in London, for example, contains props that were used in his films, and Cameron Mackintosh has a mosaic pavement incorporating images from his theatre productions, including a bowl and spoon for *Oliver!* and a conical Asian-style hat for *Miss Saigon*.

Andrew Lloyd Webber has transformed a 16th-century chapel, which stands in the garden just metres from the house, into a theatre, complete with a piano which takes pride of place on the stage. And Sting's garden has a calm, contemplative feel – even in the

Below: The actor Rupert Everett's garden in Wiltshire is on the banks of the River Avon, and a small rill runs through a large lawn, echoing the meandering river beyond and terminating in a lily pond. The rill was installed by a previous owner, but most of the current design was created by Rupert's mother, Sara. An old granary in the garden reflects its historical setting.

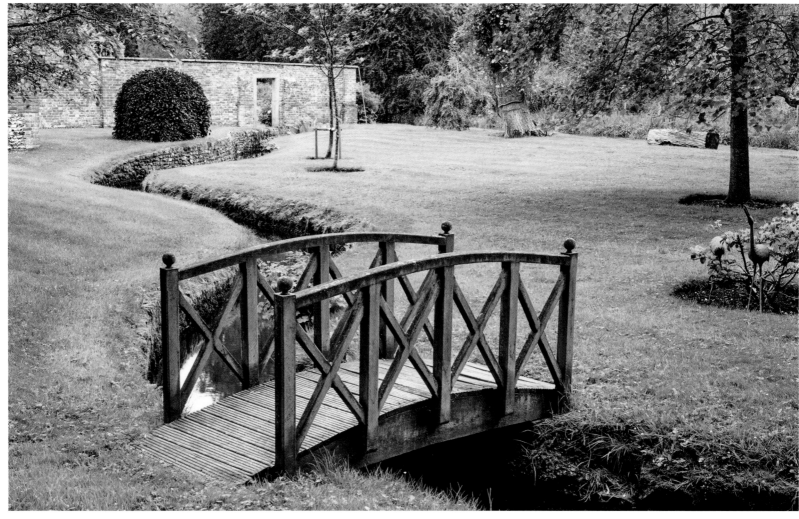

kitchen garden which, like any vegetable plot, requires a lot of hard physical work to keep it productive.

Ah yes, the work. Surely they don't do it all themselves? Don't they employ teams of gardeners? Well, it is true that, like most people with large properties, the garden owners in this book do not have time to do all the gardening themselves. However, many of them, including Griff Rhys Jones, Trudie Styler, Terry Gilliam's wife Maggie Weston, and Julian Clary, talk about their gardeners with respect and affection. They have a genuine appreciation of the part their gardeners play in their lives, and asked me to ensure that the individuals concerned were given the credit for their work.

It should also be remembered that these owners, while privileged, are providing employment and, at a time when skilled, qualified gardeners are a rare commodity, they are offering those who work for them the chance of valuable career progression and a secure future.

I'm never sure whether this is a particularly British phenomenon, but I am absolutely certain that for many of us, gardens are as much about nostalgia and memory as they are about horticulture. I love rock gardens, for example, because when I was a child, they were (or had been) very fashionable, and I was fascinated by the idea of miniature landscapes, especially those that had a little stream or waterfall running through them.

Griff Rhys Jones and Allen Jones talked about being influenced by the landscapes they saw while on holiday as children. Others, such as Cath Kidston and Kirstie Allsopp, who both grew up in the countryside, have woven the happy memories of their rural childhoods into their gardens. Prue Leith's love of hot colours is a legacy of being brought up in South Africa, and Trudie Styler and Maggie Weston come from families where parents and grandparents grew their own flowers and vegetables. Evgeny Lebedev talks of the scent of lilacs transporting him back to his childhood in Russia, and how spending time with Mollie Salisbury, who designed his garden at Hampton Court, reminded him of being put to work in his grandparents' garden.

All artists, whether they are writers, musicians, actors, painters or sculptors, use their experience of life as raw material for their work. The owners in this book have applied the same process to their gardens, and because they are used to creating and analysing visual and performance effects, they have been able to describe what they have achieved in a way that is not only articulate, but has proved fascinating.

I would like to thank all of the garden owners for their help in making this book.

Right, clockwise from top: The home of Nick Mason, drummer of Pink Floyd and classic car enthusiast; Ozzy and Sharon Osbourne's red telephone box; a lamb on Hugh Fearnley-Whittingstall's land in Devon; the view to the river from Griff Rhys Jones' garden in Suffolk; Holly and Sam Branson as children, playing with their father Richard. Below: Sting and his wife Trudie Styler running through the turf labyrinth in their Wiltshire garden.

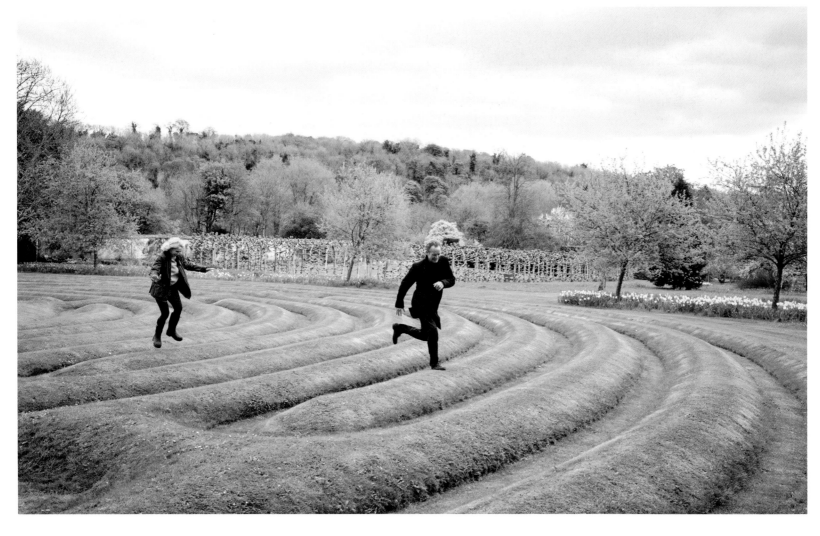

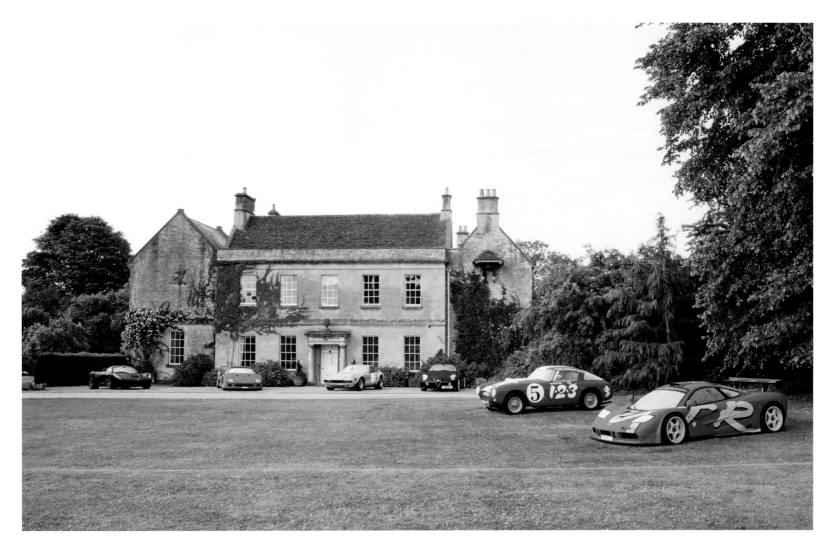

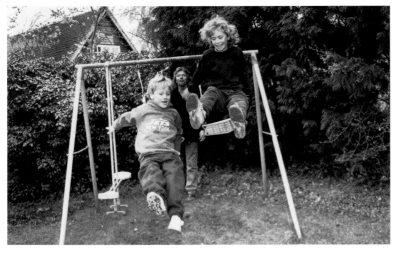

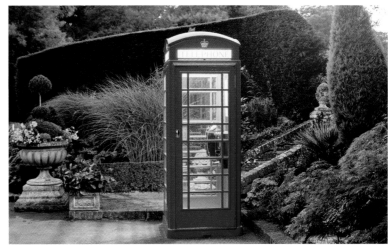

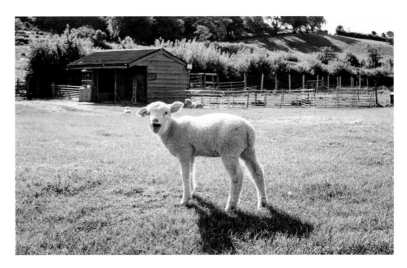

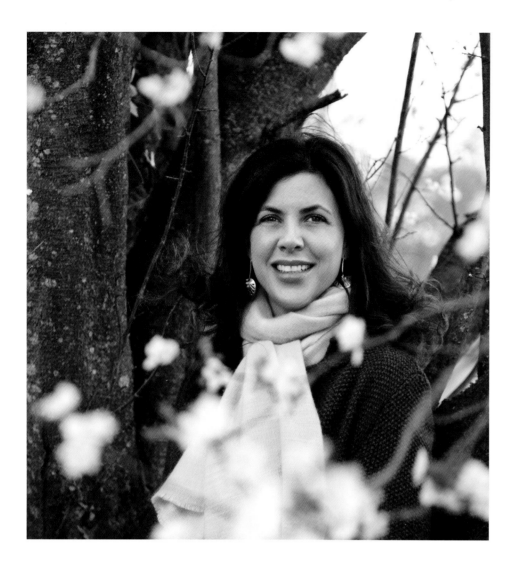

Kirstie Allsopp
Born: 1971
Partner: Ben Andersen
TV presenter, interior
designer, champion of vintage
and handmade style,
and quad bike rider

Left: Television presenter
Kirstie Allsopp grew up
in Berkshire and is keen
for her own two sons to
experience rural life.
Right: The south-facing
terrace of her house in Devon
has two enormous tables for
summer dinner parties.

KIRSTIE ALLSOPP

DEVON

Claudette Margand, who looks after the gardens at Kirstie Allsopp's Devonshire home, has an abiding memory of her boss speeding across the grass on a quad bike, bearing a freshly poached egg on toast. The egg was for Kirstie's partner, Ben Andersen, who was tending a bonfire at the time.

It is a wonderful image, and sums up what this garden means to Kirstie and her family. It's about spending as much time as possible outdoors and allowing the children to enjoy adventures climbing trees and damming streams. It's about wearing old clothes and letting the windfalls in the orchard lie on the ground for the birds and other wildlife. And it's about celebrating the English countryside in all its seasons and moods.

Many gardeners will tell you that when they were children they had their own patch of garden, where they discovered the magic of sowing seeds and growing plants. I'm sure this is true, but many others come to gardening simply because it means being in the fascinating world of "outside". If you inhibit children with too many safeguards, they never have a chance to discover this world for themselves, but this is not the case for Kirstie's two sons, Bay and Oscar, and their half-brothers, Orion and Hal.

The boys are free to race around the garden as fast as they like on quad bikes or mini-motorbikes. They have a tree house in an enormous copper beech – which is, admittedly, within view of their mother's bedroom window – and they are given space to explore the river, with its weirs, bridges, and places to paddle and swim. The boys also love helping their father dredge the pond, or build a bonfire.

Dandy, the border terrier, is allowed to run in and out of the house all day long, too, and it doesn't seem to matter that there are 90 million tennis balls in the

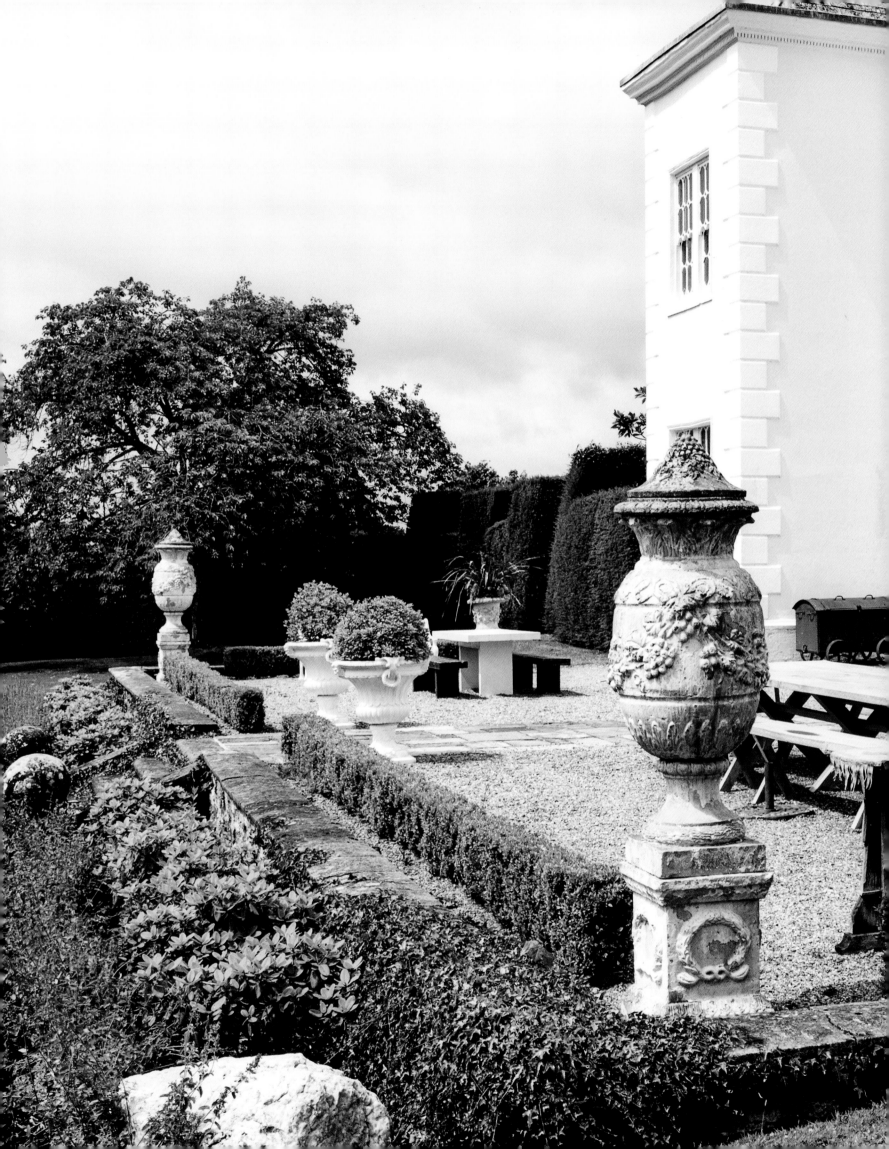

Above: The enormous copper beech has a tree house built in its branches, which in summer is almost entirely hidden by the dense foliage.

Opposite, above: The yew hedges that surround the house are clipped to look like the ancient walls of a castle.

Opposite, below: The original house was built around 1610 but has been extended and altered many times since then.

yew hedges, which he has failed to retrieve, according to Claudette. It's a *Swallows and Amazons* meets *Swiss Family Robinson* existence here at Kirstie's place.

The house itself has an interesting history. It was the grange, or manor house, of Dunkeswell Abbey, which was founded in 1201 and disbanded in 1539, following the Dissolution of the Monasteries. The property was acquired soon after by Thomas Wriothesley (pronounced Rizz-ley), 1st Earl of Southampton, and his grandson then sold it to Edward Drew, a member of one of Devon's most influential families.

The Drews, or Drewes, owned the estate until 1903 and at some point in the 1920s, the Jacobean oak panelling of what is now the enormous kitchen was sold to William Randolph Hearst, who put it into storage in one of his warehouses. Orson Welles refers to this in his screenplay for *Citizen Kane*: "Paintings,

pictures, statues, the very stones of many another palace, shipped to Florida from every corner of the earth, from other Kane houses and warehouses, where they mouldered for years." The panelling was eventually rescued and can now be seen in the Speed Art Museum in Louisville, Kentucky.

Outwardly, the house has changed little in the past 200 years and you can still see the old Abbey's fish ponds from the house. It sits on the edge of the Blackdown Hills Area of Outstanding Natural Beauty, and the meadows in front of the house are spangled with wild flowers.

The formal gardens to the rear are dominated by huge chunky yew hedges that resemble the ruined walls of an ancient castle. They are clipped, but not symmetrically, forming solid walls and lending a wonderful impression of security, like giant arms wrapped around the house. Kirstie's mother, Fiona

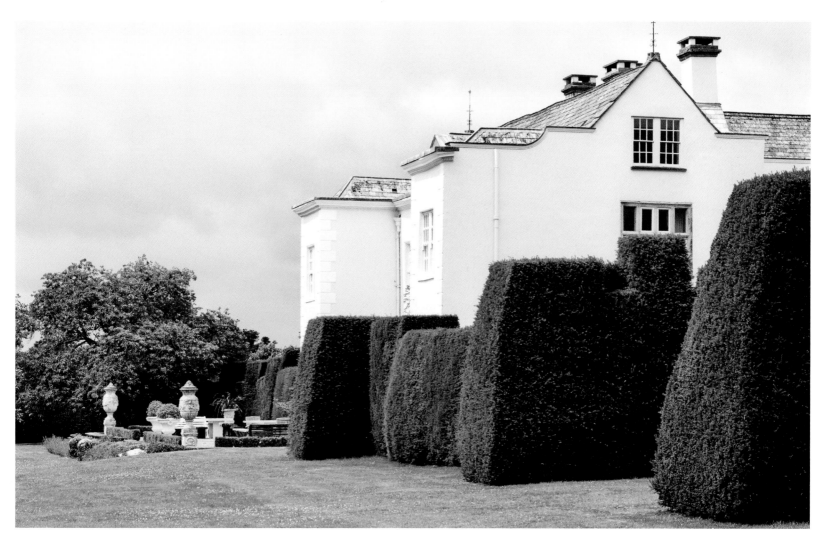

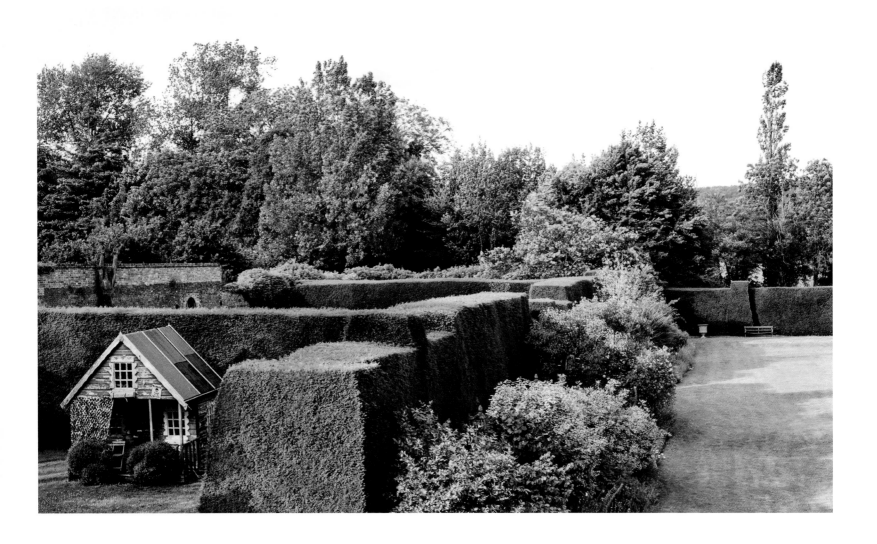

Above: A Wendy house is hidden by yew hedges in the first of three garden "rooms". Opposite, clockwise from top: The main border faces south, and features shrubs, such as berberis, hydrangea, fuchsia, and climbing roses on obelisks; sweet williams (Dianthus barbatus) *in fondant colours; agapanthus flower heads; California poppies* (Eschscholzia californica) *and globe thistles* (Echinops ritro) *bask in a sunny spot.*

Hindlip, died of breast cancer in 2014, and clippings from the yew hedges are donated to a company that processes them for use in cancer treatments. Only the new growth is used, because it contains the highest concentration of the compound 10-Deacetylbaccatin III, which kills leukaemia cells and cancerous growths. The chemotherapy drugs that include yew tree extract are mainly used to combat breast and ovarian cancer, and although they can be produced semi-synthetically, fresh yew is still an important part of the process.

The gardens surround the house on all sides, and each section has its own character. On the south side is a large gravelled terrace, a good solution if you need lots of space for seating, but don't want your garden to look like a car park. The two enormous tables with matching benches on the terrace can accommodate around 20 people. They were specially made for

Kirstie, and you can imagine the adults sitting and chatting here on a summer's day while their offspring tear around on the lawn beyond.

Next to the terrace is the most formal part of the garden, with a long mixed border on one side, and a row of magnolias along the other. Even when they are not in flower, the magnolias' silvery bark shines out against the backdrop of dark yew. The border is mostly comprised of flowering shrubs, including roses, hydrangeas and the scented winter-flowering honeysuckle, *Lonicera fragrantissima*. Behind the long border is the swimming pool — heated by solar panels — and a tennis court.

From late winter onwards, the garden is awash with a range of beautiful flowering bulbs. Snowdrops, daffodils and bluebells, together with carpets of dainty wood anemones (*Anemone nemorosa*), decorate the meadows and woodland, while thousands of tulips

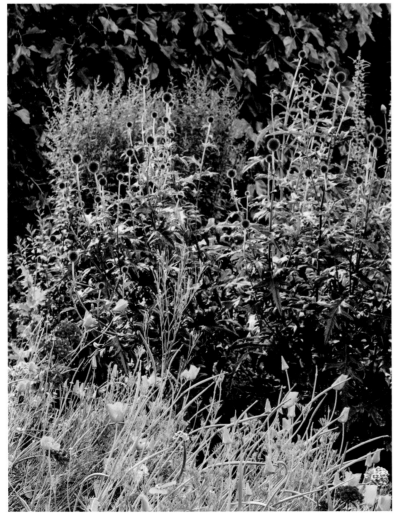

"The long border is mostly comprised
of shrubs, including roses, hydrangeas
and a winter-flowering honeysuckle."

*Above: A row of magnolias
stands like a guard of honour
along the yew "battlements".
Opposite, clockwise from top:
The shrub border, with its
edging of catmint (Nepeta),
is laden with blossom in early
summer; a flourishing patch
of sage; a cheeky self-seeded
red poppy emerges from a bed
of catmint; runner beans in
the kitchen garden.*

come to life from mid-spring, bringing a blaze of
colour and interest to the formal part of the garden.

The front of the house looks out onto grassy
meadows, where a herd of sheep graze and the River
Tale, which flows through the estate, broadens out
into a small lake. At the far end of the lake, the water
flows under a wooden bridge and over a weir, forming
a deep pool, ideal for swimming.

Finally, on the north side of the house, there is
the kitchen garden, accessed via a gate in a high wall.
It includes an apple tree orchard, and a vegetable
garden, with beds outlined in lavender and box
hedging. Along one wall, Claudette has used an old
overgrown fruit cage as a chicken run, which has a
double advantage: the hens have cleared the ground
of weeds and they produce manure for the veg beds.
She has also planted a cutting garden, which provides
flowers for the house. Annuals and biennials, such

as California poppies (*Eschscholzia californica*) and sweet
williams (*Dianthus barbatus*), are grown here, and flower
for weeks on end if you cut them regularly. Claudette
advises plunging the lower third of the California
poppy stems into boiling water for 30 seconds to
make them last in a vase.

Most of the apples from the orchard are turned
into juice for the family, but some of the windfalls
are left on the ground for the local wildlife to enjoy.
Blackbirds are regular visitors to Kirstie's garden
and are particularly fond of apples; the squishier
the better, as it makes them easier to eat.

Ben, a property developer, already owned the
house when the couple first met, and while Kirstie
may be the person television viewers associate
with vintage makeovers, she says her partner is the
one who deserves the credit for their home. "I am
responsible for the soft furnishings — what my

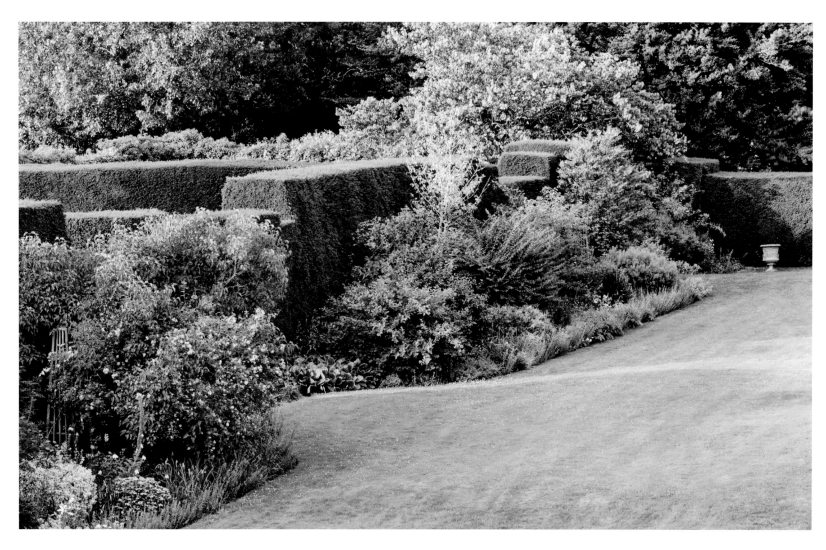

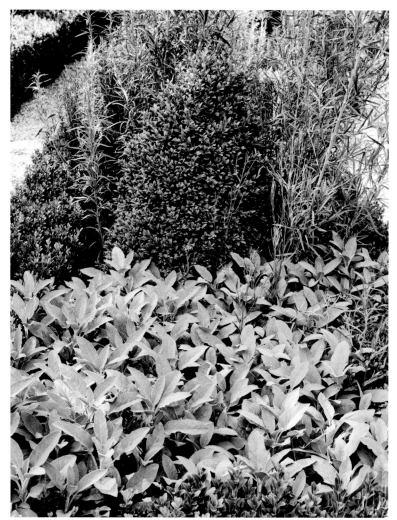

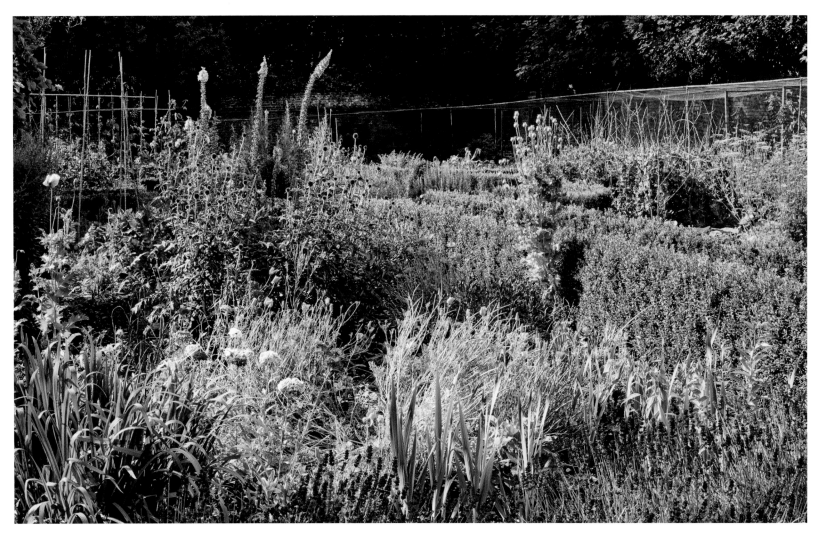

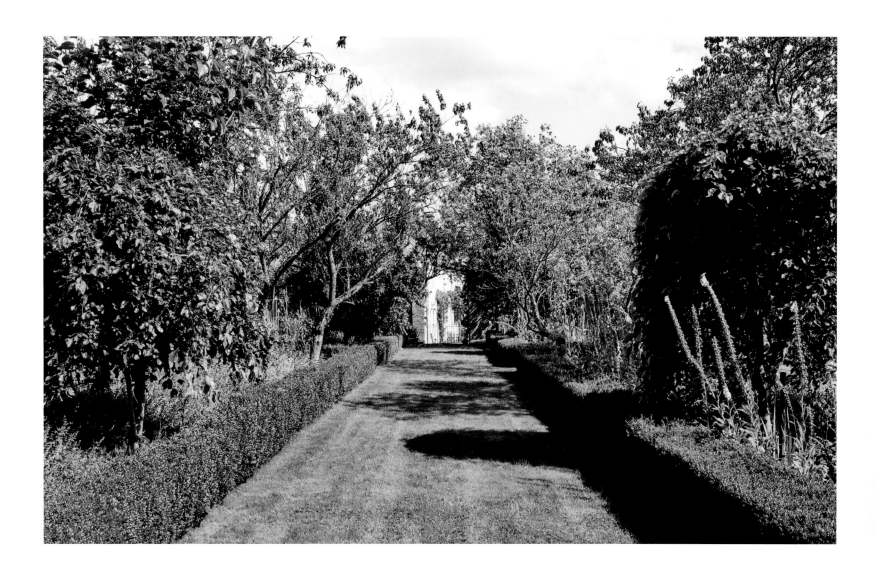

friends call 'operation valance' – the curtains, the cushions, the tablecloths and china, and so on, but the true eccentricity of the house comes from Ben. It's a combination of his desire to create a home that is both *Boy's Own* fantasy, full of interesting and historical things, and somewhere that friends can relax and escape to, which makes Grange what it is.

"We are both the children of antique dealers after all. My dad [Lord Hindlip, a former chairman of Christie's] and Ben's mum are the best of the best, and that love of the auction room is in our DNA."

Kirstie began her television career in 2000 on Channel 4's *Location, Location, Location*, with property specialist Phil Spencer. The format was an instant hit and it has been followed by series such as *Escape to the Country* and *Homes by the Sea*. A crucial ingredient that contributed to the programme's success was Kirstie and Phil's blend of blunt advice and personal charm,

whether they were managing the expectations of potential buyers, or haggling with estate agents. Since then, Kirstie has presented further series with Phil, including *Love It or List It*, and ten series on the theme of upcycling or crafting, including *Kirstie's Vintage Home* and *Kirstie's Handmade Christmas*.

She has written three books, including *Kirstie's Real Kitchen*, published in 2017. She said: "Much of the book was shot at Grange, and it's about my journey from a non-cooking family to someone who often has a house full of people." She has also designed a gift and homewares range for Marks & Spencer, and her own Home Living range, which combines vintage style with a modern twist.

It's no wonder she looks forward to jumping in the car on a Friday night and spending the weekend in Devon, where she can relax. The only wonder is that she has the time to make poached eggs on toast.

Above: The tree-lined grass walkway that links the gardens to the house.
Opposite, clockwise from top: The cutting garden, where annuals and biennials are grown like a crop to provide flowers for the house; an ornate metal gate between two high brick piers on the gravelled path leading from the kitchen garden to the house; foxgloves and ferns flourish in the shade of an old pear tree; the apple orchard.

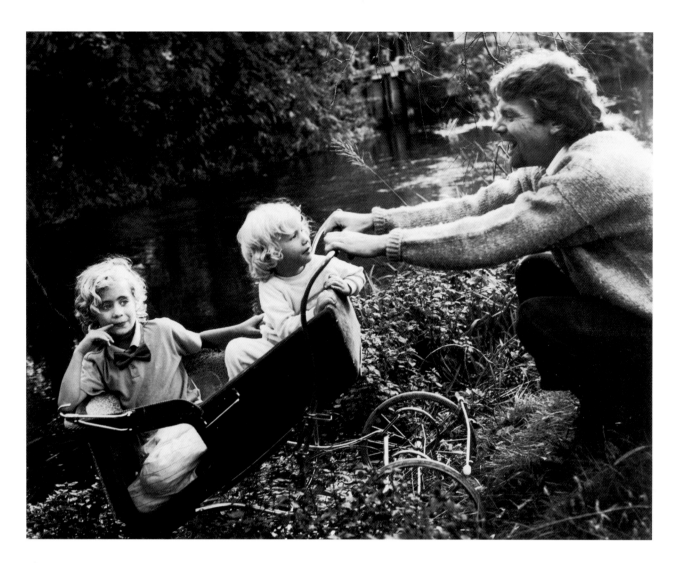

Holly Branson
Born: 1982
Qualified doctor, the chair of
Virgin Unite and co-founder
of Big Change charity, and
lover of riverbanks

Sam Branson
Born: 1985
Adventurer, filmmaker,
founder of Sundog Pictures
and Strive Challenge,
co-founder of Big Change
charity, expert lawn chiller
and tree climber

THE BRANSON FAMILY

OXFORDSHIRE

According to Sam Branson, you haven't had a proper childhood unless you have climbed a tree. He should know: he and his sister Holly spent most of their time doing just that when they were children, encouraged by their father, the entrepreneur and businessman, Sir Richard Branson, who wanted them to develop the same sense of adventure and love of the outdoors that his own parents had nurtured.

As children, Sam and Holly spent most weekends and all summer at the family's house near Kidlington, ice-skating on the lake if it was cold enough to freeze, and building forts in the trees. "Dad worked from home," said Sam, "so he was around. He definitely encouraged us to spend time outdoors."

After their parents moved to the British Virgin Islands some years ago, Sam and Holly bought the estate where they grew up. Most of the acreage is given over to woodland and water, and the huge lake is home to a colony of Canada geese, as well as kingfishers and herons, while the boundaries take the form of trees and hedgerows, rather than high walls and razor wire.

It was their father's idea to dig out the lake – it was one of the first things he did after buying the property. "Dad loves a project," said Sam. He was too young to remember the construction work, but Holly was nearly three when the Bransons moved in, and she recalls "lots of diggers and lots of mud". Holly was also fascinated by the islands, which were created to provide secure habitats for the waterfowl. There are several in the lake, and some are completely untouched by humans. The islands also help to make the water feature look even larger than it is – masking parts of it, so you can't see the whole lake all at once.

Sam says that any time Richard visits from his home in the British Virgin Islands, he loves to walk around the lake and watch the birds. Apart from the

Above: Richard Branson
with his daughter Holly (left)
and son Sam, playing by
the river that flows by their
Oxfordshire home.
Right: The lake that Richard
dug out for waterfowl and
other wildlife.

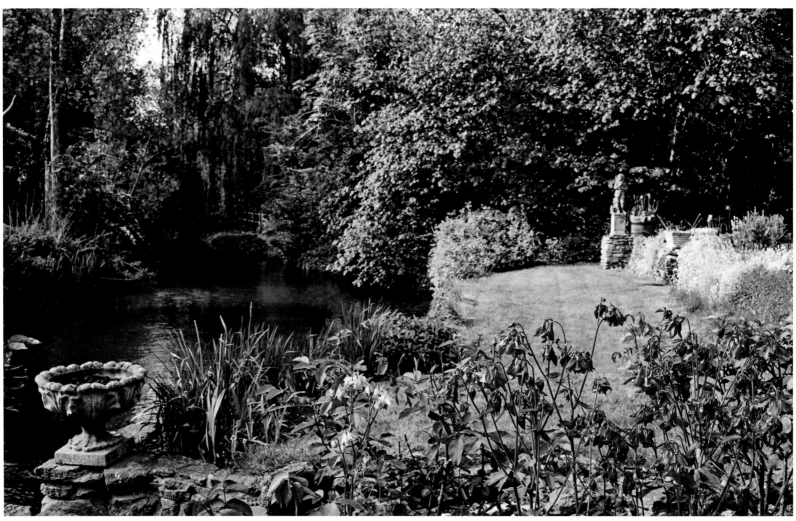

fact that the Bransons wanted to create a wildlife-friendly feature, the lake also provides an important overflow area for the River Cherwell when the water is running high after a storm. The river, which flows through this section of the garden, is Holly's favourite area, and features graceful weeping willows and rough naturalistic planting along its banks.

If you look towards the north-west, you can see the tall spire of the church at Kidlington poking up above the boundary hedge, but apart from that, there is nothing to suggest a bustling community beyond the gates, or traffic roaring along the main road, only a mile or so away. You get the same effect in reverse as you approach the estate. Driving down a suburban side road, with neat houses and a row of local shops, it is only when you pass through the gates that you realise there is an extraordinary oasis of parkland in the middle of it all.

The family use the back drive, which enters the property via an avenue of cricket bat willows (*Salix alba* var. *caerulea*). Sam recounts an extraordinary coincidence when he and his wife, Bellie (short for Isabella), were on honeymoon in Namibia. Their guide was a friend who Sam had met on a previous trip to Africa, and the friend's father made cricket bats. Sam was given one as a present, and to his astonishment, he found it was made from wood from his own cricket bat willows.

The estate also boasts a cricket oval, with a pavilion that has windows on both sides, so it faces the lake and the wicket. Richard is a huge cricket fan (he's a batsman), and Holly and Sam vividly remember the annual cricket matches during their childhood, and climbing the trees around the pitch while the game was in progress. They have kept this tradition going, and now that they both have young families living on

Above: The spire of Kidlington church is just visible through the trees on the western side of the lake.

Opposite, above: Kidlington Mill, one of the four properties on the estate, was originally a corn mill.

Opposite, below: Aquilegias in flower on the banks of the Cherwell, which runs through the gardens of the estate.

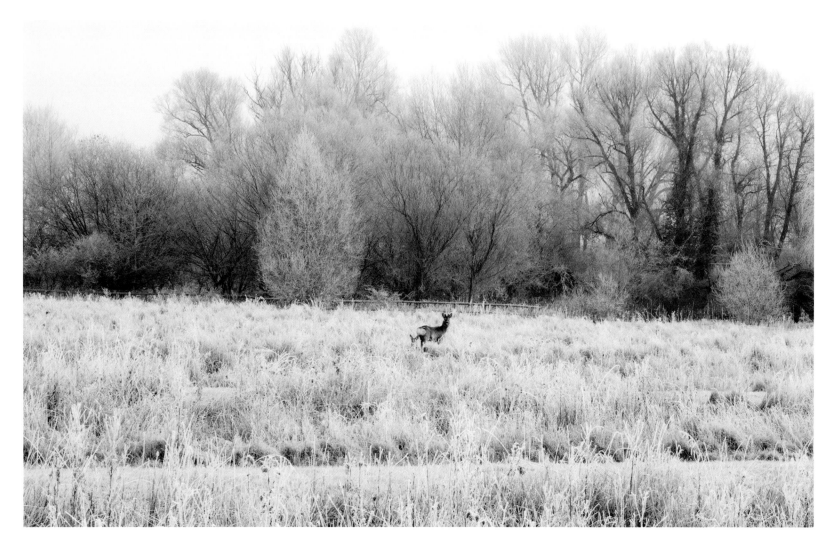

"It was Richard's idea to dig out the lake, and it was one of the first things he did after he bought the property."

Above: Roe deer are among the many species that find a haven on the Branson estate. Opposite, clockwise from top left: The lake in winter; an old rope bridge provides access across the Cherwell; the ridge and furrow area, now planted with wild flowers; bulrushes (Typha latifolia) growing at the water's edge are dusted with frost on a cold morning.

the estate, there is usually a bouncy castle alongside the pitch for their — and friends' — children.

A short stroll from the cricket pitch, on the western side of the lake, there is a wildflower area, where the plants are grown in long strips. While it is common practice to mow paths through a meadow — it looks nice and saves getting your feet wet on a rainy day — this meadow is divided into sections, like an allotment or orderly beds in a botanical garden.

This pattern is the result of ridge and furrow, a system of cultivation used in the Middle Ages. Known as the open-field system, each local family was allowed one strip to cultivate in a huge field containing lots of strips, just like a modern allotment. However, in those days, ploughs were only designed to go one way, so when you cultivated your strip, you went round the outside of the plot in a clockwise direction, instead of up and down, throwing the earth up as you went.

As time went on, the strip itself grew higher and higher as more earth was thrown up onto it, while the land in between got lower. The archaeological pattern of ridge and furrow on the Branson estate can be seen in a few other places in the UK, where the land has not been cultivated since the system was abandoned, and the ridges look spectacular when in flower.

All the Bransons, it seems, share a love of natural, wild gardens. Holly, who now lives in her parents' old house with her husband, Freddie Andrewes, says her father and mother hated the idea of anything too formal. She and Sam have a similar vision. They bought the property from their father in 2008, and later commissioned Sam's old school friend Nick Hudson, of Nicholas Obolensky Design, to reinvigorate the gardens. Their brief to him was for nothing too manicured but they wanted lots of colour. As Holly explained, they spend a lot of time at

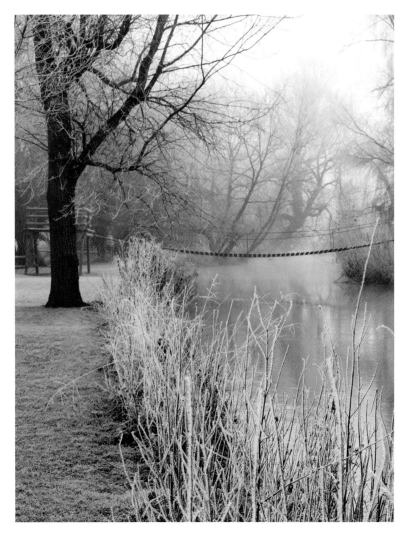

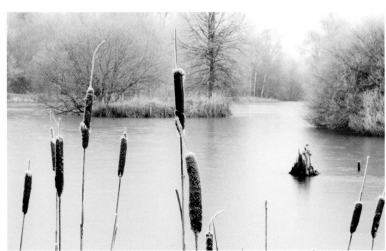

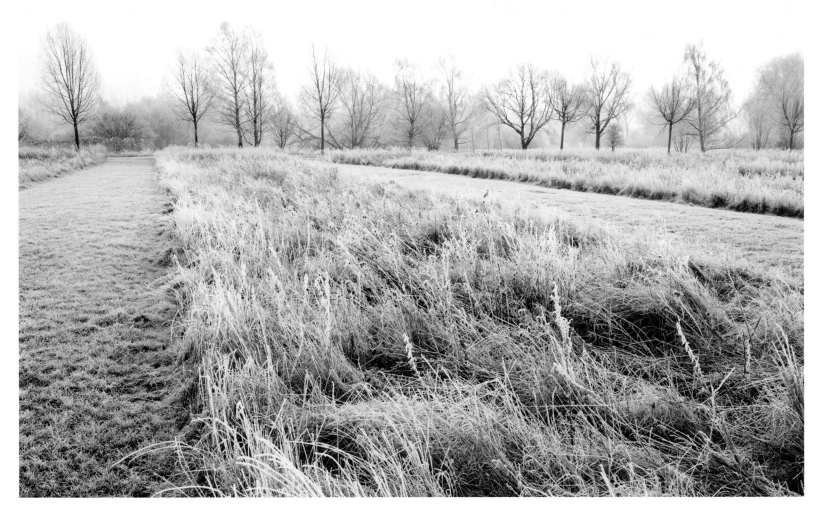

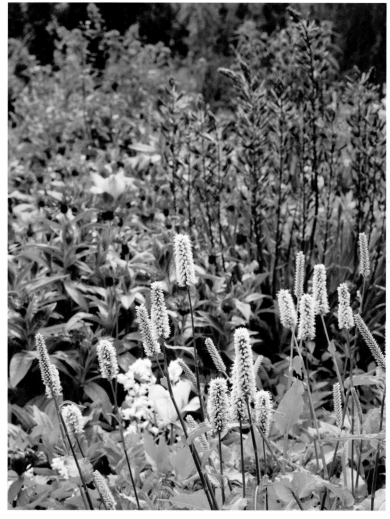

their parents' Caribbean home in the British Virgin Islands, so they wanted plants that reminded them of their time there, such as bougainvillea. The design also had to be sympathetic to the sustainable ethos of the rest of the garden, but apart from that, Nick was given full creative licence.

Sam and Nick had been friends at St Edward's school, Oxford, and Nick went on to study garden design at the Inchbald School of Design. "He knew me and my wife, he knew our personalities, and we trusted his judgement," said Sam. "He then showed us a selection of plants that he thought we would like, and which would be suitable for Oxfordshire." Nick added: "I love grasses and bee-friendly plants, and prairie planting, so I really enjoyed myself."

Mill House, Sam and Bellie's home, was owned in the pre-Branson days by a botanist, and one of the windowpanes was engraved with a list of the rare trees in the garden. These include a subtropical *Jacaranda*, and while Sam says that it doesn't flower very prolifically, it's a wonder that it flowers at all, given Oxfordshire's less than tropical climate.

Nick divided the garden into two sections. The first is lawn, where small children can play within sight of the house. The second section, screened by a pergola that runs the width of the garden, consists of a series of box parterres planted with perennials, such as *Verbena bonariensis*, salvias, sedums, echinaceas, stachys, agastache and acanthus.

Alongside the two properties, the siblings share a converted barn, known as the party barn, which lay derelict until around 2015. When it was restored, Nick designed a large terrace with lots of seating and large olive trees in pots, which thrive in the sunny site. To provide seasonal interest, he included small trees called amelanchiers, which have white flowers in

Above: Sam and Bellie's garden is bisected by a timber pergola, with a large lawn nearest the house.
Opposite, clockwise from top left: The hot tub is sited behind the pergola; pale pink spires of Persicaria bistorta *'Superba' draw the eye to the flower beds; variegated hostas provide foliage interest; 'China Pink' tulips emerge from a clump of perennial cornflowers* (Centaurea montana).

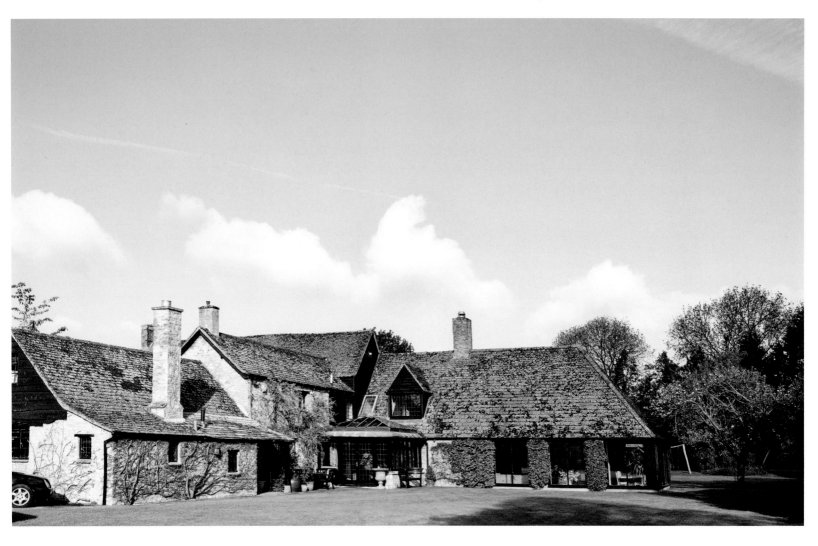

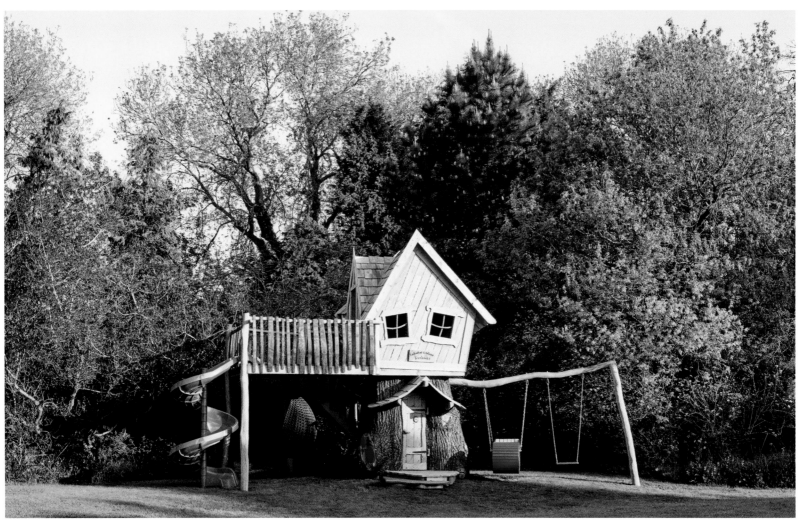

spring and copper-coloured leaves in both spring and autumn. An evergreen star jasmine (*Trachelospermum jasminoides*), with its twining stems and tiny white flowers, creates a scented screen in high summer.

Both Holly and Sam work in London for part of the week. Holly trained as a doctor, and now chairs Virgin Unite, a non-profit organisation funded by Richard Branson and the Virgin Group. She also launched Big Change, a youth charity, along with her brother and his wife, and Princess Beatrice of York. "We do have some amazing gatherings where we get together lots of experts to look at problems," she explained. "A recent one was on the future of education in America and the UK. At the moment, we are driving kids towards passing exams instead of teaching them to think."

In 2012, Sam founded Sundog Pictures, together with Johnny Webb, to "use the power of television,

film, and digital media to tell stories that matter, and bring new audiences to important subjects."

Since starting their families, however, both have spent more time at home in Oxfordshire, where the layout of houses and barns gives the impression of a small village. Each dwelling has its own outdoor space, linked by communal areas, such as the swimming pool and two little meadows. Sam says he and Holly have always been very close, partly because they've spent so much time together. "Now I have my sister next door, our children are the best of friends, and they love playing together outside."

Holly and her husband, Freddie Andrewes, have twins Etta and Artie, while Sam and his wife, the actress Isabella "Bellie" Calthorpe, have a daughter, Eva-Deia, and a son, Bluey. It sounds as if it won't be too long before the next generation of Bransons is climbing those trees.

Above: Wisteria and clematis swathe the walls of Sam and Bellie's house.
Opposite, above: Mill End was originally the Branson family home. Holly now lives there with her husband Freddie and twins Etta and Artie.
Opposite, below: The quirky tree house provides swings and a slide for Holly and Sam's young families.

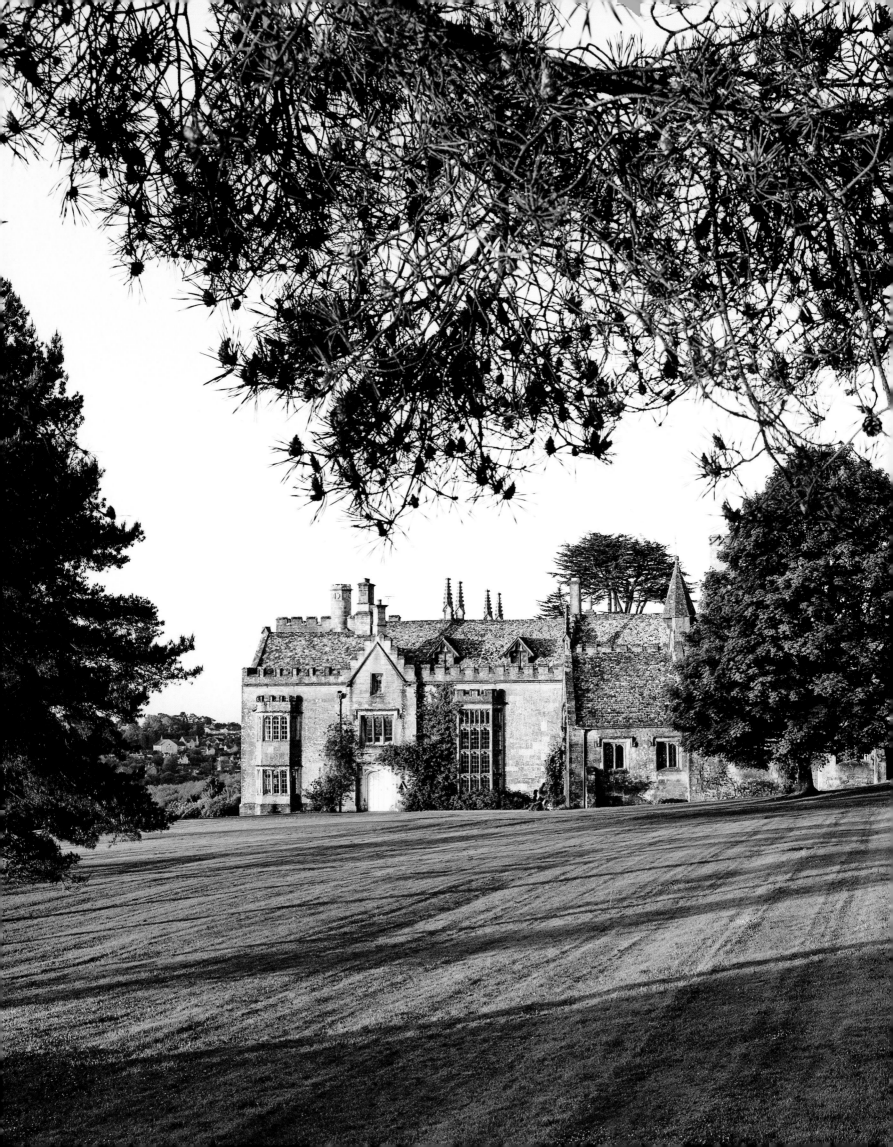

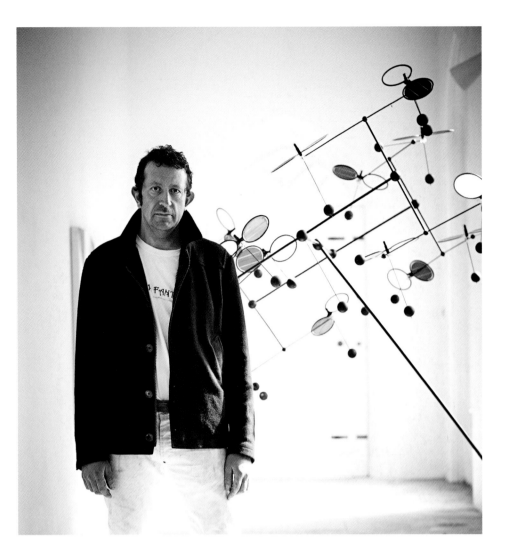

Daniel Chadwick
Born: 1965
Wife: Juliet
Sculptor, owner of iconic Woolpack Inn, and maker of tree-inspired mobiles

Left: The sculptor Daniel Chadwick with one of his mobiles inspired by trees. Opposite: Lypiatt Park, bought by Daniel's father, Lynn Chadwick, whose dream was that one of his children would take on the estate after he died.

DANIEL CHADWICK

GLOUCESTERSHIRE

The sculptor Lynn Chadwick once said that he bought his house, Lypiatt Park, for the same price as a three-bedroom house. He got the house cheaply because it was in a bad state of repair, and although he and his family have lived there for 50 years (Lynn died in 2003), the aura of Sleeping Beauty's castle still clings to its turrets and battlements.

The name "Lypiatt" comes from the Middle English word *hliepgeat*, or "leap-gate", meaning a low gate that can be jumped by deer or horses, but not by sheep or cattle, and refers to a time when the estate was farmland. Even today, Lypiatt Park is not so much a garden as a landscape. It offers spectacular views towards Eastcombe and the Toadsmoor Valley, and makes a wonderful setting for sculpture.

So it's rather disconcerting to discover from Daniel Chadwick, Lynn's son and himself a successful artist, that his father did not approve of sculpture

in gardens. "He hated the idea of it," said Daniel. "He never intended them to be framed in nature; he thought sculpture should be framed in a room or a gallery. But the space was there, so it seemed as good a place as any to put his work."

Lynn's sculptures are represented in the world's most famous art galleries, including the Tate, MoMA in New York, and the Centre Pompidou in Paris. They are very distinctive and often, but not always, on a monumental scale, and much of his work is inspired by natural forms. In 1956, he was the youngest sculptor ever to be awarded the sculpture prize at the Venice Biennale — beating the Swiss sculptor Alberto Giacometti, who was the favourite to win, and fellow Briton Eduardo Luigi Paolozzi.

However, even though he disliked the idea of displaying his work outside, he took a great deal of care in siting it, says Daniel — it wasn't just plonked

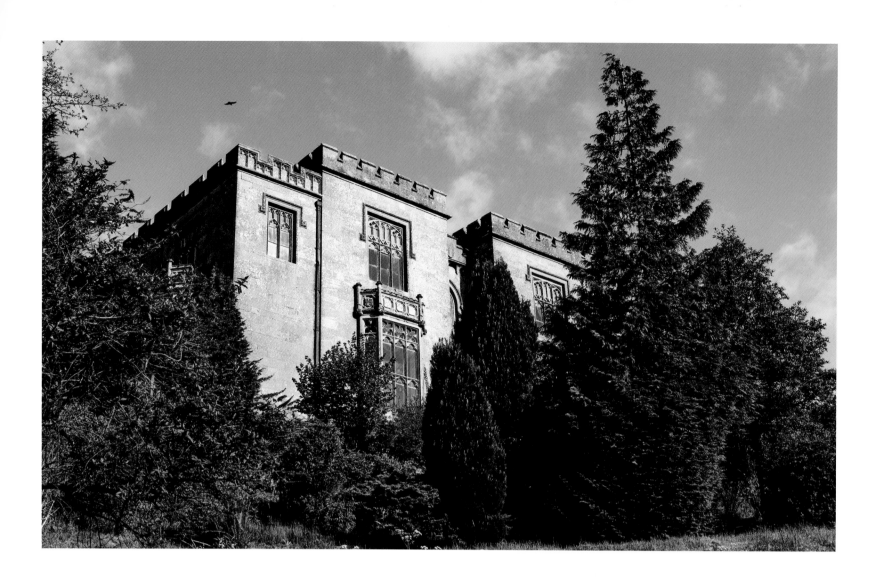

down in the first convenient spot. For a start,
such massive pieces need substantial plinths that
complement the sculptures and support their weight.

Ironically, while Lynn's works can be found *in*
the landscape, Daniel's art is *of* the landscape. One
of his pieces, an immense terrain that covers one
wall of the gallery inside the house, is created from
a topographical map of an area nearby.

He also produces kinetic sculptures, or mobiles,
inspired by trees and leaves or solar systems. His tree
mobiles, for example, which use brightly coloured
perspex shapes to represent leaves, are carefully
engineered so that, just like real trees, they are
stronger and more stable towards the base and more
flexible at the top. When I visited Lypiatt Park,
one of these mobiles was hanging over a stone ledge
outside the house, in the way that a tree might hang
over a cliff or a precipice.

Daniel studied engineering initially, but then
went to work with Zaha Hadid, the celebrated Iraqi-
born architect who died in 2016. He was employed
as a draughtsman and model maker, a job which
inspired him to develop his own kinetic sculpture.
Interestingly, Lynn also worked as a draughtsman
during the 1930s. He was studying architecture but
his studies were interrupted, never to be finished,
when war broke out. In 1941 he joined the Fleet Air
Arm as a pilot and after the war he returned to his
old employer, the architect Rodney Thomas, where
his work designing trade-fair stands inspired his
early sculptures.

It must be odd for an artist to share a space that
is associated so strongly with another artist, even
if that person happens to be your father. Visiting
groups will often arrive to see Lynn Chadwick's work
and more or less ignore the fact that Daniel, Lynn's

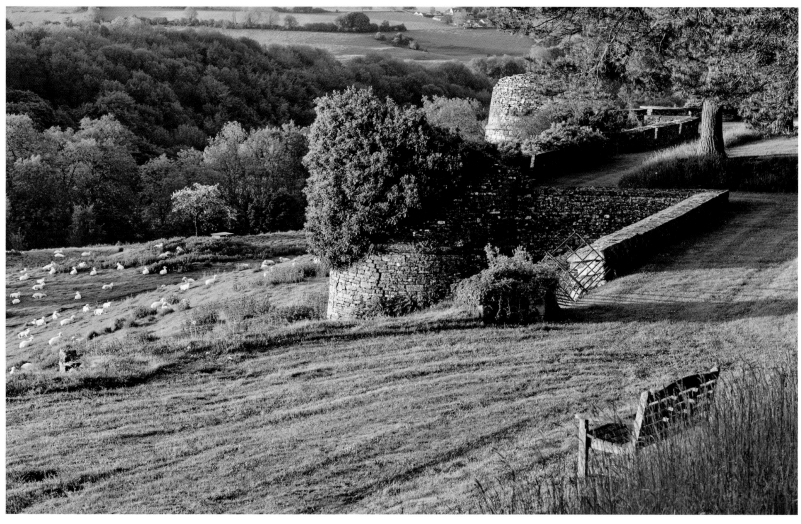

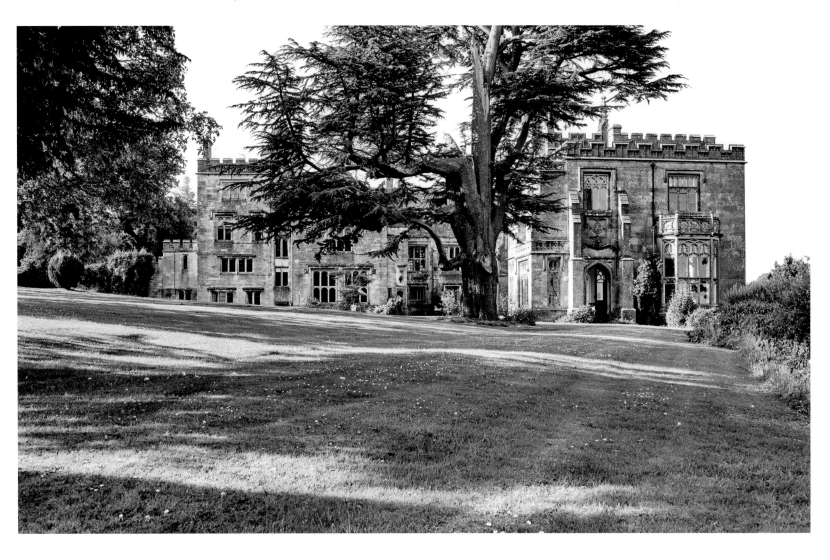

son by his third wife Eva Reiner, is an artist as well. "We are not used to the idea of artistic legacy in this country," said Daniel.

In 2014, the family opened the grounds of Lypiatt Park to the public to commemorate the 100th anniversary of Lynn Chadwick's birth, but while Daniel may maintain the house and grounds as a gallery for his own and his father's work, he takes issue with some of his father's taste in plants. "Towards the end of his life he planted all these pink things [Abelia]. I can never remember the name of them because I dislike them so much – I don't want to know what they are!"

Daniel may loathe Abelia x grandiflora, but it is a very useful plant, coming into bloom in late summer and autumn when most other flowering shrubs have given up for the year. Its tubular, scented flowers provide a clue that it's a member of the honeysuckle family, and

you can topiarise it into a neat ball or leave it to spread naturally. Semi-evergreen, it's described as being borderline hardy and most nurseries advise growing it in a sheltered spot, perhaps by a wall. This could be why the abelias at Lypiatt Park have survived so well – all those turrets provide the necessary protection. They grow alongside the white cedar, Thuja occidentalis 'Rheingold', whose feathery foliage complements the abelias' mahogany-tinted outer petals, and turns a coppery-bronze in winter.

Lynn had a fondness for cedars and many other conifers. He planted dozens of them – yews, false cypresses (Chamaecyparis) and larches, as well as cedars – and they now form a pinetum that covers two acres (0.8 hectares) of the site. Lynn is also buried here among his favourite plants beneath a huge stone slab.

The conifers add to the gothic atmosphere of Lypiatt Park, although much of the house and

Above: Lynn Chadwick's sculpture, Little Girl III, *sits in the shade of the pinetum. Opposite, clockwise from top: On the south side of the house, a cedar of Lebanon towers over the lawn while a carpet of* Cyclamen coum *provides spring colour at its base; Lynn Chadwick's sculpture,* Teddy Boy and Girl *looks out over a meadow; pink dahlias enhance the borders; a white magnolia blooms in the glasshouse.*

"*The chapel was reconsecrated in 1943 for American soldiers, who camped at Lypiatt Park ahead of the D-Day landings.*"

Above: The circular drive with a view of the valley beyond. Opposite, clockwise from top left: The sculpture High Wind, *one of a series by Lynn Chadwick, takes the gaze towards the trees; roses and clematis grow up the side of the 14th-century chapel; leopard's bane (*Doronicum*) provides a splash of colour at the base of a tree;* Sitting Couple on Bench, *by Lynn Chadwick.*

surrounding buildings are Gothic Revival, rather than medieval. The style is described by Historic England as "baronial fortress", and all the arrow slits and castellations are Victorian, although there is a medieval core, which includes the chapel.

The existence of a house on this site is first mentioned in 1220, but it is thought that both the granary and the chapel — now connected to the house by a Victorian covered walkway — date from the 14th century. The chapel was reconsecrated in 1943 for the use of American soldiers (the 158th Engineer Combat Battalion), who camped at Lypiatt Park ahead of the D-Day landings. Services then continued to be held there for local people until the early 1950s.

In 1395, it is recorded that Richard Whittington, lord mayor of London — the very same Dick Whittington who features in the pantomime story, along with his cat — took over the house in lieu of

payment of a debt, possibly of the gambling variety. The Dick Whittington story has documentary evidence to support it, but another popular story that describes Lypiatt Park as a meeting place for the men involved in the Gunpowder Plot is thought to be erroneous. It is true, however, that the house was used as a recording studio by the singer Lily Allen, who lives locally and whose father, the actor Keith Allen, is a friend of Daniel's.

It is doubtful that anyone would take over Lypiatt Park today in payment of a debt. It may have cost Lynn the same price as a small house, but the reason it was so cheap was because a landslip in 1946 had caused substantial damage. That damage was repaired but the upkeep of this extraordinary estate is still on a far grander scale than that of any suburban home.

To the south-west of the house, a neat, productive vegetable garden contrasts with the romantic

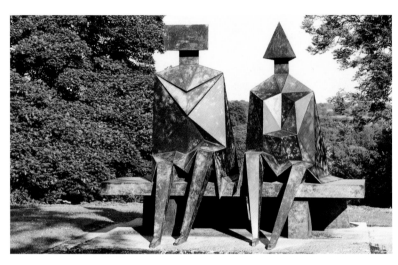

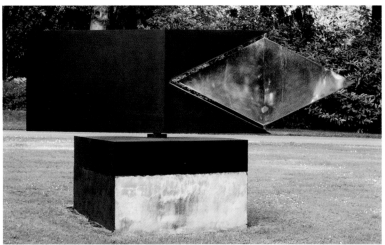

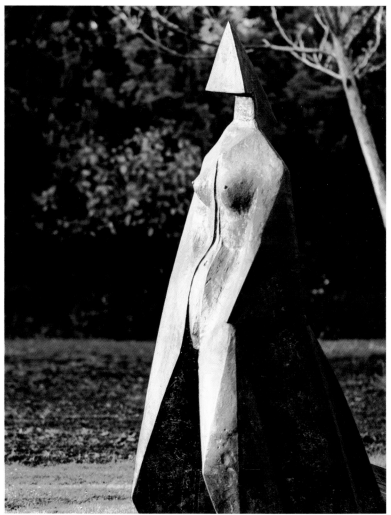

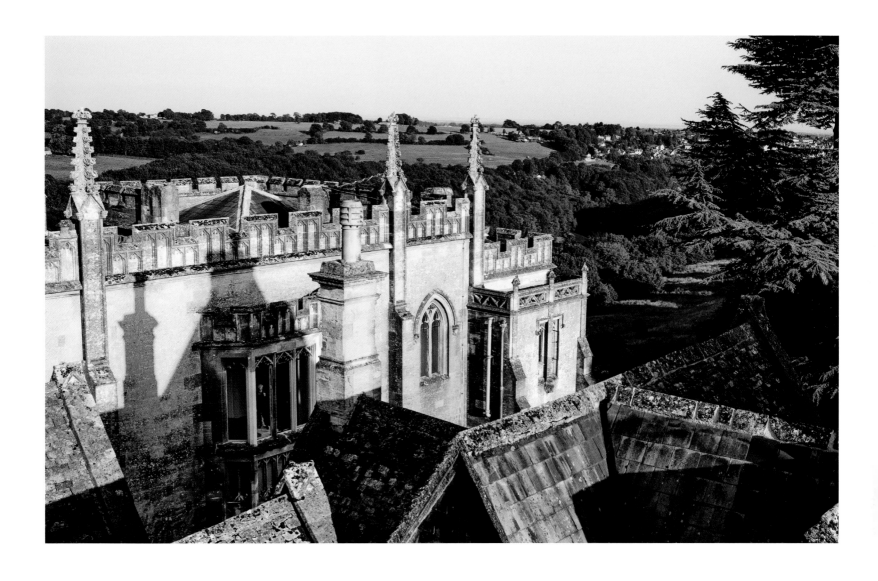

wilderness that is a feature of the rest of the estate. "We love our food," admitted Daniel.

At the far end of the garden to the west, there is a glazed summer house and a circular greenhouse that looks a bit like a miniature version of the Eden Project in Cornwall. Daniel can remember his parents sitting in there on wintry afternoons. A leylandii maze forms a focal point between the two structures, while one of Lynn's sculptures, a portrayal of two figures, stands behind a gate towards the edge of the estate. The sculpture reminds me of a couple waiting on the doorstep with a bottle of wine and wondering if their host has heard the doorbell.

Anne Wareham, garden critic and founder of the website thinkinGardens, believes there are three ways to make sculpture work in a garden. You can have what is basically an outdoor gallery, where the art takes precedence over everything else. Or you can design a garden around an artwork, so that from the start, the issues of proportion and contrast are addressed. The third option, says Wareham, is when the need for something sculptural emerges from the garden itself, and has some sort of meaning.

Sensibly, Daniel Chadwick is following the first option and wants to simplify the garden so that the detail of the sculptures, and the house, can take precedence. In an art gallery, the walls are plain and without frills, and the same principle applies to gardens that display artworks. Busy planting combined with lots of sculpture can look cluttered and fussy, and at Lypiatt Park, with its commanding position at the top of a ridge, the dramatic landscape provides the perfect setting.

Perhaps if the best person to position a plant in the right place is a gardener, then the best person to design a sculpture garden is a sculptor.

Above: The decorative stonework on this part of the house is Jacobean. Opposite, clockwise from top: Two Watchers V, *by Lynn Chadwick, behind the ornamental gates leading to the glasshouse;* Cloaked Figure IX *by Lynn Chadwick; the vast leaves of giant butterbur* (Petasites japonicus) *line a grassy path;* Ace of Diamonds, *one of Lynn Chadwick's kinetic sculptures.*

Gus Christie
......................................
Born: 1963
Chairman of Glyndebourne,
and owner of gardens that
help musicians perform and
visitors enjoy opera

Danielle de Niese
......................................
Born: 1979
Opera's coolest soprano,
according to The New York
Times, *and mother of*
Bacchus Christie

Left: Gus Christie and his
wife Danielle de Niese.
Right: The elegant house in
East Sussex that inspired the
Glyndebourne opera festival.

GUS CHRISTIE

EAST SUSSEX

If one ever needed to tempt an ardent English opera fan from the path of righteousness, then a ticket to the annual opera festival at Glyndebourne may well serve successfully as a bribe. One of the world's most famous country house opera festivals, it has everything that the aficionado could desire: world-class music, wonderful staging, an enticing mix of new work and old favourites, and a delightful setting in the South Downs. It's only an hour from London by train (two hours by car), yet it feels a world away from the bustling capital.

Glyndebourne's most magical ingredient is, perhaps, the sense of occasion that imbues an evening spent there. In an era when theatregoers routinely wear jeans, and even a first night is characterised by office suits rather than evening wear, the idea of dressing up holds a nostalgic appeal. The British love their dress codes (it saves so much trouble), but more

than that, they love their gardens, and they love their music. Put the three together, throw in a picnic and a glass or two of champagne, and you've come pretty close to their idea of paradise.

While visitors can enjoy the ambience, the gardens are, in fact, designed primarily to benefit the performers. From the beginning, founder John Christie, followed by his son George and grandson Gus, now chairman, have been faithful to the idea that if you take people out of a chaotic, stressful world and put them in Arcadia, they make better art.

Gus now lives at Glyndebourne with his wife, the Australian-American soprano Danielle de Niese, and their son Bacchus. Danielle made her debut at the Glyndebourne festival in 2005, when she stepped in at the last minute to take over the part of Cleopatra in Handel's opera, *Giulio Cesare*. Bacchus was born in June 2015 and just three months later, Danielle was

Above: The intense blue of salvias dominates the border by the main lawn, with asters and campanula in the foreground.
Opposite, above: Columns of Portugal laurel and box punctuate the borders by the house, providing an evergreen foil for the herbaceous plants.
Opposite, below: Plants are allowed to spill onto the path to create an atmosphere of celebratory exuberance.

back on stage, performing at the Last Night of the Proms at the Royal Albert Hall in London.

John Hoyland, gardens adviser at Glyndebourne, says that working there is like being in a beautiful bubble. "If you talk to the singers, they all say they've done their best work at Glyndebourne. Paul Brown [the opera designer] said that when you come out of the stage door in a big city, you're normally in a dark alley where they keep the bins. At Glyndebourne, you come out of the stage door and you're faced with the most extraordinary landscape."

The festival runs from the end of May to the end of August, but rehearsals begin in March. During this period, the conductors, directors and designers stay at the house, which helps to explain why Glyndebourne has a vegetable garden. According to John, they all have healthy appetites, so while running the garden is labour-intensive, it offers a

practical solution, and helps maintain a low carbon footprint. As well as limiting the food miles, the Christies are also keen to reduce plant miles. Everything is propagated on site, apart from some of the trees, which helps to keep these horticultural skills alive and means the gardeners can grow what they like, rather than what the nurseries can offer.

The estate also includes a cutting garden where flowers are grown for the public rooms in the house, such as the Organ Room, and if you look at the Glyndebourne website, you can see a video of head gardener Kevin Martin demonstrating how to make a beautiful bouquet.

The gardens are intrinsic to the Glyndebourne experience, and as the opera festival has evolved over the years, so have they. Even the best gardens benefit from periodic reappraisal, and when John Hoyland — plantsman and award-winning garden writer — was

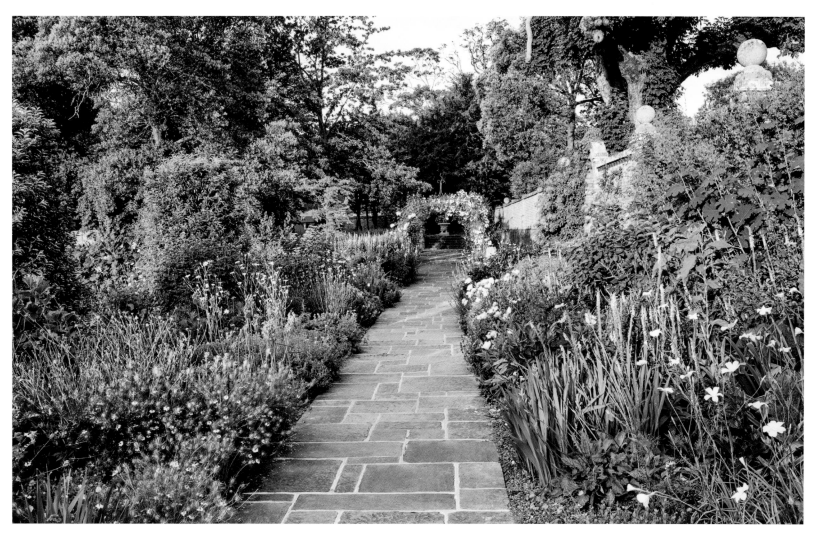

Above: Free-flowering Rosa *'Bonica' alternates with laurel pillars in a pattern that is reminiscent of the final chords of a Mozart overture. Opposite, clockwise from top: The Mary Christie Rose Garden, named after Gus's mother and opened in 2015; the Figaro Garden; the Henry Moore sculpture, called* Draped Reclining Woman *(1957-8); foxgloves and verbascums mingle in a pastel colour-themed border.*

appointed gardens adviser in 2010, he worked with Kevin Martin on overseeing these changes, taking one section of the garden at a time. The coach park was moved and a wildflower meadow established in its place, and the Mary Christie Rose Garden, named after Gus's mother, was also created.

John explains that different operatic works can evoke very different emotions, and areas of the gardens have been designed with this in mind. "We're aware that when you come out of an opera with a huge, upbeat finale, you're buzzing: you want colour and excitement, like the exuberance of the double borders alongside the house. If you've just seen *Jenufa* [by Leoš Janáček], with its grim storyline involving infanticide, you don't want all that brouhaha, and a walk around the lake may suit your mood better."

The exotic Bourne Garden, with its jungly planting, leads up to the opera house itself, and

coming out into this area during the interval for a breath of fresh air is like leaving the drama inside the theatre and finding new drama outside. By the doors, scented plants waft their fragrance over the opera-goers. Hardy white gloxinias (*Sinningia tubiflora*), with their grey foliage and white tubular flowers, and night phlox (*Zaluzianskya ovata*) are used because their perfume is strongest as evening approaches.

It goes without saying that the gardens have to look their best during the festival, but it's a tricky time. May, June and July are no problem, but August is a notoriously difficult month. Many roses and summer-flowering perennials have gone over, while the later summer and autumn stalwarts, such as asters and rudbeckias, haven't got into their stride. "The August dip is hard," admitted John, "but we fill the gaps with lots of annuals and tender perennials."

Apart from John, who spends two days a week

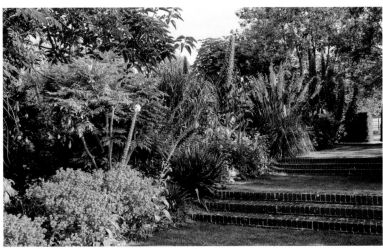

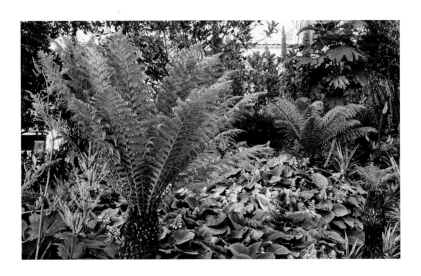

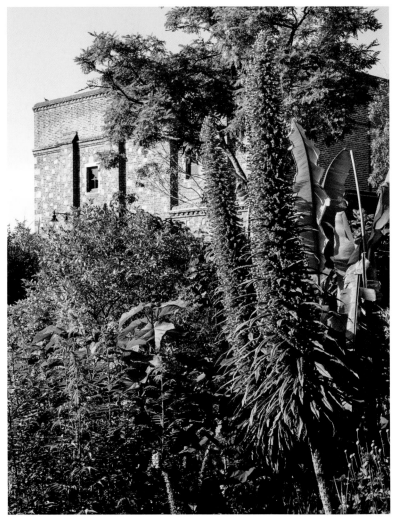

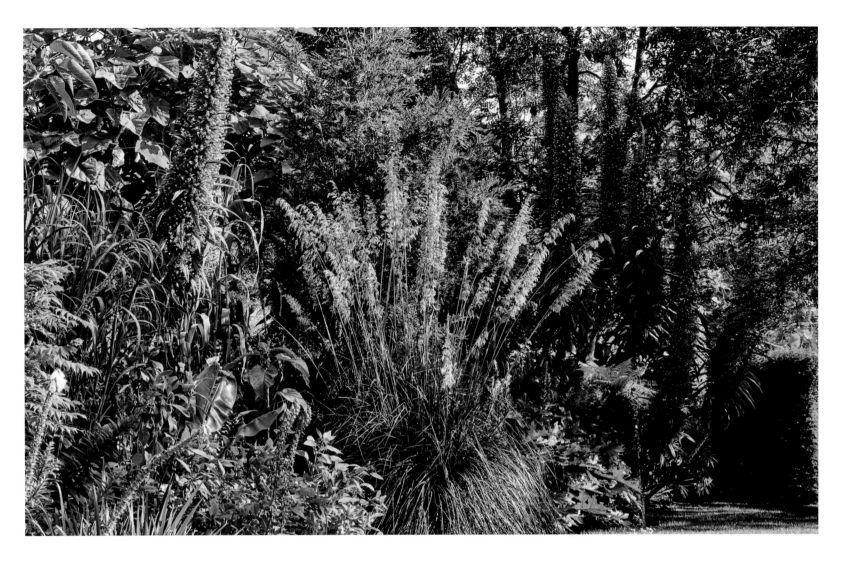

"*Different operatic works can evoke very different emotions, and the gardens have been designed with this in mind.*"

at Glyndebourne, and Kevin Martin, who has been there for 22 years, there are six full-time gardeners, including one apprentice. In the past, the gardens were seen as the province of the wives: Gus's grandmother, Audrey, looked after the garden herself, then his mother Mary took over the reins. Mary said she knew nothing about gardening when she first arrived but luckily Moran Caplat, the general manager at the time, knew a man who did. He introduced Lady Mary to the late Christopher Lloyd, an ardent opera fan and world-famous plantsman, whose garden at Great Dixter was just an hour away.

"Christo kept me going," she said. "He would arrive here and say, come on, what are you going to do about this bit — even when I was heavily pregnant. He used to bring his head gardener Fergus [Garrett] with him, and we would walk around the garden together. Christo also loved having lunch in the

canteen with all the singers when he visited. His colour sense was not mine, though — he loved putting purple next to yellow, and orange next to pink, and that's not me, but he was wonderful."

Lady Mary and her husband, Sir George, who died in 2014, oversaw the building of the new opera house, which opened in 1994. She also took creative control of the changes to the gardens. It sounds rather daunting, but she declared that she has never enjoyed anything so much, and a picture of her and George on the building site at the time, both beaming from ear to ear, bears this out.

Her role in the development of the estate has been largely unsung, if you will excuse the pun, and this is one of the reasons for the Rose Garden, created in her honour and the first new garden to be opened since 1994. "People were a bit surprised when we said we were making a rose garden," said John, "but Lady

Above: The grass **Stipa** **gigantea** *dominates a border. Opposite, clockwise from top: The Bourne Garden, by the entrance to the opera house and sheltered by its brick walls, is filled with huge jungly leaves and dramatic spires; the tall flower heads of giant viper's bugloss (*Echium pininana*) compete with hardy bananas; tree ferns (*Dicksonia antarctica*) rise up from clumps of glaucous hostas; a tapestry of leaf shapes make up the Bourne Garden, created by Mary Christie.*

*Above: The White Cube gallery at Glyndebourne, with the frothy cream flower heads of goat's beard (*Aruncus dioicus*) in the foreground.*
Opposite, above: Behind the White Cube gallery, the formal gardens give way to a more rural landscape.
Opposite, below: Gus uses this lake studded with water lilies for the occasional swim.

Christie deserves to be celebrated. She was the backbone of Glyndebourne for 50 years, at the same time as she was bringing up four children. We haven't done anything too Edwardian; we wanted it to be quite lighthearted, with whimsical topiary and so on." One of the roses that features in the garden is, naturally, *Rosa* 'Glyndebourne', a modern shrub rose with shell pink flowers and a soft fragrance.

The opera festival was founded in 1934 by Sir John Christie, who inherited the property in 1920. In 1923, he acquired the organ firm Hill, Norman and Beard (an amalgamation of two of the UK's most famous organ builders), and as part of the renovations to the house, he built an organ room, in which he held concerts for friends.

At one of these events, a young soprano called Audrey Mildmay was hired to perform in a production of Mozart's *Die Entführung aus dem Serail*

(*The Abduction from the Seraglio*). John fell in love on the spot, and after they were married, he decided to build an opera house.

There is a common misconception that the operas at Glyndebourne are staged outside or in a marquee. This is not the case. The opera house is a world-class venue, with very high production standards, and seating for 1,200 people. Singers also love it because of the long rehearsal period and long run of performances, which gives them time to relax in this wonderful environment.

Asking Lady Mary if she has a favourite part of the gardens where she has spent so much of her life is like asking her which of her four children she likes the best. After much thought, she said: "I think the position of the gardens. Coming out of the house and seeing the magnificent South Downs around us, that is the best thing about Glyndebourne."

Julian Clary
Born: 1959
Husband: Ian Mackley
Comedian, actor, novelist
and admirer of Vita Sackville-
West and Sissinghurst

*Left: Julian Clary grew up
in Teddington, where he
remembers his father growing
runner beans and pink roses.
Opposite: The 15th-century
manor house where Julian has
lived since 2006 was once
the home of the writer and
actor Noël Coward.*

JULIAN CLARY

KENT

When Julian Clary moved into his cottage in the Kentish village of Aldington, he was aware that it had once been the home of the actor, playwright and songwriter Noël Coward. What he didn't realise was that the spirit of Coward had yet to move out, and manifested its disapproval of the new owners by knocking pictures off the walls and breaking things.

Julian brought in a friend who was a medium to issue a sort of supernatural ASBO, and the incidents stopped. However, I think that if Vita Sackville-West chose to haunt the house, Julian would be absolutely delighted. He is a huge admirer of the gardens at Sissinghurst Castle, which Vita developed with her husband Harold Nicolson from 1930 until her death in 1962. It is just 30 minutes away by car from Julian's home, and if a fairy godmother were to wave her wand, he would like to have his garden transformed into a smaller version. He has a *Rosa mulliganii*, the

famous rose that grows at the centre of Vita's White Garden, and a white border with 'Iceberg' roses and an 'Albéric Barbier' scrambling up the wall.

Fairy godmothers have waved their wands quite a lot in Julian's life. He has played the slave of the ring in *Aladdin*, and Dandini in *Cinderella*, reprising this role alongside his friend and neighbour Paul O'Grady, who played the wicked stepmother, at the London Palladium in December 2016. In fact, it was Paul who told Julian that the Aldington cottage was up for sale. He himself had moved to Kent in 1999, buying a farmhouse from comedian Vic Reeves with enough land for a smallholding to keep his beloved animals.

Aldington is 15 minutes by car from Ashford International station, and from there it's just a 45-minute train journey to the centre of London. Listed in 2016 by *Country Life* magazine as one of the six best villages and towns in Kent for commuters,

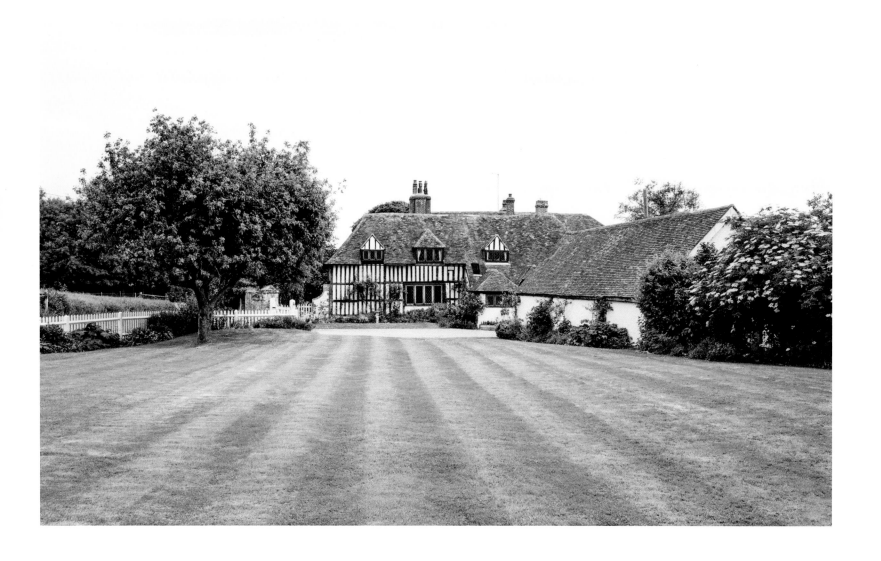

Above: When Julian first moved in, the garden contained nothing but weeds and Michaelmas daisies. Now a neat lawn contrasts with the cottage-garden borders. Opposite, clockwise from top: Pink mophead hydrangeas provide colour when their backdrop of climbing roses are not in bloom; Clematis 'Étoile Violette' and Paeonia lactiflora 'Duchesse de Nemours' decorate the white-washed walls; the sumptuous climbing rose 'Sir John Mills'.

it has always been popular with celebrities, offering a rural idyll within easy reach of the capital.

Coward had moved to Aldington at the age of 26, initially renting the cottage and then buying it. At the time, his parents, his aunt Vida and his manager and partner Jack Wilson shared his house in Ebury Street, in a fashionable part of London, and his mother was less than impressed by the idea of moving to the country. She wrote to him, lamenting: "After settling me in this comfortable house you want to send me to live in the cottage. How much better to have gone while you still loved me."

The house was extended to accommodate all of these relatives and friends, as well as the many guests who came to stay, by converting the barn next door and an adjoining cottage. Coward did much of his writing there, including one of his best-known songs, "A Room with a View" (1928). However, his

attitude to the beauty of nature was ambiguous, reflected in the line "Very flat, Norfolk" (*Private Lives*, 1930). Visiting friends would often comment on the wonderful sunsets over Romney Marsh, but on one occasion Coward glanced at the vermilion sky and pronounced it: "Too red. Very affected."

The house looks like a Hollywood vision of a typical English cottage. The oldest parts are 16th century, and it is half-timbered, with the traditional black beams, plaster infill and a roof made of red clay tiles. But these features come at a price, and the cost of maintaining such a property eventually became prohibitive. Coward sold it in 1956 to the theatre director Milo Lewis, setting out the reasons for the sale in a letter to Laurence Olivier the following year: "Goldenhurst (five gardeners all year round, lighting, heat, etc.) was costing a fortune." Milo Lewis then divided the house in two, and Julian owns

"*Roses do well on clay, and Andrew has planted lots of them, including* Rosa mulliganii, *which grows over the gate.*"

what was the adjoining cottage, which formed part of Coward's extension.

Julian began his career in the mid-80s, first on the alternative comedy circuit and then on television. He has appeared as an actor, presenter and a performer, and he has also written several books, including an autobiography and three novels, the latest of which, *Briefs Encountered*, is loosely based on his paranormal experiences at the cottage.

He is a controversial comedian, criticised by some members of the gay community for perpetuating a stereotypical image of camp bitchiness, and by the more conservative press for the smuttiness of his jokes. His performance in *Cinderella* at the Palladium, for example, unleashed a paroxysm of harrumphing from *The Daily Telegraph*.

He never uses bad language, but relies on innuendo, the lines delivered in a gentle, languid tone. This probably explains his legions of female fans, who find it a refreshing change from traditional mother-in-law jokes and expletive-laden rants.

The thought of Julian Clary gardening, or cleaning out chickens, or discussing carrot fly and organic slug deterrents with Paul O'Grady, is a somewhat surreal one, but he rejects the idea that he is not capable of doing mundane chores like everyone else. "Maybe people imagine I'm camp and outrageous all the time, and that I wear full make-up and glittery outfits when I'm at home doing the hoovering. In fact, I wear just a touch of raspberry lip balm and a drip-dry kimono — just like anyone else."

Julian shares the house with his partner, Ian Mackley. The two met in 2005, and were married in November 2016. They have a dog, Albert, and a chicken called Maureen. There were more chickens, and even a couple of ducks, but the fox got them.

Above: Julian has a potted herb garden just outside the back door, where it is ideally located for the kitchen. Opposite, clockwise from top: The rose growing over the gate is Rosa mulliganii, *supplemented with* Rosa 'Iceberg'; *a pot of airy* Gypsophila elegans *adds to the cottage garden theme; lupins are one of Julian's favourite flowers; edible chive flowers adorn the herb garden.*

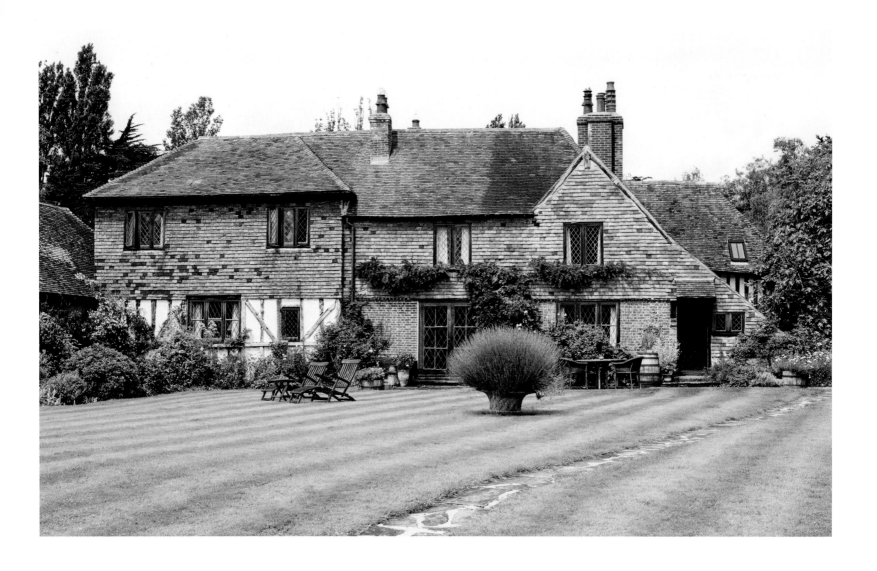

Above: A crazy-paving path provides a route across the lawn, past an enormous stone urn of lavender.

Opposite page, clockwise from top: The view from the lavender urn; the rustic-style swing seat has a little thatched canopy; a sunny cottage-garden border contains Shirley poppies, lamb's ears (Stachys byzantina) and rose campion (Lychnis coronaria); the stump of the 400-year-old mulberry tree is adorned with a pink-flowered clematis.

This came as a bit of a relief to Julian's gardener, Andrew Ashton, who has worked for the couple for eight years. Animals are allowed to roam freely around the garden, and the combination of chickens and precious plants is not always a happy one, even if – like Julian – you favour the cottage-garden style, rather than something more formal.

When Andrew first arrived, the garden was in a bit of a mess. "It was a sea of weeds, and there was an aster [probably *Symphyotrichum* x *salignum*, the common Michaelmas daisy] that had seeded itself all over the place. There's also a big seam of clay that runs right through the garden, and certain things just won't grow there. So we had to try some more robust plants and see what worked."

Roses do well on clay, and Andrew has planted lots of them, including 'Sir John Mills', 'Shot Silk', 'Paul's Himalayan Musk', and the famous *Rosa*

mulliganii, which grows on an arch above the gate. "It flowers for about five weeks," said Andrew, "and it has the most wonderful fragrance. 'Paul's Himalayan Musk' is also supposed to be very fragrant but I can't say I've noticed particularly."

Aside from roses, there are hellebores in early spring, aquilegias and alliums, including the huge-headed *Allium* 'Globemaster' in late spring, followed by peonies (*Paeonia lactiflora*) and lupins in early summer. From late summer, white hibiscus, grown with *Verbena bonariensis*, decorate the borders close to the traditional white picket fence.

The hibiscus is *Hibiscus syriacus*, which is hardy in the UK, unlike its Caribbean cousin, *Hibiscus rosa-sinensis*, which has brighter-coloured flowers. The former is a pretty shrub with white, blue or pink blooms, but it comes into leaf very late and it can be tempting to think the plant has died in early spring before the

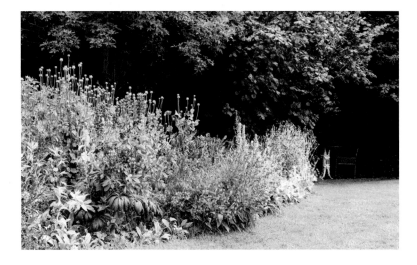

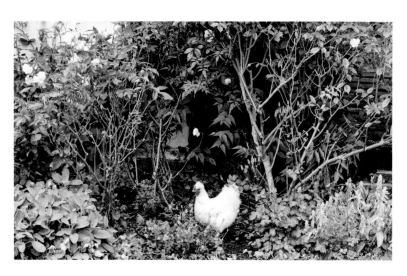

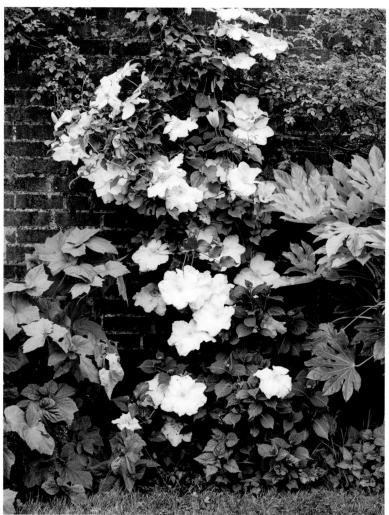

foliage emerges. Your patience will be rewarded, though, if you can provide the full sun and good drainage it needs to thrive, and by late summer the large flowers put on a spectacular show. They are similar to mallow, or lavatera, and look good with grey-leaved perennials, such as rose campion (*Lychnis coronaria*) and lamb's ears (*Stachys byzantina*). Julian has a border filled with these drought-tolerant stalwarts alongside Shirley poppies, the tall, glaucous-leaved relatives of the common corn poppy.

A herb bed at the front of the house includes chives, thyme, golden oregano and dill, with pots of seasonal bedding set around it providing colour. Andrew buys all his bedding from the Canterbury Oast Trust, which runs a nursery that provides work and training for adults with learning disabilities.

The mulberry tree stump halfway down the crazy-paving path, which cuts through the back garden,

is the subject of many stories, or urban myths, as Andrew calls them. He believes the tree could be 400 years old, while the clematis that scrambles over it was a present to Julian from a friend. The clematis label has been lost, so no one knows what it is, and the large pink late spring flowers don't exactly narrow down the choices.

Andrew's own background is in fine art. He studied at Stourbridge College of Art (now part of Stourbridge College) and Central St Martins. He then did a teaching qualification and still teaches art history at adult education classes. Modest about his gardening skills, he says that while his mother was a good gardener, he just uses his instincts. "Gardening is a bit like art. You try something and if it doesn't work, you adjust it." His approach to Julian's garden is just as straightforward. "I have an idea of what he likes, and I just try to replicate it."

Above: The pale Geranium clarkei *'Kashmir White', combines with bright red and pink flowers of a shrubby salvia, rock rose (*Cistus*) and rose campion (*Lychnis*). Opposite, clockwise from top: The bird motif on the house has been there since Noël Coward's time; the early summer flowers of* Clematis *'The Bride'; Maureen the chicken — the rest of Julian's hens were eaten by a fox; the rock rose,* Cistus x argenteus *'Silver Pink'.*

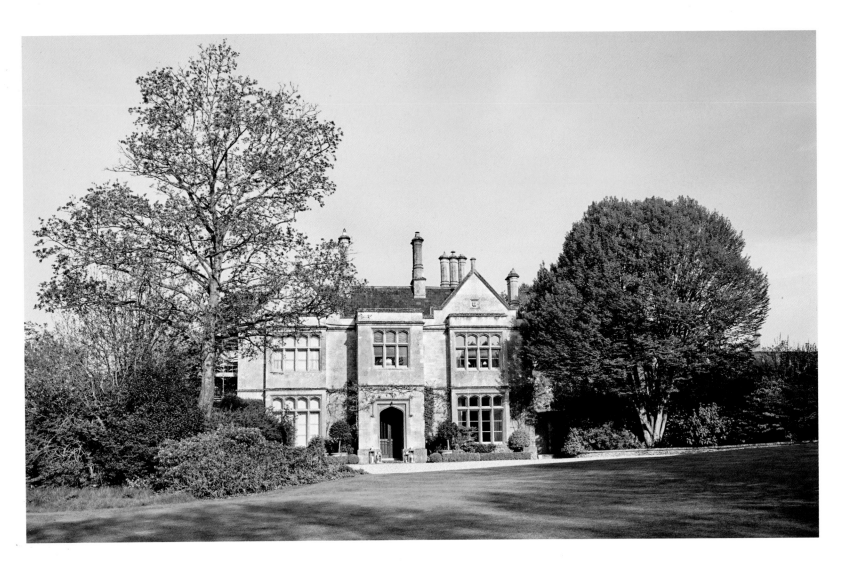

CHRISTOPHER & ANNE EVANS

GLOUCESTERSHIRE

Professor Brian Cox may have swapped the life of a rockstar playing keyboards with D:Ream for the Large Hadron Collider, but society today has a tendency to assume that art and science are opposites and quite separate. Science is seen as being about facts (and rather boring), whereas art is about creativity (and much more exciting).

It is an attitude that Anne Evans, the wife of biotechnology pioneer and entrepreneur Sir Christopher Evans, finds frustrating. "During the Renaissance, these barriers didn't exist, and art and science were the same thing. Look at Leonardo da Vinci — he was both an artist and an engineer."

Good science, like good art, is the result of investigation and observation. Chris Evans knows this from first-hand experience: he studied microbiology at Imperial College in London, followed by a PhD in biochemistry at Hull, where he met his wife.

He then took up a research fellowship at the University of Michigan where his post-doc pay packet was so low, he used to scrounge leftover pizza crusts to get by. His luck changed when he started giving lectures to American companies on microbial physiology, which resulted in the offer of a much better-paid job.

He was still a scientist, and still in a laboratory, but this time he was working on a patent application. He realised that applying scientific discoveries to everyday life involved doing deals, and the person most equipped to do this was, as he put it, the one "who can best convey the real value of what has been created". In other words, scientists are most qualified to tell the story of their product in a way that is both compelling and authoritative.

Chris is now chairman of Excalibur (formerly Merlin Biosciences), with a string of biotechnology start-ups behind him, and more letters after his

Christopher Evans
...
Born: 1957
...
Wife: Anne
...
Scientist, investor,
entrepreneur, fan of poolside
...
business meetings and
cheerleader for the garden shed
...

Above: The former vicarage where Christopher and Anne Evans live nestles in 15 acres (6 hectares) of land.
Right: The laburnum walk, designed by Rosemary Verey, is similar to the one she made in her own garden at Barnsley House in the Cotswolds.

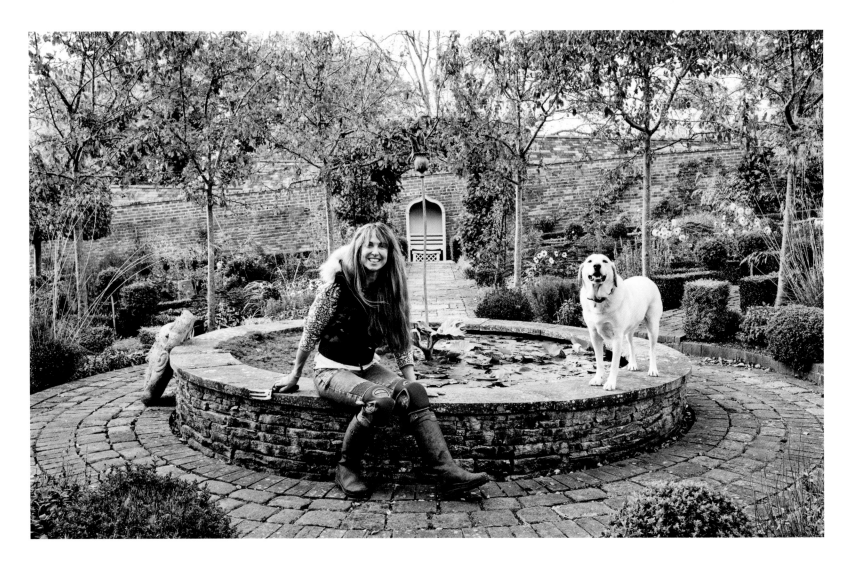

"Anne doesn't believe that historic gardens should be preserved unchanged and feels that they should evolve naturally."

name than there are in the Russian alphabet. Not bad for a steelworker's son from a council estate in Port Talbot. He still has strong links with Wales: he is close to his family and often heads off to the rugby (he has a box at Cardiff's Millennium Stadium) with his old school mates.

Anne Evans, on the other hand, dreamed of going to art school. She was also musical and played violin in the local youth orchestra, but was encouraged to do a degree in English literature, which her parents felt might result in a "proper" job. Since then, she has devoured knowledge of art and the applied arts in a way that some people eat chocolate. If she's interested in something, she will read up on it extensively, a process she calls "feeding my soul".

The couple bought their former 19th-century vicarage in 2000. The limestone building with its Welsh slate roof was possibly designed by the

architect Anthony Salvin, who was working for Lord Sherborne in 1844 when it was built. Sherborne owned the "living", which meant he had the right to decide who should be appointed as vicar. In such cases, the clergyman was often a member of the family, so could expect fairly good accommodation.

Although the house and grounds are in a village popular with tourists, it is so secluded, you would hardly know it's there. The only clue is a glimpse of honey-coloured Cotswold stone cottages, built in the local limestone, through gaps in the trees. At first, Chris and Anne used the house as a weekend home, but they have now lived there full-time for 12 years. It took two and a half years to restore, recalls Anne, because while they didn't plan to recreate the 1844 original, they wanted to respect its historic integrity.

When Anne finally turned her attention to the garden, it was looking sad and neglected, although

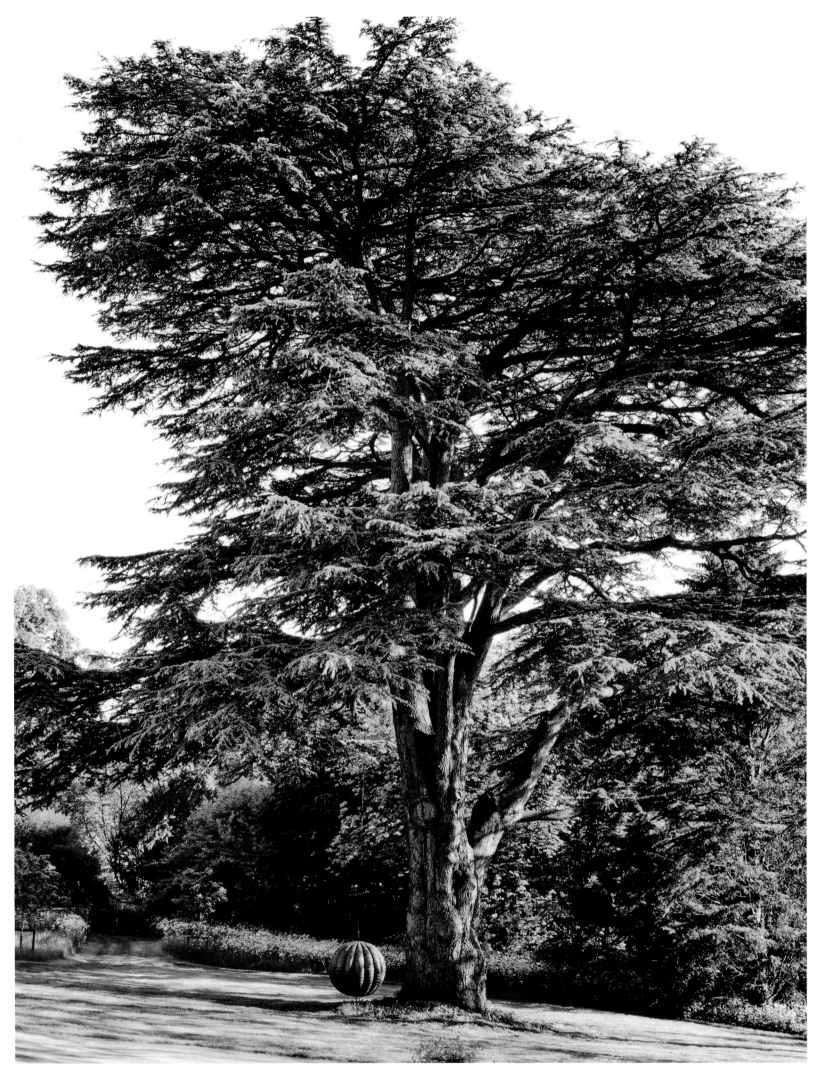

Above: The Italian Garden was designed by Stephen Woodhams, and features a stone pergola covered in pink and white roses.

Opposite, clockwise from top: The box parterres beneath the pergola are filled with peonies; a garland of Rosa *'Veilchenblau'; the parterres are punctuated by pencil-thin Italian cypresses (*Cupressus sempervirens*); a formal pond provides the focus of the Italian Garden.*

the structure seemed to have changed very little since it was created in the 1840s. Anne discovered that the late Rosemary Verey had designed the garden 30 years previously. Rosemary was one of the most celebrated designers of the 20th century, who famously helped Prince Charles to design his gardens at Highgrove. "Rosemary's plan was very sympathetic to the original," said Anne. "She put her layer on it but didn't change it too much."

Like many couples, Anne and Chris use the garden in different ways. For Chris, it is a place to work and relax, which may sound contradictory, but he uses different spaces for different things. His sanctuary is a log cabin, hidden from view behind the garages, with its sunny lawn screened by large shrubs such as fuchsias. "Sometimes I sit inside, sometimes I sit outside on the step with a cup of tea. It's a great place to think," he explained. Chris also

has a second "shed", as he likes to call it. This is a much larger structure where he works, plays guitar, holds meetings and throws parties. Another work space is, surprisingly, the pool area, where there is a bar and a coffee machine, and big, comfortable faux rattan sofas that allow you to sprawl in comfort. Work? By the pool? Seriously?

"You go out there in the morning on a sunny day," explained Chris, "and it's warm, and the sun is sparkling on the water, and it makes you feel great. We have meetings there — people can spread out their papers on the sofas or the tables, and there's superfast Wi-Fi and my Sonos sound system."

Chris is quick to credit Anne with the creative style of the garden. "We sometimes walk round the garden, often with a glass of champagne, and I say to her, 'this is just perfect.' The trouble is, you want it to stay exactly like that." Anne is more pragmatic.

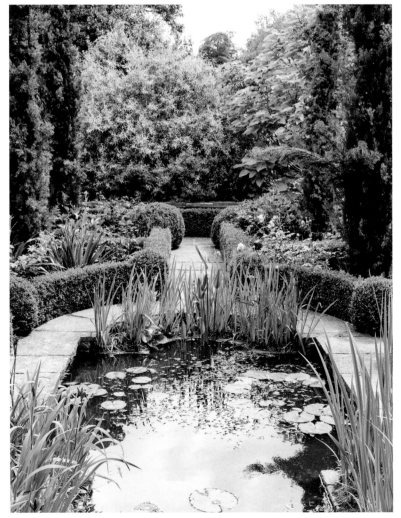

She doesn't believe that gardens, even historic ones, should be preserved unchanged and feels that they are best allowed to evolve naturally. She also knows that gardening involves hard work, pointing to the herbaceous border in front of the main terrace. "I dug that border out, I put manure on it, and I planted it. I did it all, because I wanted it done properly."

In an ideal world, she would have liked to ask Rosemary Verey to help her restore the garden, but Mrs Verey died in 2001. Instead, she commissioned Stephen Woodhams, who designed the pool area and the Italian Garden, with its cypress trees and pergolas supported on classical stone columns, clad in climbing roses. The pool area is sunny and secluded, and here Stephen has created a Mediterranean-style garden, with palms and olive trees in enormous pots.

Stephen also designed the main terrace, adding topiary to create structure and provide a unifying theme. The formal pool on the terrace has a fountain of bronze leaves by the New Zealand sculptor Simon Allison, who created a similar one for Kiftsgate Court Gardens, not far from the Evans' estate.

Stephen says he enjoys working on a project like Chris and Anne's garden, where you can come back and see how things look, and add something new, even years later. One of his most recent additions is a small grove of silver birches (*Betula pendula* 'Swiss Glory') between the pool enclosure and the Cedar of Lebanon on the west lawn, which he has underplanted with ribbons of cream narcissi. The design is inspired by Bridget Riley's paintings.

On the opposite side of the house is the kitchen garden, walled on three sides and situated on a south-facing slope. It used to have four walls but one side is now screened by a hornbeam hedge. It was completely derelict, apart from some old espaliers, recalls Anne,

Above: The bronze leaf fountain is by the renowned sculptor Simon Allison. Opposite, clockwise from top: The Courtyard Garden is Anne Evans' own design; the bronze sculpture of The Red Queen, *by Robert Ellis and James Coplestone, is one of several* Alice in Wonderland *characters in the garden;* Lady Hare with Minotaur *by Sophie Ryder stands by a box hedge;* The Mad Hatter *by Robert Ellis and James Coplestone.*

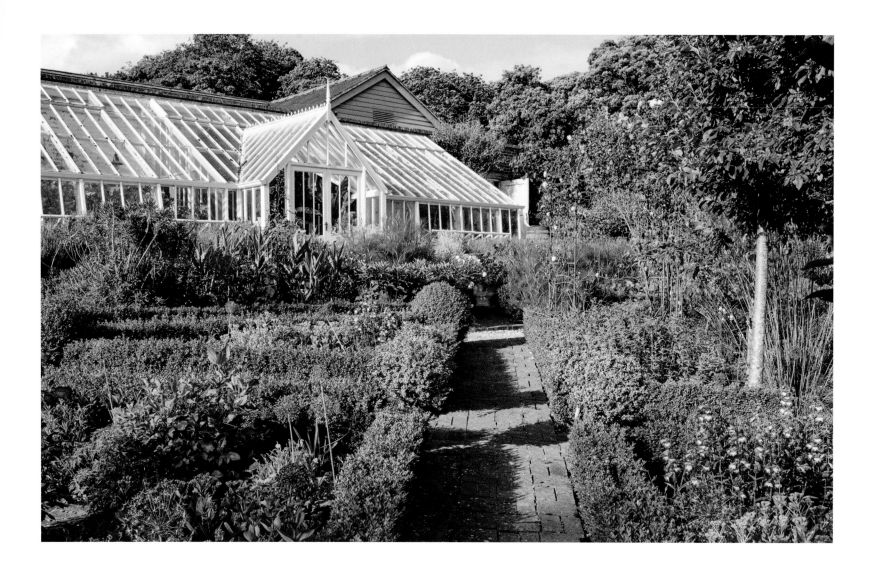

who asked the greenhouse specialists Alitex to build
a replacement glasshouse on the original footprint.

There is now a series of clipped box enclosures,
with two pergolas made from apple trees (including
cox, russet and cookers) trained over hoops, and a
circle of crab apples around a central pond. Anne
grows a few vegetables here, but most of the planting
is ornamental. As with many old Victorian kitchen
gardens, the site is just too big for the needs of one
modern family.

The garden that is closest to Anne's heart is the
Courtyard Garden on the north side of the house,
which has an *Alice in Wonderland* theme. It is very much
her personal creation and features many of her
favourite plants, such as foxgloves, delphiniums,
lupins and the purple-leaved American redbud,
Cercis canadensis 'Forest Pansy'. She loves glowing Pre-
Raphaelite colours, such as deep purple and burnt

orange, and shows me a painting by the English
artist, Eleanor Fortescue-Brickdale, which inspired
the palette she has used here.

The planting schemes are subtle and assured, with
the white edges of *Hosta* 'Minuteman' picking up the
pale colours of the soaring Camelot Series foxgloves
and white flowers of bachelor's buttons (*Ranunculus
aconitifolius* 'Flore Pleno') and Siberian bugloss
(*Brunnera macrophylla* 'Betty Bowring'). In another bed,
contrast is provided by the dark foliage of an acer
and *Persicaria microcephala* 'Red Dragon', with *Tiarella*
'Appalachian Trail', another favourite.

Anne likes her plants to flow through a border,
rather than huddle together in big clumps, to create
a naturalistic effect. However, the most important
thing to remember, she says, is to edit. No matter how
many creative ideas you come up with, for the best
effect, you have to be able to take away as well as add.

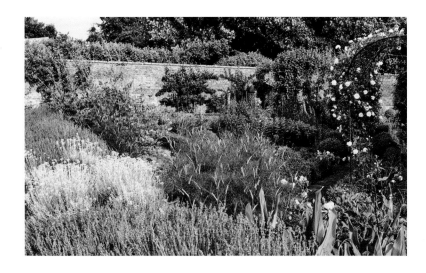

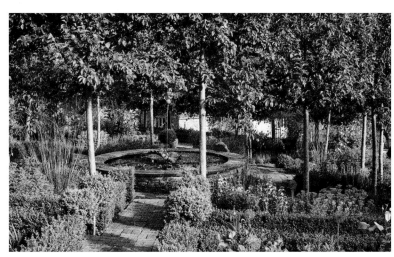

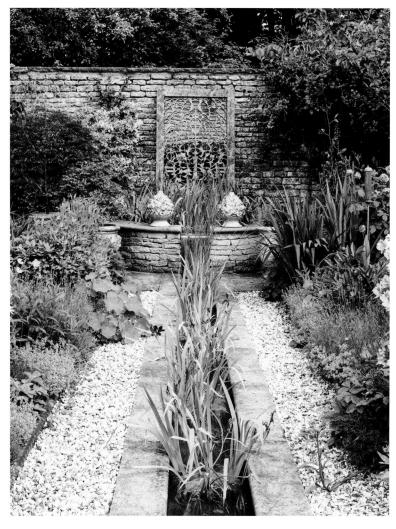

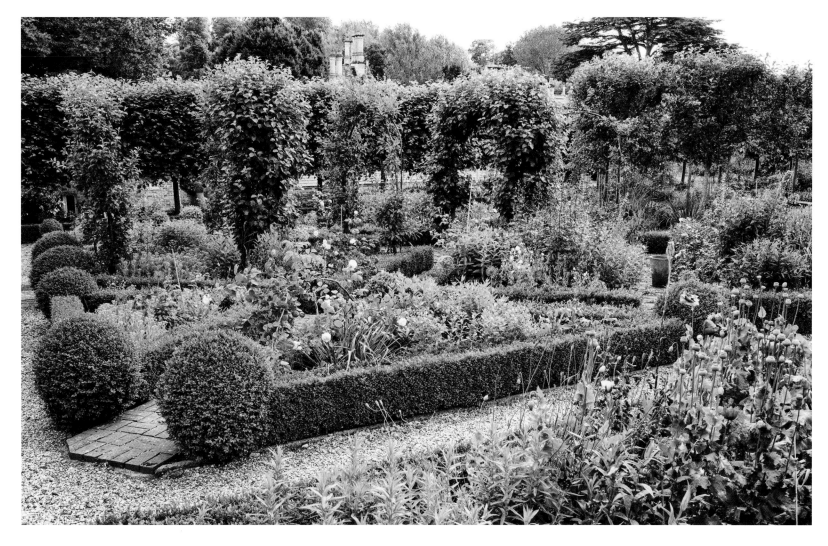

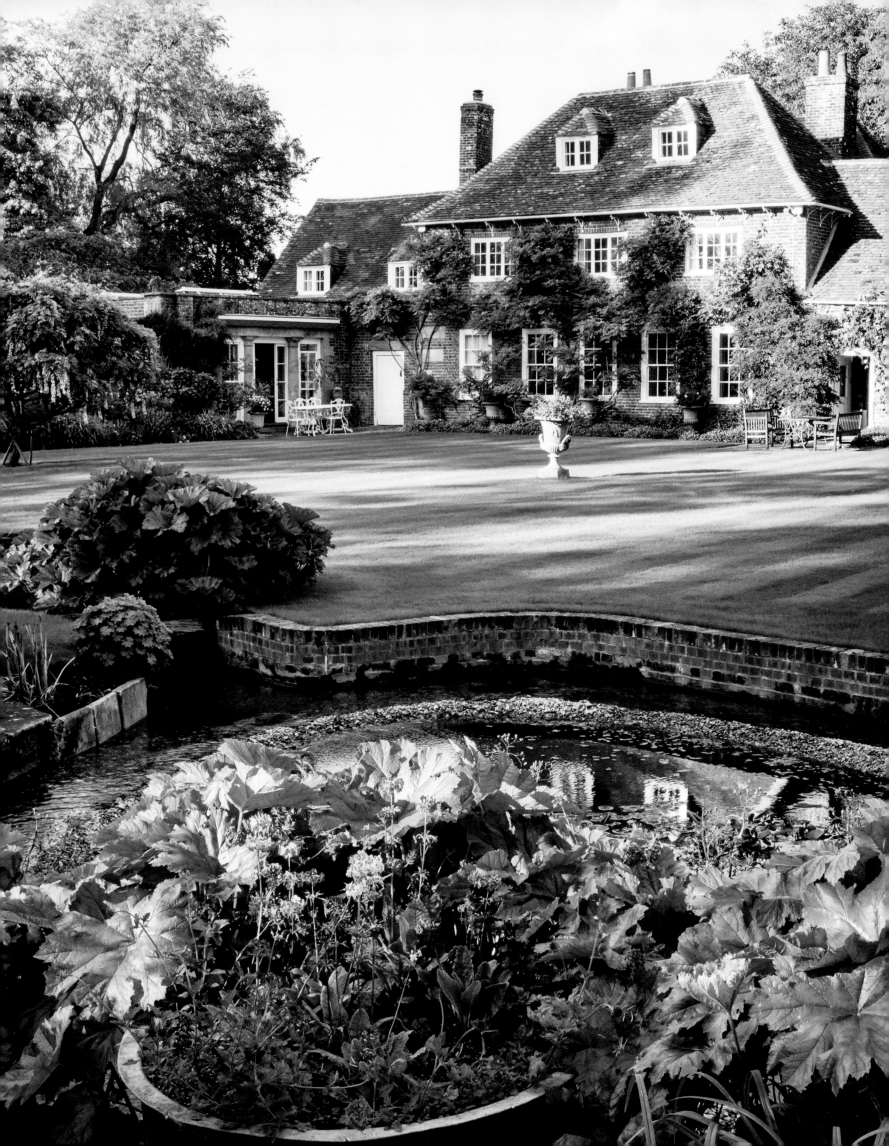

RUPERT EVERETT

WILTSHIRE

Actor Rupert Everett says he has got to the age where he prefers gardening to sex. This is just as well, because when he takes over his mother Sara's garden on the banks of the River Avon, he will have a tough act to follow.

The first view of the house is through a pair of ornamental gates guarded by stone greyhounds and set into a flint and limestone chequerwork wall — it's the sort normally found on very old buildings, but this is a modern reproduction. Adapted by the previous owner, the portrait artist John Merton RA, the wall provided extra privacy for his clients, who included the Queen, Princess Margaret, and Princess Diana. Merton always insisted that the sitter came to his studio (converted from an old barn and coach house), no matter how important they were.

The Everetts bought the house when Rupert and his brother Simon were teenagers, by which time they were away at school. They went to Ampleforth College, the Roman Catholic public school, which, like all Benedictine communities, follows the rule of St Benedict: *pax, ora et labora* (peace, prayer and work). This proved a bit too earnest for young Rupert, who left school at 16 to become an actor.

He and Simon spent their childhood in East Anglia, but the first thing that strikes you about the garden in Wiltshire is that it would be a wonderful place for two boys to grow up. Not only does the garden border the river, but there is a stone-edged rill, a bit like a mini-moat, that snakes its way across the lawns before terminating in a large lily pond.

The Avon in this case is sometimes called the Salisbury Avon, to distinguish it from the Bristol Avon. It runs down through Wiltshire from the Vale of Pewsey, across Salisbury Plain, and finally flows into the sea at Christchurch in Dorset. A system

Rupert Everett

Born: 1959

Partner: Enrico

Actor, writer, producer, director, and recent convert to the wearing of wellies

Above: Rupert Everett with his mother, Sara, at their home in Wiltshire.
Opposite: A view of the back of the house from the pond.
Darmera peltata *grows around an old washing copper, which is planted up with annuals in summer.*

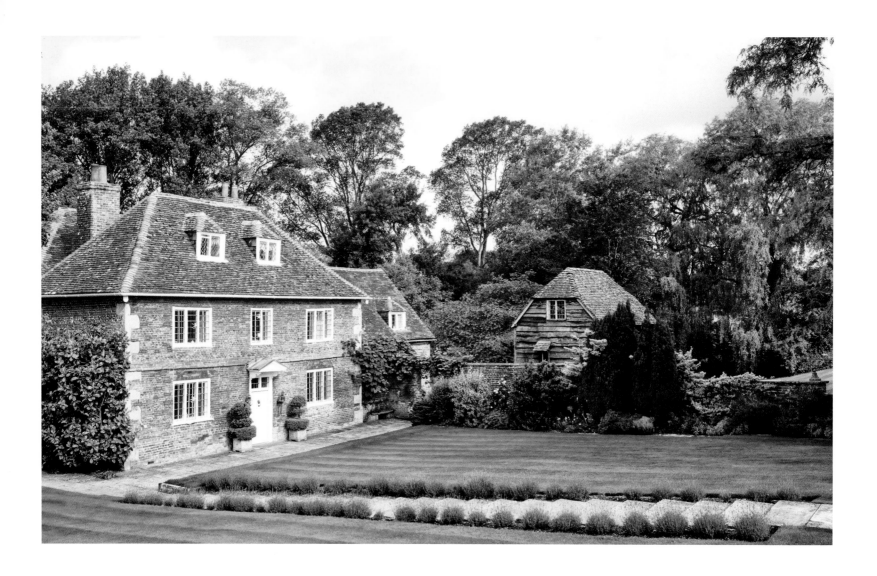

Above: Lavender lines the flight of shallow steps that lead down to the front of the house.

Opposite, above: The south-east-facing side of the wall that divides up the garden provides shelter for the herbaceous border.

Opposite, below: A circular brick terrace set in a neatly manicured lawn offers the chance to sit by the river and enjoy the plants and wildlife.

of water meadows historically followed its course through Wiltshire and today the landscape is tranquil and pastoral, with willows and alders growing along the riverbanks. The Everetts are known as "riparian owners", a traditional term for those who own the land alongside the river.

Riparian ownership has one huge advantage. You often own the fishing rights, which can be sold or rented, and are usually deemed to own the land up to the middle of the watercourse. However, there are lots of downsides too. For example, you have to keep the edge of the riverbank clear, and ensure that no rubbish, including animal carcasses, blocks sluice gates or weirs, even if waste didn't come from your household. You must not obstruct or pollute the water, and you have to control invasive plant species too. When you read all these Environment Agency rules and regulations, you feel it's a wonder

anyone chooses to live beside a river at all. However, wandering round the Everetts' garden, you can see why it all seems worthwhile. There's something totally magical about water in a garden, and the more natural it is, the more attractive it appears.

The gardens surround the house on all sides. Shallow steps flanked by clumps of English lavender and a sloping lawn lead down from the greyhound gates to the front door, and on the right, behind a brick wall, is the old granary, on its base of staddle stones. These are the stone mushrooms that you often see in country gardens, used these days mainly to line paths or mark entrances. Their original use was to raise structures, such as granaries, hayricks or game larders, off the ground, to prevent the contents getting damp and protect them from vermin. The wide flat tops not only provided a stable support for beams but were supposed to prevent mice and rats

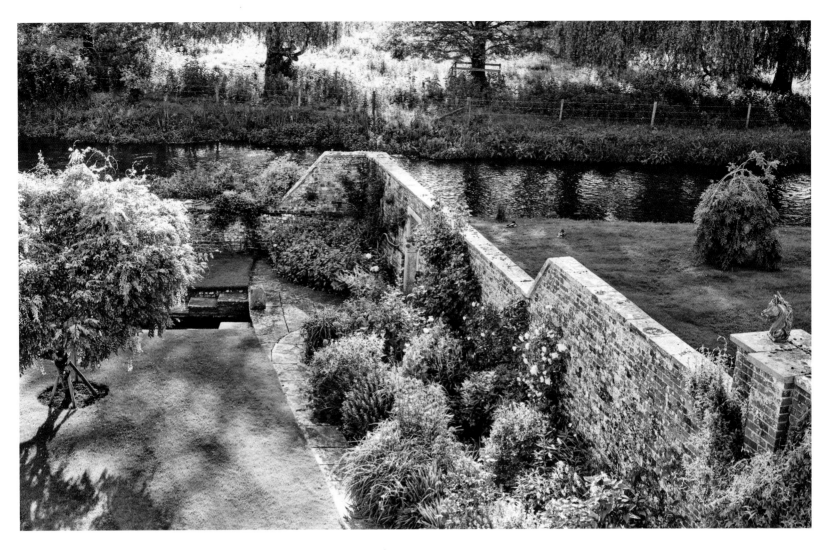

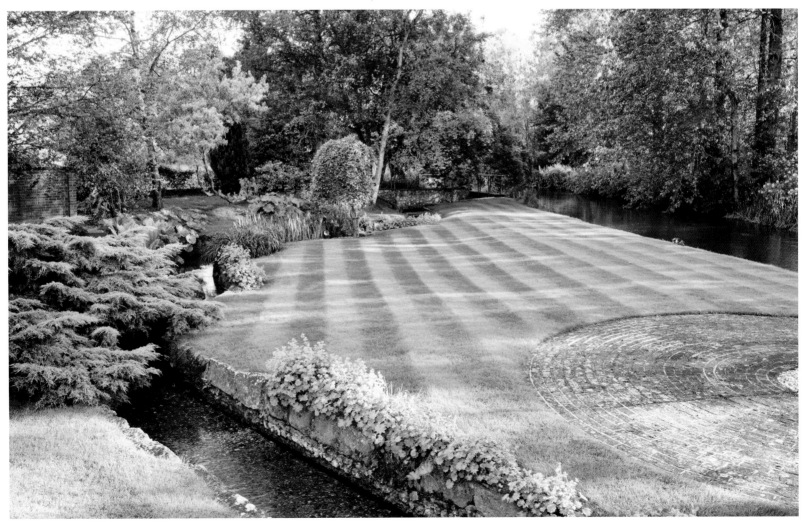

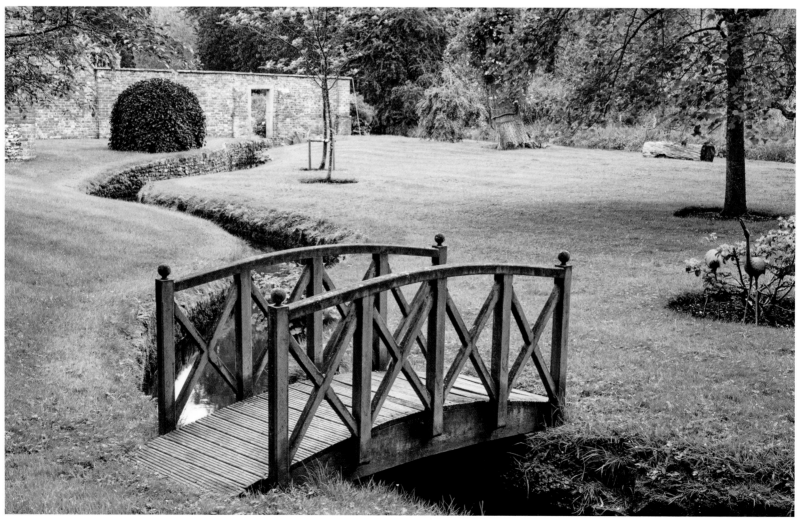

"A stone-edged rill, a bit like a mini-moat, snakes its way across the lawns before terminating in a large lily pond."

from climbing up. They follow the same principle as the dome-shaped lids on bird feeders, designed to keep squirrels at bay.

The house is early 18th century, and Grade II listed. It is built of brick and flint, with limestone quoins, or corner stones, and together with the garden walls and expanses of grass, it gives an impression of rosy warmth and sunkissed lawns. Old brick always looks so beautiful and on close inspection, reflects a kaleidoscope of subtle colours.

Although the garden isn't really divided into rooms, the wall, with doors at either end allowing access to each section, creates that effect. Rupert's mother, Sara, says this is all very well, but you can't get a ride-on mower through the doors, which means the rear lawn has to be mowed by hand.

Sara is often described affectionately in Rupert's autobiographies, *Red Carpets and Other Banana Skins*

(2007), and *Vanished Years* (2013), as a force of nature. She "screeches around the house"; she "storms around the house"; she "speeds off"; she "whips round the room like a force 10 wind." Taken out of context, this may sound as if Sara is a restless soul bent on her own preoccupations, but this energy is always employed in the service of the family, whether it was caring for Rupert's father, Anthony (or Tony) who died in 2009, or rushing around closing all the windows when they lived in their cottage in Essex because the local farmer was burning fields of stubble (one of Rupert's earliest memories).

And then there is the ultimate accolade from Rupert, which occurs more than once: "Next to Mummy, X was the person I loved most in the world." For her part, Sara adores her son, whose family nickname is "Roo". Telling me about his film, *The Happy Prince*, which presents the story of the last

Above: The old granary is supported by staddle stones, which deter vermin and keep the floor dry.
Opposite, clockwise from top left: Conifers and evergreen shrubs, such as Ceanothus, *create a more formal atmosphere in the front garden; the herbaceous border at the rear of the house includes roses on the walls, red valerian (*Centranthus*) and alliums; a little wooden bridge crosses the winding rill.*

days of Oscar Wilde, she said proudly: "He's written it, he's directed it and he's acting in it."

What Sara doesn't mention, however, is the inspiration that she herself provided for the film. According to Rupert, Sara used to read the original Oscar Wilde fairy tale to him at bedtime. One of a collection of five stories for children, "The Happy Prince" tells how a swallow is left behind when his companions fly south for the winter. He finds a perch on the statue of the prince, who has never experienced sorrow, and brings him stories of hardship from around the city. In one interview, Rupert recalled: "Whenever I hear the catchphrase, which is the prince saying 'swallow, swallow, little swallow', I always think of my mother reading to me before I went to sleep at night."

It has taken Rupert eight years to get this project, which co-stars Colin Firth, off the ground, and

when shooting finished in December 2016, he was looking forward to relocating to Wiltshire, where the house has been remodelled. "There are two parts, so my mum's moving out of her bit to the next-door bit and I'm moving in."

Outwardly, things will continue to look exactly the same, with roses and wisteria growing up and along the back of the house, and terracotta urns brimming with brightly coloured annuals in summer. More terracotta pots filled with bedding plants are positioned along the stone rill, and there is a huge antique washing copper that has been transformed into a planter by the pond.

The south-facing herbaceous border that runs between the rill and the back of the house is packed with roses and herbaceous perennials, with a few bulbs for spring interest. Sara likes hot, sultry colours, such as the spiky-bloomed *Dahlia* 'Nuit d Eté'

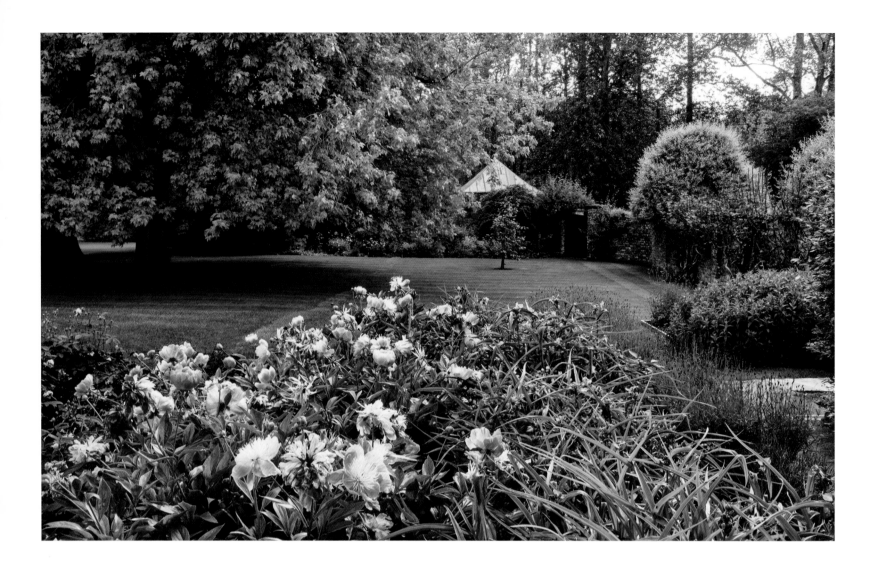

('Summer Night') and the velvety crimson fragrant
rose 'William Shakespeare 2000', bred by David
Austin and a great choice for a thespian household.

In the large front garden, which faces east, Sara
says she has grassed over several small flower beds
which she thought were too fussy. To the north,
before you come to the granary, a formal stone-edged
pond is decorated with stone urns at each corner
and mats of water lily leaves floating on the surface.
Along the northern boundary, mature trees provide
a shelter belt for a towering *Liquidambar*, with its fiery
autumn leaves, and a honey locust (*Gleditsia*). Beneath
the shade of the branches, the berries of a *Cotoneaster*
provide splashes of colour in the autumn.

A low wall separates the garden from the river,
but you can walk along the banks and back into the
garden through yet another gateway by the swimming
pool pavilion. Between the pool and the southern-
most part of the house is the vegetable garden,
which features a fruit cage containing an abundance
of strawberry, raspberry and gooseberry plants.

It must be difficult for Rupert's many fans to
imagine him pottering about in wellies, dead-
heading, weeding and pruning. It's such a contrast
to his Hollywood life: co-starring with Madonna,
Bob Dylan and Julia Roberts, among others, or
schmoozing with Catherine Deneuve, or the late
Rudolf Nureyev and Lauren Bacall – who once told
him: "You are the wickedest woman in Paris."

Rupert says he wants a different sort of life now,
and that the middle-class values he once thought
boring hold more charm for him. Discussing this
change of heart with Sara, I suggested that perhaps
gardening is like opera – you only begin to like it
when you are over 30. "Hmm," she replied dubiously,
"but I still hate opera."

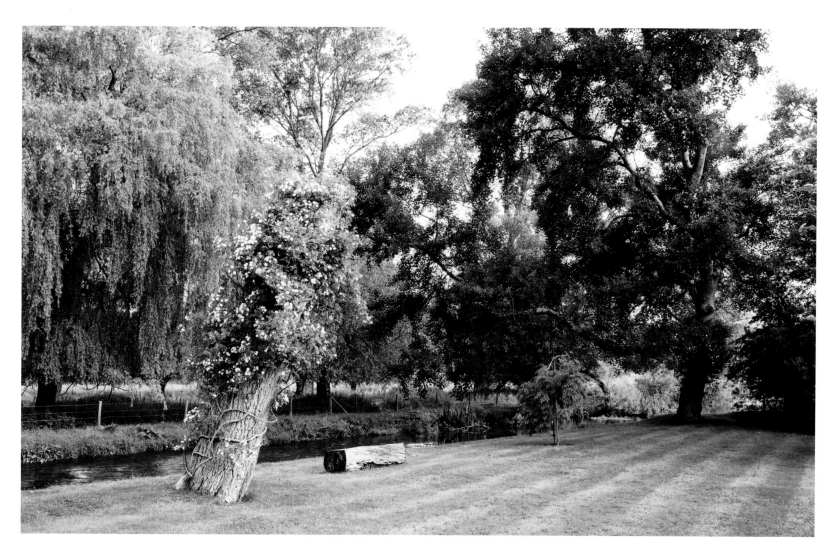

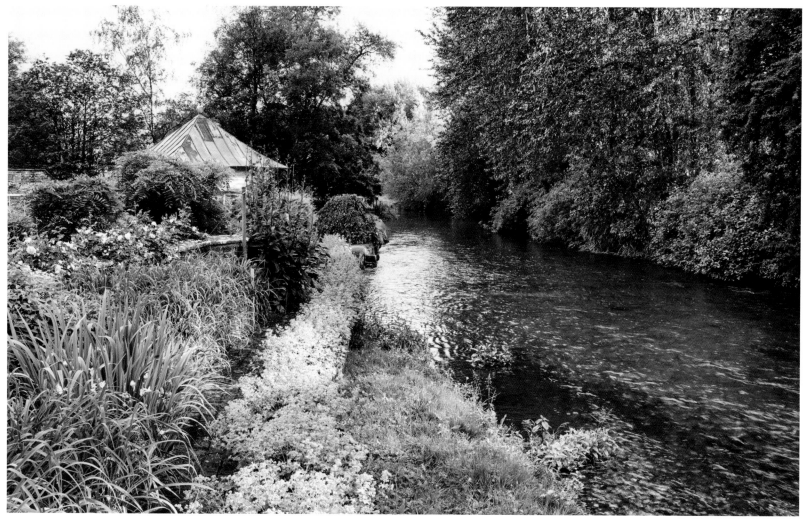

Hugh Fearnley-Whittingstall

Born: 1965

Wife: Marie

Chef, television presenter, food writer, and the man who made the smallholding dream come true

Will Livingstone

Born: 1987

Gardener, writer, and defender of vegetables against marauding slugs and chefs

Left: Hugh Fearnley-Whittingstall, left, and head gardener Will Livingstone at Park Farm, which is now the River Cottage HQ. Right: A view of the farm and the Axe Valley from Trinity Hill.

HUGH FEARNLEY-WHITTINGSTALL

DEVON

There are millions of people growing their own vegetables up and down the country, and there are thousands of smallholders too. So what is it about River Cottage that makes it special? How did it become a byword for sustainability and self-sufficiency in the UK? And why do people flock there to visit it?

The answers, of course, lie in its creator Hugh Fearnley-Whittingstall's skill as a writer, journalist and broadcaster to get his message across to those who have watched his television series, read his articles and bought his cookery books. He has shown them a vision of paradise with mud on its boots and dirt on its hands, and they love it.

Hugh's mother Jane is a garden designer and writer, and his father Robert was in advertising so, as Hugh points out, he inherited from both sides the ability to pitch an idea. His mother says that there are three key elements to his career: he's always

been interested in cooking, he's always been good at communicating and performing, and he has a crusading instinct that drives him to take on issues such as battery-caged chickens, consumer waste and sustainability in the fishing industry.

The original River Cottage, which gave Hugh's successful TV series its name, was a former gamekeeper's cottage in Dorset. As the programmes became more and more successful, the location moved to the Dorset village of Broadoak, and then in 2006 to its present location near Axminster in Devon. This is now known as River Cottage HQ, and Hugh himself lives on a smallholding nearby.

The ethos for each of Hugh's ventures has remained the same since the beginning. Like the previous locations, the Devonshire River Cottage is a centre for small-scale food production, with high welfare standards, a restaurant and a cookery school,

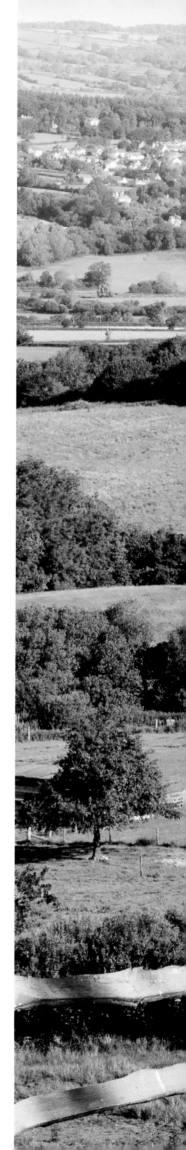

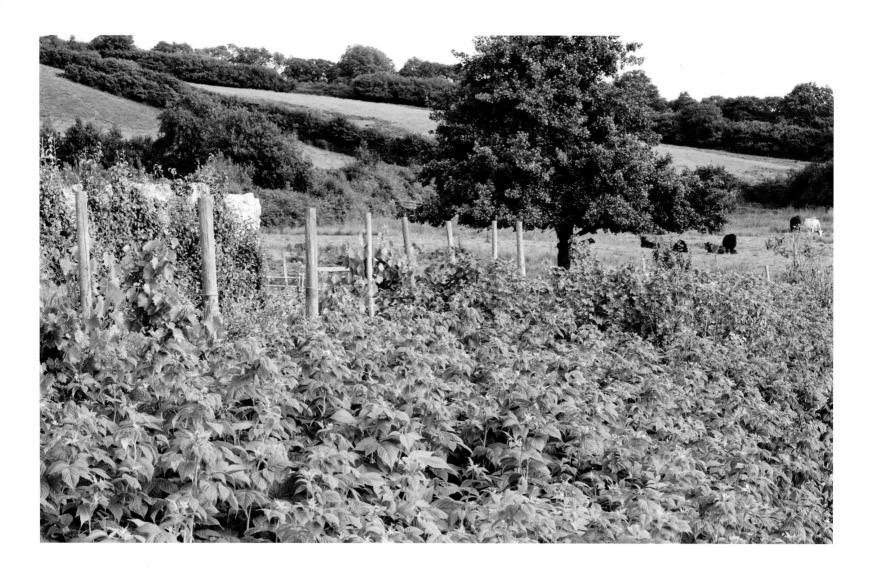

where visitors can sample dishes and try cooking their own versions. Courses include seasonal nutrition and gluten-free cookery, preserves, foraging, and baking, among others. They are held in a large airy barn that looks out over the countryside – I think I would have to work with my back to the window so as not to be distracted by the breathtaking views. The restaurant is fitted out with long refectory tables and benches, and bunches of dried flowers adorn the whitewashed walls. It's very simple, but stylish.

If it wasn't for the restaurant and cookery school, River Cottage HQ would look just like any other smallholding, although possibly a bit neater (the gardeners' shed is the neatest I've ever seen). Its position is quite challenging, though: set on a hill above the Axe Valley, there is almost as much flint as soil. There are 90 acres (36 hectares) altogether, most of which is pasture for the sheep and cattle, with

just over an acre (0.4 hectares) devoted to vegetable and fruit crops. A cider orchard and stone fruit orchard were also planted in 2009.

To ensure the fruiting crops are pollinated and to help reverse a declining bee population, the farm includes an apiary, with half a dozen National hives facing south over the valley, protected from the cold by a belt of gorse behind them.

Nearly every single bit of level ground is under cultivation, but such is the popularity of the restaurant, some produce has to be bought in from local farmers who have built up a good relationship with the head chef, Gelf Anderson.

Gelf has a reputation for his "can-do" attitude when it comes to using seasonal produce, and he relishes the creative challenge of delivering delicious menus with whatever is available. He's also realistic about the possibility of cosmetic blemishes on organic

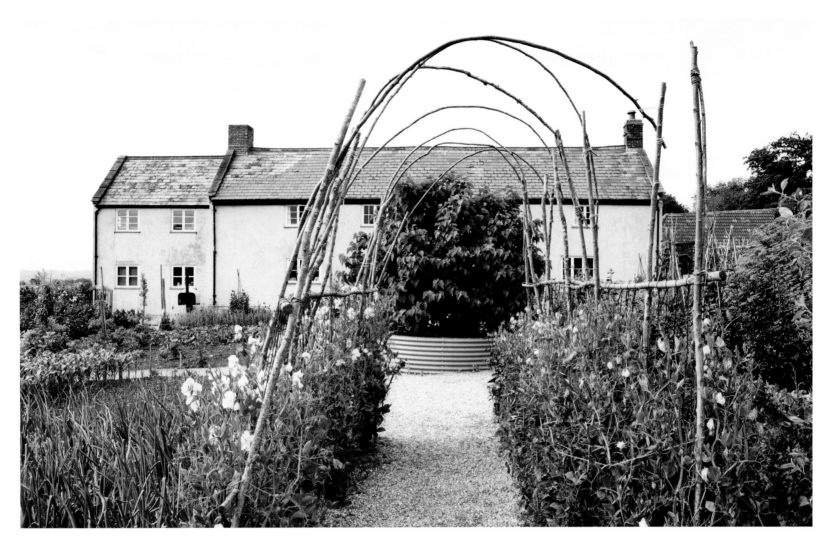

"The real showpiece at River Cottage
is the Victorian-style kitchen garden,
which is divided into four large beds."

produce – not that I could see many on the fruit
and vegetables I sampled during my visit. While I was
there, Harry, one of the local farmers, turned up
with a load of spinach and flower sprouts (Brussels
sprouts crossed with kale, sometimes known as
kalettes). They looked pretty perfect to me, and those
I pinched from the box tasted good too.

Local farmers like Harry also top up the supply of
free-range eggs, because even though River Cottage
has around 50 laying birds, it feeds about 20,000
people a year. In this way, Hugh and his team are not
only creating work opportunities on their own site,
but also supporting the farming communities nearby.

The real showpiece at River Cottage is the
Victorian-style kitchen garden. It is divided into four
large beds, planted with legumes, brassicas, the onion
family, and miscellaneous crops, such as potatoes
and root vegetables. These four groups are rotated

clockwise annually to prevent a build-up of pests
and diseases and reduced soil fertility. At the centre
of the garden is a mulberry tree, underplanted with
tulips, while an arch of chestnut stems supports sweet
peas. Strawberry plants edge each of the beds around
the mulberry, and include early, mid, late, and late
autumn varieties, providing a long season of fruit.

Along the south-facing wall, beds of Jerusalem
and globe artichokes bask in the sun, together with
a patch of cutting flowers, used to decorate the
restaurant. In the fruit garden next door, cordon
pears grow diagonally along the walls behind rows of
prickly gooseberry bushes. There is an asparagus bed,
a rhubarb bed (perennial vegetables don't need to be
rotated) and lots of berries and currants.

Hugh and head gardener Will Livingstone run the
entire farm using organic principles: a reed bed deals
with the sewage, there is a huge underground storage

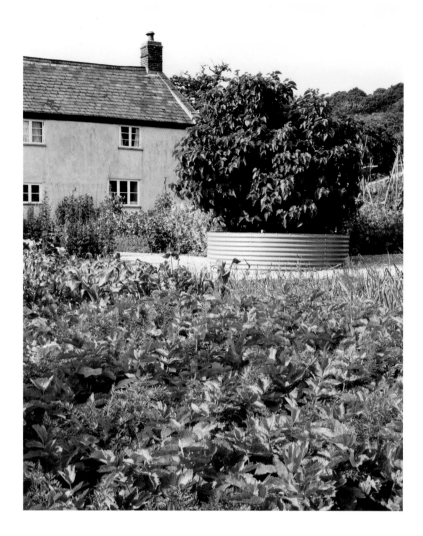

tank for harvested rainwater, and some of the beds are grown using the no-dig principle. This method, advocated by Charles Dowding, means that you don't dig over the soil before planting each year, as this brings more weed seeds to the surface. A thick layer of organic mulch is applied to the soil surface, too, which suppresses weed growth and slowly releases key plant nutrients as it gradually decomposes.

Will uses a mixture of home-grown compost and community green waste, which is produced from garden waste by local authorities. It's not particularly rich in nutrients, but makes a good soil conditioner and mulch. What about pests and diseases? "Our number one pest is the chefs," he says with a straight face. "The second biggest problem is slugs and snails. We don't have much trouble with carrot root fly, but we do a lot of companion planting. We sow nasturtiums next to the brassicas, and plant French

marigolds (*Tagetes patula*) in the polytunnels with the tomatoes to keep away whitefly. Alliums are woven between the carrots to help ward off carrot root fly, and we also plant flowers, such as violas, phacelia and borage, to encourage insect pollinators."

As you come out of the restaurant and walk up the slope, you pass a 'Manaccan' plum tree (a Cornish variety), which was donated by Prince Charles from the Duchy of Cornwall nursery during a visit in 2014. "He told us not to kill it," said Will.

Above this is what many would consider the classic image of a smallholding. A couple of sheds are used both as a gardening office and a seed store — Will saves lots of seed and is a Seed Guardian for Garden Organic's Heritage Seed Library. The polytunnels here are used to grow tender fruit and vegetables, such as tomatoes and nectarines, as well as winter salad crops. Close by, allotment-style plots of

Above: A mouth-watering crop of redcurrants. Opposite, clockwise from top left: The mulberry tree at the centre of the kitchen garden is in a raised bed made from a galvanised cattle drinking trough; ripe gooseberries; purple-podded drying peas ('Ezetas Krombek Blauwschokker'); courgettes ('Rondo di Nizza', 'Cocozelle' and 'Green Bush') with an edging of celeriac ('Prinz').

*Above: An edging of common
and lemon thyme provides a
decorative skirt of edible leaves
in the tomato polytunnel.
Opposite, clockwise from
top left: 'Darling' peaches in
the fruit polytunnel; eggs are
provided by hybrid chickens,
crossbreeds that are good
layers; a Poll Dorset lamb; the
pigs are Oxford Sandy and
Blacks, a rare breed.*

vegetables are rotated with pig and chicken pens –
the animal waste in turn helps to feed the soil.

Lambing takes place at the end of March or
beginning of April, while the sow, an Oxford Sandy
and Black called Dot, farrows her piglets a month
earlier, in her specially built birthing shed. Early
lambing has slightly gone out of fashion in the UK
during the past few years, and while winter-farrowed
pigs are always in demand, spring farrowing makes
life a lot easier for the smallholder – the weather is
better and there's more light at this time of year for
the regular trips to feed and check on the piglets.

Will's own background is in agriculture. He is a
local Devon boy, and grew up "just over the valley"
in Axminster, where his parents had a large vegetable
garden. He studied countryside management at
college, but also found time to complete the Royal
Horticultural Society's Level 2 and 3 exams, and

courses on conservation and biodynamics, which uses
the lunar calendar and organic principles. He joined
River Cottage as a gardener in 2008, under the
former head gardener Mark Diacono, but left to
spend a year in Canada. When he returned, he was
given his old job back, and in 2014 he was appointed
head gardener. And all this by the age of 27.

Will writes a regular column for a smallholding
magazine, with an accompanying recipe, and you get
the impression that for him, as for millions of others,
Hugh is his inspiration.

As well as ensuring his food crops are grown using
organic principles, Hugh also believes that we should
pay more for meat raised with the animal's welfare in
mind – and eat less of it. If we are going to kill an
animal for food, he argues, we should give it a good
life, and that means a life that is as close as possible
to the one it was biologically designed to lead.

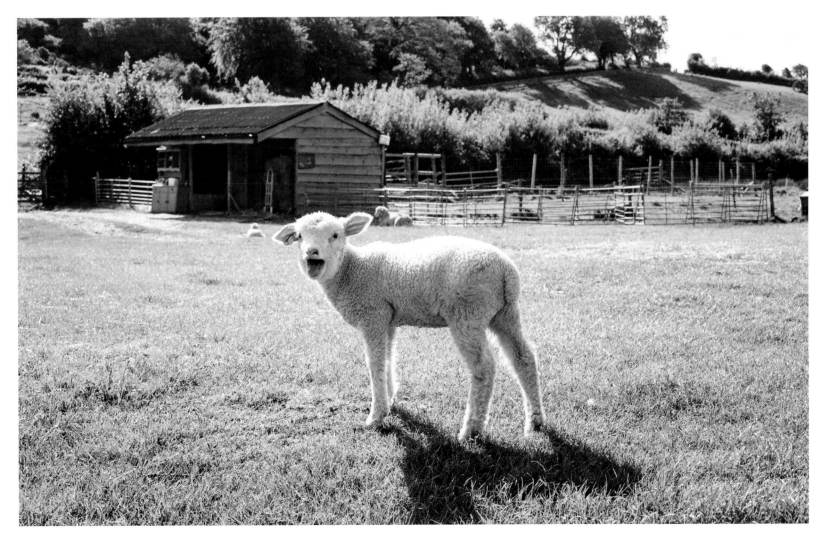

ERIC FELLNER

OXFORDSHIRE

As the sun begins to triumph over the early morning mist, a group of roe deer scampers into view. They pause in the clearing beyond the formal lawn, framed by yew hedges and magnificent trees. Above them, a red kite soars and spirals, while behind, the ancient carp pond glitters in the sunlight.

The moment seems almost cinematic, and you find yourself waiting for the score to begin; a solo violin or flute, perhaps, expounding an Elgarian theme that is then taken up by the full orchestra. An appropriate response, for this is Pyrton Manor estate, home of Eric Fellner who, together with Tim Bevan, is co-chairman of the hugely successful film production company, Working Title Films.

Working Title is responsible for so many hit movies that to list them all would be impractical, but their most well-known include *The Big Lebowski*, *Four Weddings and a Funeral*, *Love Actually*, *Shaun of the Dead*, *Fargo*

and, more recently, *The Danish Girl* and *The Theory of Everything*. Although Pyrton Manor itself has never been used as a film location, Jude Law, playing Watson in *Sherlock Holmes: A Game of Shadows*, drives past the cottage of head gardener Nick Foot on the way to his wedding at St Mary's, the little church that stands just outside the gates of the estate. Before Eric Fellner and his family moved to the manor house, it also featured in a Blur video, but it's now very much a family home, with toys in the hall and on the terrace, and a playground featuring a slide and tree house.

The house itself is late 16th century, built of rosy Elizabethan brick. Like most houses of its age, it is a charming, higgledy-piggledy affair, with a facade featuring gables and tall chimneys that present a united front, while wings and outbuildings built on at later dates cluster around a rear courtyard. The parish of Pyrton, in south Oxfordshire, is mentioned

Eric Fellner
...
Born: 1959
...
Partner: Laura Bailey
...
Film producer, co-chairman
...
of Working Title Films and
...
planter of wildflower meadows

*Above: Film producer
Eric Fellner in his garden in
south Oxfordshire.
Opposite: Winding paths
are mown through the wild
flowers, so the family and their
guests can wander freely in
the woodland and meadows.
Overleaf: Eric's elegant
16th-century manor house.*

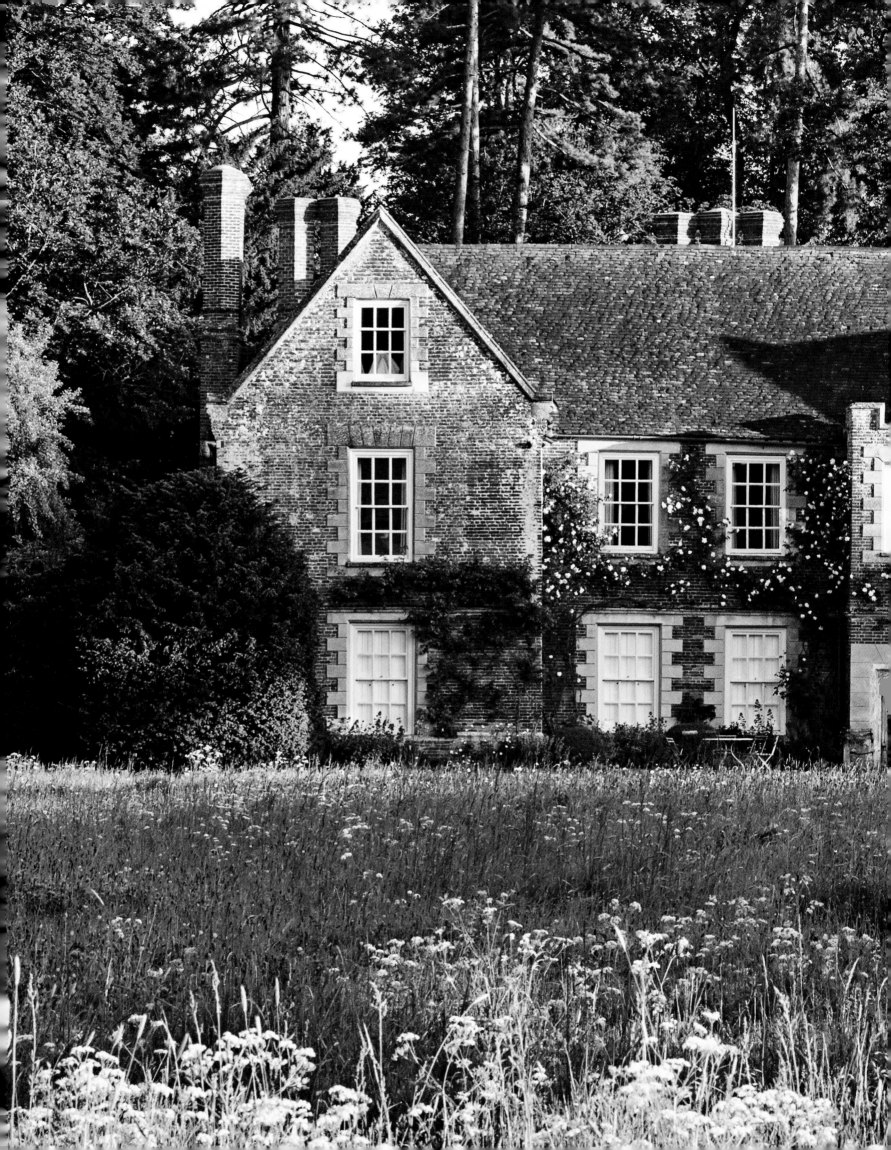

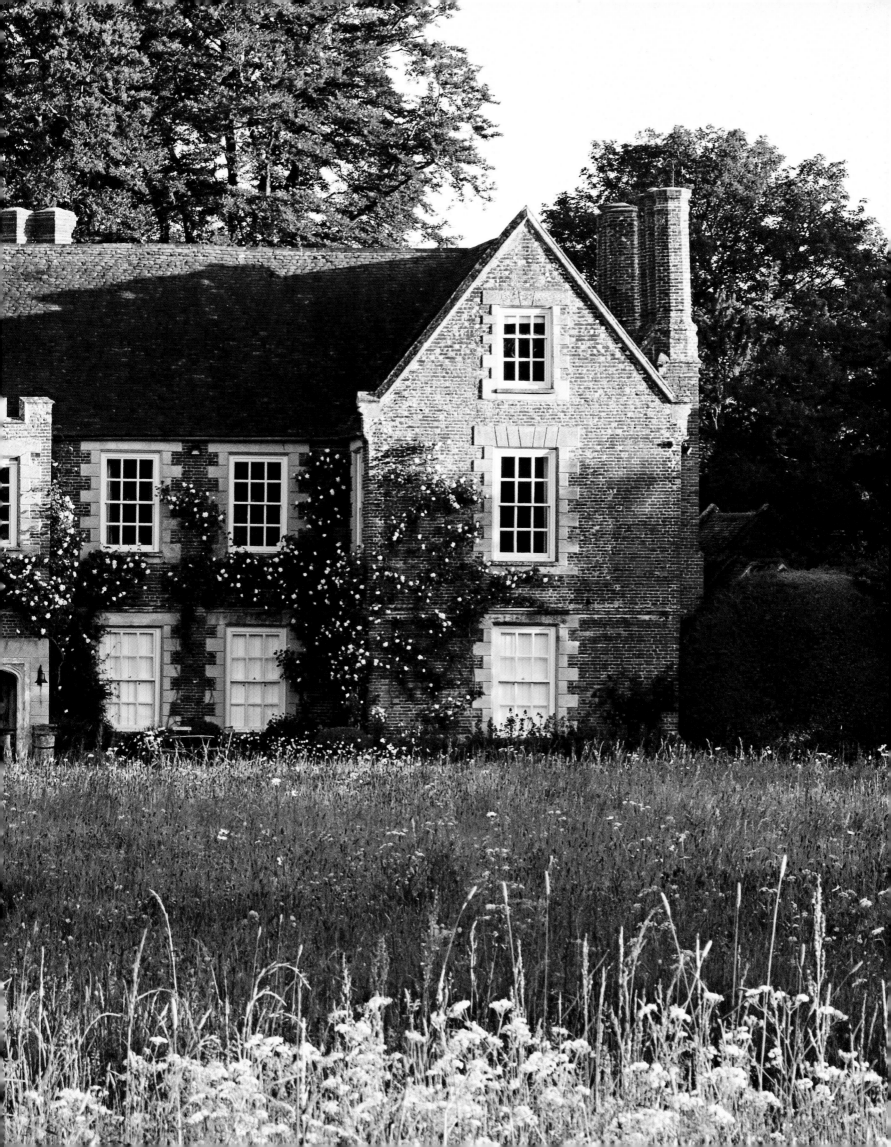

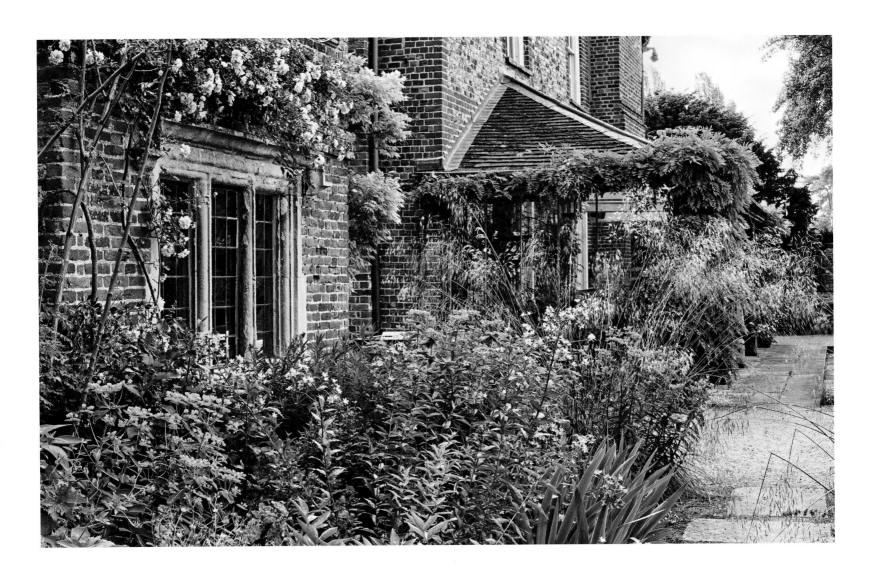

Above: Sun-loving plants, such as rock roses, iris and the giant oat, Stipa gigantea, *thrive on the south-west-facing rear terrace, designed by Mary Keen and Pip Morrison. Opposite, above: The long herbaceous border. Opposite, below: Al fresco dinner parties are given an idyllic setting between a bank of lavender for scent and a pizza oven and barbecue for sustenance.*

in the Domesday Book, and there is some historical documentary evidence that suggests an earlier manor house with a moat, built in 1327, stood on the site of Eric's home. Only the moat, now converted into a lake, remains, but the presence of the carp pond also supports the theory that this estate has been a substantial holding for centuries.

Substantial it may be, but there is nothing showy or glitzy about Pyrton Manor. It is as far from the archetypal image of a Hollywood film producer's home as you can get, and you sense that this was the main attraction. Eric is originally from Sussex, while his partner, the model and writer Laura Bailey, grew up in Oxfordshire, near Waterperry Gardens — famous for its herbaceous border. The couple have two children, Luc and Lola.

Apart from a superb herbaceous border alongside the lawn to the south-west of the house, there is very

little in the way of formal gardens. Most of the estate's 40 acres (16 hectares) are parkland, punctuated by impressive stands of Austrian pines (*Pinus nigra*), vast holm oaks (*Quercus ilex*) and ash trees. Even the area to the front of the house is meadow, albeit with a path mown round it, and the only concessions to formality are what Nick Foot calls the "blobberies".

The blobberies are topiarised shrubberies, mainly composed of box, yew and Portugal laurel (*Prunus lusitanica*), and they perform two main functions. First, they provide a windbreak, which is very welcome on colder days when the wind is in the east and whistles across the meadows. Second, with so much meadow, and so many mature trees, you need something that bridges the gap between the tree canopies and ground level. You could simply grow shade-loving shrubs and small trees, such as ornamental cherries, viburnums and amelanchiers — Nick has planted these too — but

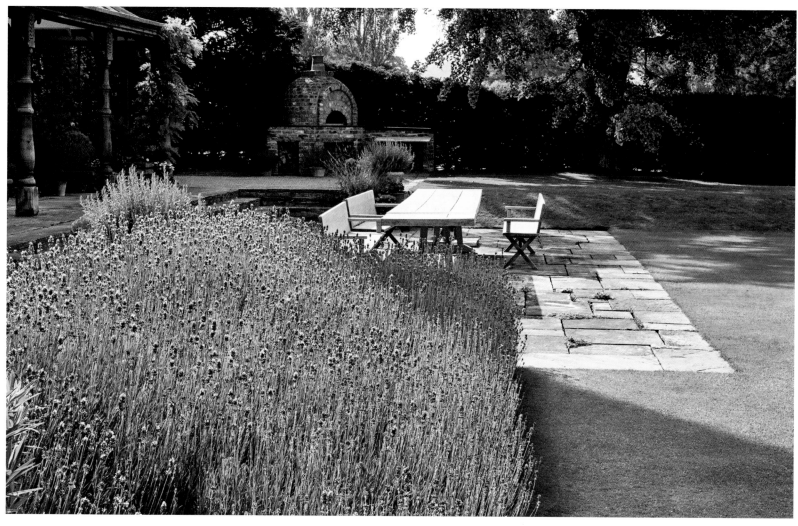

"Pyrton is like a scene from a historical drama in which idyllic English countryside is peopled by characters in sumptuous costumes."

the evergreen spheres add year-round interest. The yew and box plants used for the topiaries are also easy to establish in the dry shade beneath the trees. The blobberies' effect is almost abstract, reducing what would normally be humps and mounds of shrubs to a pure form. They remind me of a garden design drawing, where circles are used to denote the presence of plants.

Ideas like this may seem simple, but they require thought. Pyrton is a bit like a scene from a historical drama in which idyllic English countryside is peopled by characters in sumptuous costumes. It may look effortless but you only have to read the film credits to realise how much work is involved.

The formal lawn, for example, was levelled in 2006 at the suggestion of Mary Keen and Pip Morrison, of the garden design practice Designed Landscapes. They also tamed the yew hedges either side of the lawn, and created a herbaceous border along part of the south side. About five years later, the old limestone wall behind the border needed to be repaired, and a large yew "blob" halfway along was removed, which allowed the planting to run the full length of the wall.

Eric loved the idea of having lots of plants creating billowing shapes, and while Nick liked Mary and Pip's initial plan, he and Eric decided it might be simpler to plant the whole border again. Nick asked Tom Price, garden curator at the University of Oxford Botanic Garden, to advise on the planting, and the flowers here now include hardy geraniums, lavender, day lilies (*Hemerocallis*), achilleas, *Campanula lactiflora*, *Actaea simplex* and *Aruncus dioicus*, while the walls are clad with climbing roses and clematis.

The wildflower meadows were planted with a seed mix from the specialist supplier Charles Flower

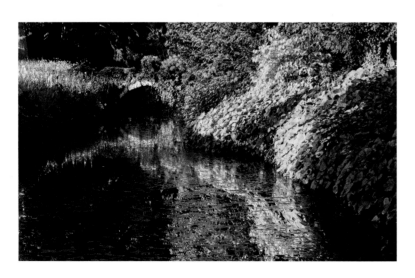

(yes, that really is his name), who will happily come and conduct a site visit to advise on establishing a new meadow or restoring an old one.

Anyone who has tried to grow a meadow knows that they require a delicate balance of plants and involve more work than their airy, insouciant appearance may suggest. The area to be planted or sown must be prepared properly and the soil checked to ensure it is not too fertile — rich soil results in lush grass growth but few flowers. Once established, the meadow then needs to be mown several times in the first year, to give the slower-growing perennial species a chance to establish. In subsequent years, it should be mown or grazed once a year, after the wild flowers have set seed.

Nick has been a gardener for 20 years, and trained at West Dean Gardens in Sussex, but there is something about wild flowers that brings out the child in all of us. He described seeing the meadow blooms with the enthusiasm of a little boy who has just seen his first steam engine. "The first year, there were very few flowers," he recalled. "The second year there were more, and in the third year, there was a blizzard of ox-eye daisies (*Leucanthemum vulgare*). It was the same with the orchids. First I saw one, then I saw six, then I saw dozens. It's such a fantastic feeling — you know you are doing something right." Three wild orchid species have now established at Pyrton: pyramidal (*Anacamptis pyramidalis*); common spotted (*Dactylorhiza fuchsii*); and bee (*Ophrys apifera*). They were not included in the wildflower seed mix, but have taken advantage of the ideal conditions here to colonise.

In summer, when paths are mown through the meadows, and the evening sun gilds the soft Oxfordshire landscape, it must seem to Eric as if he has come home from Hollywood to heaven.

Above: An Antony Gormley sculpture looks out over one of the wildflower walks. Opposite, clockwise from top: The circular lawn in front of the house; one of the massive holm oaks stands in a meadow; an old stone bridge leads over the stream that feeds the lake; a small doorway transforms a vast "blob" of yew into a little house.

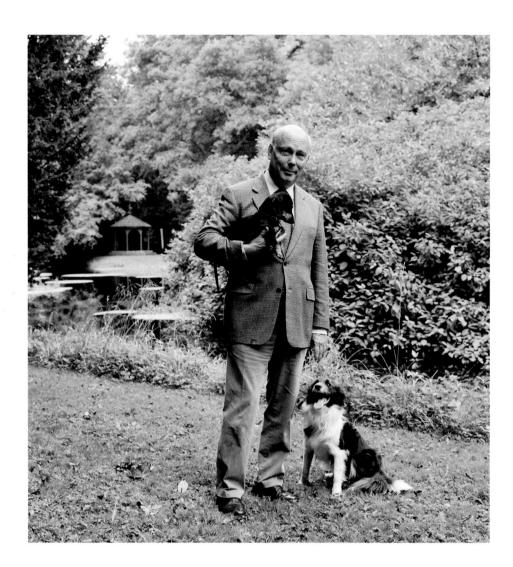

Julian Fellowes
Born: 1949
Actor, director, novelist,
creator of the acerbic
Violet, Countess of
Grantham, and guardian
of wildlife of all kinds

Emma Fellowes
Born: 1963
Downton Abbey story
editor, lady-in-waiting
to HRH Princess Michael
of Kent, and great-great
niece of Lord Kitchener

*Left: Julian Fellowes with
Humbug, a miniature
dachshund, and Meg,
a border collie.
Right: The riverbank
at his Dorset home.*

JULIAN & EMMA FELLOWES

DORSET

Julian Fellowes – creator of Downton Abbey, writer of musicals, author of screenplays (including *Gosford Park*, for which he won an Oscar), actor, director, producer, novelist and peer of the realm – may be multi-talented, but he is not a gardener. At least, not in the conventional sense.

You will search in vain for extensive herbaceous borders or regimentally striped lawns at his home in Dorset. There are no box parterres, no wisteria-clad gazebos or pergolas dripping with clematis, no auricula theatres, no glasshouses offering glimpses through steamed-up windows of rare plants in their vaporous interiors.

There isn't even a swimming pool, and there are no designer sun loungers on the terrace. (There will shortly be a Rosemary Verey-style potager, or formal kitchen garden, but more of that later.) But who needs a swimming pool when you have not one

but three rivers encircling the garden? And who needs vast herbaceous borders when you have your very own woodland and riverbanks to explore, where snowdrops emerge from a carpet of dead winter leaves like a newly laundered sheet, and the azure haze of bluebells mimics the transient blue of an April sky? Who also needs a glasshouse when your garden is adorned with lush native ferns?

Julian and his wife Emma may not have a perfectly manicured garden but they are passionately protective of the creatures that share their land, right down to the fungi on the painted wooden Versailles planters on the terrace at the back of the house. Everything is encouraged to get on with life unhindered, whether it is a hedgehog, a fox, a fungus or a fish, and these are the principles that have dictated the garden's design.

Those seeking some sort of historic garden pedigree can console themselves with the fact that the

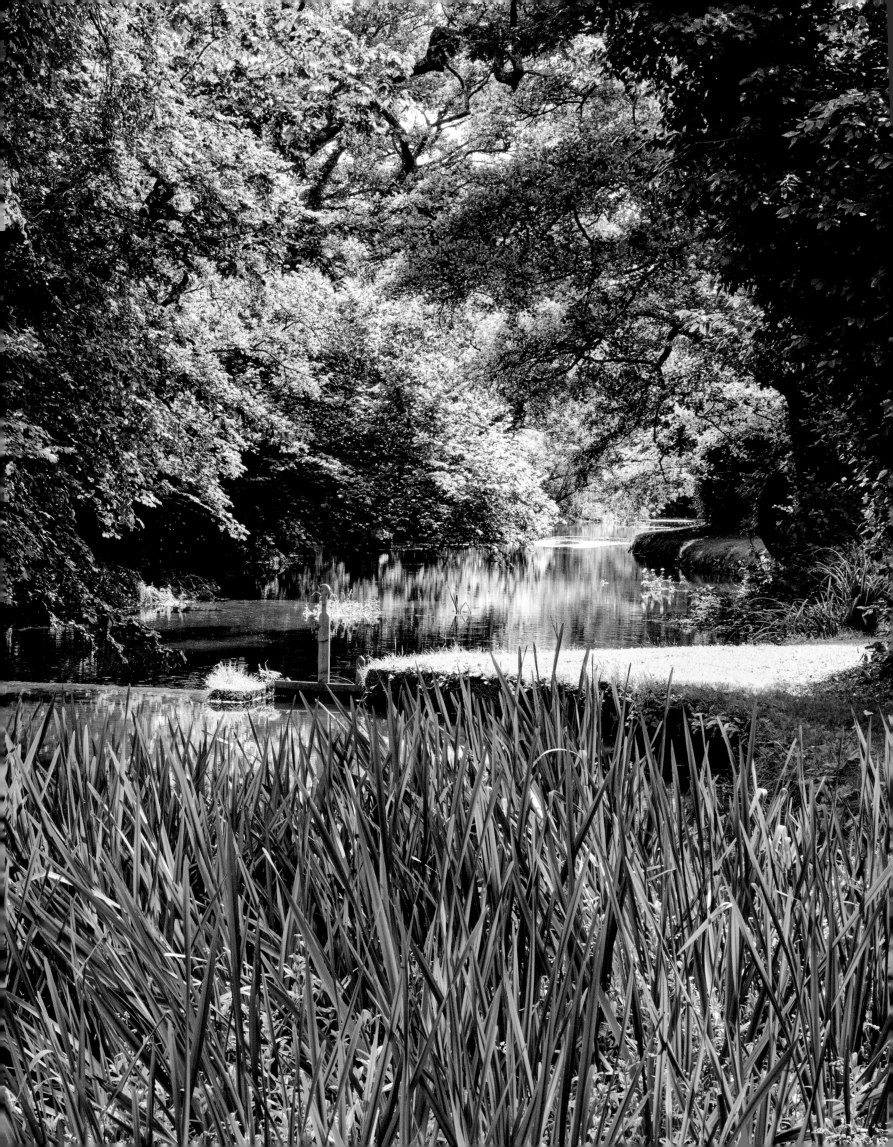

great English landscape designer, Humphry Repton, mentioned the Felloweses' property in his book, *Fragments on the Theory and Practice of Landscape Gardening*, published in 1816.

Repton said of its situation: "Firstly, the present site is too low. Secondly, it is too near the water; and thirdly, it is on the verge of the estate." Discussing his first objection, Repton argued that it would be impossible to raise the site, because "in the champaign country of Dorset" (in other words, the open level countryside), there would be no shelter from the wind. Of the second, he stated: "If the water were a stagnant pool … it might be objectionable to place a mansion so near its misty shores, but where the water is constantly gliding or in rapid motion, where a hard pebbly bottom appears through the limpid stream, and where the banks are not swamps or bogs, the current of the stream increases the

wholesome current of the air." Addressing the issue of the house being "on the verge of the estate", and without any formal parkland, Repton observed: "When a property is bounded by a natural river, it is surely advisable to take advantage of so interesting a feature." He advised cutting down the willows and aquatic plants that had been allowed to grow up, which made the land look swampier than it actually was, and digging channels for drainage to allow the land to bear "all sorts of trees and shrubs".

If Repton were alive today, he would have no difficulty recognising the estate, or noticing that the alterations he recommended had been made. A keen botanist and entomologist, he would also be delighted to find that the grounds are full of wildlife.

There are still plenty of fish in the gravel-bottomed rivers – grayling, salmon, trout, pike and even eels – although since 1991, the numbers of

Above: The rivers are a rich breeding ground and home for grayling, salmon, trout, pike and eels.
*Opposite, clockwise from top: The weir has a practical use in helping to control the flow of water; the wooden handle of a sluice gate; touch-me-not balsam (*Impatiens noli-tangere*), a rare annual and British native that loves damp places; one of the many bridges on the estate.*

salmon returning to spawn have crashed, as they have in most salmon rivers in the North Atlantic region.

As Julian said in his contribution to the Royal Horticultural Society's Tree of Knowledge campaign in 2010: "An odd anomaly of the modern, fast-changing world, is that private gardens have become vital protection zones for a good deal of our natural wildlife. The shelter of our animals, plants and insects has become a duty … for British gardeners."

The Felloweses even embrace wildlife that others may regard as pests. Deer can cause serious damage, nibbling their way through roses and many other ornamental plants, but Emma overlooks this trait and instead recounts with delight how the deer come up to the house and lick the windows in winter, presumably in search of salt and minerals left behind by the rain.

The plants in the grounds are mainly deer-resistant in any case. Masses of rhododendrons in

pink, white and purple, and cherry laurel (*Prunus laurocerasus* 'Rotundifolia') remain untouched among the trees. However, one area will be made deer-proof, and that is the potager Emma is planning to introduce. It will have a low brick wall with wrought-iron railings above, and is inspired by the potager at Barnsley House, created by the eminent late garden designer and plantswoman, Rosemary Verey, who was a friend of the couple's.

It will be a formal kitchen garden, and Emma has designed the layout, and researched and chosen her plants, but even here, weeds will be tolerated. Would she consider including a bit of companion planting to keep pests at bay naturally? French marigolds (*Tagetes patula*) growing alongside tomatoes to deter whitefly, or nasturtiums (*Tropaeolum majus*) to attract cabbage white butterflies and lure these pests away from the crops? She loves the idea, but admits to being "not

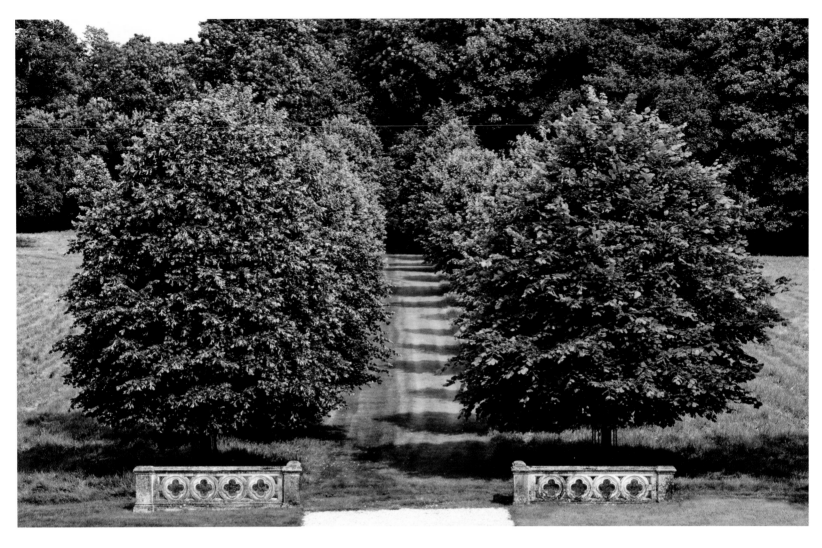

> *"The path cuts through an enormous clump of rhododendrons to create a vista, at the end of which stands Lolita."*

terribly keen on orange", which is the colour of most forms of these useful plants.

While Julian and Emma may not be the kind of gardeners who spend their time fighting a losing battle against ground elder or dandelions, neither do they spend their time "singing 'oh, how beautiful', and sitting in the shade", as Kipling put it. They are regular attendees of the RHS Chelsea Flower Show, where Emma loves looking around the show gardens for inspiration, and taking all the leaflets on offer. "I'm not the sort of person who would say, 'I want that garden, just as it is', but it's a great place to pick up ideas that you can then tweak for yourself."

Julian loves a project, according to his wife, and one of these was the creation of a path which leads north from the house and beneath the branches of an enormous oak that is said to have been planted in 1633, the year the east facade of the house was built.

Emma wasn't totally convinced about the project at first, partly because the path cuts through a huge clump of rhododendron bushes in order to create a vista, at the end of which stands a statue of a naked woman, nicknamed "Lolita". However, Emma now admits that it looks wonderful and the statue makes an eye-catching focal point.

The grassy path that leads east through an avenue of lime trees (*Tilia* x *europaea*) is another one of Julian's design ideas and creates a dramatic feature. Other projects include the many bridges over the rivers and streams around the grounds, and the wooden summer house close to one of the waterways. The couple spend time here every day in summer, and the rear wall is fitted with mirrored panels, so that even if you are sitting with your back to the view, you can still see the river. The ceiling is painted to look like a gazebo, with trailing plants and decorative flowers.

Above: The rear of the house, which is now the terrace, was originally the front.
Opposite, above: The majestic dining table, made by a local carpenter out of wood from the estate, is in the shape of an oak tree planted in 1633.
Opposite, below: The statue nicknamed "Lolita" stands proud at the end of a vista created by Julian.

Above: The pale pink flowers of Primula japonica *'Apple Blossom', together with the statuesque shuttlecock fern,* Matteuccia struthiopteris. *Opposite, clockwise from top right: The shepherd's hut; bridges across the "Mead", a small stream that flows into the river; the stag and the lion sculptures were made of expanded polystyrene for Julian's film* From Time to Time *— they will eventually be covered in ivy.*

Then there is the brick pizza oven which bears the family's initials, JE&P. The P stands for Peregrine, their son, who has also embarked on a film career but on the production side, working on *Rogue One*, *Cinderella* and *Me Before You*. Did Julian build the oven himself? "Let's say he caused it to be built," replies Emma.

The overwhelming impression when you visit this garden is that it has been designed for relaxation. The couple have another house in London, and while they love the buzz and energy of the capital, their Dorset home is where the tensions of their busy lives evaporate in the fresh air.

The riverbanks, which are home to two pairs of kingfishers, as well as little egrets, herons and swans, also feature a shepherd's hut, numerous benches and even a giant chess set, hinting at the way the couple use their garden to rest and unwind. From these vantage points you can look at the garden in detail,

enjoying the little British native ferns (*Polypodium vulgare*) that have established themselves on the mossy branches of a tree, or looking down into the water at the huge fish hiding among the water weeds.

This is also a garden for wellies, dogs, and long walks. There are two walks that the couple take regularly: the short circuit and the long circuit. The short circuit is ideal for people who have to catch a train back to London after Sunday lunch, while the longer route is perfect for those who have spent too much time sitting on a train or plane, and want a more rigorous post-prandial work-out. There is even a golf buggy so that visitors with walking difficulties can still go for a riverside picnic.

Sadly, there is no sign of a faithful Carson at the Fellowes' residence. Instead, Emma makes do with the golf buggy, which she says comes in very useful for taking the picnic paraphernalia to the summer house.

TERRY & MAGGIE GILLIAM

LONDON

Like Terry Gilliam's films, his garden is a mixture of the prosaic and the phantasmagorical. Despite the fact that he lives close to one of London's most famous church spires, visible for miles because of its hilltop position, he has a church spire of his own in the back garden. Not only that, but Terry's is far older than the one next door.

"We were having a new kitchen done and one of the builders said to me that a mate of his was salvaging a bell tower in Guildford and did I want it," he said. "It's 17th century, the same age as the house. So they brought it up here and we put it in the garden."

You can see the spire from the back of the house, but other intriguing features are hidden from view, including a yew topiary that has been cut into the shape of a galleon, inspired by the cinema poster for *Time Bandits*, and two cannons from the set of *The Adventures of Baron Munchausen*, whose mouths are in

the shape of monstrous jaws. Like the plot of a movie, the garden has been designed to reveal itself gradually. It didn't always look like this, however, and when the Gilliams first moved in, the garden was "one big boring rectangle", according to Terry's wife, Maggie.

Their house is one of three that were previously part of a larger property. The original house has a colourful history – the novelist Rumer Godden once had a flat there, as did the actress Margaret Rutherford, and the English philosopher Francis Bacon is said to have died in the house in 1626.

When the Gilliams acquired the property, at first you could only tell whose garden was whose because each neighbour mowed their grass in a different direction. The Gilliams had a small rose garden, but apart from that, there were no features or boundaries. Now, all that remains of the rose garden is what looks like a brick-built well, with a frill of

Terry Gilliam
Born: 1940
Screenwriter, film director, animator, actor, comedian and church-spire saviour

Maggie Gilliam
Born: 1948
BAFTA Award-winning and Academy Award-nominated hair & make-up designer (as Maggie Weston), and hands-on gardener

Above: Maggie and Terry Gilliam in their garden.
Opposite: The silver birches planted along the boundary.

Above: A view of the 17th-century house from the garden. The English philosopher Francis Bacon is said to have died here in 1626.

Opposite, above: The curved balustrade around the terrace echoes the curve of the lawn, while trees and shrubs screen the area from the neighbours.

Opposite, below: Tulips and hellebores bring late spring colour to the borders.

ferns growing out of the mortar and the thorny stems of a miniature climbing rose sprawling over it.

The Gilliams' garden is at the top of a hill, and according to Terry, it can lay claim to being one of the coldest in London. "The wind comes straight down here from Siberia without a break," he said, "so we put in the silver birches as a kind of shelter belt, although we've lost a couple over the years." The birches provide the perfect screen. These airy, elegant trees have something to offer all year round, whether it is golden autumn foliage, catkins in spring or stark white trunks in winter.

Originally, the shared lawn (Maggie has a hilarious picture showing stripes radiating in all directions) came up to a much smaller terrace outside the back door. The Gilliams then cut back the lawn and extended the terrace to make it more useable, adding a flight of steps leading down to the garden

and a curved balustrade. The house has a basement, and the larger terrace makes this look more graceful, as well as providing somewhere to relax and eat. It is a good example of how a later addition can often make a property look more authentic by creating better architectural proportions.

With the help of John Plummer from Clifton Nurseries, Maggie also set about creating a new layout, which divided the garden into three main sections, connected by a number of paths and with a variety of focal points en route. The two borders on either side of the garden closest to the house curve in to form a narrow entrance to the second part, where the old wooden bell tower has been turned into the spire of a purpose-built summer house, set on brick foundations to take the weight.

The summer house and its circular lawn dominate this section of the garden, while a selection

"*Intriguing features include a yew topiary cut into the shape of a galleon, inspired by the cinema poster for* Time Bandits.*"*

of flowering shrubs, such as *Magnolia* x *soulangeana* 'Rustica Rubra' and *Clerodendrum trichotomum*, which sports blue berries framed by crimson bracts in autumn, provide colour at different times of the year. The bell tower itself looks as if it would provide an ideal home for bats, but Maggie and Terry have covered the wooden vents — designed to protect the bells but allow the sound to be heard — with netting.

Behind the summer house, the potting shed is screened by the immense galleon topiary, created by gardener David Brown. It was inspired by the poster designed by Terry for the 1981 fantasy film *Time Bandits,* which he co-wrote (with Michael Palin), produced and directed, that featured a giant wearing a galleon on his head.

From here you turn left into the third part of the garden, where there is a large lily pond with a little wooden bridge spanning the water. On the sunny

bank on the opposite side, two beehives, complete with bees, are set in a small wildflower meadow next to a self-seeded yew, which has been clipped into the shape of a wedding cake.

It may seem odd to think of keeping bees in London, but the capital's back gardens provide almost year-round forage for honeybees and other pollinators, who benefit from the milder big city microclimate. The flowers, shrubs and trees in the Gilliams' garden offer a rich feeding ground for these beneficial insects, which are thriving here.

Maggie Gilliam (née Weston) grew up among keen gardeners in the Essex resort of Leigh-on-Sea. Her father was an enthusiast, and her grandfather was an "amazing" gardener, who sold the flowers and vegetables he grew to neighbours from his garage. Maggie can remember as a little girl being fascinated by the upturned flower pots on bamboo canes that

Above: A yellow azalea and clumps of bamboo help to create an Asian ambience by the pond.
Opposite: Gilliam's work as a filmmaker has inspired many of the garden features, such as (clockwise from top left) a hut made from Indonesian carvings; a topiary spire; the topiary galleon; a lion and a rhinoceros cannon from Baron Munchausen.

Above: The beehives have an ideal situation in a meadow, facing south and protected from the north wind by the huge yew topiary in the shape of a wedding cake and other shrubs behind them.

Opposite, clockwise from top left: The spire of the salvaged bell tower and some of the "found" objects that have been used as sculptures; the mixed border below the terrace, which receives sun in the afternoon and evenings.

her grandfather used to trap earwigs to prevent them munching on his dahlias.

Maggie appears to have inherited his workman-like, hands-on approach, because the name of every plant in the garden is marked with a sticky label in a huge Royal Horticultural Society plant encyclopedia, while a massive album of photographs chronicles the development of the garden.

Like many plots in London, the Gilliams' garden features lots of mature trees, and on first glance, the initial impression is that it is mainly woodland. The trees are joined in the brighter spots between the canopies by a host of flowering shrubs, including hebes, choisyas, rhododendrons and roses, but it is only when you take a closer look that you realise there's a dense understorey of perennials too, adding another layer of seasonal colour. Maggie has included some beautiful shade-loving hellebores, euphorbias,

hardy geraniums, pulmonarias and aquilegias, together with brightly coloured rudbeckias and crocosmias in the sunnier parts.

One of the warmest places in the garden is on the terrace by the house, where Maggie grows angel's trumpets (*Brugmansia*) in pots, taking them inside if really cold weather is forecast in winter. *Brugmansia* is a member of the nightshade family and all parts of it are deadly poisonous, but the scent from its drooping trumpet-shaped flowers is delicious.

On the church side, an exotic area has been created with bamboos and tree ferns, whose trunks are wrapped in coir matting during the winter months to protect them from the cold. The edges of the pond are decorated with a clump of Chilean rhubarb (*Gunnera manicata*), which sports giant leaves the size of table tops. Other pond-side plants include irises, hydrangeas, foxgloves and *Persicaria bistorta*

'Superba', which covers the ground with pale pink spires from late summer to mid-autumn. At the end of the garden, there is a potting shed and huge iron gates, salvaged from a local hospital, which open on to the compost heap area.

Maggie, a BAFTA Award-winning and Academy Award-nominated hair and make-up designer, who worked on films including *Jabberwocky*, *Time Bandits*, *Brazil* and *The Adventures of Baron Munchausen*, is clearly a creative person, and Terry insists that she takes all the credit for the garden. She, in turn, praises their gardening staff who help to keep everything looking good.

I think Maggie would agree that Terry specialises in a unique form of theatrical garden design. None of it seems contrived or self-conscious, partly because it has evolved over the years and also because most of the objects he's used obviously had a previous life before ending up here. These include a wooden horse,

wearing a saddle and a bucket on its head, which the couple have nicknamed Rocinante after Don Quixote's long-suffering steed; Terry is currently working on a movie inspired by the famous 17th-century novel by Miguel de Cervantes.

Other recurring motifs are the chimney pots that appear throughout the garden, one with a teapot on top. The African-looking hut, made from Indonesian wood carvings, is also quirky; inside, it features the Minotaur's head from *Time Bandits*. These eclectic elements combine to produce an overall effect that is both eccentric and intriguing.

The wonderful garden Terry now enjoys is a far cry from his childhood home in America – he was born in Minnesota and grew up in a house that was basically a summer cottage with an outside toilet, not made for the harsh winters that frequently experience temperatures well below freezing.

Above: Rhododendrons flank the path that leads from the bell-tower section of the garden to the main lawn. Opposite, clockwise from top: Bluebells in flower beneath a yellow azalea; a view of the lily pond looking back towards the house; rhododendrons in bloom; "Rocinante", Terry's representation of Don Quixote's famous steed, complete with a saddle and bucket on his head.

Jeremy Irons
Born: 1948
Wife: Sinéad Cusack
Academy Award-winning actor, campaigner and planter of romantic English borders

Left: The trellised porch, gate and bench are painted in a subtle blue-grey-green, which complements the honey-coloured stone of the house. Right: Ornate metal gates open onto a view of a fountain supported by swans.

JEREMY IRONS

OXFORDSHIRE

Jeremy Irons is probably the only person in this book who has earned money from horticulture. After leaving school, he trained at the Bristol Old Vic Theatre School, and then moved to London, where he supplemented his income from acting by doing cleaning and gardening jobs.

He is also definitely the only person in this book who has rescued its photographer, Hugo Rittson Thomas, after a tobogganing accident on Watlington Hill, a steep ascent between High Wycombe and Oxford. Hugo hit his head after coming off his toboggan, and as he came to, was groggily aware that a vaguely familiar face was preparing to drive him to the John Radcliffe Hospital. It was Jeremy Irons, and he may well have saved Hugo's life.

Jeremy often plays characters that are patrician, sometimes with a hidden flaw or weakness, such as the sinister architect Anthony Royal in the British

thriller *High-Rise* (2015), Claus von Bulow in *Reversal of Fortune* (1990), for which he won an Oscar, and Dr Stephen Fleming in *Damage* (1992). Then, just as you think he's in danger of becoming typecast, he does something completely different. One of his recent roles was the socially awkward Cambridge mathematics professor G. H. Hardy in *The Man who knew Infinity* (2016), directed by Matthew Brown.

As on screen, as in life: he seems allergic to predictability. He often says that he thought about becoming a gypsy while he was busking in Bristol to earn some cash, and he still has a gypsy caravan at his home in Watlington.

Jeremy epitomises the upper-class Englishman, but he loves Ireland too, and spends as much time as he can at Kilcoe Castle, the property he owns in West Cork. He goes to the local pub with the builders working on the renovations there, and even learned

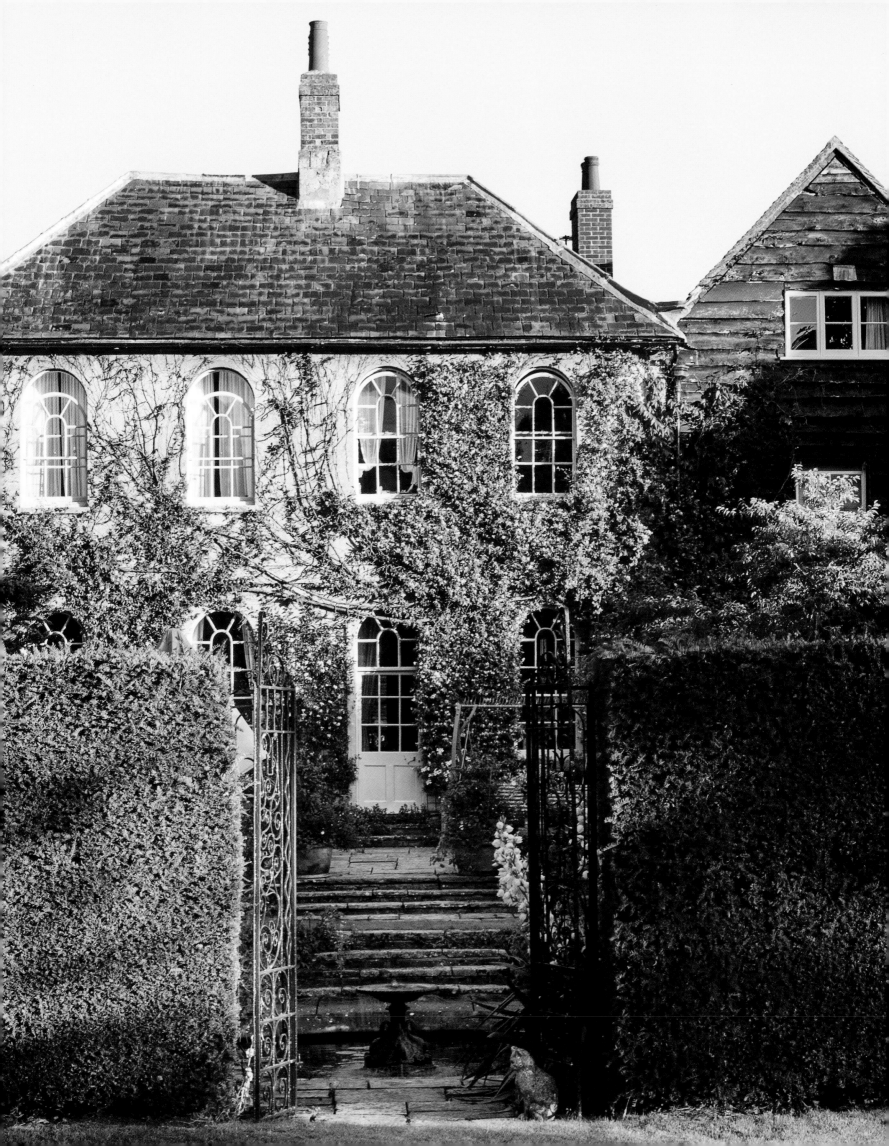

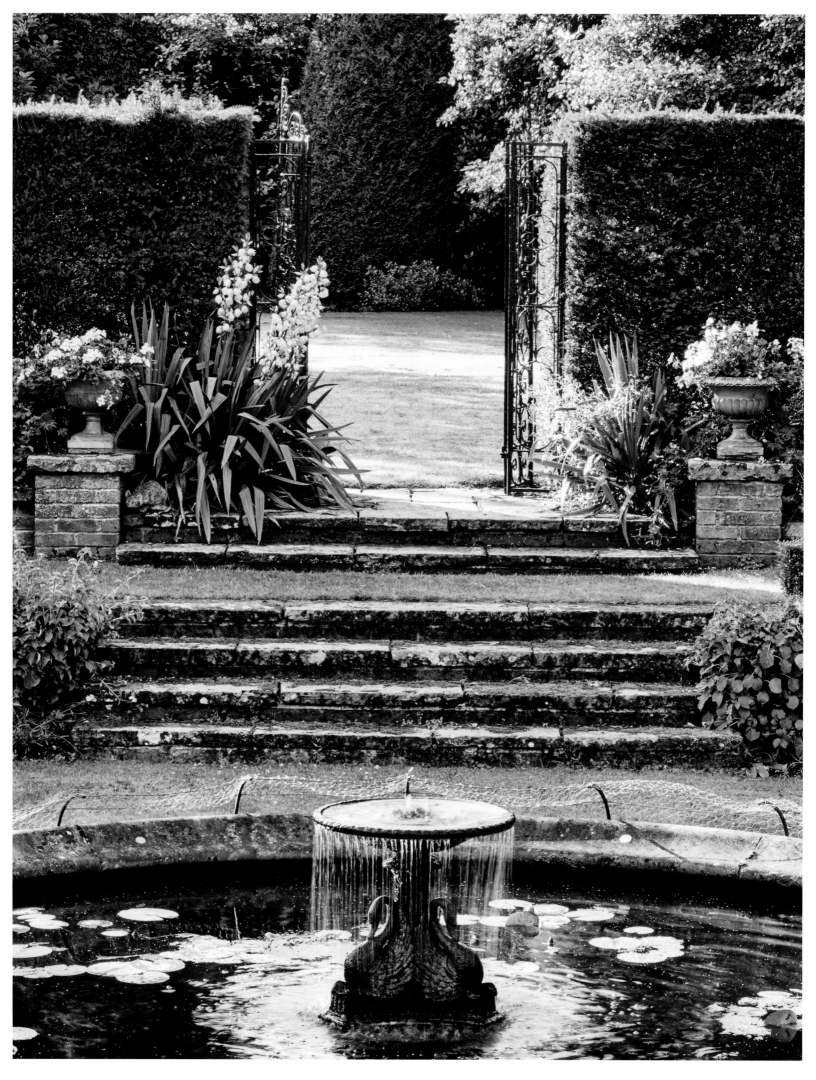

to play traditional fiddle so he could take part in the impromptu musical sessions that are a feature of many Irish hostelries.

His long, lean figure and classic good looks make him a wonderfully elegant clothes horse, but he's also quite happy to host the Watlington flower show in T-shirt and jeans, presenting the awards for homemade cakes and vegetables along with his wife, the actress Sinéad Cusack. It's fantastic to think of an actor of his fame and stature opening up his home to local people, but he merely commented that it gives him an excuse to clean out the barn.

His home in Watlington is a Regency house. Built of limestone with a Welsh slate roof, it has a Grade II listing, as has the barn, which is a timber building on a brick base. The date of the house is thought to be 1820, and since Welsh slate did not become affordable for most people until the advent

of the railways later that century, it suggests that the original owner was a person of substance. The house also has a hipped roof, which means it slopes down to the eaves on all four sides, not just at the front and back, and, together with the arched windows, creates the impression of an elegant doll's house.

The garden is quintessentially, unequivocally English in its design and planting style. Masses of climbing roses wreathe the walls and the trellised portico, and the borders are filled with plants that billow and froth, such as *Hydrangea arborescens* 'Annabelle', the milky bellflower *Campanula lactiflora*, catmint (*Nepeta*), and everlasting sweet peas (*Lathyrus latifolius*), which are the colour of raspberry sorbet.

The garden also features a beautiful weeping pear (*Pyrus salicifolia* 'Pendula'), which is a great choice for any garden, with its grey willow-like leaves, white flowers in spring and ornamental inedible autumn

Above left: Stipa gigantea, whose towering flower heads look good all year.
Above right, top: The fountain has its own dwarf boundary hedge, punctuated with roses in each corner.
Above right, bottom: Jeremy Irons and his wife Sinéad Cusack with members of the local horticultural society.
Opposite: Yuccas flanking gates at an entrance; similar plants were used by Gertrude Jekyll in her garden at Munstead Wood.

Above: Flowering trees, such as the weeping pear (Pyrus salicifolia 'Pendula') provide a sense of intimacy without being oppressive.

Opposite, clockwise from top: The finely cut leaves of the elder, Sambucus nigra *f.* laciniata, *contrast with the clipped hedge behind; clouds of pale blue* Campanula lactiflora; *Mexican daisy, or* Erigeron karvinskianus *'Profusion'; a statue is given added emphasis by its placement in a niche.*

fruits. Many of the beds are punctuated with *Stipa gigantea*, or giant oats, which produces a mound of evergreen grassy foliage, and stems two metres (seven feet) long topped with dainty summer flowers, followed by seed heads that last through the winter.

You can tell by the way Irons talks about gardening that he is a hands-on horticulturist. He loves visiting other gardens, for example: "It's fun to see what other people do – what do they plant? What works for them? You think, that looks good, I might try one of those." You can also imagine him pottering around while his dog Smudge, a border terrier/Parson Russell cross from Battersea Dogs Home, investigates hidden corners that may yield a rat.

Jeremy is passionate about the environment too, and took on the role of roving reporter in Candida Brady's documentary feature film *Trashed* (2012), which looks at the scale and devastating impact our

wasteful, throw-away society is having on our planet. He was also executive producer and said at the time that he wanted to make a film on a subject of real social importance.

Like most environmentalists, he doesn't believe that gardens should be too tidy, and favours plants that embrace with enthusiasm the business of growing, such as the diminutive Mexican daisy, *Erigeron karvinskianus*. I swear this plant has the ability to seed itself into solid rock, and if you want your garden to be full of it, simply buy a couple of decent-sized plants, plonk them in the garden somewhere, sit down with a glass of white wine and by the end of the evening it will be everywhere.

So that may be a slight exaggeration, but it is an incredibly invasive plant, yet no one ever complains about it. I have never heard anyone say (as they often warn about the spurge *Euphorbia cyparissias*, or snow-

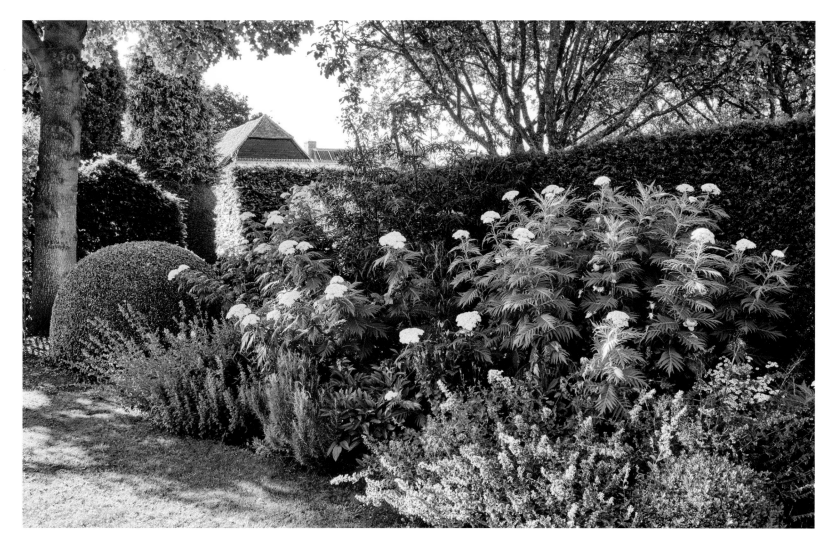

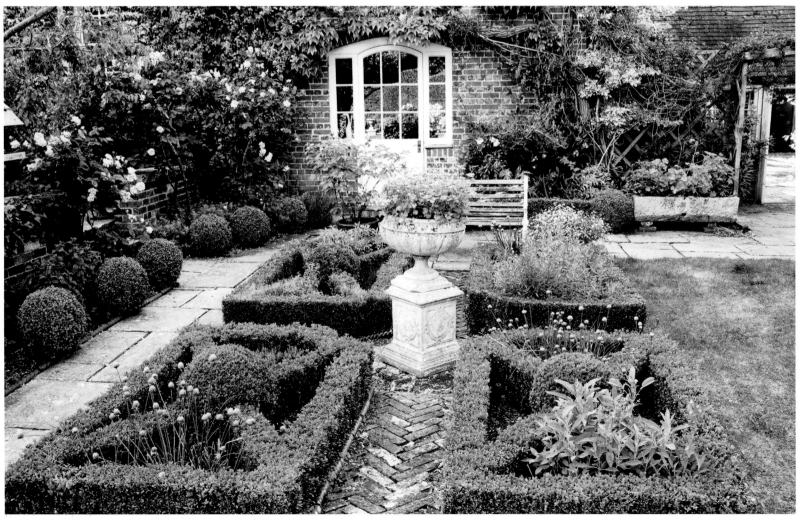

"The pond margins are crowded with yellow flag iris, angel's fishing rod, and large clumps of elegant arum lilies."

in-summer, *Cerastium tomentosum*): "For goodness' sake, don't plant that. It will be everywhere." This is a plant to be celebrated, its dainty white and pink flowers, which bloom all summer and for much of the autumn, will have you egging it on in the hope that it spreads into every nook and cranny.

Although this daisy and many other seemingly traditional plants here may not be natives, they have long been used in English gardens. *Erigeron karvinskianus*, for example, was first introduced to the UK in 1836, and used by the great garden designer and plantswoman, Gertrude Jekyll, in the early 20th century to decorate the garden at Hestercombe in Somerset, where it forms a lacy frill along the stone steps and terrace.

The pond in Jeremy's garden features water soldiers (*Stratiotes aloides*), which were first recorded in Britain in 1633. Indeed, there is a bit of a debate

about whether they are native or not, but there is no debate about whether they spread like mad: I can tell you from first-hand experience that they do. Then there are the yuccas, which Jeremy has growing on either side of a wrought-iron gate, in the same way that Gertrude Jekyll grew them in her own garden. The Spanish dagger, *Yucca gloriosa*, has been in this country since 1596 and, despite its exotic looks, it's as hardy as they come, withstanding anything the freezing Oxfordshire weather can throw at it. If you can grow it in Watlington, you can grow it anywhere.

Although most of the garden has a carefree look, a traditional herb garden brings a touch of formality to the design. Chives, sage and tarragon are set out in a neatly clipped parterre just beyond the back door, an ideal spot for the family to pop out and pick a few fresh sprigs to add to their meals. A stone urn overflowing in summer with grey-leaved *Helichrysum*

Opposite, clockwise from top left: A tree house half-hidden in the branches looks down on the fountain garden; climbing roses scramble up the walls of the old barn, with its charming porthole windows; herbs growing in a box parterre. Above: Surrounded by lush foliage, a metal bench offers an enticing spot by the water to sit and dream.

Above: A little bridge crosses the pond, where aquatic plants provide a thick carpet of textural leaves. Opposite, clockwise from top: Statuesque arum lilies (Zantedeschia aethiopica) can be grown as marginals; the figure of a nymph gazes into the water; the spiky leaves of water soldiers (Stratiotes aloides); Ligularia stenocephala sends up dramatic spires of yellow flowers in late summer.

petiolare forms a focal point in the centre of the parterre, and brick paths in a herringbone pattern provide easy access to the herbs.

While the pond itself is packed with water soldiers and lilies, the margins are crowded with yellow flag iris (*Iris pseudacorus*), the pink pendent flowers of angel's fishing rod (*Dierama pulcherrimum*) and large clumps of elegant white arum lilies (*Zantedeschia aethiopica*). A wooden canoe is moored here as if someone was about to push off down the river, in the style of Jerome K. Jerome's classic novel *Three Men in a Boat (To Say Nothing of the Dog)*. A little wooden bridge spans the water and brings to mind Claude Monet's garden at Giverny in France, although Jeremy's is painted a dark red rather than the artist's blue-green.

There is another pond in a sunken garden close to the house, but it is much more formal: a perfect stone circle enclosed by rose beds and tall hedges.

The bowl of the fountain at the centre is supported by swans, and rather than shooting up in the air, the water flows gently over the sides, which visually has a very calming effect. The sound of the water is also relaxing, and sets the tone for the rest of the garden.

Jeremy may have been describing his own garden when he said in an interview with *The Irish Examiner*: "You can do anything with a garden. You can make it very clipped and very precise, or you can let it be wild and blowsy. You can divide it into rooms, so that you walk through a gap in the hedge and then suddenly there's somewhere else completely different.

"Not only do you see inside other people's souls [when you visit their gardens], but you find your own. They say you're nearer to God in a garden than anywhere else and I think there's some truth in that. It's very peaceful and very calming in this bustling world that we live in." Amen to that.

ALLEN JONES

COTSWOLDS

Allen Jones RA created his garden in his own image. This may not be obvious from ground level or if you are lucky enough to look out from one of the windows of his Cotswolds farmhouse, but the outline is there nonetheless. It echoes a self-portrait that hangs in his drawing room, entitled *The Artist Thinks*. The painting depicts what is almost a caricature of Jones's face, showing the curve of the skull, two eyes and a nose, while a huge red cloud erupts like a thought bubble from the brain.

In the garden, this curving skull shape serves a practical use: it has been translated into a long curving hedge which acts as a shelter belt to protect the garden from the storms and strong winds that sweep in from the north and west. Surprisingly — given its current unpopularity among householders — the hedge is Leyland cypress (x *Cuprocyparis leylandii*), clipped to an almost carpet-like texture. The hedge

is a source of fascination for Allen. It has always been tightly clipped, and he is intrigued by the patterns that appear on it in certain lights. They look like the shadows of branches, and at first he thought perhaps it was the marks left by the hedge trimmer. Was it the way it was cut, or perhaps the way the sap travelled through the plants? It seems likely that the shadow branches are real branches, inside the hedge, which bounce the light back in a different way, so you can see the ghost of the tree that never was.

Allen and his wife, Deirdre Morrow, are very private people and never open their garden to the public. So you'll have to take my word for it that from every single window in what Deirdre describes as their "higgledy-piggledy" house, there is a perfectly composed view. You can tell that this is an artist's garden: it is the product of the sort of analysis and visual investigation that makes good art.

Allen Jones

Born: 1937

Wife: Deirdre Morrow

Artist, sculptor, Royal Academician and inventor of "tsunami" hedges

Above: Allen Jones and his wife, Deirdre Morrow, with their marmalade cat, Cyrus. Opposite: A climbing hydrangea in flower on the front wall of their former farmhouse; the gate on the left leads to the orchard.

The site itself was unpromising. It was originally a farm, and when Allen and Deirdre bought the property, it was one of several lots of cottages and farm buildings. Deirdre told me it was like something out of the novel *Cold Comfort Farm*, and because the main water supply to the nearby village ran a metre (yard) from their back wall, even the idea of levelling the ground to build a terrace was out of the question.

The water supply has since been moved, and the couple have negotiated with neighbours to swap bits of land around. They now have the old orchard next to their house, while the neighbours, who used to own it, have a paddock for their ponies.

The rambling layout of the old farm buildings has dictated a series of enclosed gardens at angles to one another, but it is difficult to tell, looking at the mature trees and the serpentine Leyland hedge, just how daunting the initial prospect of making

any sort of garden actually was. Indeed, it was while Allen was studying the Ordnance Survey map of the property, and pondering how to create a shelter belt — the garden is nearly 200 metres (650 feet) above sea level — that he came up with the idea of using his own face as a template for the design. It fitted so neatly into the shape of the site.

Allen and Deirdre set about designing their garden in much the same way as an artist will lay down a pencil line as a guide. Hedges and fences provide the outlines, while areas of lawn and shrubs and trees create texture and contrast. One long yew hedge is called the tsunami hedge. It's clipped at one end into a series of waves and breakers, as if the prevailing west wind had caught the top and lashed it into a storm-tossed frenzy.

There is a good reason for this unusual shape, as there is for most of the planting ideas in the garden.

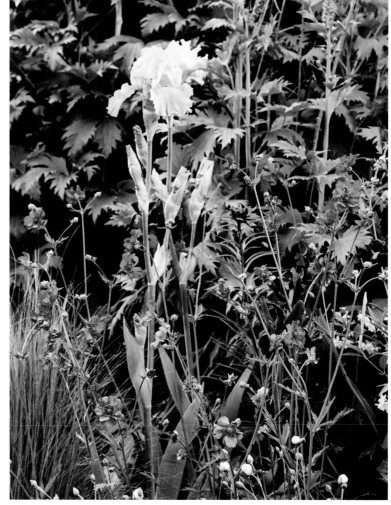

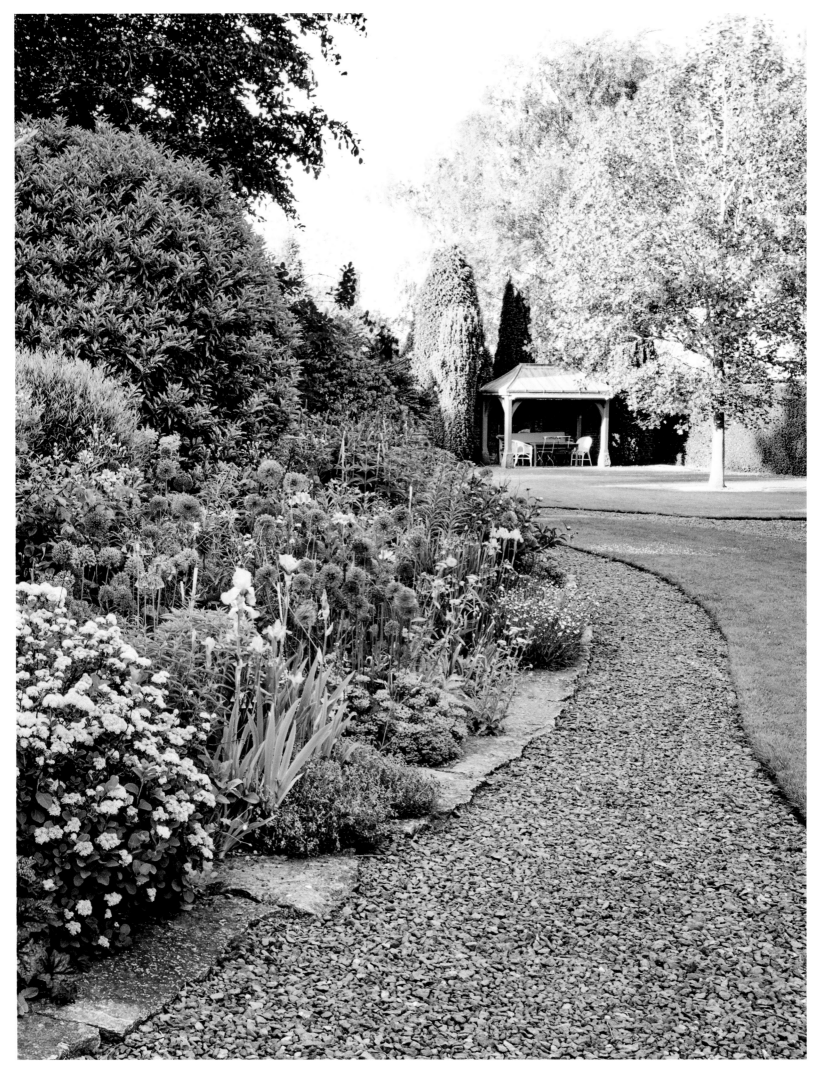

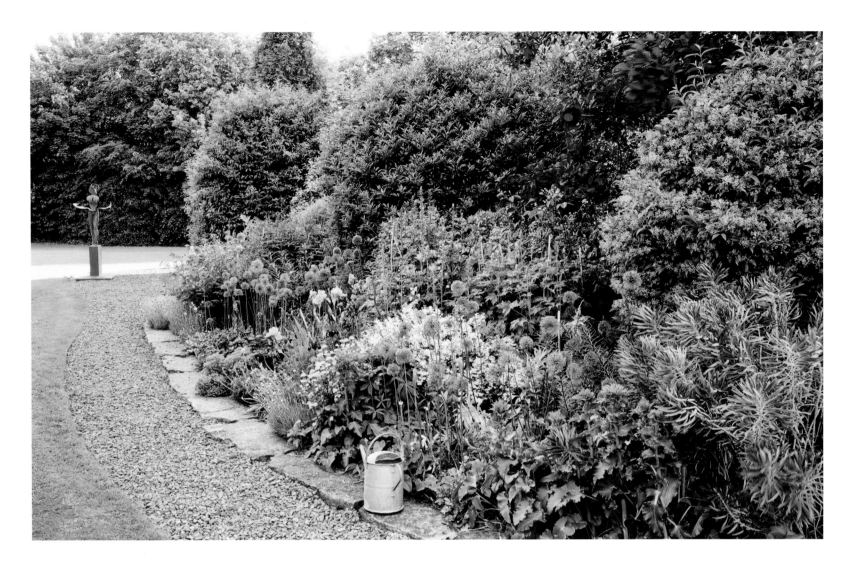

"Allen and Deirdre set about designing the garden in much the same way as an artist will lay down a pencil line as a guide."

When the hedging plants arrived, they all looked the same, recalled Allen, but as they grew it became obvious that while some were the common species of yew, *Taxus baccata*, others were the fastigiate variety, which grows into columns rather than spreading outwards. Reluctant to dig up these anomalies, Allen decided to make a feature of their different shapes and forms.

Aside from Allen's own sculpture, there is an eclectic mix of objects in the garden. What look like ancient stone baptismal fonts or basins were handmade from tufa in a village in Bali. The man who was making them didn't speak much English, and although Allen was very keen to buy some — "I said to him, 'I've got just the place in my garden for those'" — he was a bit worried about how he would transport them home. However, to his surprise and delight, the craftsman whipped out

a Blackberry phone, calculated the shipping cost to the UK, and the deal was done.

The three rocks in the Japanese gravel garden come from China, Scotland and Wales. The Chinese rock is a "scholar's stone" formation, and was given to Allen after one of his works was installed at the Yuzi Paradise sculpture park in Guilin. Allen likes to sit on a bench next to the Japanese garden and look at the stones while thinking through projects: "It's a natural thing for me to ponder about something, then see how it develops."

For an artist who provokes so much controversy, Allen Jones comes across in person as temperate and reflective. One of the generation of British pop artists, who include David Hockney and Peter Blake, his erotic mannequin sculptures, such as *Hatstand, Table and Chair*, and his more recent figure of Kate Moss wearing a gold breastplate, have been both

Above: According to Allen, Deirdre takes more interest in the floriferous planting, such as this wonderful border with its alliums and irises. The sculpture is called Iron Maiden *and combines Allen's two sculptural languages: the realistic and the abstract. Opposite: A different view of the same border, with the summer house in the distance, sheltered by tall conifers.*

Above: A series of terraces and walls accommodate the change of levels in the sloping garden, while columnar conifers add architectural interest.

Opposite, clockwise from top: Gaps in the wall prevent it becoming too oppressive; the double gates to the entrance of the house; the Sumo *sculpture (1989); the "face" screen.*

admired and condemned for their explicit sexuality. Yet when he talks about his work, there is no hint of a desire to shock or *épater les bourgeois*.

This is possibly because so much of his art, including the pieces in the garden, are a response to a design problem, or a new way of seeing something. Take the "face" screen on the wall behind the house. When the area was levelled and terraced, the wall was originally going to be solid, but Allen decided he wanted to see through it. However, he was also worried that someone might fall through the opening. "I looked through my drawings and came up with something that I thought looked a bit like a head my friend Roy Lichtenstein may have drawn."

The double gates at the entrance to the property were originally a single, asymmetrical gate, but as the garden developed, Allen wanted to make more of a statement as you arrived at the front of the house.

He gave the single gate to a local blacksmith who reproduced an exact replica, and matched it so well that it was difficult to tell which was the original. Allen was also delighted to find that the "mirror image" double gates have a dip in the middle, which lead the eye perfectly through to the garden beyond.

There is also a moon gate in the garden, which is a smaller version of one commissioned by the then Marquess of Hartington (now the 12th Duke of Devonshire) and his wife, who wanted a gate that could be used as a stile. Built in cast iron, the original design shows two outline figures with a picnic basket, through which the couple's Jack Russells could run, and it is now installed at Chatsworth House.

When it comes to colour, this is very much a green garden. Allen and Deirdre love their trees, and they have a wonderful collection of rare and unusual types, including the dawn redwood (*Metasequoia*

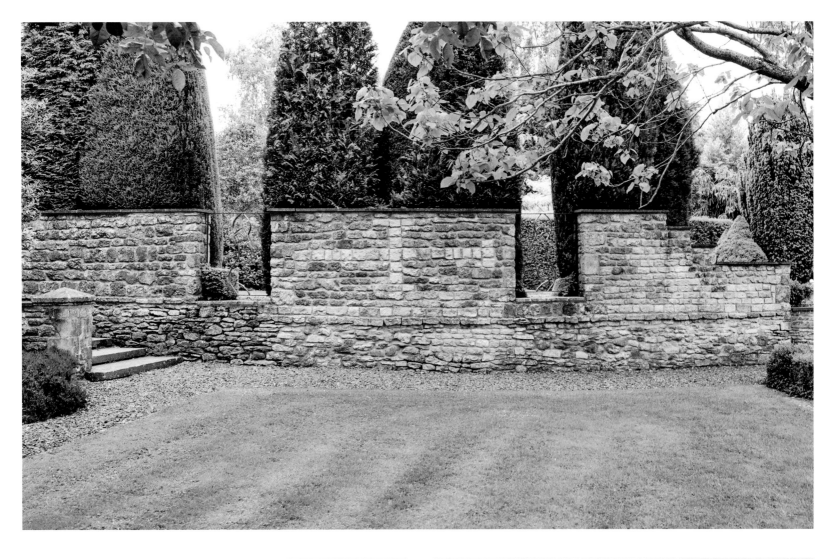

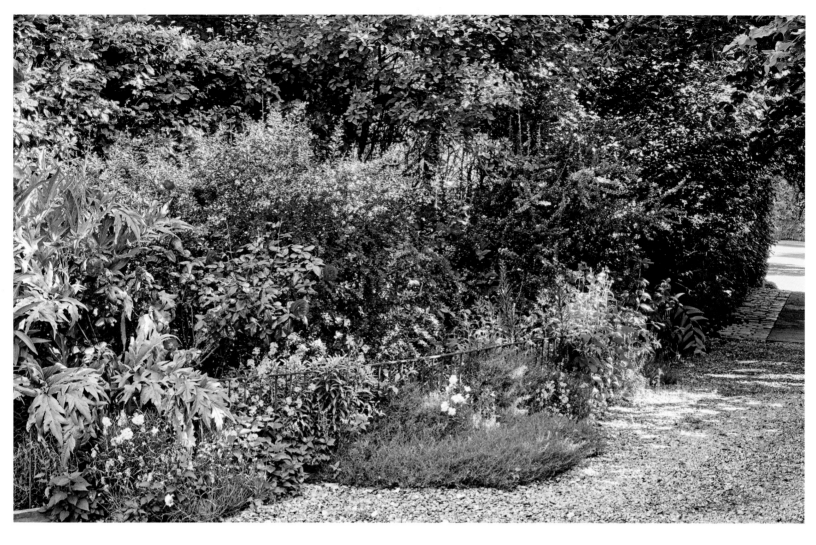

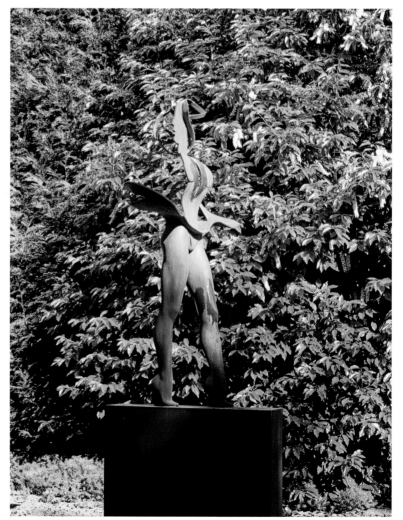

glyptostroboides), giant redwood (*Sequoiadendron giganteum*) — one of the largest trees in the world — red oaks (*Quercus rubra*), a tulip tree (*Liriodendron tulipifera*) and an expansive great white cherry (*Prunus* 'Tai-haku').

Along the side of the garden that borders the road to the village, mature native trees, such as beech, create both a shelter belt and a noise barrier, helping to muffle the sound of passing traffic. Beneath the beech trees is a massed planting of ferns, such as *Dryopteris* and *Polystichum*, that tolerate dry shade. The ferns offer a long period of interest, from the moment their croziers first emerge in spring to the end of winter; some are evergreen and others semi-evergreen, retaining their old leaves during the cold months, depending on how sheltered their site is.

Ferns often perform the role of backing group in the woodland garden, and are used to fill out borders in which the star attractions are more showy

performers, such as hellebores and hostas. It is only when the spotlight falls directly on them — as here, or in a fernery — that you become aware of the intricate beauty of these ancient plants.

Although green foliage dominates, there are areas of colour in the garden. A large mixed border close to the summer house is filled with an assortment of perennials and bulbs, including alliums and irises. There are flowers too: the blossom of the fruit trees in the orchard, a tree peony and the white cherry create a spectacle in spring, when they are joined by camassias, erythroniums, white narcissi and wood anemones, which also bloom at that time of year. Purple foliage from heucheras, a smoke bush (*Cotinus*) and barberry (*Berberis thunbergii*) also heightens interest in the borders. The main emphasis, however, is on greenery and structure, on vistas and ideas that have come to life in a growing form.

Above: The conifers include thujas and Leyland cypress (x Cuprocyparis leylandii), clipped into neat bullet-shaped columns. Opposite, clockwise from top: Tree peonies and a purple-leaved barberry (Berberis) decorate a border; a closer view of the Iron Maiden *sculpture; the serpentine tightly clipped Leyland cypress hedge; the moon gate, inspired by a traditional Japanese bamboo fence, which leads to Allen's studio.*

Anish Kapoor
Born: 1954
Partner: Sophie Walker
Sculptor, winner of the 1991
Turner Prize, and protector
of the landscape park

Opposite: Brightwell Park,
the home of sculptor Anish
Kapoor. The park is reputed
to have been designed by
Humphry Repton, but there
is no evidence to support this.
Left: A majestic cedar of
Lebanon (Cedrus libani).

ANISH KAPOOR

OXFORDSHIRE

The cedars of Lebanon along the avenue that leads from the lodge gates, over the Waterloo Bridge, and on to what remains of the Georgian house at Brightwell Park have witnessed great changes in their 200 years. On one of them, a local teenager has carved the name of his sweetheart, but perhaps a more fitting inscription for this site would be *sic transit gloria mundi*, which means "thus passes the glory of the world" or, in more layman's terms, "worldly things are fleeting". And yet there is still a glory at Brightwell Park today: the glory of a landscape untrammelled by the restlessness of modern life. The ruins of the past might be here, but there is still a lot to celebrate.

Brightwell Park, which nestles in a tiny hamlet in the heart of the Oxfordshire countryside, is the home of the internationally renowned sculptor Sir Anish Kapoor. He lives there with his partner,

garden designer Sophie Walker, who in 2014 became the youngest woman to design a show garden at the prestigious RHS Chelsea Flower Show.

Anish moved to London from Bombay in the 1970s to study art and he is a former winner of the Turner Prize. He is also the creator of the famous *Orbit*, the bright red sculpture and observation tower at the Queen Elizabeth Olympic Park in London, which stands almost 115 metres (377 feet) in height and forms one of the park's main focal points.

A few rose bushes and some wildflower meadows decorate parts of the garden at Brightwell, but most of the land has been sensitively managed to look as natural as possible, and comprises mainly trees, grass and water. There is a programme of replanting too, with a focus on British natives, ensuring that the landscape and wildlife are not compromised.

Anish and Sophie live in what used to be the mews

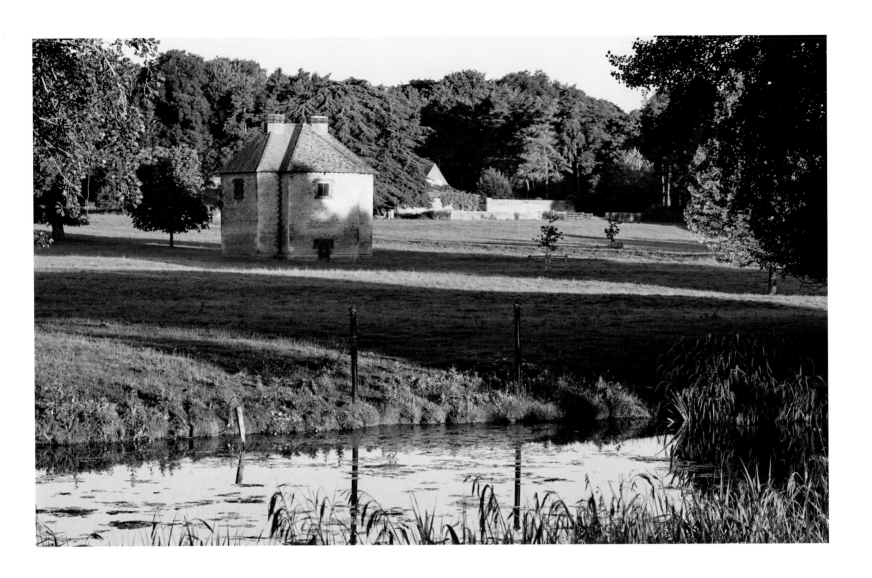

or coach house, since the main house, built in 1790, was demolished when dry rot was found in the roof after the Second World War. Only the ground floor remains, but apparently a ballroom ran the entire length of the first floor in its heyday.

The Georgian building actually replaced an even older manor house which burned down in 1788. Recent archaeological investigations revealed that this earlier property was not built on the same site, as had been traditionally thought, but further down the slope towards the lake.

According to the local newspaper reports of the time, the blaze lit up the sky. Thieves took advantage of the family's absence to loot the property, stealing furniture, wine and other valuables, and five men were later hauled up before the local magistrate.

All that remains of the manor house today is the dovecote, thought to date from the 17th century, and

the ice house, serviced by a tunnel from the main building, so that servants could walk the 100 metres (328 feet) or so to collect ice without cluttering up the view from the drawing room windows.

Interestingly, from a garden history point of view, the dovecote stands on footings that are thought to be part of an island. According to Donald Chilvers in his history of Brightwell village, *Quiet Times, Cruel Times*, it may have been at the centre of an ornamental water garden, fed by the "bright well" or stream that today still runs into the lake. An archaeological survey of the property also found vestiges of terraced formal gardens between the house and lake.

One of the former owners of the old manor house was Sir Adrian Fortescue, a second cousin of Anne Boleyn, who had a distinguished military career and was present at her coronation. He was also a devout Catholic and a Dominican tertiary (lay member

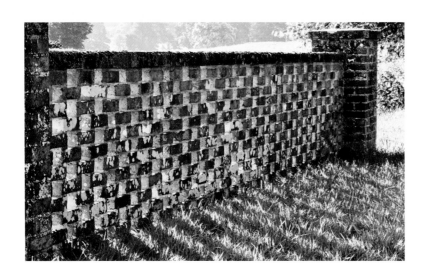

"*Anish commissioned a full ecological survey and conservation management plan after he bought the property.*"

of the order), and in 1532 he joined the Order of St John of Jerusalem. His religion, together with his connections to Anne Boleyn, put him in a very dangerous position, and he was arrested and ordered to swear the Oath of Supremacy, acknowledging Henry VIII as the supreme governor of the Church of England. Sir Adrian refused and was condemned to death without trial. His property was confiscated and he was beheaded on Tower Hill in July 1539, while his servants were hung, drawn and quartered at Tyburn. He is regarded as a martyr by the Catholic church, and was beatified by Pope Leo XIII in 1895.

The dovecote is in the shape of a cross, rather than the more common square, circle or octagon. I have no evidence to support this speculation, other than the Tudor tradition of symbolism in gardens, but it made me wonder whether this was a subtle sign, in uncertain times, of the family's religious allegiance.

The grand houses may have disappeared or fallen into ruin, but the estate's wildlife population has flourished in recent years. It is now an important habitat, and Anish commissioned a full ecological survey and conservation management plan after he bought the property. According to Stuart Horne, the estate manager, it was a fascinating process, revealing the existence of creatures he suspected were in the grounds but hadn't personally seen. One of these was an otter, caught on a wildlife camera as it helped itself to the fish in the lake.

Another discovery was not as cute and fluffy, but it was of intense interest to entomologists. The survey found evidence of *Elodes tricuspis*, Britain's rarest scirtid (leaf litter-shredding) beetle. Their larvae are aquatic, burrowing into the muddy bed of a pond when it is time to pupate, so they require a damp woodland habitat. *Elodes tricuspis* has been found

Above: At one time, the walled garden boasted an orchard and heated glasshouses. Opposite, clockwise from top: Roses and catmint in the coach house garden, which also contains a purple-leaved plum, Prunus cerasifera *'Nigra'; remnants of the orchard; the wall between what was the rose garden and the tennis court; the door to the walled garden.*

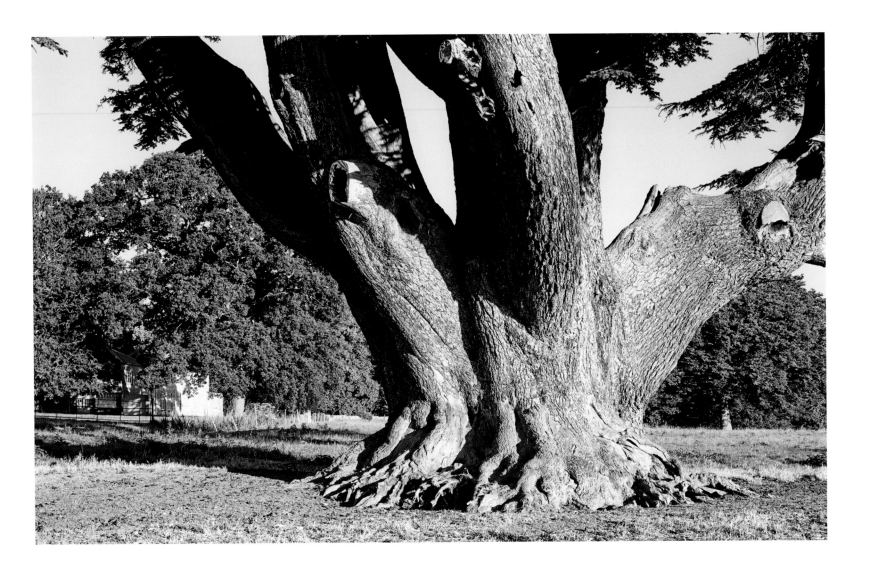

Above: The majestic cedar of Lebanon that stands in front of what used to be the main house makes a dramatic statement in the park. Opposite, clockwise from top: Another view of the same cedar; a climbing rose on the wall of the coach house; climbing hydrangea (Hydrangea anomala subsp. petiolaris) on an outbuilding; an old stone urn leans at a precarious angle.

in only six other sites in Britain, and has never been recorded in Oxfordshire until now. Of the six sites, only two have reported sitings of the beetle in the past 20 years.

The survey also revealed a number of "red list" birds, which are those of conservation concern, including cuckoos and lesser spotted woodpeckers, as well as five nesting pairs of red kites, unmistakable thanks to their V-shaped tails. Looking up at these birds on a still, sunny day, when they're gliding on outstretched wings that seem to imitate the spreading branches of the monumental cedars, it's as if someone has pressed the pause button on life for a moment.

On and around the lake there are ducks, Canada geese and a young solitary swan, who arrived still with some of his or her grey cygnet feathers and has yet to find a mate. Foxes and badgers have staked claims too, but one of the biggest threats to the waterfowl

comes from the red kites and American mink. Stuart Horne said: "I know the kites are supposed to be carrion birds, but when they are rearing their own young, they will swoop down and snatch ducklings."

Between the ice house and the cedar drive, pieces of stonework mark the position of an air raid shelter, installed when two evacuated prep schools moved into Brightwell during the Second World War, while more recent evidence of the former ornamental gardens is found by the tennis court, where a rusty metal support bears witness to long-gone fencing. Next to the court, there used to be a rose garden and a huge kitchen garden, of which only the brick walls and a bit of greenhouse remain. In its heyday, the kitchen garden fed the entire village, as well as the inhabitants of the big house, and when the estate was sold in 1942, it was described as having two heated greenhouses, a vinery (the old grapevine is still

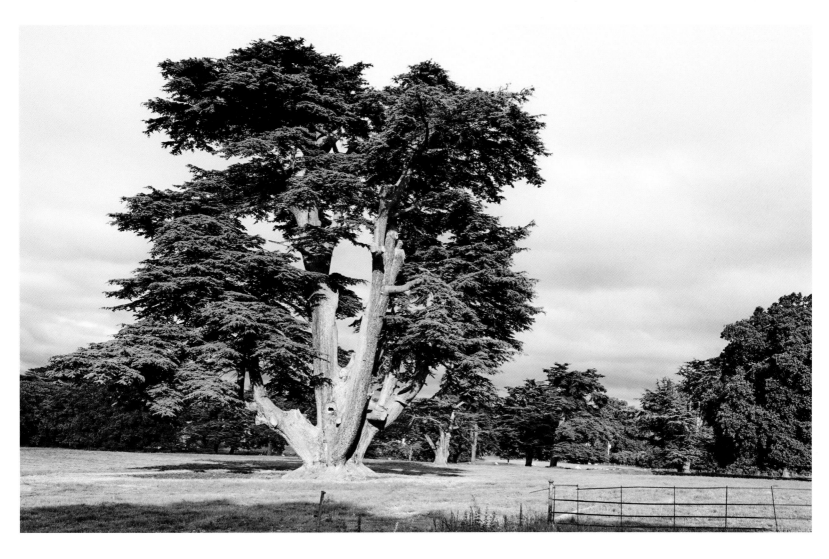

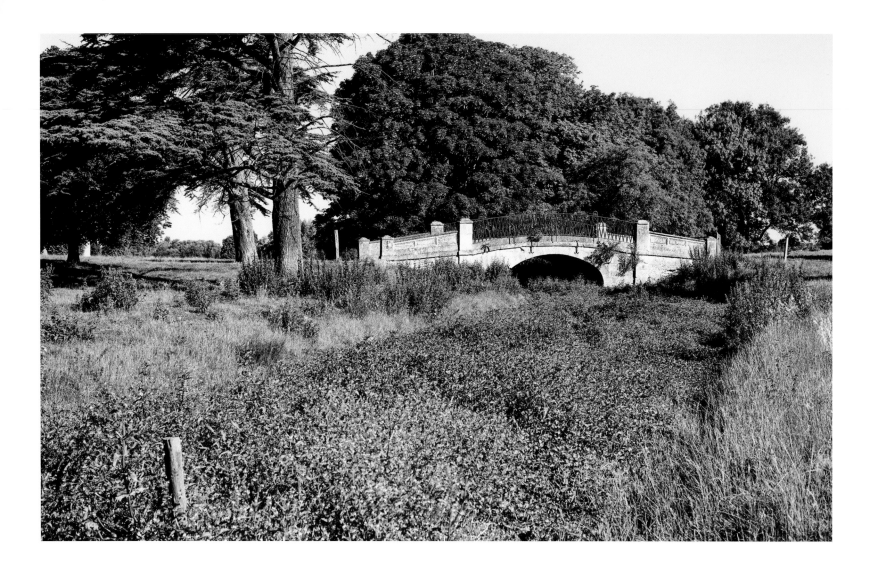

Above: The Waterloo Bridge, which is Grade II listed, was probably built before the famous battle, but given the name to celebrate the victory.
Opposite, above: Early morning mist creates an ethereal veil over the land.
Opposite, below: The lake, formed by widening the river, supports all sorts of wildlife, including otters, kingfishers and waterfowl.

there), a peach and nectarine house, a cucumber house, potting shed, bothy and a pump and well. The north section of the garden was an orchard.

The 1942 sale of the old Brightwell Park manor house took place at the Randolph Hotel in Oxford, and the property details say that it had 26 bedrooms, "easily reduced to 14 bedrooms" – visions of sledgehammers come to mind. The entire village was owned by the estate at that time, and the list of lots included Grove House, a six-bedroom property, now the home of Lady Pamela Hicks; six dairy and corn-growing farms; the Lord Nelson pub (since demoted from the peerage and now known merely as the Nelson); and a total of 24 farm cottages.

Anish has made the cedar avenue a permissive path, which means that local people can walk through the estate. Visitors to Brightwell can enjoy stunning views of the landscape, following the route from the

south-west lodge across the Waterloo Bridge, named after the battle, although it was built quite a few years before Napoleon's final defeat.

The cedars that flank the path are impressive, but a specimen tree between the avenue and house is an even more awesome sight. Its girth is so vast, you would need at least four tree-huggers to embrace it. Cedar of Lebanon (*Cedrus libani*) was first introduced to Britain in the 17th century, and although we now think of it as an ornamental tree, it has long been prized in the Middle East for its wood. According to the Old Testament, the timber was used by King Solomon to build the Temple of Jerusalem.

This magnificent cedar bears a slight resemblance to the *Orbit* sculpture, which Anish designed for the London Olympics in 2012, and Stuart believes the sculptor may have been inspired by the Brightwell giant, which itself looks like an amazing piece of art.

Cath Kidston
Born: 1958
Husband: Hugh Padgham
Interior and product
designer, businesswoman and
miniature orchard owner

*Left: The designer and
businesswoman Cath Kidston
in her London garden.
Right: The front garden is
dominated by an enormous
clump of honey spurge
(Euphorbia mellifera).
The privet hedge, with its
arched gateway, leads to the
riverside garden over the road.*

CATH KIDSTON

WEST LONDON

The garden of designer Cath Kidston is set in one of those extraordinary corners of London – and there are quite a few of them – where the mood, light, architecture, noise and even the smells change abruptly as you turn from one street into another.

She lives near a major roundabout, with routes taking you on to two major motorways, including the main road to London's Heathrow airport. It is one of those junctions that boasts a permanent queue of traffic in all directions. For Cath, however, the roundabout is a benefit, offering easy access out of London, while a tall building separating her from the main road provides a solid noise barrier and shelter from the north and west. Stand in her enclosed back garden and all you can hear is birdsong.

The house is late 17th/early 18th century, flat-fronted, with the sort of proportions that make those of us who live in properties of a much later

date deeply envious. The design of the outdoor space complements these proportions, with the main axis following a line that runs right through the house.

Cath and her husband, the record producer Hugh Padgham, bought the property in 2001, but didn't get around to doing the garden until 2007, when Cath decided to design a new kitchen extension and revamp the garden at the same time. The kitchen is modern, glazed on two sides, and extends out into the garden from the back of the house. The units are simple and uncluttered, with a colour scheme of apple-green and white, and she wanted the garden to echo this contemporary style: "It is a luxury to have open space in London, and I was after something quite simple and airy," she said.

She drew up a sketch of what she wanted on the back of an envelope, but commissioned garden designer Brita von Schoenaich to make the design

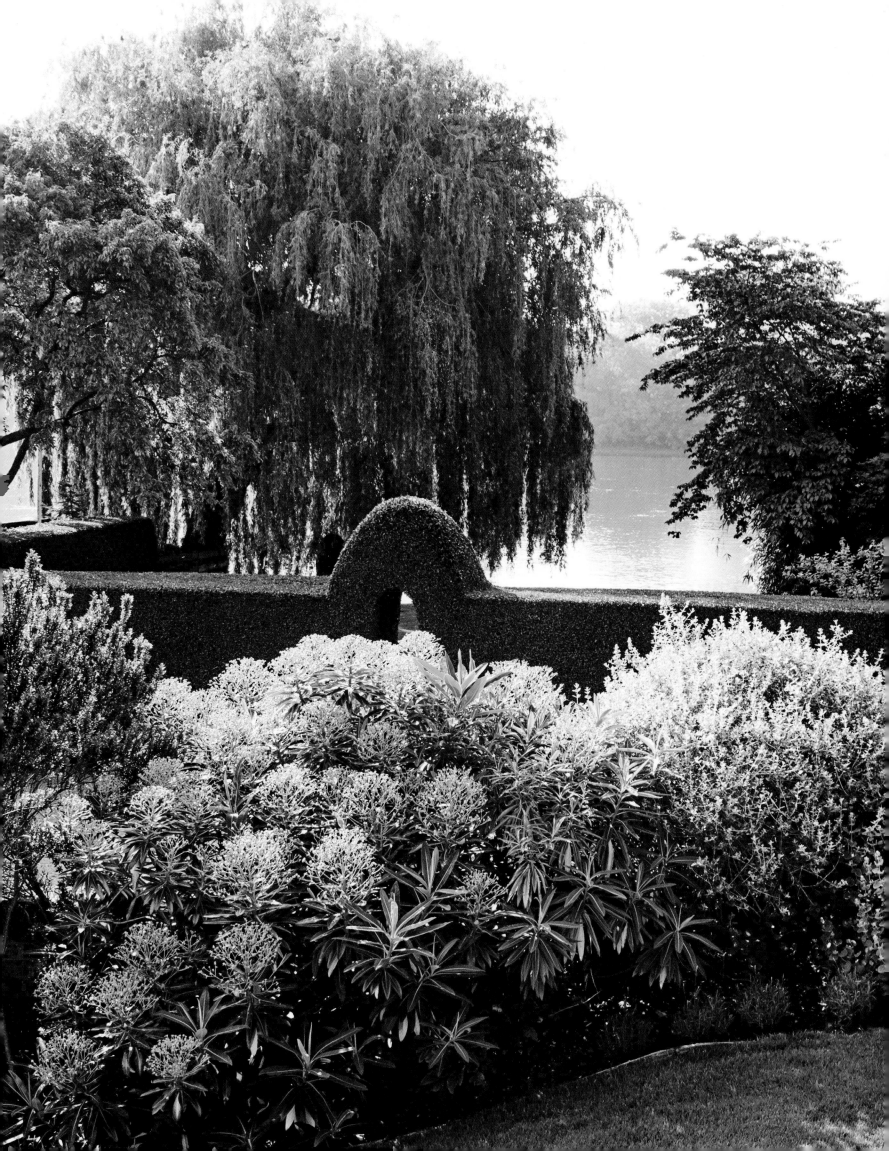

a reality. The property actually comprises three
separate outdoor spaces: a back garden, a front garden
and a river garden, which is across the road from the
house, on the banks of the Thames. The back garden
has its advantages — a lovely old 18th-century wall, for
example — but it also has its challenges, the biggest of
which is the fact that the lawn is not level, but slopes
from side to side.

Brita's ingenious solution was to install paving
set out in a pattern that looks a bit like a bar chart,
with slabs of different lengths extending into the
lawn, parallel to the terrace. The kitchen floor is
laid with the same stone as the terrace, which makes
the latter appear larger by blurring the dividing line
between inside and out.

Opposite the extension is an enormous London
plane (*Platanus* x *hispanica*), with an egg-shaped wooden
seat set around its trunk, and beyond the terrace,

slabs of uniform length create a path to the bottom
of the garden. This area is divided from the lawn by a
rectangular canal that runs across the entire width. A
short box hedge and taller beech hedge help to screen
the view into this section from the house. Where the
path crosses the pool, there is another inventive bit of
design: the canal is in two parts, with a shallow end
suitable for paddling, and a longer deeper end.

The "bar chart" slabs fool the eye so completely
that you are not aware of the slope in the lawn until
you get to the end of the garden and look back. To
see how the axis through the garden works, however,
you have to go up to Cath's bedroom and look down.
From here, you can see that the path in the back
garden lines up with the path in the front garden,
which also lines up with the entrance to the river
garden. "I like order and symmetry," Cath explained,
which may seem a surprising comment from a woman

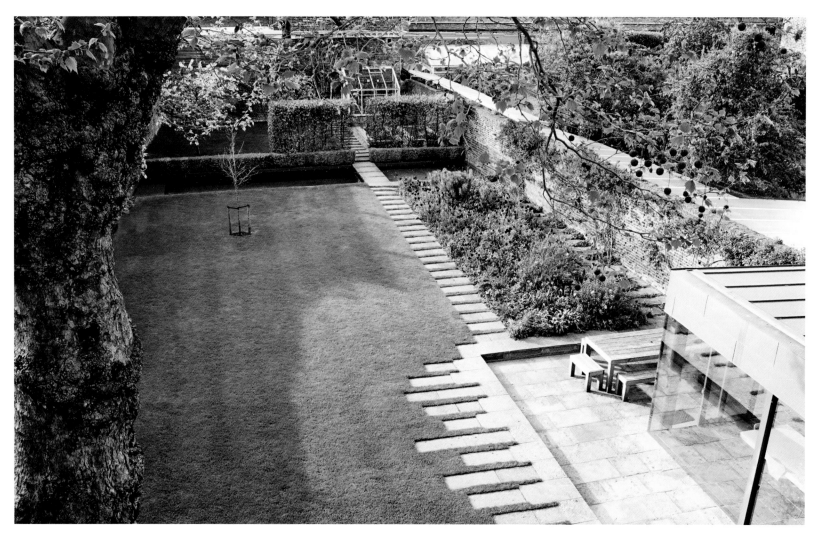

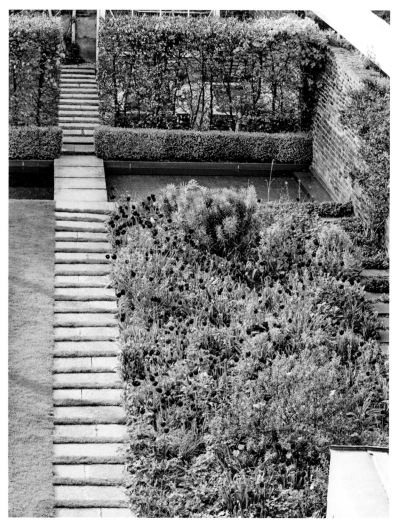

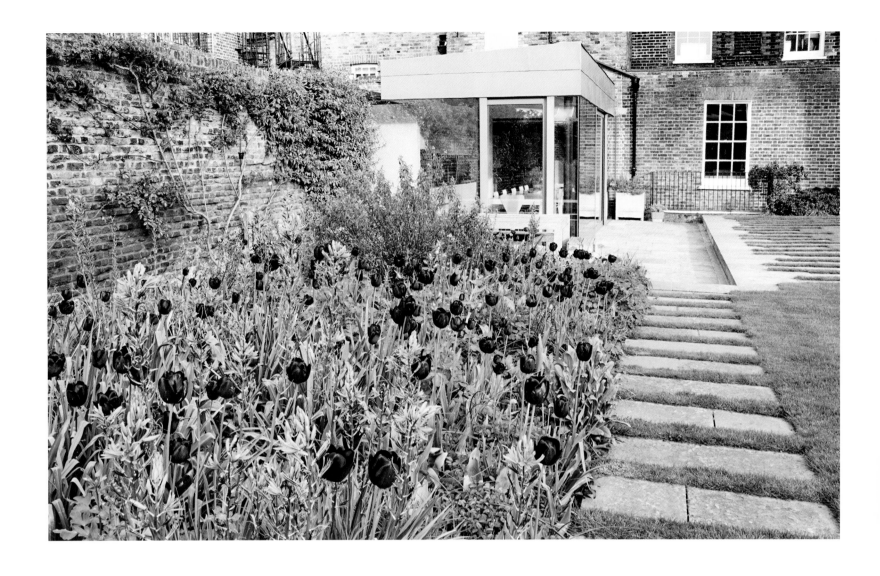

famous for florals. Flowers are at the heart of the fashion and textile empire she created, which extends as far as China, and although Baring Private Equity Asia acquired control of the group in September 2016, she retains a minority stake. She is now working on various freelance creative projects.

Cath grew up in Hampshire and says she spent most of her childhood in the garden, where she had a shop in a laurel bush. She also loved riding ponies, and says she was constantly revamping her bedroom. She was a fan of the BBC programme *Blue Peter*, which inspired a generation of children to create things out of sticky-backed plastic and washing-up liquid bottles. Kirstie Allsopp (*see pages 12-21*), the television presenter who has championed homemade, handmade and vintage design, is her cousin.

Cath attended West Heath, then a girls' boarding school, where she was in the year above Princess Diana, but she didn't really have much idea of what she wanted to do as a career until she went to work for the interior designer Nicky Haslam, on the recommendation of her cousin, art dealer Dave Ker. She began by walking Nicky's dog, she says, and ended up measuring curtains for the film star Ava Gardner.

Cath went on to launch her own interior design business – her husband was a former client – and opened a shop in Notting Hill in 1993, selling vintage items that she had picked up from car boot sales and charity shops. When she found that she couldn't find a vintage-style ironing board cover, she decided to design her own, and the Cath Kidston brand and style was born.

Her London garden is more contemporary than you would perhaps expect, and very much about structure, architecture, and simple shapes. The only really flowery bit of the back garden is not so much a

Above: The view from the canal back up to the house, with the border bursting with spring bulbs.
Opposite, clockwise from top: the "bar chart" pattern of the paving, designed by Brita von Schoenaich to help disguise the sloping lawn, can be clearly seen from above; as they cross the garden, the paving slabs become a path; the blue spires of Camassia leichtlinii *erupt from a clump of rock roses (*Cistus x purpureus*); a profile view of the paving.*

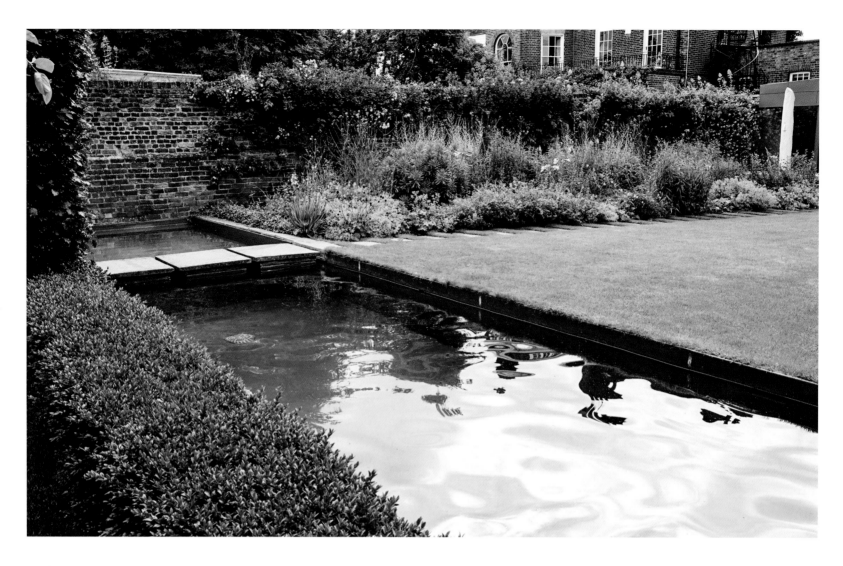

"*The canal is in two parts, with a shallow end suitable for paddling, and a longer deeper end beyond the bridge.*"

border, she says, as a "jungly path". In spring, it is a mass of dark tulips, before a cottage-garden mixture of foxgloves, irises, euphorbia, rock roses and fennel comes into flower. Honeysuckle and jasmine scramble up the old brick wall and in among the paving are clumps of *Alchemilla mollis*.

Beyond the canal is a small orchard, planted with quinces, and apple and cherry trees, with a little greenhouse bursting with pelargoniums tucked away at the back. This area also includes a vegetable patch alongside a small cutting garden full of dahlias, which she uses to decorate the house.

Cath is too busy to be a hands-on gardener — although Hugh takes charge of the mowing — but it is obvious that she loves flowers. She has strong ideas about what should be planted, and a very clear vision of the effect she wants to achieve. Fans of the Cath Kidston look might wonder whether the garden

inspires her product designs, but I would say it's the other way around: the inspiration for her homeware and fashion range — her childhood, vintage objects she has always loved — have influenced her ideas for the garden, especially at the front of the house.

The front garden is much more formal than the back, with climbing roses and neat shrubs, including myrtle, clumps of the honey spurge *Euphorbia mellifera*, a smoke bush (*Cotinus* 'Grace'), black-leaved elder (*Sambucus*), and some box topiary. Cath's gardener, Toby Davis, is proud of the fact that the garden has no box blight, which he puts down to good biosecurity. He not only disinfects his tools before trimming each of the plants, but keeps a separate set of shears for his individual clients.

One of Toby's biggest jobs is clipping the privet hedge that screens the river garden from the road and forms an arch around the gate. This gets one big cut,

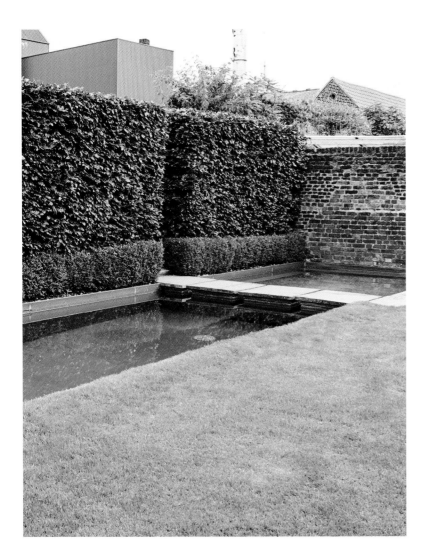

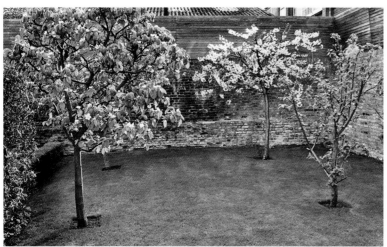

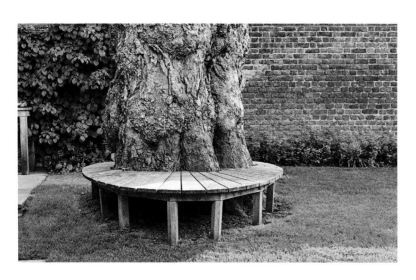

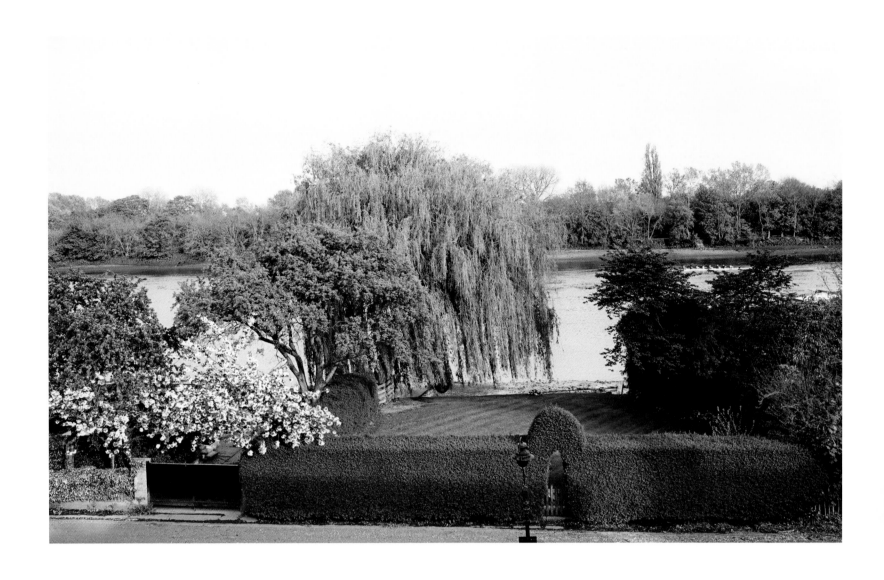

then perhaps two or three more trims each year. The river garden floods regularly – two or three times a month at high tide, says Toby – but although you can clearly see the tidemark this leaves along the base of the privet, the hedge doesn't seem to suffer at all.

Many people hate privet, either because they think it's boring, or dislike the smell of the flowers. Others love the scent, saying it reminds them of summertime. Either way, it is a perfect hedging plant for town and city gardens. It will grow in sun or shade, it shrugs off pollution and it's tolerant of bad pruning, because it regrows from old wood.

Apart from the hedge, the river garden is mainly laid to lawn, with a willow tree that loves the damp conditions, and roses and philadelphus at the drier end nearest the road. Grass, of course, is tolerant of flooding and even brackish water, as long as it does not remain submerged for long periods. The seat

hanging from the willow tree provides the perfect vantage point to watch the river traffic, which on Cath's section of the water is mainly comprised of leisure craft and rowing eights – there are dozens of rowing clubs based along this stretch of the Thames.

The garden is also on the route of the annual Boat Race between Oxford and Cambridge, which starts at Putney Bridge and finishes at Chiswick Bridge, at Mortlake. This race is famous throughout the world, but there are several others, such as the Head of the River Race, in which 400 eights take part.

Cath says the idea of being a celebrity is "just not my thing". She's softly spoken, casually dressed and copes effortlessly with holding a business meeting, talking to the gardener and having a conversation with her husband all at the same time. Like her elegant house and garden, Cath radiates calm in the middle of a very busy world.

Above: Apart from the trees, the view of the river has hardly changed for hundreds of years. Opposite, clockwise from top: A view of the house from the river garden; a swing seat hangs invitingly from a branch of the willow tree beside the Thames; the wooden bench around the base of the plane tree in the back garden; quince, cherry and apple trees in the orchard provide fresh fruit in the summer and autumn.

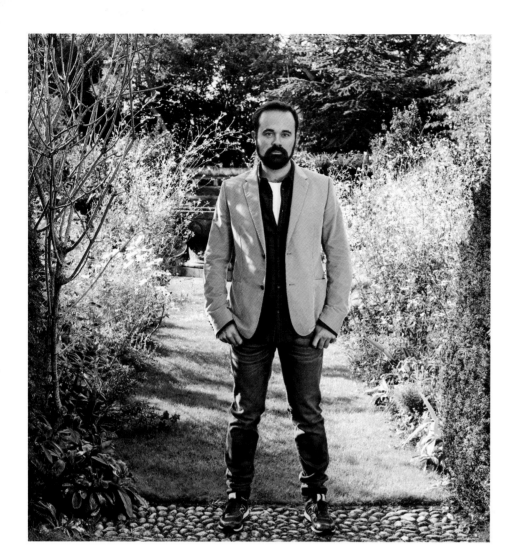

Evgeny Lebedev
Born: 1980
Publisher, journalist,
art collector, foxglove fan
and planter of lilacs

Left: Evgeny Lebedev,
owner of The London
Evening Standard *and the*
Independent *newspapers*
in the UK.
Right: Stud House, the 18th-
century home of the Master
of the Horse at Hampton
Court, where George IV
bred his racehorses.

EVGENY LEBEDEV

LONDON

Unless you are Russian, you may not be familiar with the face, or indeed the work, of Alexander Sergeyevich Pushkin, one of Russia's greatest literary heroes. If so, you may not recognise the statue in Evgeny Lebedev's garden, which gestures towards a convenient bench, as if inviting you to sit and read for a while. The statue is the only obvious clue to the nationality of the owner, because this is a very English garden, with garden rooms and parterres, as well as a modern water "enclosure", which creates a complementary setting for the historic house.

Writer, publisher, philanthropist and art collector, Evgeny is chairman of Lebedev Holdings Limited, owners of *The London Evening Standard* and *The Independent,* and the television station London Live. His home is Stud House, a Grade II listed Regency villa in Hampton Court Park, built in the early 18th century for the Master of the Horse – during the 19th

century, the Stud was the centre of royal bloodstock breeding. This historic property requires sensitive treatment, and in 2008, a year after buying the lease, Evgeny commissioned the person he thought best suited to the task of designing the garden: Mollie, Dowager Marchioness of Salisbury.

Lady Salisbury, who died at the age of 94 in 2016, famously masterminded the restoration of the gardens at Hatfield House, her husband's ancestral home. She also created a critically acclaimed garden at Cranborne Manor in Dorset, and advised Prince Charles on his garden at Highgrove – she was also responsible for encouraging him to talk to his plants.

Mollie Salisbury had no formal training in garden design or landscape architecture, yet her eye was unerring. At Stud House, which is a somewhat lopsided thanks to the stables that run at right-angles to the house, she created a yew parterre on

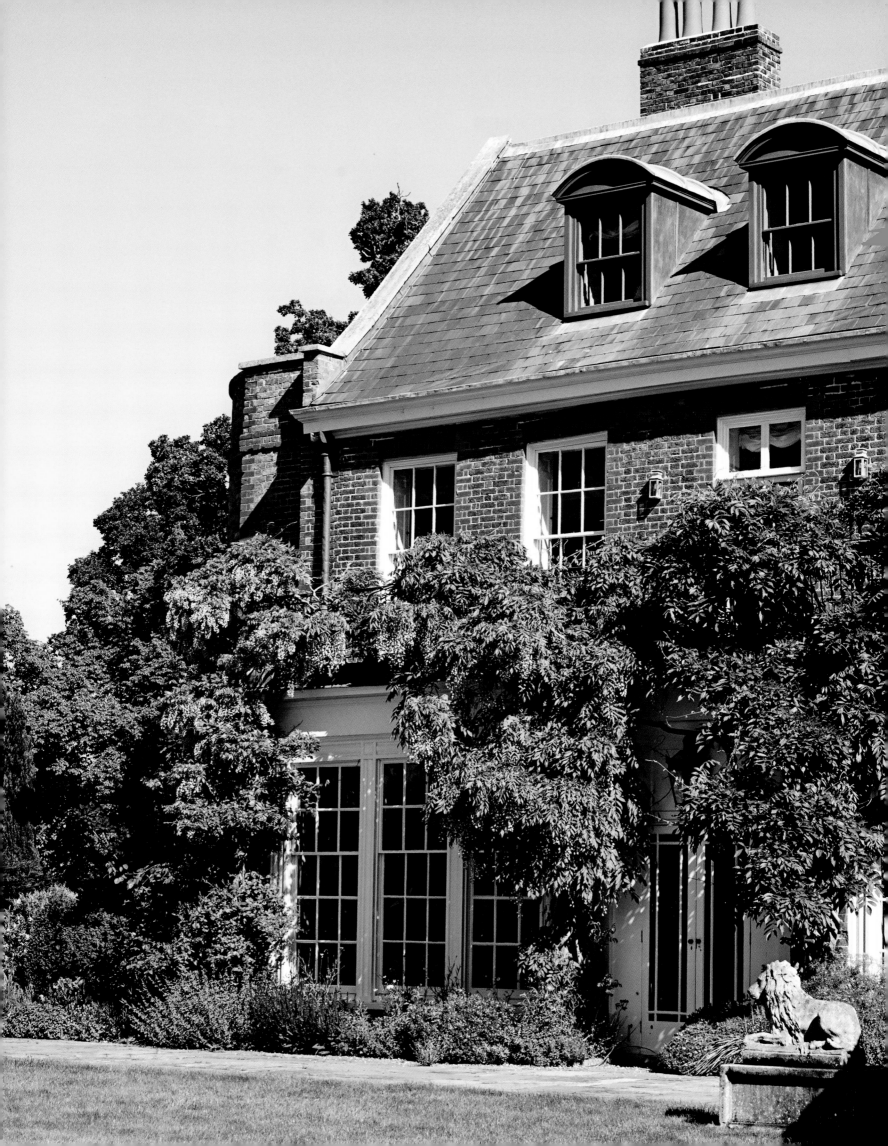

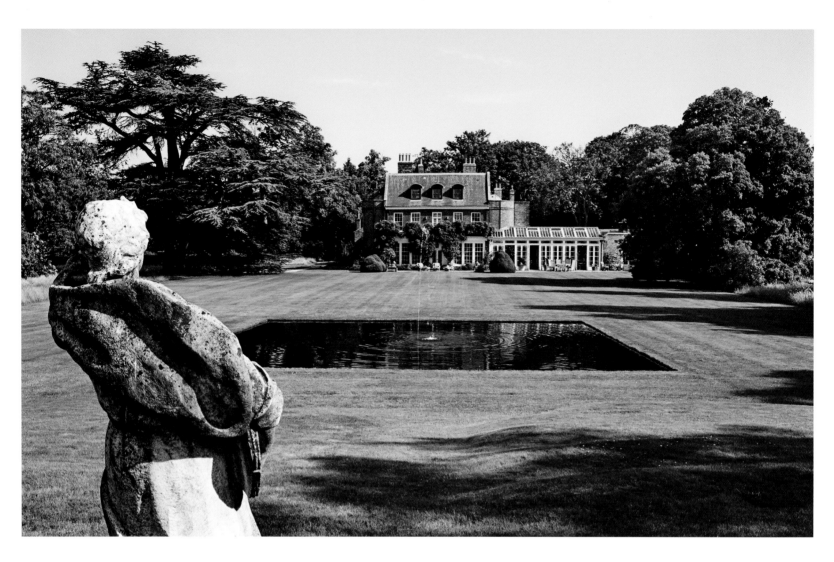

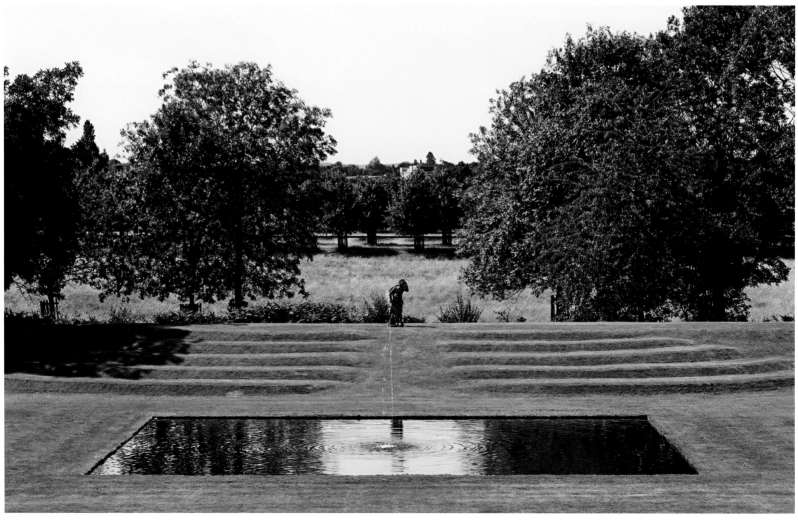

the opposite side to create visual balance. Filled with black and white plants, it includes snowdrops and black hellebores in early spring, followed by dark 'Queen of Night' and 'White Triumphator' tulips, then white peonies and foxgloves, and black poppies, cornflowers, and 'Rip City' dahlias later in summer.

The Black and White Garden, at its peak in June and July, is one of Evgeny's favourite spots, but when Mollie first told him of the extensive changes she had planned for the whole property, he was slightly taken aback by the scale of it all.

"She wanted to take this tree out, take that tree out, change the ground levels, move paths. We had earth-moving equipment here for months, at the worst time of the year, so everything was covered in mud. Then I started to understand what she was trying to do. I learned a lot from her — not just the names of plants, but from her design eye too. She

taught me, for example, that plant species were usually more sophisticated than the hybrids."

Working with Mollie Salisbury brought back memories of Evgeny's childhood and teenage years. He was educated in England, but spent the holidays in Russia, either with his grandparents at their dacha (country cottage), or travelling with his grandfather.

"My grandmother was a botanist and worked at the Moscow Botanical Gardens, and my grandfather was a zoologist with a passion for gardening. They had a typically Russian dacha — built in the 1950s of wood, with a verandah — and a garden of about one hectare [about two and a half acres], which was a substantial piece of land by Soviet standards.

"As a child and teenager, I was used by my grandparents for manual labour. I wasn't terribly interested in gardening then, but it all came back to me when I started working with Mollie. After the

Above: Paths are mown through the meadow area to the front of the house, which is planted with thousands of white pheasant's eye narcissi. Opposite: two views of the dramatic Water Enclosure, designed by Mollie Salisbury. Grassed steps behind the feature provide a vantage point from which to view the reflections and house beyond.

Above: In the main courtyard, spires of giant viper's bugloss (Echium pininana) *stand to attention along the wall. Opposite, clockwise from top left: The auricula theatre is planted all year round with seasonal alternatives, in this case Cape primroses* (Streptocarpus)*; Evgeny is a great art collector, and the garden is full of antique statuary and objects; the Pushkin borders, with globe artichokes* (Cynara cardunculus) *and Inula helenium.*

landscaping was done, we kept in close touch and I used to go to the RHS Chelsea Flower Show and Hampton Court Palace Flower Show with her."

According to head gardener David Shipp, Evgeny spends all his time at Chelsea in the Great Pavilion, looking at new varieties on the plant stands to see if there are any he can add to his collection. Foxgloves are a particular favourite, says David, but herbaceous peonies, roses and poppies follow close behind.

The planting style at Stud House is a mixture of relaxed and formal. The meadow areas on either side of the drive are full of wild flowers and naturalised bulbs, including thousands of snowdrops and pheasant's eye narcissus, followed by Turk's cap lilies (*Lilium martagon*) and autumn crocuses (*Colchicum*).

A derelict yard has been transformed into a walled garden, with a glasshouse at one end housing all sorts of treasures, such as tender tree ferns (*Cyathea*),

tobacco plants (*Nicotiana mutabilis*), the golden polypody fern (*Phlebodium aureum*), *Begonia sizemoreae* – a rare begonia with strange hairy leaves – and dramatic staghorn ferns (*Platycerium bifurcatum*).

Outside the glasshouse, in the walled garden itself, a framework of silver birch branches supports sweet peas in summer. Russians regard the silver birch in much the same way as the British regard the oak. Both its sap and its bark are used in traditional folk medicine, and it was believed that planting birches around the village would protect the community from cholera. "The silver birch is an iconic Russian tree," says Evgeny, "and you see them everywhere, even in the far east of Russia, a ten-hour flight from Moscow." The silver birch is commemorated in a poem by Sergei Esenin which Russian children still learn at school, and Evgeny and Mollie planted a small grove of them near the statue of Pushkin.

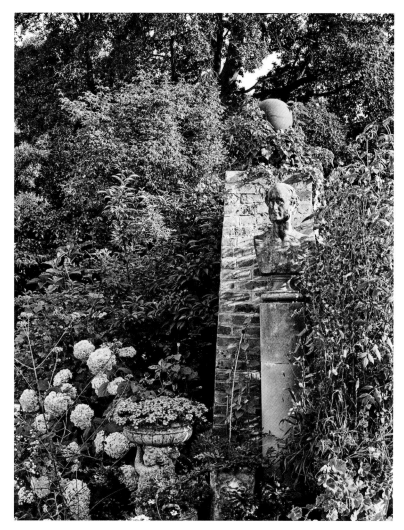

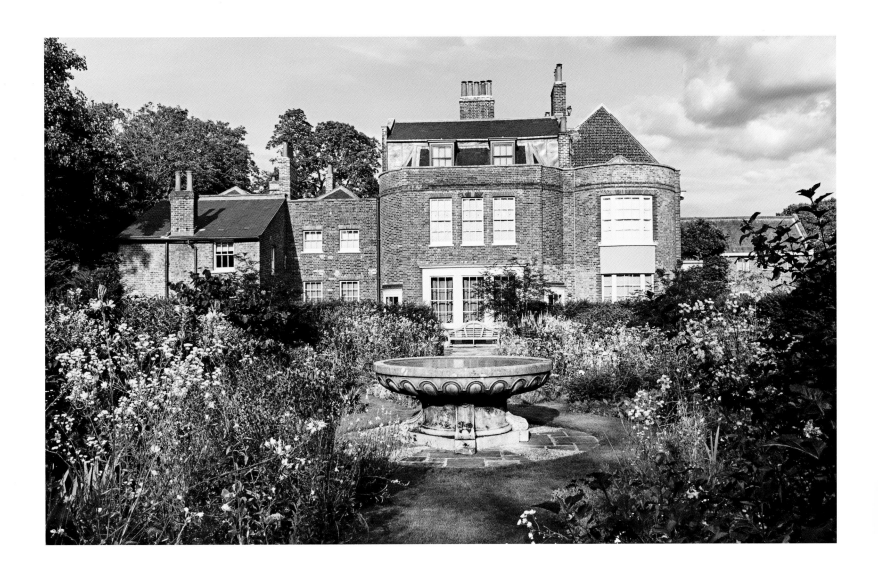

The walled garden leads into the main courtyard, where a neoclassical pediment above the main entrance is decorated with ammonites. They give the effect of carvings on an ancient Greek temple, and were one of Lady Salisbury's innovations.

Another idea of hers was the auricula theatre, painted a rich sea green. Auricula theatres are decorative shelves but they have a practical purpose too. The plants secrete a waxy substance called farina, which dries to a flour-like powder that's easily washed away by rain. It's the dusting of farina on petals, stems and leaves that gives auriculas their hand-painted appearance and the theatres provide rain protection.

In the 19th century, auriculas were "florists' flowers", along with anemones, ranunculi, tulips and carnations, which were grown and shown extensively by factory, mill and mine workers, particularly in the north of England. (The term "florist" at that time

had nothing to do with selling or arranging flowers, but simply meant someone who grew them for show.)

The florists were fiercely competitive and their competitions were the forerunner of the traditional flower show we know today. They grew their show auriculas in the bookcase-like theatres to ensure their plants were in pristine condition. At Stud House, the auricula theatre is used year-round, with Cape primroses (*Streptocarpus*) in summer and cyclamen in winter filling the seasonal gaps when the auriculas are not in bloom.

To the north side of the house is the Black and White Garden, beyond which is a tiered mound, like an amphitheatre, with a bench at the top. Sitting there, you have a view through the central axis of the Black and White Garden, with its massive marble-bowl fountain, and back to the house. Around the perimeter of the garden, beneath the

Above: The antique marble bowl fountain in the Black and White Garden creates a soothing atmosphere here. Opposite, clockwise from top: In the Black and White Garden, foliage and flowers are chosen for dramatic contrast; hydrangeas line the path to the walled garden; the cobbled courtyard behind the former stables; the grassed amphitheatre is topped with a curved stone bench.

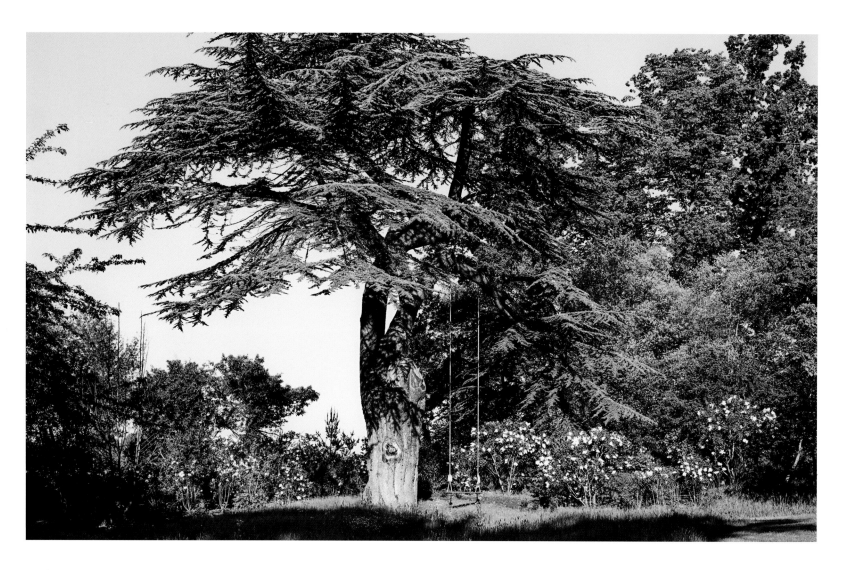

"The statue of Pushkin is a copy of the one that stands in St Petersburg, but ironically Evgeny bought it in London."

trees and masking the boundaries, are the lilac banks, planted with white lilac bushes and other white-flowering shrubs, such as oak-leaf hydrangeas, *Hydrangea arborescens* 'Annabelle' with its massive blooms, scented mock oranges (*Philadelphus*), and sweet box (*Sarcococca*) for winter perfume. "Smell is one of the most powerful senses for bringing back memories," said Evgeny. "We had a lot of lilacs in our garden when I was a child, and I remember that if you found a lilac flower with five petals instead of the normal four it was supposed to bring you luck."

Lilacs are native to the Balkan Peninsula, but were introduced to northern Europe from Turkey where they were used in Ottoman gardens. One of the most famous lilac hybridists was the Russian Leonid Kolesnikov, who in 1943 bred one of the most popular forms in the world, *Syringa vulgaris* 'Krasavitsa Moskvy' or 'Beauty of Moscow'. It is a beautiful

cultivar, with large heads of double white, highly fragrant flowers emerging from pale pink buds.

There is another woodland garden on the other side of the lawn, and between the two is the Water Enclosure, also designed by Mollie. A large square pool set in the middle of the lawn, it features a dramatic geyser-style fountain in the centre. The sloping ground behind the water has been tiered like rows of cinema seats, providing an informal place to sit and view the pool and house.

The second woodland garden, beyond the pool, is a winter garden, designed to provide scent and flowers throughout the darkest months of the year. There are mahonias, hellebores, camellias and sweet box (*Sarcococca*), as well as the paperbush, *Edgeworthia chrysantha*, which has pale yellow fragrant flowers.

In summer, giant Himalayan lilies (*Cardiocrinum giganteum*), emerge from the ferns, and at the end of

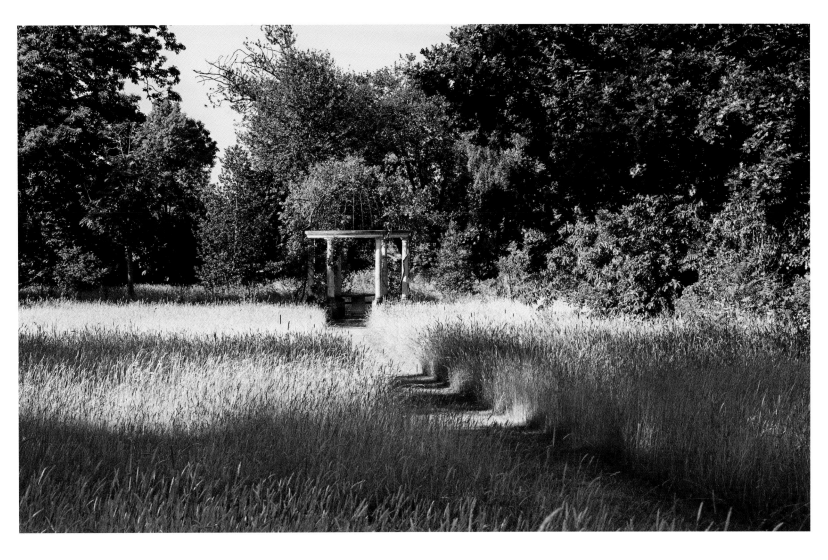

the path that leads through this part of the garden are two eucryphia trees, which David Shipp describes as "towers of flowers" when they bloom in summer.

In contrast to the woodland gardens, the south-facing Pushkin Borders are planted with hot colours and grasses. One of David's favourite plants here is *Tagetes* 'Cinnabar', a tall African marigold with coppery flowers that almost glow on a late summer evening under the gaze of the Russian writer.

The statue of Pushkin is, in fact, a copy of the one that stands in Arts Square, St Petersburg, but ironically Evgeny bought it in London in an antique shop off the Edgware Road. It was one of a series donated by the Soviet Union during the 1950s to countries around the world, and this particular statue originally graced the grounds of a school in Calcutta. Like its owner, Evgeny's Pushkin has led a cosmopolitan life before settling down at Stud House.

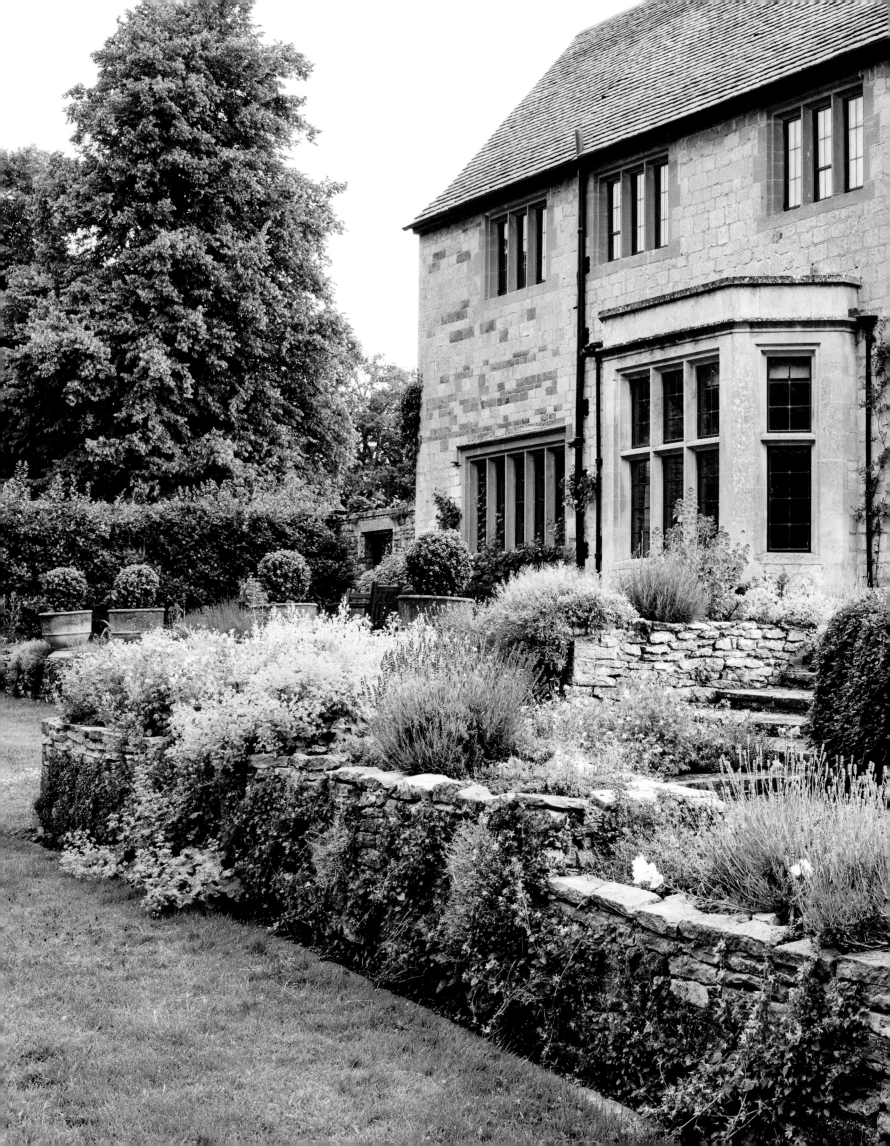

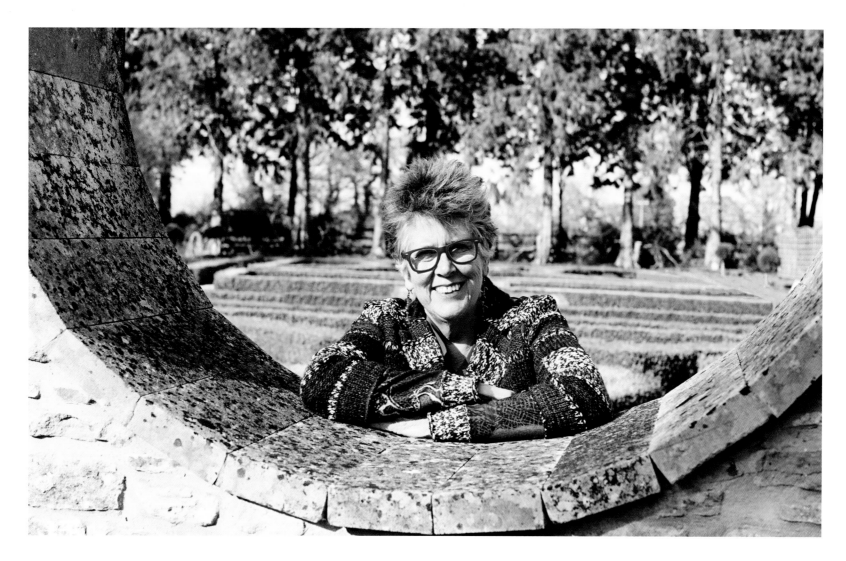

PRUE LEITH

OXFORDSHIRE

There were a number of reasons why chef and food writer Prue Leith decided to move to Oxfordshire 40 years ago, but the desire for a bigger, more beautiful garden was not among them. The main aim was to set up a duck farm.

At the time, Prue was running her eponymous Michelin-starred restaurant, and one of the most popular items on the menu was duck. She explained: "We used to have to buy so much duck, and it was so expensive that I thought perhaps we could produce our own. So we bought this old rectory plus a few acres of land with that intention in mind, but when we did the sums, we realised that duck is expensive because it costs a lot to produce — you need thousands of ducks to justify the cost of a dry-plucking machine and hand plucking was just not viable."

Prue and her first husband, the late Rayne Kruger, who died in 2002, decided to give up the idea of duck farming and simply enjoyed the rural setting around their beautiful honey-coloured stone house, although they didn't make a garden in the conventional sense. Rayne wasn't keen on flowery gardens, apparently. "He preferred grass, water and stone," recalled Prue. "So the only flowers I had in the garden were rosa mundi [*Rosa gallica* 'Versicolor'] below the terrace, where he couldn't see them if he looked out of the window." This old rose, a red and white striped sport of *Rosa gallica* var. *officinalis*, possesses a wonderful classic damask scent, but despite its antique origins, it's a hardy, easy plant to grow.

There were other flowers on the site, but these were grown, along with vegetables, for the restaurant. Today, that pattern has been reversed. The large walled vegetable garden is now filled with ornamental plants, with pink achilleas in place of herbs and brassicas in the formal parterres, flanked by rows

Prue Leith
..
Born: 1940
..
Husband: John Playfair
..
Chef, food writer, novelist,
hosta fan and lover of hot
colours in the garden
..

*Above: Prue Leith — chef,
restaurateur, cookery writer,
novelist and* Great British
Bake Off *judge.*
*Opposite: The Yorkstone
terrace around her Georgian
manor house, planted with
fragrant clumps of French
lavender (*Lavandula
stoechas*) and box topiary.*

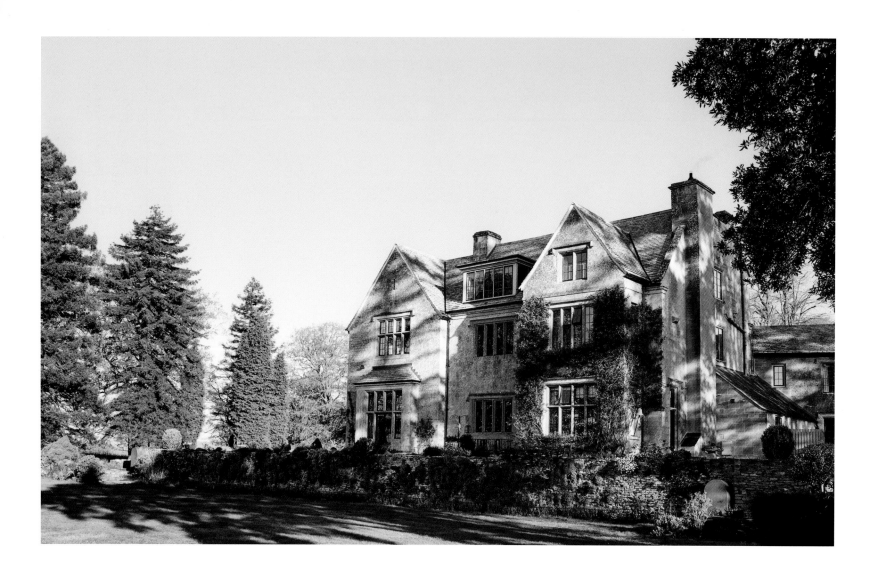

Above: The terrace acts like a ha-ha, dropping down onto a wide expanse of meadow which is dotted with flowers in the summer. Opposite, clockwise from top: The kitchen garden is now mainly ornamental; the formal beds were initially used for vegetables; the porthole window in the kitchen garden wall; alpines growing on the wall beneath the terrace.

of standard Japanese cedars (*Cryptomeria*). Prue still grows vegetables but they are protected from birds and other flying pests in fruit cages and cold frames.

The five-acre (two-hectare) garden surrounds the house, with the kitchen garden, featuring a round window in the wall, on the east side. The Red Garden is also here, next to the kitchen itself, with herbs growing in pots outside the back door, saving the cook a walk to the kitchen garden. There's a woodland garden brimming with hostas on this side too.

To the west of the house, a box parterre planted with roses acts as a counterbalance to the kitchen garden, and beyond that there's a tunnel of 'Perle d'Azur' clematis and the rambling white rose 'Sander's White'. At the back, you look out over a meadow towards the lake, which Prue and Rayne dug out when their children had learned to swim.

The lake is artificial, rather than being fed by

a river or stream, and an underground reservoir ensures it never dries up. Both the lake and reservoir fill up during the winter, so that in the summer months, when the levels drop, the lake can be topped up without anyone noticing. The water is also used for the irrigation system that runs through the planted areas. "It works very well in theory," observed Prue, "but last year the pump broke."

The garden is now more open than it used to be. Originally, a tall screen of holly and brambles surrounded the property on the western side, but this has now been cleared away. To the east, a massive hedge of Lawson's cypress (*Chamaecyparis lawsoniana*) has also been drastically cut back. Prue's second husband, John Playfair, who she married in 2016, is responsible for much of this work. Handy with a chainsaw, he has a very good eye for landscape design, and by raising the crowns of many of the trees he has

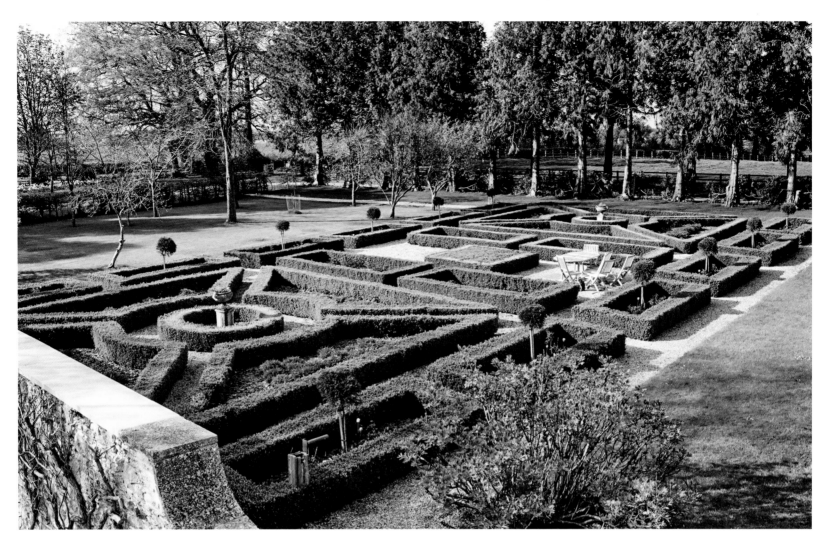

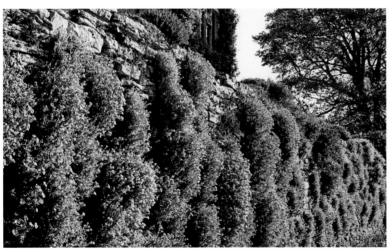

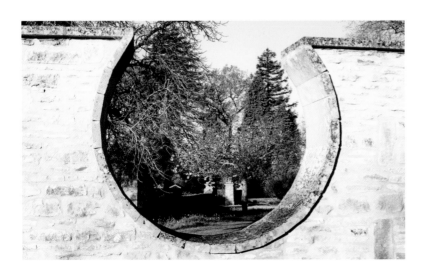

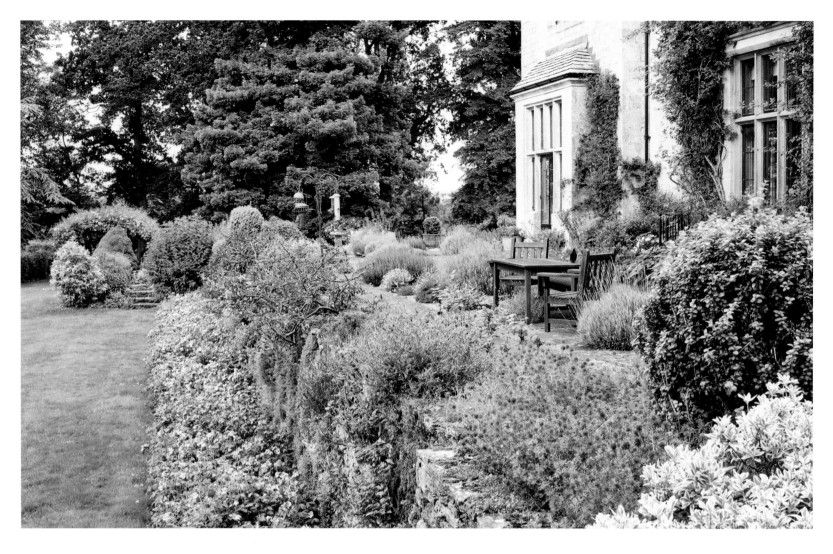

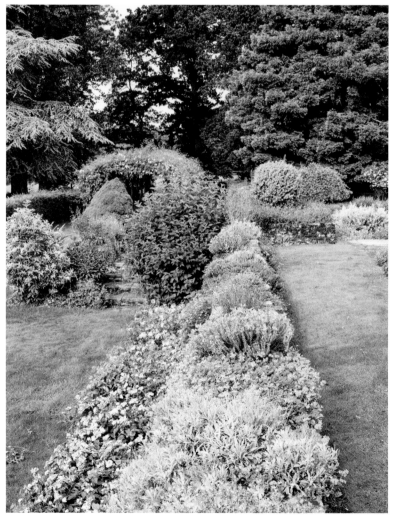

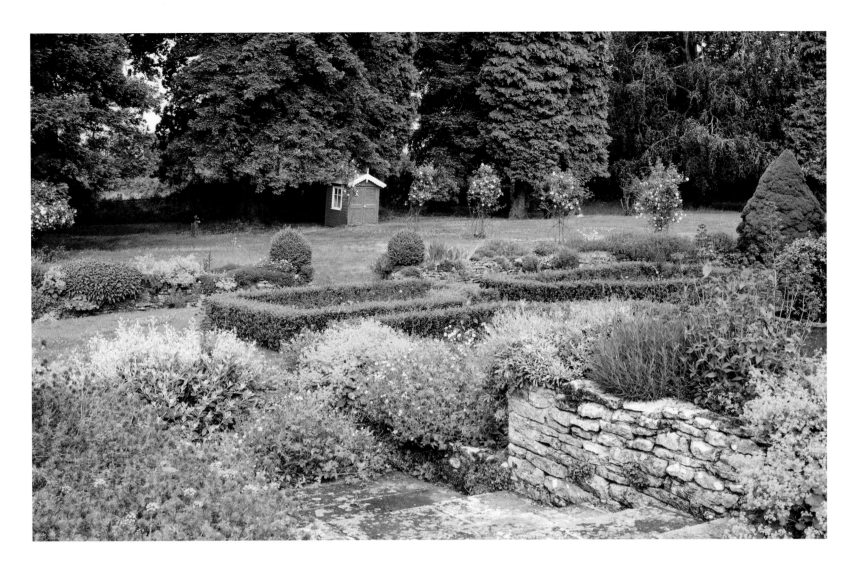

"Prue may insist she is not a plantswoman, but her Oxfordshire garden shows ample evidence of good horticultural practice."

opened up hitherto unseen vistas. It is a common and understandable impulse to wall yourself off from an evermore stressful and busy world in a town or city, but in the countryside opening up garden boundaries like this can have an unexpected and very positive effect. If your view is of serene meadows and farmland, punctuated by hedgerows and copses, it offers an equally powerful impression of sanctuary as an enclosed garden.

John has also built an impressive playground for the couple's mutual grandchildren, with zip lines and platforms, and trapezes. On top of a grassy mound, on a seat made from an old tree stump, is the figure of a man. It's actually a prop, bought from the Royal Shakespeare Company at Stratford-upon-Avon during one of their periodic decluttering sales. Sadly, Prue does not know for which production or play it was made. Originally painted white, it is now black,

and over the years it has lost most of its clothes. The figure was once used by Prue's children, Danny and Li-Da, in a prank to tease their father, whose study looked out from the house towards the lake. They positioned the figure with a rod to look like someone had wandered in and started fishing. "The reaction was all we hoped for," said Prue with a broad grin.

Although John plays his part, Prue is the main driving force in the garden, aided by her "wonderful" gardener, Malcolm. Her approach here could be said to mirror her approach to life in general: there is a sound, practical reason for everything she does, allied to a sense of design that combines flashes of flamboyancy with attention to detail.

Beside the kitchen, a stone pergola shelters a long table on the terrace that can seat up to 24 people; apparently Rayne used to tease Prue, saying that for the price of building the pergola, they could have

Above: Steps lead from the terrace to the box parterre, planted with 'White Pet' and 'New Dawn' roses.
Opposite, clockwise from top: The terrace, with rosa mundi (Rosa gallica 'Versicolor') planted below it; at terrace level, there are sun-lovers such as sage, thyme and santolina; baskets of pelargoniums hang from the pergola; box balls in terracotta pots add formality to this area of the garden.

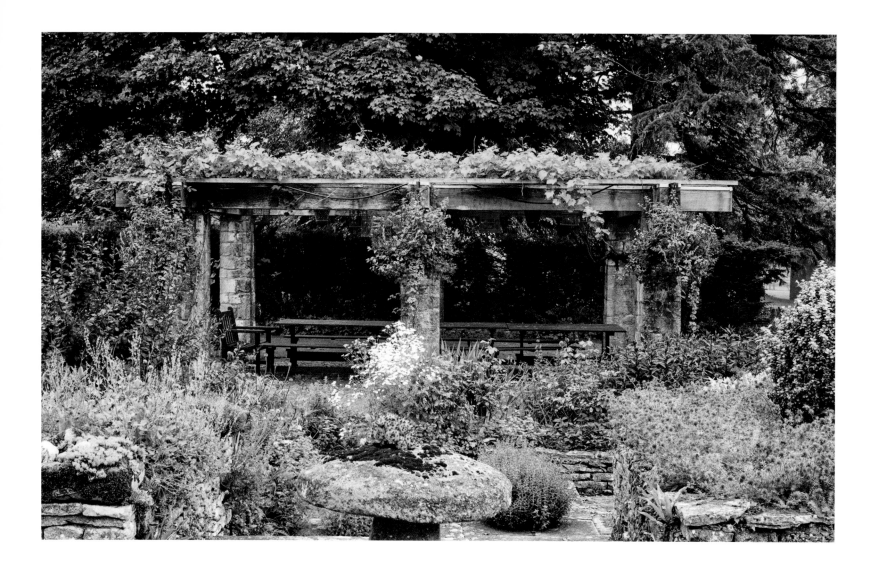

Above: The pergola is decorated with lanterns and hanging baskets that complement the glowing colours in the Red Garden. Opposite, clockwise from top: The seating beneath the pergola is simple, just a wooden table and benches; a serene Buddha sits at the end of the rose tunnel; the rambling rose on the tunnel is 'Sander's White'; an old sundial creates a focal point on the terrace.

flown 24 people to the south of France and given them lunch in a top restaurant.

Friends and family are obviously important to Prue. She herself had no connection to Oxfordshire before she moved here, but her and Rayne's great friends Sir Peter Parker (the former chairman of British Rail) and his wife Jill had bought Manor Farm at Minster Lovell, near Burford, where they created a wonderful garden. "Our husbands played tennis together, and we wanted somewhere that wasn't too far away," said Prue. "They were just 30 minutes drive from here. Our house is also close to Wiltshire, Somerset and Bath – all places I love to visit."

Prue's second husband John says that she is the best colour coordinator he knows, and he has encouraged her use of colour in the garden, particularly hot shades, a taste that she attributes to her childhood in South Africa. The Red Garden,

where the pergola is situated, bears testament to this. Prue has planted 'Bishop of Llandaff' dahlias, with their scarlet flowers and dark foliage; *Crocosmia* 'Lucifer', probably the most vibrant of all the montbretia; and the smoke bush, *Cotinus coggygria* 'Royal Purple', with its sultry maroon foliage.

The planting palette on the south-facing terrace includes cooler shades of blue and white, and a box parterre on the other side of the house features the rose 'White Pet', a dwarf shrub variety, originally bred from a sport of the rambler 'Félicité Perpétue', that produces clusters of pompon flowers.

Prue may insist she is not a plantswoman, but her garden shows ample evidence of good horticultural practice. She is a great believer in mulch – no less than 12 centimetres (5 inches) on each planting area – and proudly shows off her extensive series of compost heaps, where garden detritus steadily rots

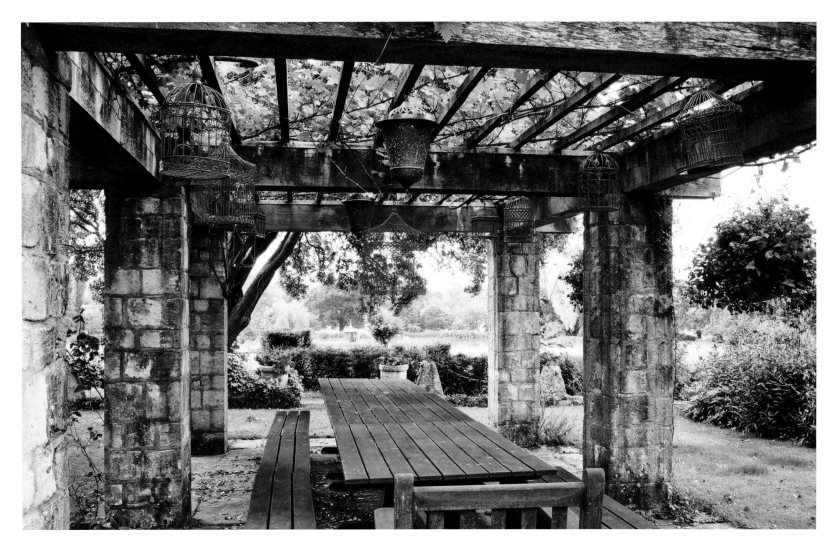

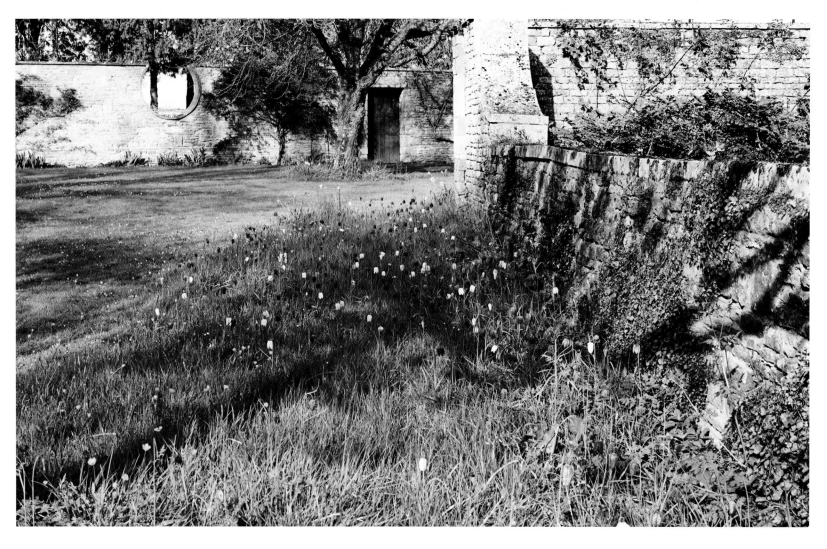

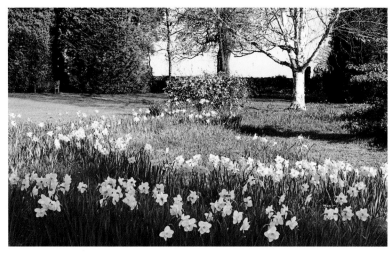

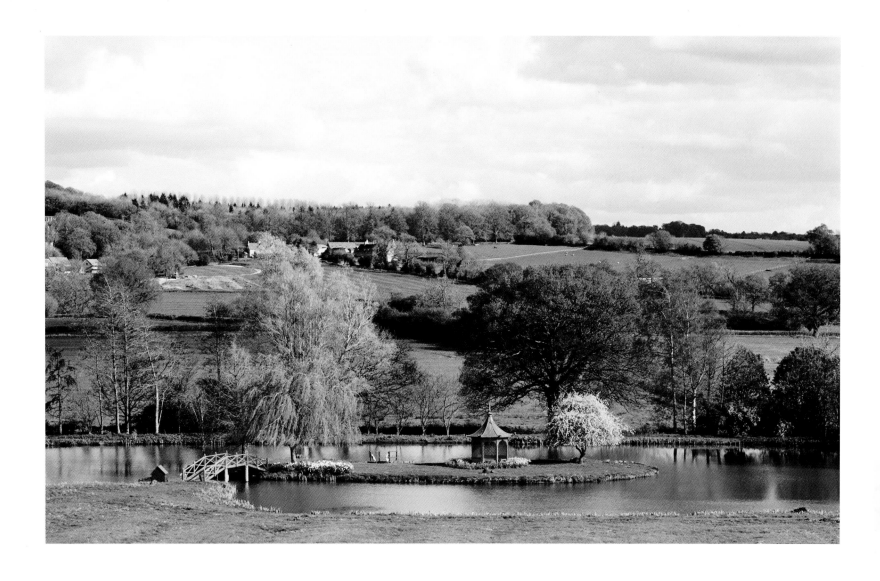

down into black crumbly goodness. She mulches twice – once with this general compost and once with leafmould. Her principal philosophy is "right plant, right place", pointing out that if the conditions are suitable, you can let the plant get on with it.

Prue's favourite job in the garden is a real hands-on task: sorting out a border by removing everything and putting it on a tarpaulin before dividing and replanting. She prefers to restrict annuals to pots, but admits that poppies are good for planting in borders. She loves the Ladybird types (*Papaver commutatum* 'Ladybird'), which have bright scarlet flowers with big black spots, like the insect after which they're named.

Like her garden, you could describe Prue's career as multicoloured. She set up her hugely successful events and catering firm, which still retains many of its high-profile contracts today, and opened her own restaurant before she was 30. She also founded the

Leith's School of Food and Wine, offering training to both professional chefs and amateur cooks. Prue has written 12 cookery books, and in 1999 fulfilled a long-held ambition to write fiction, publishing her first novel, *Leaving Patrick*. One of her subsequent novels, *The Gardener* (2007), features a garden historian who goes to work for a millionaire. Prue's enthusiasm for gardening shines through this book, but she says she had to curb her instincts to write a planting manual and force herself to focus on the love story and characters to keep the publishers happy.

Perhaps this is what creative people value most, consciously or unconsciously, about their own gardens. In a world where agents, publishers, directors, managers, or editors always seem to want to change things, often for commercial reasons, there is an intense pleasure to be found in going home and doing exactly what you want in your own backyard.

*Above: The red pagoda on the island in the middle of the lake has a power point for cooking. Opposite, clockwise from top: Snake's-head fritillaries (*Fritillaria meleagris*) thrive in a patch of damp grass; a closer view of the pagoda; a Japanese maple coming into leaf in early spring; daffodils decorate the lawn beneath the trees.*

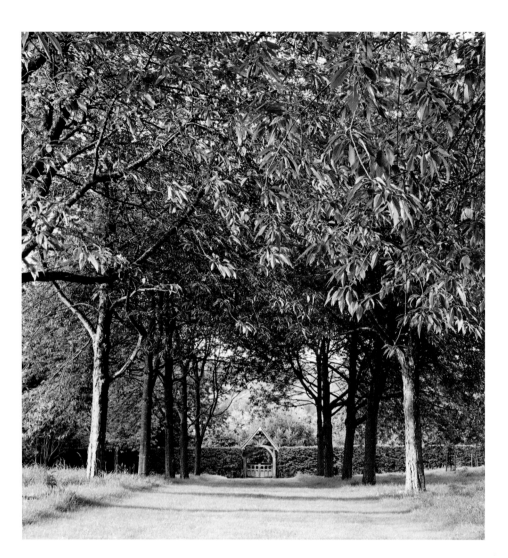

Andrew Lloyd Webber
Born: 1948
Wife: Madeleine
Composer, theatre owner,
racehorse breeder and planter
of copses and woodland

Left: Andrew Lloyd Webber's garden celebrates the English countryside, with informal planting, meadows, orchards and woodland.
Right: Pink Japanese anemones (Anemone x hybrida) grow in the border between the main lawn and the Lower Meadow.

ANDREW LLOYD WEBBER

HAMPSHIRE

If Andrew Lloyd Webber's garden was a song, you would probably come away whistling the tune. It has a sense of peace and harmony, fostered by the gentle rolling countryside, while the outbuildings and paddocks that cluster around the house are like the chorus around the star of the show.

The house dates from the 16th century, although it has been altered at regular intervals since then. Part of the estate was originally owned by Romsey Abbey, and listed as such in the Domesday Book, but following the Dissolution of the Monasteries, Henry VIII gave it to one John Kingsmill and it remained in the Kingsmill family until it was bought by Andrew in 1974. It still bears the royal coat of arms with the motto of the Order of the Garter carved in stone on the front of the house.

The main facade looks north towards the lake, over a terrace edged with lavender and 'Harlow Carr'

roses, bred by David Austin. 'Harlow Carr', named in honour of the Royal Horticultural Society's 200th anniversary, comes close to being the perfect rose. It is a compact size (growing to about hip height) and repeat-flowering, with highly fragrant blooms of the hue that defines the term "rose pink".

On the west side of the house, there is another piece of stone carving, this time contemporary. The arch around the entrance, and the window above, are copied from an 1853 design for a Gothic window by the Pre-Raphaelite artist John Everett Millais. The arch, which has fluted columns either side of the door, was carved from a single 20-tonne piece of Portland stone and took 2,500 hours to create. Fan vaulting supports the first floor balcony, and above this there is an intricate design of carved figures around a quatrefoil window. The sculptor worked from a full-size version of the 1853 Millais drawing, which

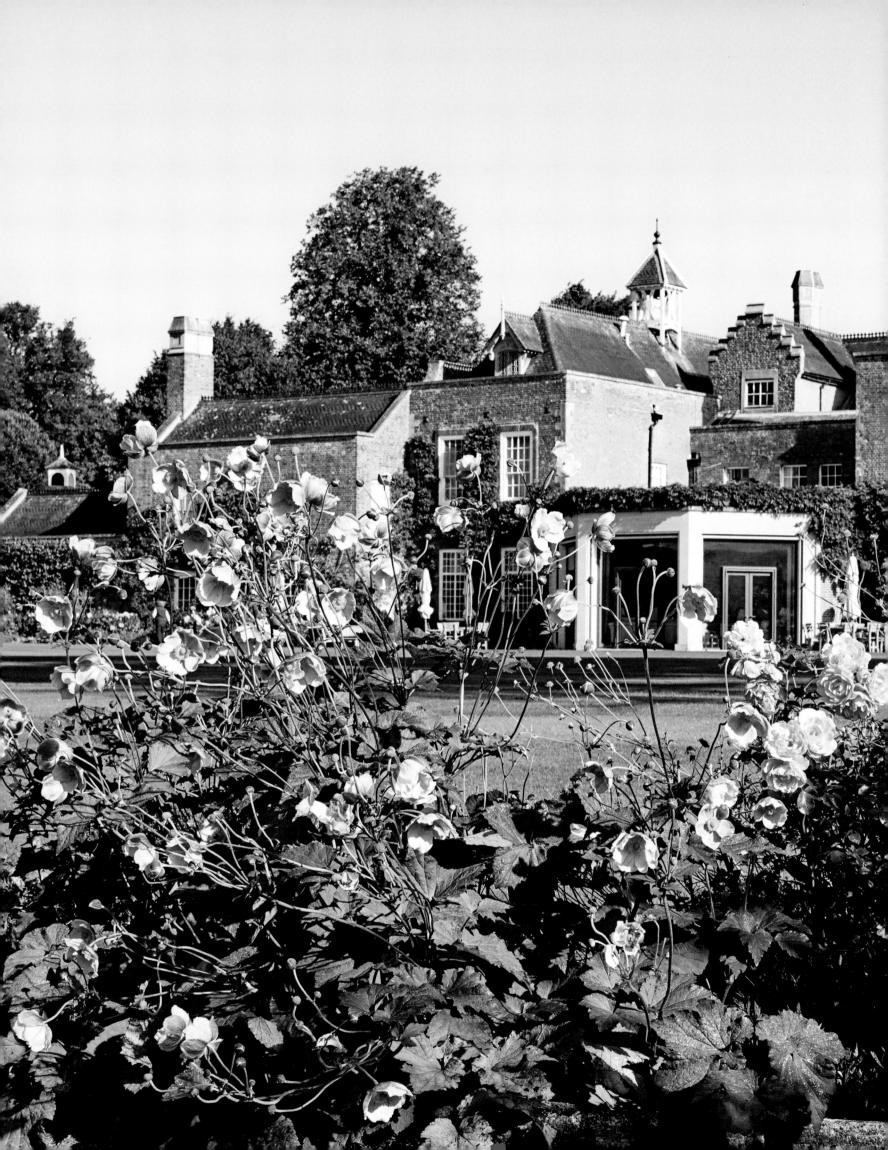

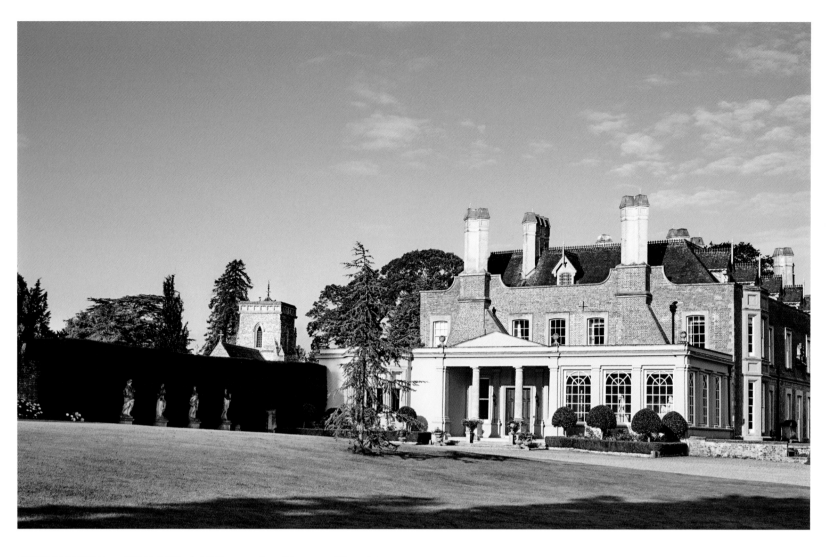

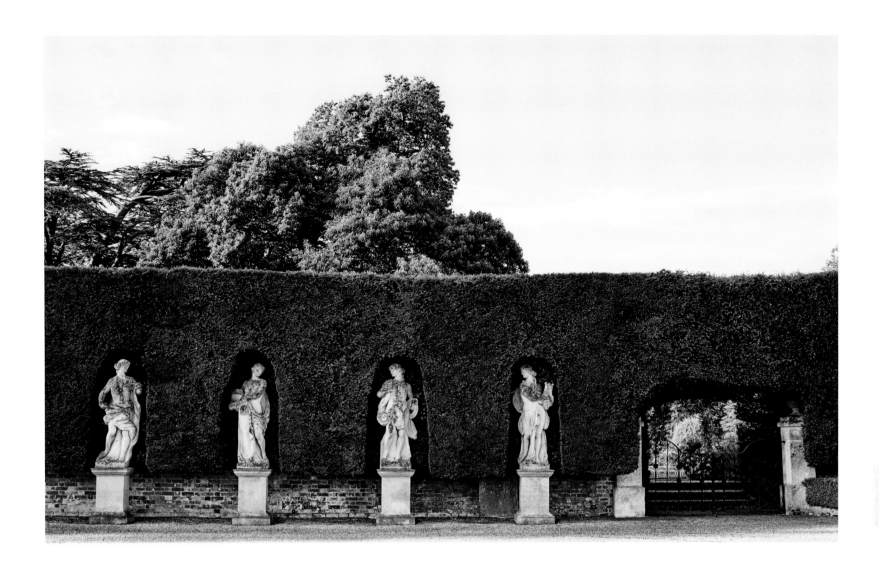

was one of the first Pre-Raphaelite works bought by Andrew for his collection.

The carving was completed in 1994, but the new area of planting, designed to create more privacy for this entrance, was installed in 2016. Although many people who live in the same place for 40 years get to the point where they stop changing things, this is not the case with Andrew. According to his staff, his brain is just as fertile when it comes to ideas for the garden as it is when writing new music.

Originally, a straight path ran directly from the estate office to the door of the house. Now a more serpentine route takes visitors to the entrance through curving borders, emphasised by large boulders. The planting is mainly evergreen, and includes ferns, bamboo and lily turf (*Liriope muscari*), with the added bonus of flowers from skimmias and scented sweet box (*Sarcococca*) in winter. A tall square

dovecote stands in one corner of the courtyard and the high laurel hedge has been trimmed so that its eaves are visible from the house. All around the garden, the views of the landscape beyond the boundaries are carefully monitored so they do not become blocked by trees or shrubs.

Andrew Lloyd Webber's biography positively glitters with awards. His musicals have dominated both the West End (where he owns seven theatres) and Broadway for decades, and even his racehorses regularly win. Andrew and his wife Madeleine, a former equestrian competitor and member of the 1992 British three-day event team, founded racing stables just a short walk from the house. They called their stud farm Watership Down, after the hill that Richard Adams immortalised in his novel of the same name. Part of the North Wessex Downs Area of Outstanding Natural Beauty, Watership Down's

Above: The east side of the house is the most formal area of the garden, with four 18th-century statues representing music, architecture, sculpture and painting set into the clipped yew hedge.
Opposite, clockwise from top: The east facade bathed in morning light; the swimming pool pavilion with its ecclesiastical-style roof; Mika, one of the Turkish Van cats; a simple bench provides a quiet place to sit in the meadow.

*Above: Hot pink and dark red dahlias blend beautifully with the soft greys and blues of lamb's ears (*Stachys byzantina*) and lavender in the south-facing border.*

Opposite, clockwise from top: The ornamental fountain by the swimming pool; a stone pavilion is cushioned by planting; summer bedding plants in a stone urn add colour to the borders by the house; fuchsias and petunias stand out in a mixed border.

Overleaf: The view of the lake from the north-facing terrace.

curving outline dominates the horizon to the north of the garden, and its chalky slopes provide the ideal turf for gallops. Lambourn, 30 miles (48 kilometres) to the north, is the biggest horseracing centre in Britain outside Newmarket, and Park House Stables, owned by broadcaster Clare Balding's family, is just a few miles to the east of the Lloyd Webbers' home.

Andrew started writing music very early in life, publishing his first compositions at the age of just nine. Encouraged by his aunt, the actress Viola Johnstone, he and his brother Julian, the cellist, used to put on shows in a toy theatre.

Today, Andrew still has his own personal theatre, which he has created in St Mary's church, the 16th-century chapel that stands in the garden just a short distance from the main terrace. Now deconsecrated, it has been converted into an auditorium with a stage and seating. Andrew puts on performances of new

works for friends here, and the long list of musicals presented to a rapt audience have included *Evita*, *The Phantom of the Opera*, *Cats*, *Starlight Express* and *Tell Me on a Sunday*. Elaine Paige, Michael Crawford and even the illusionist Derren Brown have been on the guest list.

The south-facing borders on either side of the terrace at the back of the house are adorned with hardy geraniums, irises, roses and phlox. The couple's Turkish Van cats love sunbathing here, leaving the occasional flattened plant as evidence. Although many of the climbing plants were taken down during recent repointing work, climbing roses and wisteria still scramble up the walls, but are now allowed to grow only as far as the first floor.

The terrace provides generous seating space, with benches by Gaze Burvill, and an outdoor kitchen area boasting a Big Green Egg barbecue, the latest must-have piece of al fresco kit, which can roast, grill, fry

"St Mary's church, the 16th-century chapel that
stands a short distance from the main terrace,
has been converted into an auditorium."

and probably slice the lemon for a gin and tonic as
well. Like most theatre people, the Lloyd Webbers
do a lot of entertaining.

A second border curves round the western end of
the garden, and is mainly planted with shrubs, such
as white hydrangeas, skimmias and magnolias. The
white flowers stand out well against the background of
evergreens, and the pale colour scheme is continued
in the borders around the chapel.

The evergreen backdrop to this area includes a
magnificent specimen of what we British insist on
calling a wellingtonia, but it is actually a giant sequoia
(*Sequoiadendron giganteum*). Indeed, the common name
"giant sequoia" is not strictly accurate either, because
the tree has been classified as a different genus from
the coastal redwood, *Sequoia sempervirens*. When the trees
were first discovered in the 1850s, in the foothills
of the Sierra Nevada in California, the American

naturalist Albert Kellogg wanted to call them
washingtonia, after the first US president. However,
before he could register the species, the British plant
hunter William Lobb had raced home with his own
specimens, which were christened *Wellingtonia gigantea*
by John Lindley of the Horticultural Society, in
honour of the Duke of Wellington. The Americans
were understandably peeved about this, and the name
changed several more times before it was finally
renamed in 1939.

Beyond the south lawn, the Lower Meadow is
a celebration of spring, with masses of daffodils,
witch hazel (*Hamamelis*), rhododendrons and azaleas.
The meadow then leads to the swimming pool,
which is divided from the main garden by a hedge of
Portugal laurel (*Prunus lusitanica*) and yew. It is heated
by solar panels, and in the corner is an appropriately
ecclesiastical-looking pavilion that houses a barbecue.

*Above: The 16th-century
church provides an insight into
the thriving rural community
that once lived in this slice
of Hampshire countryside.
Opposite, above: The view
of the countryside beyond
the chapel. These vistas are
carefully managed so that
they don't become obscured
by woodland.
Opposite, below: Two stone
urns mark the entrance to
the Lower Meadow.*

Above: Pink fuchsias in urns flank the door of the chapel. Opposite, clockwise from top: Billowing hydrangeas and milky bellflower (Campanula lactiflora) *complement the stone walls; the back view of the chapel; a view across the lawn from the cedar of Lebanon* (Cedrus libani); *the stone folly in the orchard is used as a glorified shed for storing tools.*

There is even a little herb garden planted here, the leaves ready for use with kebabs or cocktails. The pavilion has arched Gothic windows, and offers views of the garden beyond, which is planted with more spring-flowering shrubs. At the centre of this garden an old cheese vat serves as a planter and focal point — it was filled with spring bulbs when I visited.

Continuing through this garden, you reach the tennis court and orchard, divided in two by a pergola that supports climbing roses. To the north of the pergola are apple trees — crabs, desserts and cookers — plus quince and medlars, while at the other end are stone fruits, including plums and cherries.

The kitchen garden is on the other side of the house, and in 2016 a new heated glasshouse was built, where salad vegetables can be grown in winter, and tender fruit trees, such as peaches and lemons, are protected from frost. The construction of the glasshouse also involved rejigging the western end of the kitchen garden, and there is now an area of cutting flowers for the house, as well as raspberry canes, espalier apple trees on the brick walls, and an asparagus bed, which has been there for years, but still produces a good annual crop of tender stems.

A door from the kitchen garden leads out onto the main drive into the park. The Lloyd Webbers love to take this walk when they are at home, wandering down to the stables to see the horses. Andrew has always made a point of planting trees, creating the copses and areas of woodland that are so important to the character of the landscape.

This is the sort of British countryside that makes you think of music: of larks ascending and the first cuckoo calling out in spring; of choristers' voices singing of England's green and pleasant land, and proclaiming "I Was Glad".

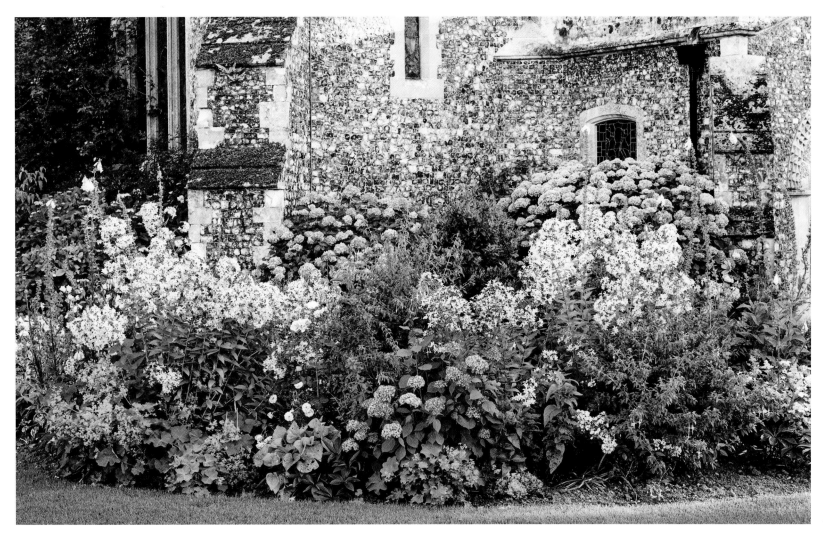

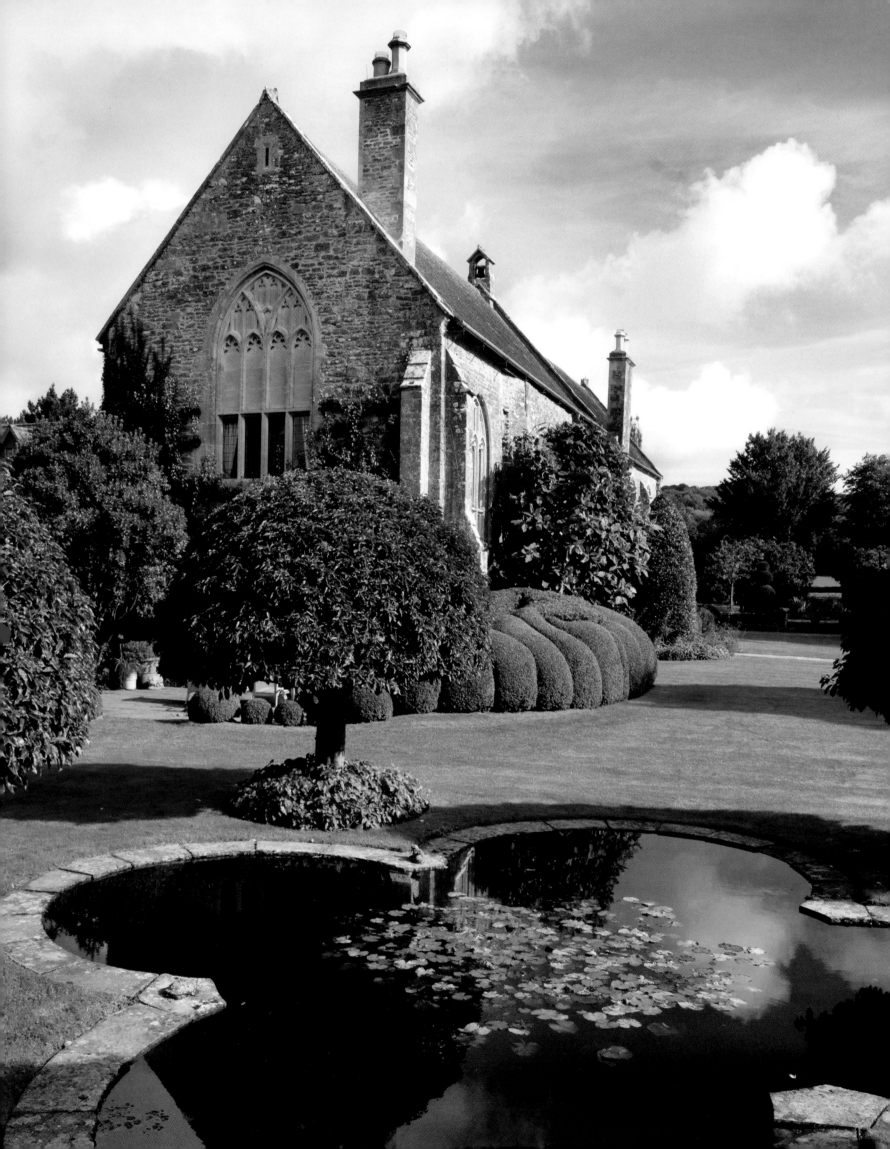

CAMERON MACKINTOSH &
MICHAEL LE POER TRENCH

SOMERSET

The temptation to compare the garden of Cameron Mackintosh with one of his phenomenally successful theatre productions is almost irresistible. It bears all the hallmarks of a sell-out show: every new vista is like a wow-factor scene change, the attention to detail is meticulous, and when you encounter the enthusiastic gardening team you half expect them to break into a few bars of "Do You Hear the People Sing?" from the musical *Les Misérables*.

Although there are many theatrical flourishes at Stavordale Priory – a blue horse from *Carousel*, for example, gallops through part of the garden known as the Dingley Dell, and the elephant of the Bastille (from *Les Misérables*) stands meditating in the woodland beyond – the plaudits for the garden should go not only to Cameron but also to Michael Le Poer Trench, his partner. In addition, both are keen to share the credit with the previous owner of

the house, the garden designer Georgia Langton, who spent 15 years creating the layout that Cameron and Michael inherited when they bought it in 1993.

Stavordale is a former Augustine priory, which was founded in 1243 and became a farm after the Dissolution in 1537. In 1905, it was transformed into a home by the architect Thomas Collcutt, who coincidentally also designed London's Palace Theatre in Cambridge Circus, where *Les Misérables* ran for 19 years before moving to the Queen's Theatre in 2004.

The house itself is L-shaped, and the inside angle of the "L" faces west, creating a sheltered space known as the Upper and Lower Cloisters. Most of the formal garden, which includes topiaries, flowers and shrubs, lies to the south-west of the house, while to the north, woodland areas surround the ponds, providing a natural barrier against the prevailing wind. To the east is the vegetable garden, the Birthday Grove which

Cameron Mackintosh

Born: 1946

Theatre producer, impresario and supplier of props for dramatic garden flourishes

Michael Le Poer Trench

Born: 1959

Agricultural science graduate, professional photographer, and gardener par excellence

Above: Aquilegias and primlulas grow around the pond.

Opposite: The quatrefoil pond at Stavordale Priory, formerly home to Augustinian monks.

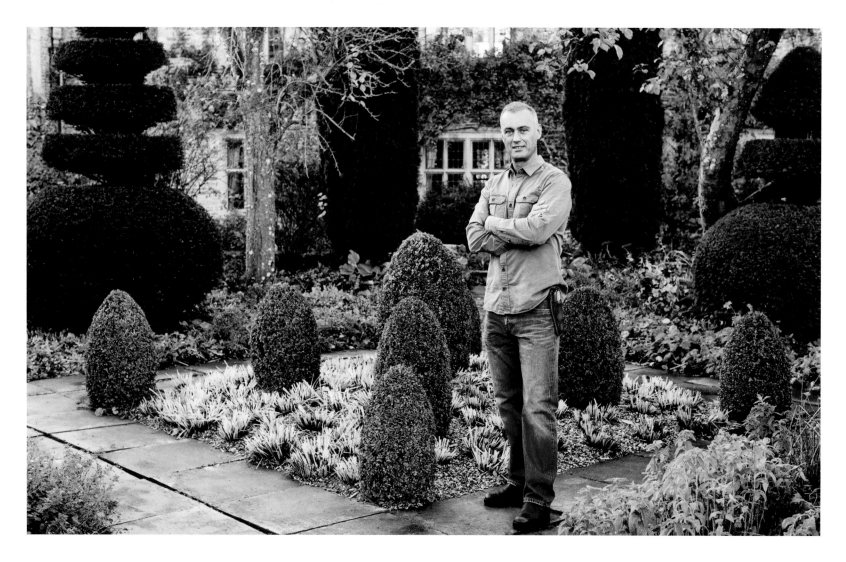

"Under Michael's supervision, the lake and pond have been cleared, the banks replanted, and new vistas created."

was planted to mark Michael's birthday in 2009, and Cameron's Meadow.

Michael photographed many of the international iconic musicals of the 1980s and 1990s, but as the garden has matured over the years, it's taken more and more of his attention, and he now spends all of his time at Stavordale — and most of that outside. He grew up in Australia, having emigrated with his parents in 1969 (Ten Pound Poms, as the Aussies dubbed British migrants). He studied agricultural science at the University of Queensland before being encouraged by an artist friend to start taking pictures, and although at that time he didn't intend becoming a gardener, his background has certainly proved useful. He is not only hands-on in terms of the practical work, but he also has a great eye for design. Under his supervision, the lake and pond have been cleared, the banks replanted, trees pruned

and new vistas created. A series of scarlet willows (*Salix alba* var. *vitellina* 'Nova'), for example, have been planted at the western end of the lake, where their bright red bare stems glow in low winter sunlight.

From the lake, a path leads back to the house along the Birch Walk, where white-stemmed Himalayan birches (*Betula utilis* var. *jacquemontii*) are underplanted with Siberian bugloss (*Brunnera*) and honesty. Spring is the season when woodland gardens take their place in the spotlight, from February, when the first snowdrops emerge, to the massed ranks of bluebells in late April, and the appearance of the candelabra primulas and Japanese iris (*Iris ensata*) which continue the display into June.

The Cloister Gardens were laid out by Georgia Langton, and instead of parterres, she used stone-edged raised beds, punctuated with fastigiate yews that are now approaching a stately maturity. The beds

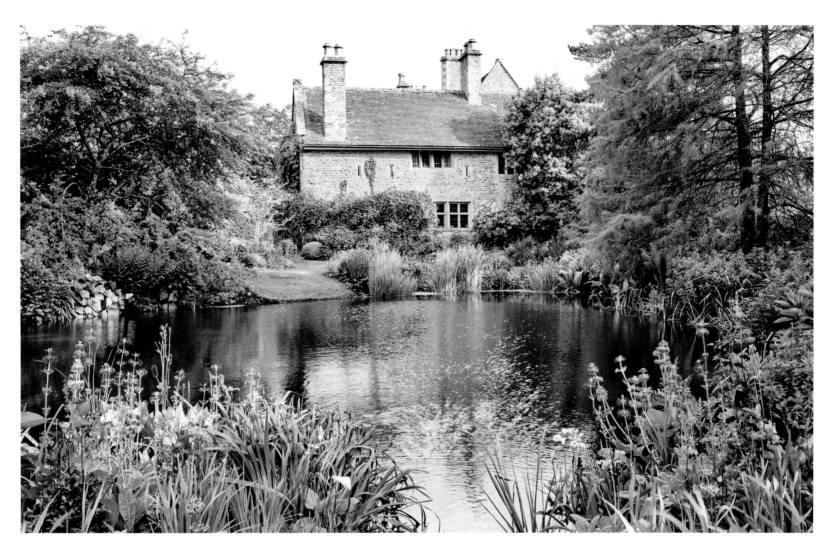

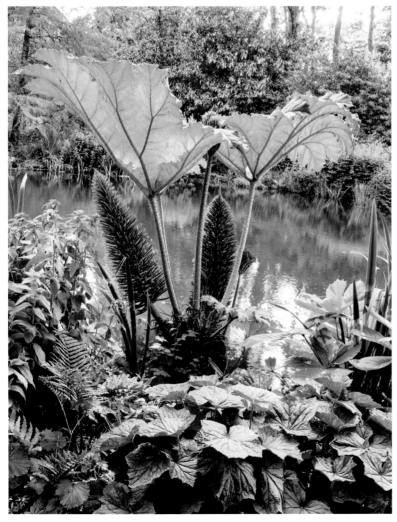

spill over with traditional English garden plants, such as aquilegias, roses, hollyhocks, catmint (*Nepeta*), peonies and phlox. Architectural box topiaries, clipped shrubby honeysuckle (*Lonicera nitida*), and purple-leaved barberry (*Berberis*) provide structure.

One particularly interesting detail is the way the box hedges around the wellhead fountain have been clipped. The fountain has four spouts, and the hedge has four sections, allowing each spout to be seen through the gaps between them.

To the south-west of the house, in the most formal part of the garden, the curving sections of a quatrefoil pond are punctuated by four standard Portugal laurels (*Prunus lusitanica*). This theme is echoed by the two pear trees (*Pyrus communis*), which are underplanted with cushions of box topiary. More box topiary can be found in the borders beside the house. The shapes have been likened to loaves

of bread or, more romantically, to the unusual lobed fruit of the coco de mer (*Lodoicea maldivica*), but Cameron and Michael simply call them "the bums", which is perhaps the most accurate description.

The colour palette in the borders beside the house and to the west of the quatrefoil pond, is mostly blue and purple. The planting comprises flowering perennials that bloom from late spring through to the autumn. They include deep blue *Salvia* 'Amistad', asters (*Symphyotrichum* 'Little Carlow' and *Symphyotrichum novi-belgii* 'Purple Dome'), pale blue monkshood (*Aconitum* 'Stainless Steel'), a dark meadow rue (*Thalictrum* 'Black Stockings'), and bergamot (*Monarda* 'Scorpion'). The tiny *Viola* 'Avril Lawson' fills early season gaps at the front and the grass, *Miscanthus sinensis* 'Kleine Silberspinne', injects additional texture.

On either side of the front drive are the Upper and Lower Orchards, planted with apple

Above: The chamfered edges of the parterres in the Upper Cloister Garden are a subtly different take on the traditional box hedge. Opposite, clockwise from top left: The red flowers of the rose 'Rambling Rosie' scramble up the walls of the grotto; an antique statue stands guard at the grotto's entrance; the Birch Walk underplanted with meadow flowers; a blue horse from the set of Carousel *gallops through the trees.*

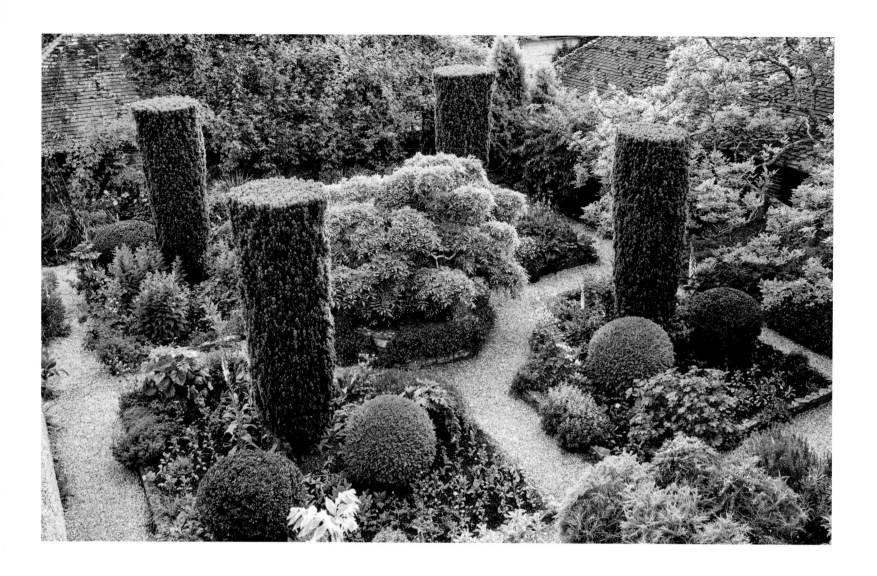

Above: Fastigiate yews in the Lower Cloister Garden have been clipped to accentuate their columnar shape. Opposite, clockwise from top left: Topiary creates a structural contrast with the perennials in the Lower Cloister Garden; a pear tree appears to sit on a cushion of box topiary; the same topiary shapes are repeated around the house walls; exuberant climbing roses decorate the house. Overleaf: The wooden gate in the rose-clad wall leads to the Cloister Gardens.

trees and rose bushes. Cameron and Michael are experimenting with wildflower turf in the orchards, which is an easier alternative to sowing seed. The plants are sown onto biodegradable matting and have already germinated when you receive them, resulting in a more even display of flowers and grasses.

The wall that runs along the edge of the meadow continues on to form the boundary of the kitchen garden. Recently restored, its aged appearance is the result of a process Michael calls "milking the wall". An old gardeners' trick is to paint the stonework with yoghurt, which creates a breeding ground for moss, algae and liverworts, making it look as if it's been there for centuries. The acid in the yoghurt helps to provide the right conditions for these plants, but modern low-fat and the Greek types are less acidic, which is why some people have found this method unsuccessful. However, the raw milk from a dairy

on the estate hadn't been treated and judging by Cameron and Michael's wall, it worked really well.

The vegetable garden is a riot of colour, where chard, leeks, cabbage and kale grow alongside dahlias and asters. Squash plants, with their bright yellow flowers, are grown here too, and allowed to ramble around the yew topiaries. The garden also includes an asparagus bed and an area that acts as a nursery bed, filled with perennial and shrub cuttings.

Just as mouth-watering for tree-lovers is Michael's Birthday Grove, an evolving arboretum that's home to a range of specimen trees given by friends to mark his 50th birthday. The trees on display here include *Malus hupehensis*, the ornamental Chinese crab apple, which has cherry-like fruit; *Fraxinus americana*, or white ash, grown for its intense autumn colour; *Catalpa* x *erubescens* 'Purpurea' with its moody purple foliage; *Quercus frainetto*, the Hungarian oak, with vast leaves

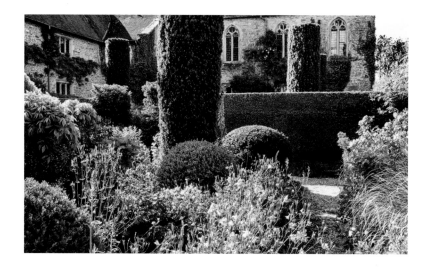

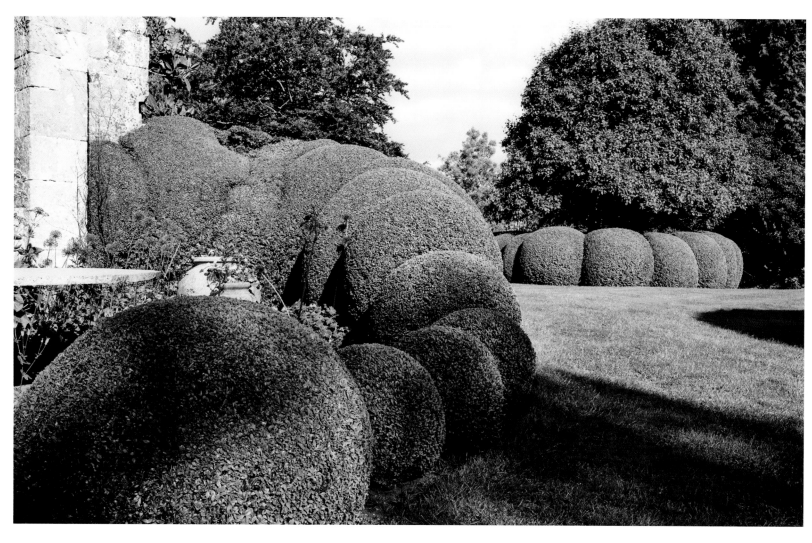

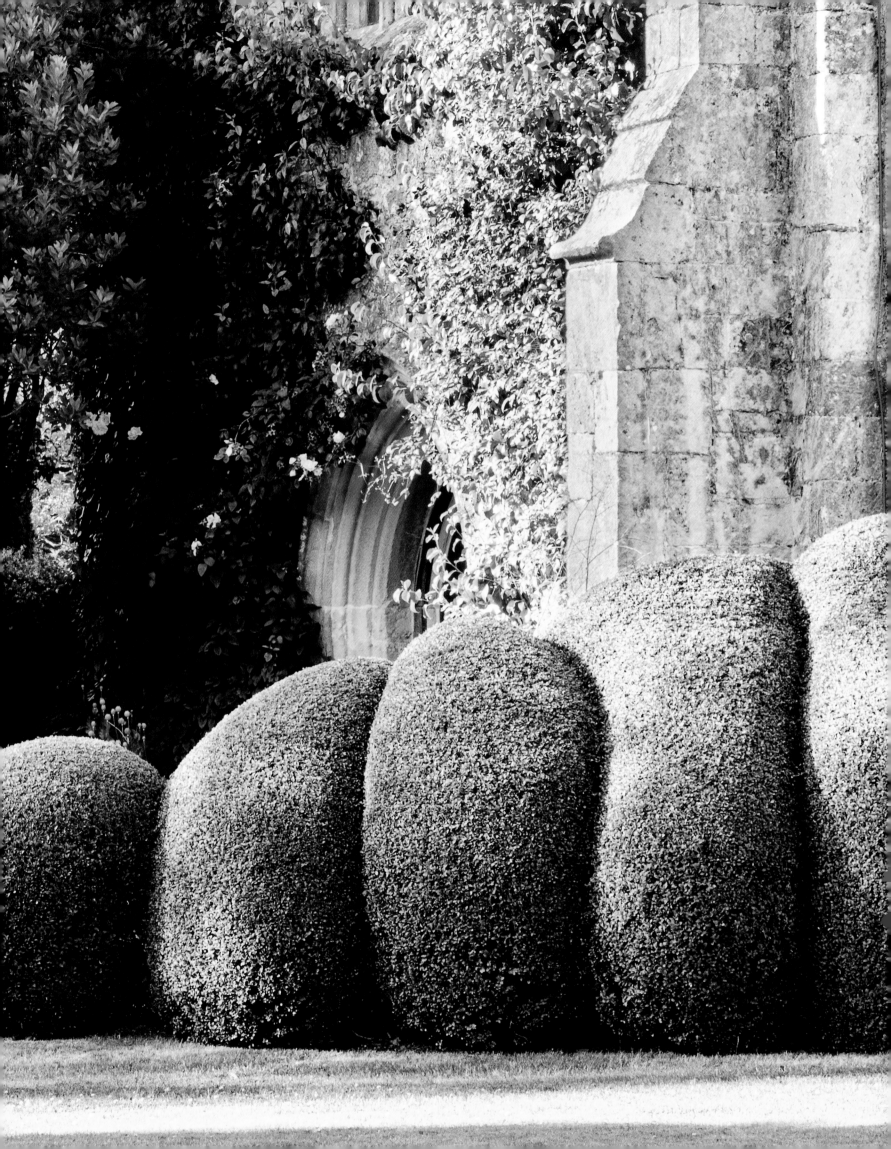

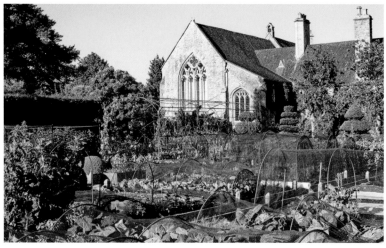

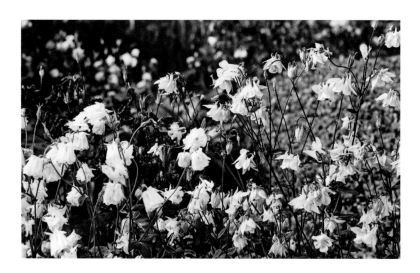

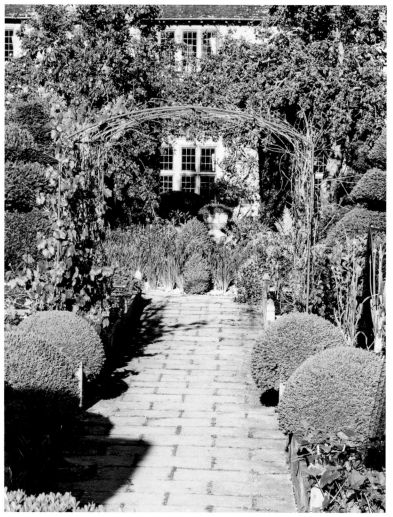

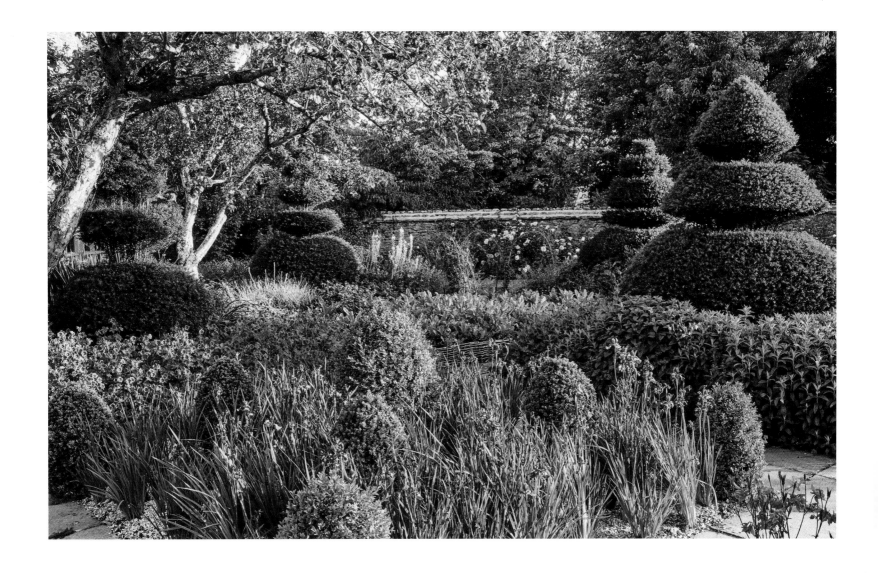

up to 25 centimetres (10 inches) in length; and *Populus deltoides* 'Purple Tower', a comparatively new introduction that forms a column of dark red leaves.

At the eastern end of the house, Cameron's Meadow features a central rill, with clumps of water forget-me-nots and flag irises planted at regular intervals along its length. A number of British aquatic plants, including flag irises, are notorious for looking messy and quickly outgrowing their allotted space, but these are contained in their own semicircular stone-edged water beds. This clever design keeps them in order, and creates exclamation marks of spiky iris leaves that add a dramatic flourish to the tranquil rill.

When the quatrefoil pond to the west of the house was being dug out, the workmen discovered the remains of skeletons, thought to be those of monks who had been buried there when the house was a priory. Cameron and Michael were at the time creating the grotto and decided to have the remains reinterred there, with a stone marking their grave. A friend from Downside Abbey, the Benedictine monastery school near Shepton Mallet in Somerset, came to perform the ceremony on Hallowe'en, the night before All Saints' Day.

The grotto has a mosaic pavement, decorated with emblems from some of Cameron's seemingly endless list of successful theatre shows. A cat (*Cats*), bowl (*Oliver!*), conical hat (*Miss Saigon*), cherries (the musical version of *Witches of Eastwick*), a tricolour (*Les Misérables*), and candlestick (*The Phantom of the Opera*) provide a record of his illustrious career. Behind the pavement, in the grotto itself, water cascades into a pool.

It may sound fanciful, but the grotto looks a little like a proscenium arch, and the tumbling water reminds me of a roar of applause at the end of a show.

Above: Siberian flag irises (Iris sibirica) and hardy geraniums grow between box topiaries on the terrace beside the kitchen garden.
Opposite, clockwise from top: Cameron's Meadow, where a narrow rill runs between an avenue of fruit trees; even the vegetable garden is decorated with box balls; aquilegias provide colour in the Upper Cloister Garden; Michael grows his leafy greens under nets to protect them from cabbage white butterflies.

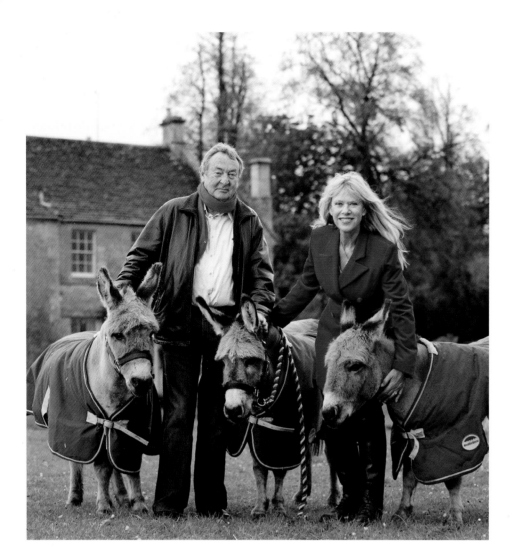

Nick Mason

Born: 1944

Wife: Annette

Pink Floyd drummer, songwriter, Ferrari collector and owner of miniature donkeys and cattle

Left: Nick Mason and his wife Annette with their miniature donkeys.
Right: The lily pond, with a sculpture of swans designed by Simon Gudgeon, who also made the Isis bird sculpture on the banks of the Serpentine in Hyde Park.

NICK MASON

WILTSHIRE

Nick and Annette Mason's garden at Middlewick House in Wiltshire defies categorisation. It's partly a farm, although the animals are treated more like pets than livestock, and it also includes formal areas of garden. The dominant feature, however, is the natural landscape. Although it's very private, accessed via a single-track country lane, the garden is open annually to visitors to raise money for local charities.

Nick is the drummer with Pink Floyd, arguably one of the greatest rock bands ever. It was founded in 1965 when Nick was studying architecture at Regent Street Polytechnic (now part of the University of Westminster) with Richard Wright and Roger Waters. The fourth member, Syd Barrett, had gone to school with Roger in Cambridge and was studying painting at Camberwell College of Art.

Middlewick House is the former home of HRH the Duchess of Cornwall, who lived there before her marriage to Prince Charles. A friend of the Masons alerted Annette, who was house-hunting in Wiltshire at the time, that Camilla Parker Bowles, as she was then, was planning to sell. An introduction was made and Camilla invited them for lunch (she cooked roast chicken, apparently), after which the deal was struck.

Annette, like Camilla, is a keen horsewoman and has even competed in the celebrity ladies' race at Goodwood. She was looking for a house with stables, while her husband was after somewhere with a large enough drive to park some of his classic cars. The cars, by the way, are not mere status symbols — they play the same role in Nick's life as Annette's horses do in hers. At the time of writing, Annette had five horses, one of which was 38 years old.

Nick's car collection is well known, and includes a 1962 Ferrari 250 GTO, rare Maseratis and classic Jaguars, as well as a Model T Ford, which

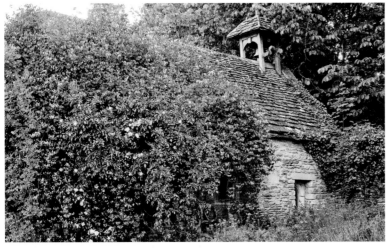

belonged to Coco the clown of Bertram Mills Circus. The Ford is designed for comic stunts, and as Nick once remarked: "It's the sort of car where you take it for a service and complain if the doors *don't* fall off."

The estate is now home not only to Annette's horses, but to three Kunekune pigs, a New Zealand breed that looks like a cuter, furrier version of a pot-bellied pig. Indeed, if you crossed a Vietnamese pot-bellied pig with a teddy bear, it would probably bear an uncanny resemblance to a Kunekune. The Maoris kept them for meat, but they were traditionally allowed the run of the house and garden, and have a gentle, friendly temperament.

The Masons also keep miniature donkeys, and a herd of Black Welsh Mountain sheep which, as their name suggests, are a small, hardy breed with inky-black fleeces. They have a reputation for lambing easily and prolifically too. The other animals that

make up the couple's menagerie include chickens, ducks, and a herd of Dexter cattle. The Dexter breed originated in Ireland and, like the sheep, they are small – the Shetland ponies of the cattle world – but very hardy and adaptable to most environments. They also make good mothers, which makes breeding them easier. Watching Frank Powell, the estate manager, feed the cattle is like being among a pack of very large, rather shy dogs.

Middlewick also makes its own honey. Annette said: "We have three hives which Frank supervises. Sadly, we can't call it organic, as you need something like a four-mile [six-kilometre] radius of organic forage around the apiary. We are also trying to grow a manuka tree [*Leptospermum scoparium*] for manuka honey, but it's only knee high at the moment."

Frank has been at Middlewick almost since Nick and Annette first moved in. "They bought the

Above: Nick and Annette invited the former owner of Middlewick House, HRH the Duchess of Cornwall, when they opened the garden for charity in 2013.
Opposite, clockwise from top: Umbrella plants (Darmera peltata), goat's beard (Aruncus dioicus), and yellow flag irises edge the jetty; the chapel, swathed in Chilean potato tree, Solanum crispum 'Glasnevin'; globe thistles (Echinops) dance in the sunlight; another view of the old chapel.

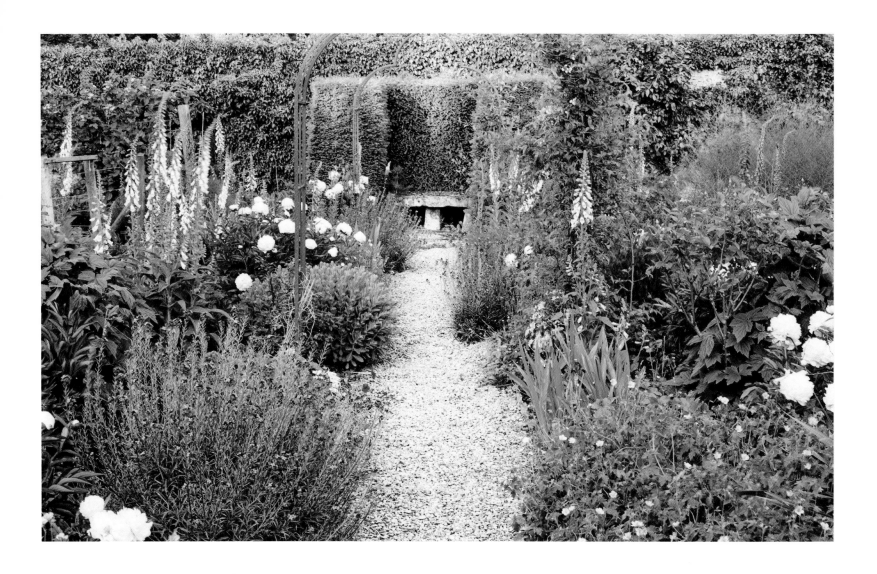

Above: The kitchen garden is a romantic mixture of ornamental and edible, providing flowers for cutting and food for the kitchen. Opposite, clockwise from top: Potatoes rub shoulders with peonies and foxgloves in the kitchen garden; cabbage is netted to deter flying pests; the white double peony 'Festiva Maxima' has red flecks at the centre of its petals; the sculpture of a lady, Elemental Dance, *is by Annette's sculpture teacher, Glynis Owen.*

house in September, and we arrived in January." His partner Angie is the housekeeper and helps with the horses, and their son Joe has now joined the team to help run the estate.

As estate manager, Frank has a wide variety of responsibilities, ranging from farmer to chauffeur, but as far as the garden is concerned, he has a clear brief: "Nick and Annette told me they didn't want Blenheim Palace." A fussy, formal garden would be inappropriate in any case, because both the back and the front of the house look out over open meadow, with a ha-ha as a barrier against marauding livestock.

The point of a ha-ha is to allow an uninterrupted view of the landscape beyond the garden, and they usually take the form of a slope, or a deep, wide ditch, with a steep vertical retaining wall on the side nearest the house. Unfortunately, no one seems to have explained the principle to the Masons' sheep, who

occasionally scramble over the ha-ha and nibble the plants in the tubs on the terrace.

There are around 60 acres (24 hectares) of pastureland on the Middlewick estate, and lots of woodland, which requires quite a bit of management, not least because the trees' branches along the network of rides have to be pruned high enough to provide clearance for someone on horseback.

Annette believes in conservation, and feels that the woodland, gardens and animals should be cared for in a totally organic way. Everything should appear to have grown naturally and some of the fallen trees should be allowed to remain to create sculptures, climbing frames for the children, jumps for the horses and habitats for wildlife.

Frank's view is that most of the old trees that have fallen should be removed, and new young trees planted to replace them. There should also be three

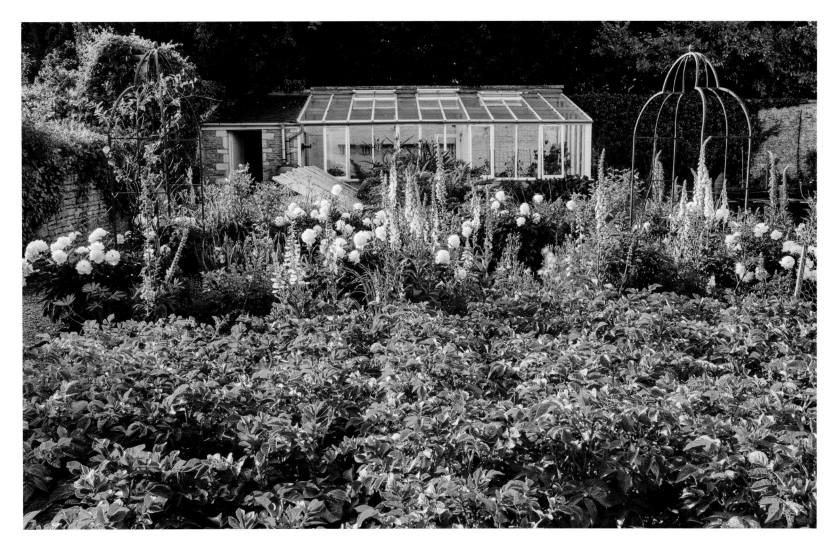

"Nick's car collection is well known, and includes a Ferrari 250 GTO, rare Maseratis and classic Jaguars."

clear levels of growth: ground level, understorey (shrubs and smaller trees, such as cherries), and the canopy. Otherwise, he argues, the young trees will be crowded out, and spring bulbs like snowdrops and bluebells that rely on the winter and early spring light, provided by the bare branches of deciduous trees, will disappear.

Annette has worked with Frank towards a healthy compromise: too much management can result in loss of habitat, but thugs such as brambles can outcompete the other plants and trees, and establish a monoculture. So if you want to encourage a diversity of plants (and thus, a diversity of animals that feed on them), a little intervention is necessary to achieve a balanced ecosystem.

Nick is a keen cook, which explains why he takes most interest in the kitchen garden, which is now a romantic combination of produce and ornamentals,

with a rusted gazebo at the centre. In early summer the fountain beneath the gazebo is almost hidden by a white climbing rose, while matching arches and obelisks support yet more of these fragrant blooms. There is also a cutting garden along one wall, and a small greenhouse that provides warmth for tender perennials, such as pelargoniums. A wrought-iron gate offers a tantalising glimpse of it from the house.

The Masons initially commissioned Cotswolds-based designer Rupert Golby to remodel the garden, and he continues to visit occasionally to ensure it is looking its best for their charity open garden weekend, held in aid of the Wiltshire Bobby Van Trust and Wiltshire Air Ambulance. On a couple of occasions, the weekend was attended by the Duchess of Cornwall, who is patron of both charities.

Rupert Golby also redesigned the pond area at the front of the house, cutting a new curved outline

Above: A Jaguar E-type Series III V12 roadster, made in the early 1970s, against a backdrop of climbing roses. Opposite, clockwise from top: The fountain at the centre of the kitchen garden, designed by Rupert Golby; a Jaguar Mark II saloon, from the early 1960s; Hydrangea macrophylla 'Forever Pink'; an antique gypsy caravan.

into the lawn. Jennie Shaw, who runs the Bobby Van Trust, suggested positioning a sculpture of two swans by Simon Gudgeon in the centre of the pond. The swans seem to float naturally on the water, their necks forming a heart shape when viewed from the drive. The sculpture has remained there ever since, and Nick and Annette subsequently bought another of Simon's works for their London garden.

The rest of the pond is edged with trees and has a more informal design. A bench and jetty provide seating from which you can admire the water lilies, and although Frank complains that the ducks, which have their own house, have trashed the marginal planting of flag irises, it is charming nonetheless.

There is a small apple orchard behind the pond, and a second orchard can be found on the other side of the property, beside the conservatory that houses the swimming pool. Even in this part of the garden,

the impression is of informality, and wildflower seed is sown each year in the beds around the conservatory, producing a blaze of colour in summer.

The conservatory has a Mediterranean theme, and the planting here includes a large grapevine and a bougainvillea, which are growing up the walls and across the ceiling. A range of containers filled with scented pelargoniums and other tender flowers add colourful highlights to the display.

There is only one herbaceous border on the estate, which stretches along the outside wall of the kitchen garden. Planted with a confection of traditional cottage-garden classics, it includes peonies, sedums and delphiniums, as well as hydrangeas and scented phlox (*Phlox paniculata*). Nick says the Duchess of Cornwall gave Annette and him some tips about gardening when they first moved in, and it appears that they've been taking her advice.

*Above: Black Welsh Mountain sheep, which have been known to scramble over the ha-ha to feed on plants on the terrace.
Opposite, above: A selection of Nick's Ferraris, including the red Ferrari F40, parked outside the front of the house.
Opposite, below: An edging of lavender below pale pink climbing roses stretching up the wall create a classic English country garden combination.*

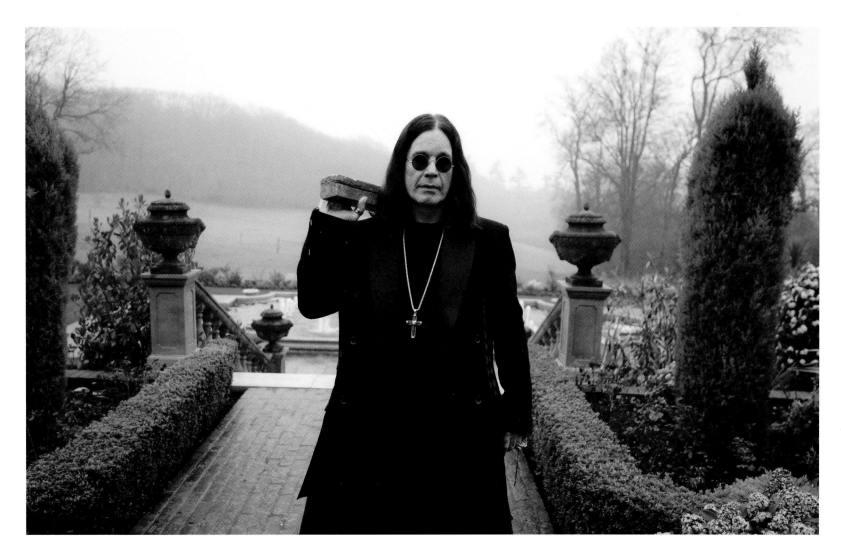

OZZY & SHARON OSBOURNE

BUCKINGHAMSHIRE

Sharon Osbourne, media personality and wife of rock musician Ozzy Osbourne, may, to those who don't know her well, appear to live life in the fast lane. She has been married to the man known as the "godfather of heavy metal" since 1982, and has not only managed his career, following his sacking by the rock band Black Sabbath in 1979, but also made a household name for herself. Starring in television programmes including the reality show *The Osbournes* and talent show *The X Factor*, she has even made an appearance in an episode of *Dr Who*.

However, you don't become a top businesswoman and media star by drifting round the garden doing nothing in particular. So there is something rather charming about the idea that when Mrs Osbourne returns to her UK home from Los Angeles, she loves nothing better than going outside to do a bit of deadheading. Dave Godman, the Osbournes'

estate manager, said: "She'll wander into the garden for an hour or so and just lose herself. She loves it."

A passion for gardening would appear to be in Sharon's blood. "My mother was a very keen gardener, as was my grandmother. My mother would spend hours pottering outside among her plants." She herself always wanted a house with a garden — "a place of beauty, a place to escape", as she puts it.

There is no denying that her and Ozzy's home in Buckinghamshire is a lovely spot. The house is late 19th century, and was designed by the architect Sir Mervyn Macartney for his father-in-law, Scottish Conservative politician Charles Thomson Ritchie, who was home secretary from 1900 to 1902, and then chancellor of the exchequer until 1903.

Sir Mervyn was a founder of the Art Workers' Guild, which sought, and still seeks, to ensure that fine art and the applied arts are represented on an

Ozzy Osbourne

Born: 1948

Heavy metal rock star, reality TV sensation and lover of the English countryside

Sharon Osbourne

Born: 1952

Reality TV sensation, collector of quirky garden statuary and animal lover

Above: Ozzy Osbourne in his Buckinghamshire garden. Opposite: The view from the terrace looks out over meadows and sika deer.

Above: The Grade II listed house, with its Dutch gables, was built in 1898–99. Opposite, above and below: The planting in the garden is mainly composed of low-maintenance shrubs, many of which are evergreen, clipped into topiary shapes that create a formal picture, complement the architecture of the house and look elegant throughout the year.

equal footing. The house is built in red brick with Dutch gables in the Artisan Mannerist style, which became popular during the 17th century when masons would design and build houses without employing architects, using pattern books instead of conventional plans.

The back of the property faces south over a meadow, which leads the eye up to where a wood perches on the crest of a hill like a breaking wave. Muntjac deer are visitors to the garden and, while picturesque, they are to blame for a slightly more rigorous form of deadheading. Nipping off buds and blooms as soon as they appear, they are the reason Sharon struggles to grow roses here.

Her rose garden is on the west side of the house, and it is in many respects an ideal location. Sheltered from the wind by a high yew hedge, it's warm and sunny, and the standard roses she grows more or

less survive, since they are tall enough to avoid the unwanted attentions of the deer. However, any small shrub or bush roses are nibbled away – including those Sharon acquired after the London Olympics in 2012, which had provided flowers for the medal-winners' bouquets. If the deer happen to miss anything, the rabbits mop up, according to Dave.

It is rather comforting to know that rabbits and deer are no respecters of fame or fortune and democratically regard all gardens as legitimate forage, but you get the clear impression that Sharon doesn't really mind. "My garden now is a place of solitude. I love the expanse of space. I love listening to all of the birds and looking at all the different animals that we have. I find it very spiritual."

In fact, not all the deer in the garden are a problem. The couple own a small herd of 25 sika deer, given to them as a gift, which are kept in a large

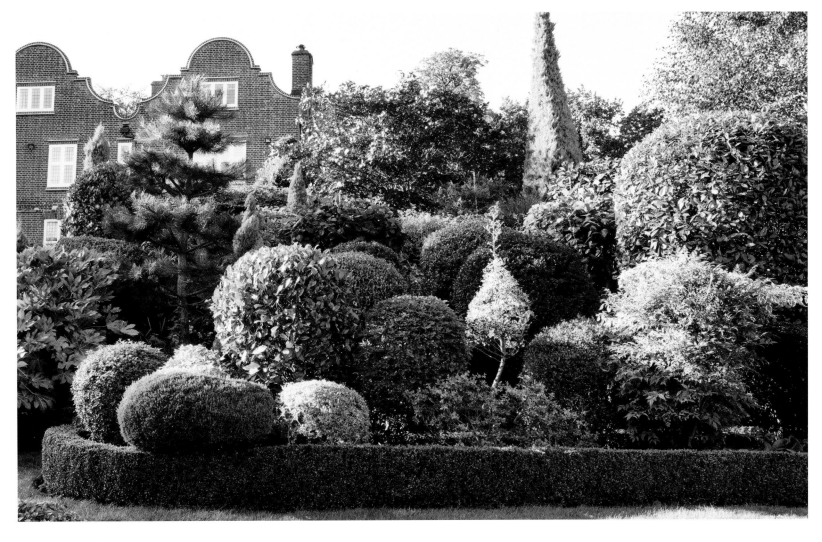

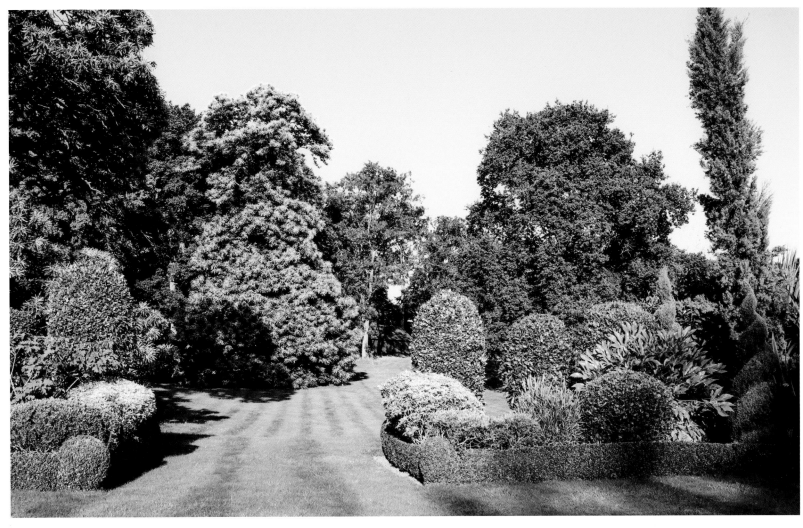

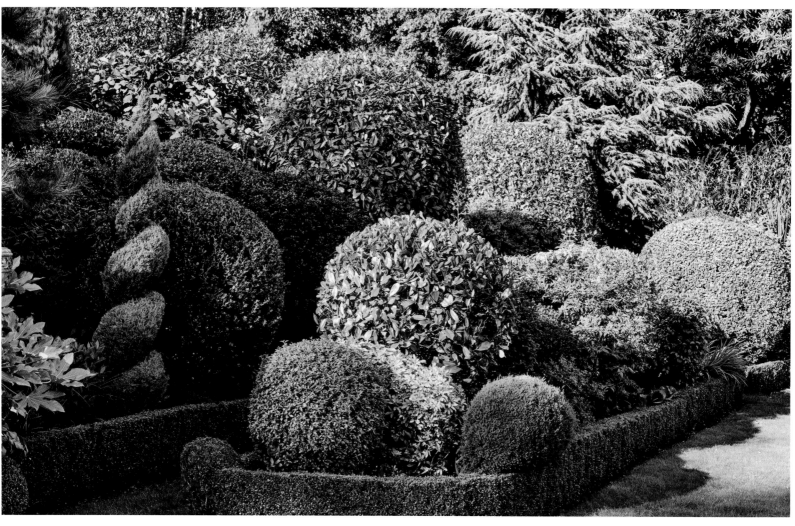

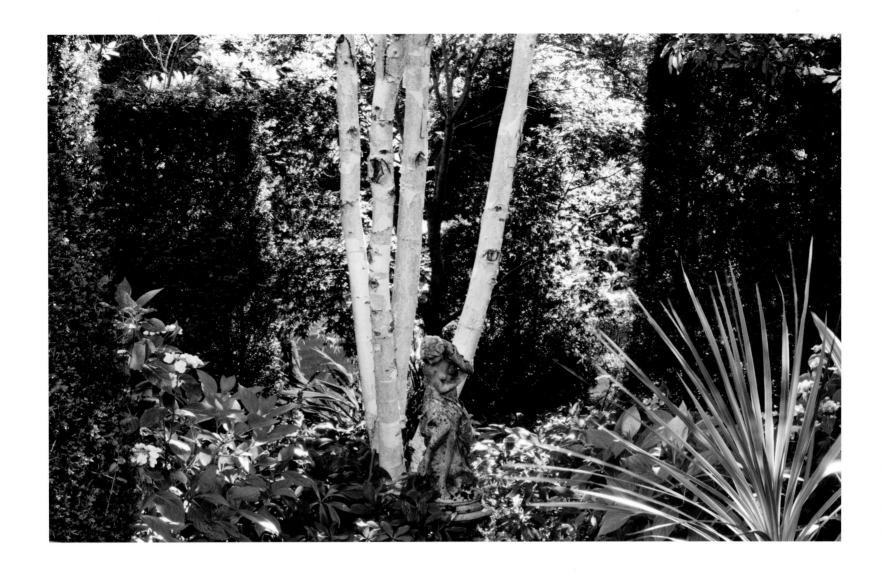

pen behind the fountain garden. Similar to fallow deer, sika stand just over 80 centimetres (30 inches) high at the shoulder.

The Osbournes spend a lot of their time in LA, so there would be no point in growing anything that needs excessive nurturing, or only flowers for a couple of weeks in the year. At the front of the house, for example, there are purple-leaved Japanese maples (*Acer palmatum* 'Bloodgood') and the green-bronze spiky foliage of New Zealand flax (*Phormium tenax* Purpureum Group), interplanted with evergreen shrubs, such as mahonias and hebes. The evergreen foliage means the garden always looks smart, while the maples offer seasonal interest, especially in autumn when their leaves turn scarlet before falling.

However, it would be unfair to their dedicated gardeners, John and Eva, to describe the Osbournes' property as "low maintenance". Ringed by mature

trees and woodland, with flower borders and seasonal bedding in stone urns to plant and maintain, there is plenty to do, and even a fairly straightforward task like leaf-clearing in autumn is a major job.

Sharon felt strongly that the design of the garden should reflect the architecture of the house. Rather than impose a preconceived vision taken from a book or magazine, she likes the garden and house to work together in harmony. "Depending on what property we lived in at the time, my idea of how to do the garden would change. I like to create something that is appropriate to the house and architecture.

"I didn't want the garden here to be filled with little flowers and perfectly manicured. I felt that it needed to be strong, packed with shrubs and perennials and a little wild, since we get so much wildlife and the property is a solid Victorian house." She's used topiary to provide a strong structure in the

Above: The sparkling white trunks of a Himalayan birch throw a spotlight on the figurative statue at its base. Opposite, above and below: The stone urns on the steps that lead from the terrace to the formal pond are planted with brightly coloured begonias to provide seasonal interest. On either side of the steps, the shrub borders are edged with tightly clipped box hedging.

"*The Osbournes' family garden features a group of ceramic ducks waddling along the border at the front of the house.*"

Above: Sharon loves collecting ornaments, such as these white ducks, which give the garden an informal, family-friendly appearance.
Opposite, clockwise from the top: The eclectic features include this red telephone box, which stands opposite the house; a stone helmet with plumes provides a focal point between yew hedges; a digging dog burrows in ivy; this traditional stone sundial complements the house.

garden, with cones and spirals twirling up through the borders like dancers in a Bob Fosse musical.

At the back of the house, steps lead from the sunny terrace down to an enormous stone pool and fountain topped by an angel - a copy of the Bethesda Fountain in Central Park in New York. On either side of the steps, two banks are planted with a variety of shrubs, including barberry (*Berberis*), shrubby honeysuckle (*Lonicera nitida*), dogwoods (*Cornus*), smoke bushes (*Cotinus*), *Escallonia*, and hydrangeas, many of which are clipped into spheres.

Looking back up at these borders from the pool, you can see how the 18th-century term "theatrical planting" — used to describe plants in borders that were graded in height from front to back — came about. It's almost like looking up at the crowds in a stadium at a rock concert. The lowest tier — the floor seats, if you like — is edged with a box hedge, and

separated from the main border by a grassy path. This helps to break up the dense planting, but also allows the gardeners to gain access for maintenance.

The planting was designed to suit the lines of the house and at one stage it was even more formal, but fears over the fungal disease box blight, and the inevitable losses inflicted by the wind and cold, have led to a more relaxed look in parts of the garden. Ornamental grasses and untrimmed shrubs, such as *Fatsia japonica*, lend an informal look.

From the pool, filled with enormous koi carp, you can walk round to the eastern side of the house, where a playhouse and climbing frame for the grandchildren bear testimony to the fact that this really is a family garden.

A family garden, yes, but with a difference, as you would expect from Sharon and Ozzy. This one features a life-size statue of a cow where the drive

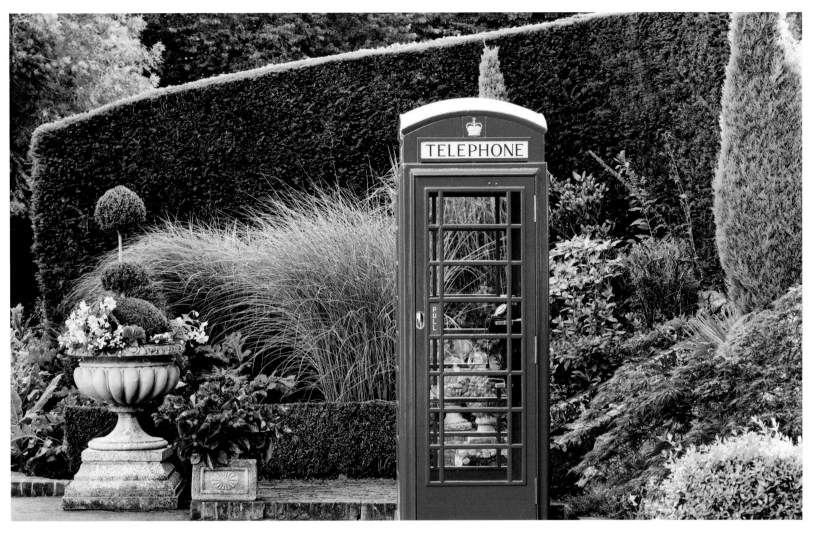

opens out in front of the house, and an iconic K6 red telephone box, with a notice inside advising new owners of television sets to "remember to buy your £2 television licence as soon as your set is installed."

Other features include a lighting system in the fountain pool that changes colour and a couple of those iron crosses that you see in French cemeteries. Between the hedges by the rose garden, a rather wonderful stone helmet, like something from a coat of arms, forms a focal point, while around the corner, a group of ceramic ducks waddles along the border at the front of the house.

In some gardens, the owners will go to great lengths to find antique statuary or scour reclamation yards for old wellheads and stone troughs. But at the Osbournes', you get the feeling that, like normal people, they simply buy stuff because they like it, whenever they happen to see it. I asked Dave Godman

where all the ornaments came from. "In containers from LA" was the answer. Apparently, unusual objects arrive fairly regularly from the States, and he unpacks the contents and distributes them, although Sharon always has the final say and will often move things around when she comes home.

The eclectic features add a sense of surprise – the garden, like its owners, is never predictable. In one courtyard, you will find a collection of what look like vintage metal dog figurines, while in another area, there's one of those digging dog statues that you can buy in any garden centre.

It's difficult to imagine Sharon Osbourne browsing in her local garden centre among the fluffy slippers and lawn treatments, but perhaps easier to visualise her wandering round this garden, listening to birdsong, watching the deer in the meadow and breathing in the fresh English air.

Above: The formal pond features a fountain topped with a stone angel, and a series of water jets, which can be lit up in different colours. Opposite, above: The life-size model cow, known affectionately as Daisy, was shipped to the couple's garden from California. Opposite, below: Lavender lines the path between the yew hedges around the rose garden.

Griff Rhys Jones
Born: 1953
Wife: Jo
Comedian, actor, writer,
television presenter, producer
and clipper of topiary

*Left: Griff Rhys Jones with his
wife Jo in the garden they have
created together in Suffolk.
Right: When Griff and Jo
first moved in, the house had
a small garden that was little
more than a field surrounded
by a high hedge, which Griff
removed to create this vista,
emphasised by yew topiary.*

GRIFF RHYS JONES

SUFFOLK

We British tend to clothe our achievements with a veil of modesty. We're not good at boasting about ourselves, and we tend to consider self-promotion a fault in others. Even if we reluctantly accept that someone is good at one thing, the manifestation of several talents in an individual is cause for alarm.

Noël Coward, a Renaissance man if ever there was one, was once asked by a journalist why he was known as "the master". "Oh, you know," he drawled. "Jack of all trades, master of none." It is as if the ownership of multiple aptitudes might be viewed as slightly suspect, like being found in possession of stolen goods.

However, in the case of Griff Rhys Jones, I am more than happy to eulogise on his behalf. He has had a long and varied career as a comedian, an actor of both stage and screen, a writer, and a presenter, setting up his own production companies and even finding time to campaign for local charities in his adopted county of Suffolk. He is also no slouch when it comes to garden design.

The garden at his Suffolk home, where he lives with his wife Jo, overlooks the Stour Estuary. From here, the river snakes its way inland, like a swirl of ink in a glass of water, along the Essex/Suffolk border to the pastoral landscapes of Flatford Mill and Dedham Vale, immortalised by the painter John Constable.

The design of the garden is formal, with confident lines forming avenues and enclosures. If you look at an aerial photograph, you can see that these clipped hedges of box and yew, and the avenue of holm oaks (*Quercus ilex*), gradually give way to a more relaxed layout, with mown paths through wildflower meadows, where the garden blurs into the landscape.

A lot of care has gone into working out vistas, so that in one direction you might have a view of the estuary, and in another, the house, its Suffolk-pink

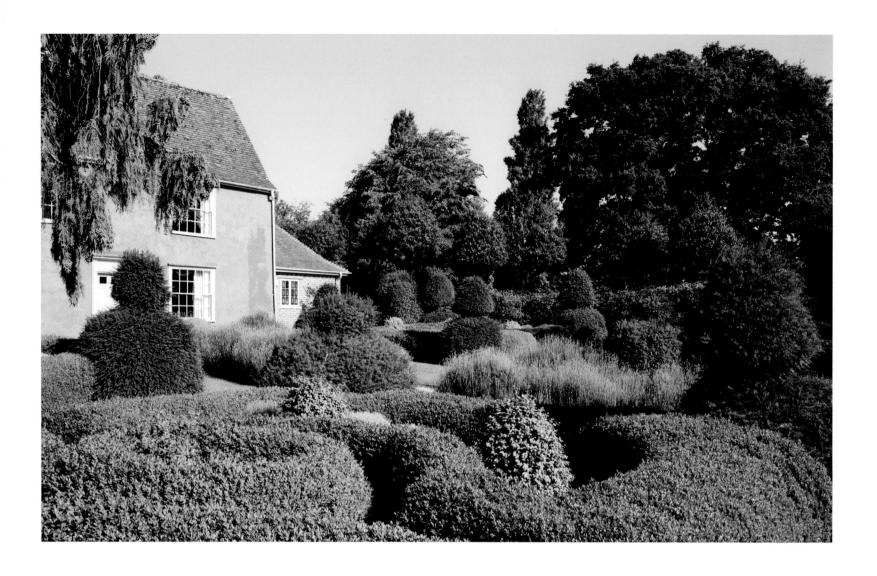

Above: Knot gardens have been a feature of English gardens since the reign of Elizabeth I, and they traditionally incorporated culinary herbs and aromatic plants such as lavender, as Griff has planted here. Opposite, above: The intricate design of the knot garden provides interest year round. Opposite, below: Lavender hedges lead the eye on towards a view of the estuary.

walls contrasting with the dark green of a knot garden and swathes of lavender.

Suffolk pink, seen on so many of the cottages in the county, ranges from shell-pink to a colour resembling terracotta. It is thought to have been developed by dyers (Suffolk once had a thriving cloth trade), who added blood from oxen or pigs to colour the limewash with which they painted their homes. As Griff points out, gallons of bull's blood are a rare commodity in Suffolk these days, so he and Jo rely on modern limewash from a specialist company.

Traditionally, domestic dwellings were built with whatever happened to be to hand locally. Suffolk has not much in the way of quarries or brickworks, so building materials included flints from the fields, reeds, clay and timber, which were then covered in plaster or render. A coat of limewash made the whole thing look smart. In the case of Griff's house, the

clay with which it was built was in the backyard. As he put it: "The house came out of the pond." Today, the pond, dug to provide the building materials and water for livestock, has one shallow sloping side, which would have allowed cattle or horses to walk in and drink, and Griff and Jo say they still find horseshoes there.

When the couple first bought the house, the garden was not as big as it is today, and measured about three-quarters of an acre (0.3 hectares) – the size of a small field. At the back of the house, the view of the estuary was once blocked by a high hedge, possibly because it faced east and thus got the brunt of the coldest weather.

The initial design for the garden was "sketched out on the back of an envelope" according to Griff, but only in the sense that it wasn't carefully drawn by a professional garden designer. He and Jo have spent hours assessing the viewpoints and deciding on planting schemes, and everything they have done in

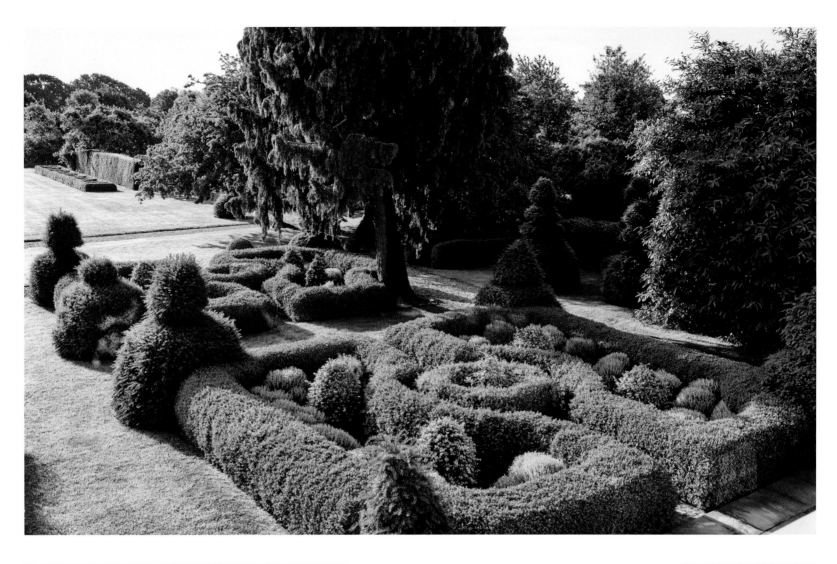

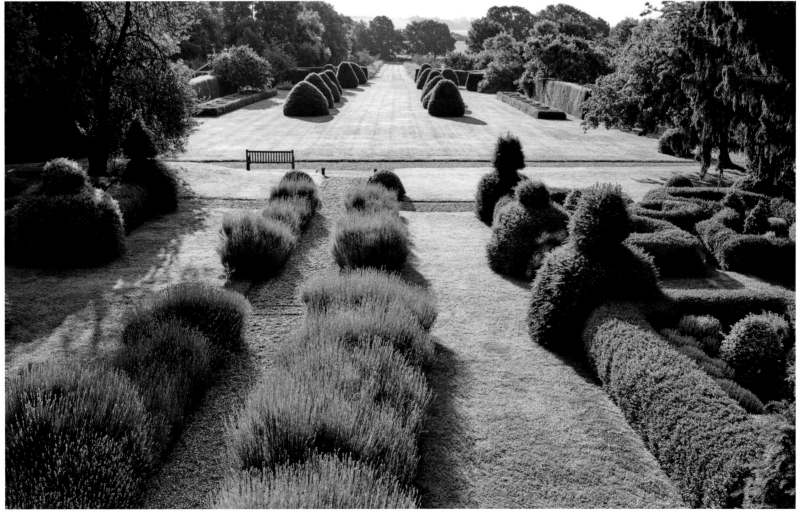

"Suffolk pink, seen on many cottages in the county, was developed by dyers who added blood from oxen to the limewash."

the garden, whether it is creating wildflower meadows, or planting deciduous hedges, is a response to the landscape. Griff got the idea of a holm oak avenue after seeing a picture of one in a gardening book.

The focus on form and function is key to the success of Griff and Jo's garden. There is an aesthetic reason for everything, but there is a practical one too. For example, the vegetable garden (which is very much Jo's domain) is laid out in a series of box parterres, each devoted to different vegetables, such as broad beans, artichokes, asparagus, onions and pumpkins. However, the main reason for the box hedge is because it masks the chicken-wire barriers that have been installed to keep out rabbits.

In the same way, the topiary shapes provide a pleasing formality and they look good all year round. From a practical point of view, Griff insists that the garden is low maintenance, and while the yew, box,

and holm oaks may need clipping once or twice a year, this is not nearly as labour-intensive as a herbaceous border, which requires endless weeding, staking, dividing and gap-filling.

The garden is split into compartments, each with a different character. It includes a pergola in one section that supports old-fashioned climbing roses, while the borders around it are filled with peonies, hardy geraniums, alchemilla, sweet rocket (*Hesperis matronalis*) and veronica. Griff describes the garden as a "sequence of events", and one great flowering event is the daffodil display in a field once rented by a Dutch bulb nursery. The nursery dug up the bulbs when they moved out, but some were left behind, and these have naturalised over the years, resulting in a river of cream-coloured flowers (the couple don't know the variety) in spring.

Griff loves growing fruit, and there are espalier pears, fig trees, a grapevine, medlars and apples here.

He has no idea what kind of apples are in the garden because he and Jo bought rootstocks, which are much cheaper than grafted varieties. Rootstocks are usually supplied to nurseries, which then graft other varieties to them to produce trees of different sizes or apples with specific flavours or attributes, but left to themselves, they will develop into mature fruit trees.

As well as the topiary trees, which include yew and holm oaks, Griff has planted natives, such as ash, oak, hawthorn and alder. Some were bought as mature specimens while others were whips (young unbranched tree seedlings) and, as he points out, it is amazing how quickly the young whips catch up with the bigger trees.

He and Jo are hands-on gardeners, but while they have paid their dues in terms of earth-moving, planting and path-laying (mini-diggers are great for removing turf, says Griff), they are keen to pay tribute to the people who have helped them. Builder

Bill Seggar, now in his eighties, has worked for Griff and Jo for years. He created the bench that overlooks the estuary from the wood of an old tree that was taken down. Jo asked Bill to also mount a section of it "on a stick", as a sculpture or memorial – the rest of the wood made the dining room floor. Bill introduced the couple to Archie, who was their gardener before he too retired, and Bill also brought in Mark, who now works alongside their other gardener, Becks.

Like much of Suffolk, the Stour Estuary is popular with ornithologists. A destination or stopping-off point for a wide range of migratory birds, there are nature reserves all along the coast, including the Royal Society for the Protection of Birds' (RSPB) flagship reserve at Minsmere, which has often been the base for the BBC's *Springwatch* series. Bird watchers from all over the country come to see the Bewick's swans (whose arrival traditionally signals the start of winter

Above: An avenue of holm oaks takes the eye to the gate at the end of a gravel path. Opposite, clockwise from top: Griff and Jo love coming up with new ideas for the garden, such as this maze, planted with young yew trees; imaginative topiary shapes create a sense of fun; dappled shade dances on a grassy walk; a pergola, draped with roses and surrounded by peonies, geraniums and Shasta daisies (Leucanthemum), contrasts with the tightly clipped formal hedges.

in the UK), white-fronted geese, wigeon ducks, and waxwings, which make a temporary home here.

Griff and Jo migrated to Suffolk after Griff's parents, Elwyn and Gwynneth, retired to the nearby town of Woodbridge. Griff was born in Cardiff, but spent his teenage years in Essex, where his father had a boat at West Mersea, on the River Blackwater. They would cruise around the Suffolk coast and the Norfolk Broads, and he remembers mooring at the newly built Levington marina near Ipswich, and the novelty of walking to the boat over a pontoon, rather than wading through mud and rowing out in a dinghy. He still sails, and owns a classic 57-foot (17-metre) Sparkman & Stephens yawl called Argyll.

Griff and Jo met while filming an episode of *Not the Nine O'Clock News*, a series of satirical sketches on current affairs which ran from 1979 to 1982. Jo had to throw a bucket of water over a semi-naked

Griff and they have been together ever since. *Not the Nine O'Clock News* starred Griff, Rowan Atkinson, Mel Smith and Pamela Stephenson. When the series ended, Griff and Mel created and starred in the comedy series *Alas Smith and Jones*, after which Griff began presenting documentary programmes, such as *Restoration* for the BBC, which ran from 2003 to 2009; *Burma, My Father and the Forgotten Army*, about his father's experiences as a medical officer during the war; and *Griff's Great Britain* for ITV. He has also worked in the theatre, and most recently appeared in *The Miser*, a revival of the French playwright Molière's 17th-century comedy, *L'Avare*.

If what he and his wife have created in Suffolk is anything to go by, it can only be a matter of time before he makes a documentary about gardening, but perhaps that would spoil the magic. "It's all about having fun," said Griff. "When the weather is good, I like nothing better than being in the garden."

Above: Sections of trunk from an old tree have been put together to form a bench that looks almost like a sculpture.
Opposite, above: The vegetable garden is Jo's domain, and each section is devoted to a different crop, such as leeks, broad beans and artichokes.
Opposite, below: The box hedges mask wire fences, erected to deter rabbits.

235

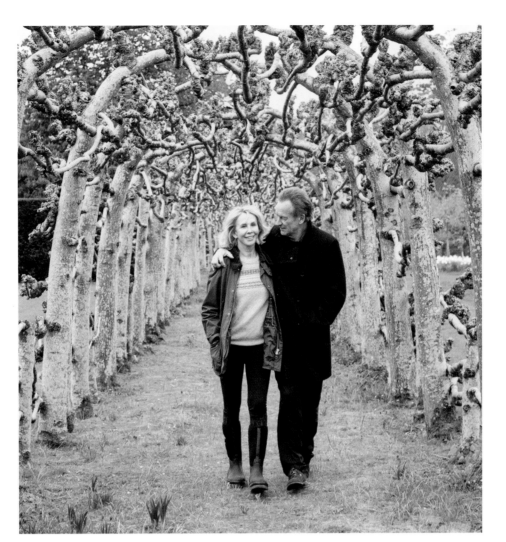

Sting
Born: 1951
Musician, singer, songwriter,
actor, organic smallholder
and supporter of grass mazes

Trudie Styler
Born: 1954
Actress, film producer and
director, environmental
campaigner and smallholder

*Left: Sting and his wife Trudie
Styler strolling through the
Lime Walk in their garden.
Opposite: The copper beech
which Trudie fell in love with
when she first viewed the house.*

STING &
TRUDIE STYLER

WILTSHIRE

It wasn't the exquisite 16th-century flint and Chilmark limestone chequerwork walls that made Trudie Styler fall in love with Lake House. Nor was it the crinkle-crankle cob walls around the kitchen garden, or the neoclassical colonnade, formerly used as an aviary. The feature that cast an enduring spell on her was, in fact, the 300-year-old copper beech tree, which stands just to the north-east of the Grade I listed house. Twenty-five years later, she and husband Sting are still enchanted by their Wiltshire garden, upon whose long history they have made their own distinctive mark.

"I'd seen the brochure for the house," said Trudie, "and rang the estate agents who told me they'd already had two offers. I beetled down to Wiltshire, and saw that there was the potential for a magical garden, but there was a lot of work to do. Then I walked around the side of the house and saw the beech tree. It was

November, but it still had its leaves on and I could tell it was really old. I rang Sting and told him that the house would need work, but there was this marvellous tree. He just said, 'Get it!'"

Today, it's difficult to imagine the state of dilapidation that greeted Sting and Trudie when they first moved in. Ian Hume, the estate manager, has been with the couple since they arrived at Lake House, and recalled that only part of the property was habitable. "While the renovation work was going on, I lived on the top floor. When Trudie and Sting were at home, I had to creep past their room on my way back from a late night at the pub."

Ian also remembers playing football with Sting on the lawn, where a grass labyrinth has now been created. Sting uses it every time he comes home, says Trudie, who estimates that it takes a good 25 minutes to walk through. The labyrinth started off as a mown

237

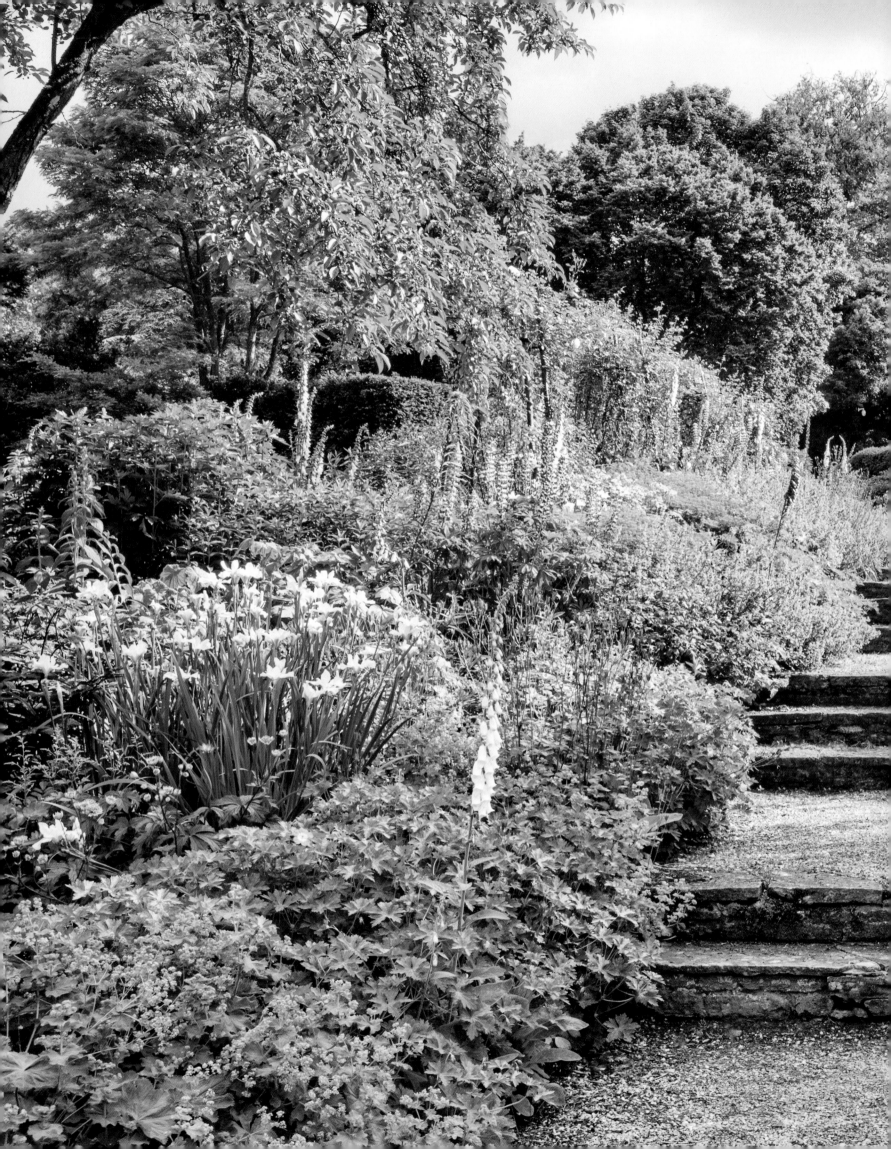

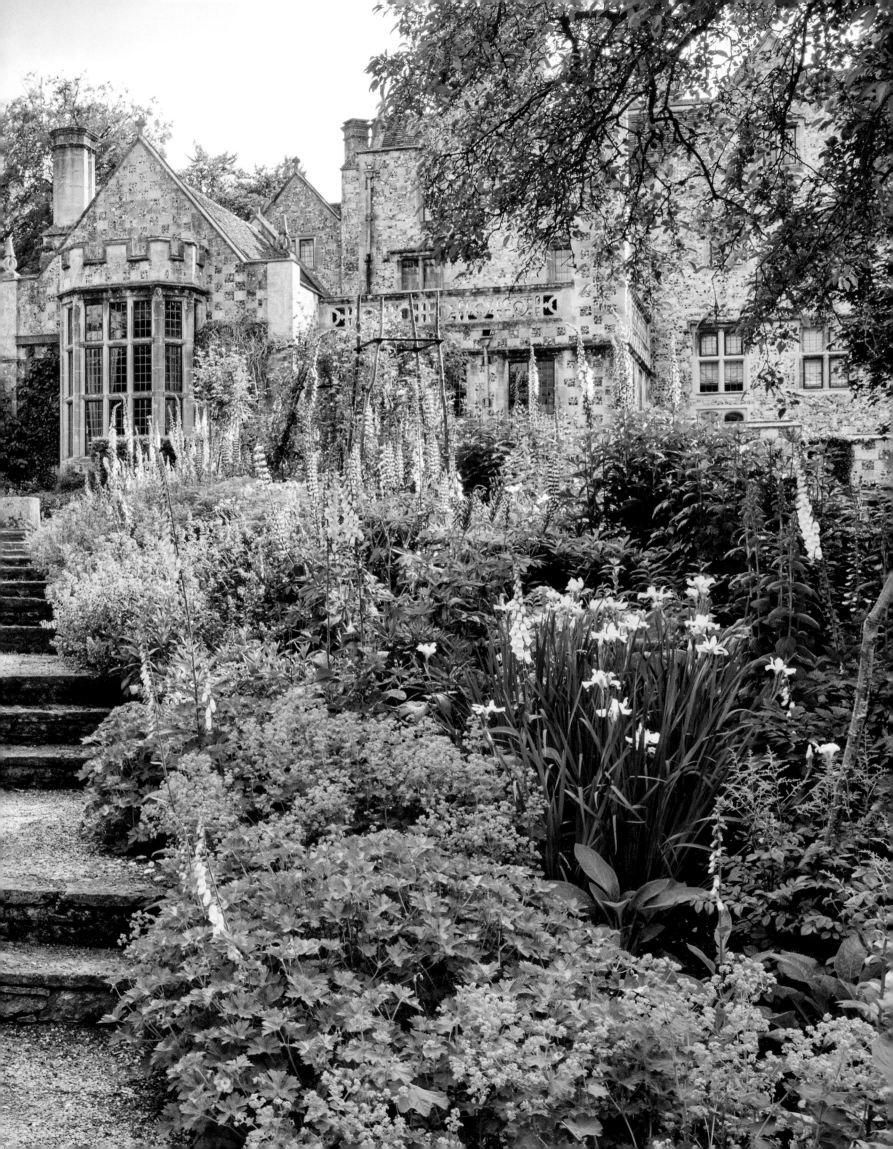

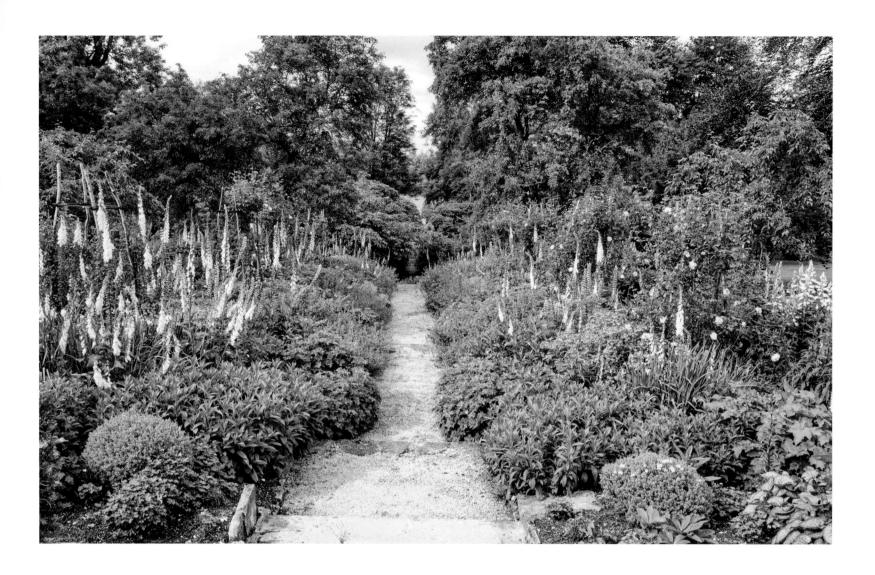

Previous page: The borders that flank the steps leading to the water garden, designed by Arabella Lennox-Boyd.

Above: A different view of the same borders, with the planting mirrored on either side of the path.

Opposite, above: The formal planting at the back of the house leads the eye through to the water garden beyond.

Opposite, below: Sting and Trudie's initials are intertwined in a parterre, which was designed to be viewed from an upstairs window.

maze, with the "walls" left to grow longer, but Sting wanted it to be more in the style of a landform, so the mounded pattern of the maze was built up with soil.

Is it difficult to mow? It's a question of finding the right technique, according to head gardener Mike Baker. "We use a narrow cylinder mower for the top, and a rotary mower for the bottom paths. The bottom is bumpier, because that bit gets walked on, and any leaves and so on drift into the channels."

The huge circle of grass is echoed by a white stone water feature, which sits in its own circular lawn, surrounded by a ring of neatly clipped yew hedging. This lawn leads on to the East Garden, next to the house, which, like much of the garden, was designed by Arabella Lennox-Boyd. The East Garden is an idyllic spot, sheltered from the west by the house, and offering a view of the water garden through the hedges to the north. "It's the first bit of the garden

to get any rays of sunshine in spring, which is so welcome after the dampness of the winter," said Trudie. "We have a big stone table there so we can have breakfast outside."

The main approach to the water garden leads down a flight of shallow steps from the house towards an ornamental stone bridge — Grade II listed, like much of the garden. From this point, a path heads west towards a former 18th-century watermill that was converted into a cottage in the 1930s. To the east is another bridge, where the stream that flows through the garden joins the River Avon.

When the couple first moved in, the water garden was silted up, and digging out the ponds created a huge mound of soil. The American film director Dito Montiel was visiting Trudie at the time, and as she was showing him round the garden, her youngest child was playing on the pile. "Giacomo was about six

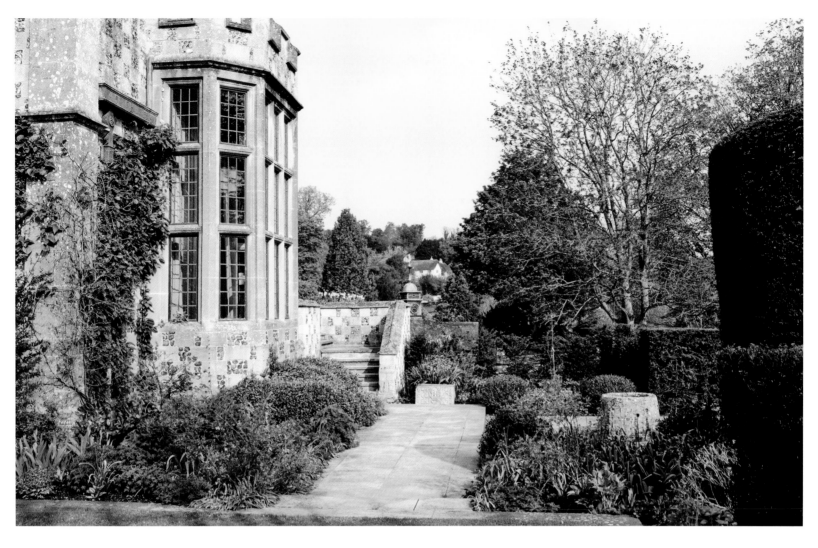

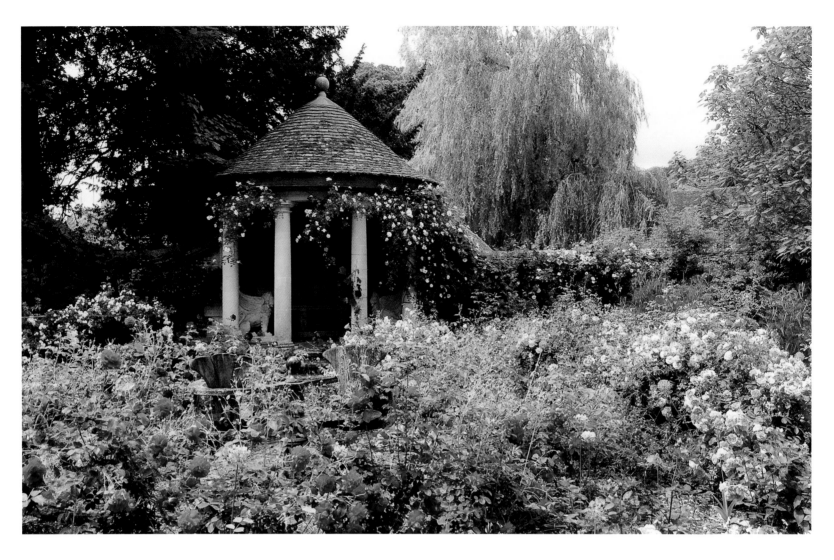

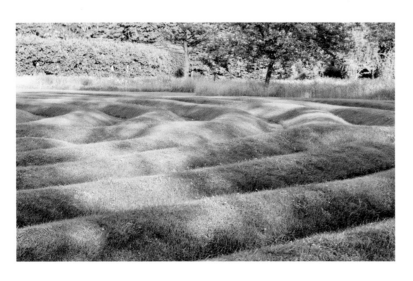

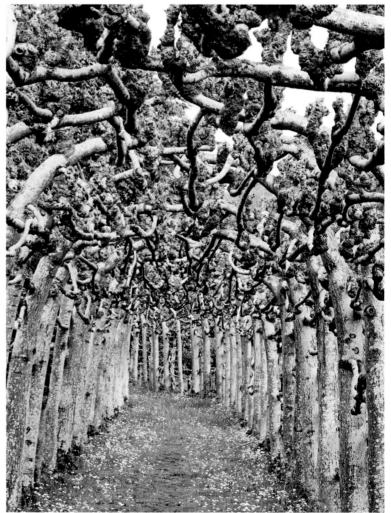

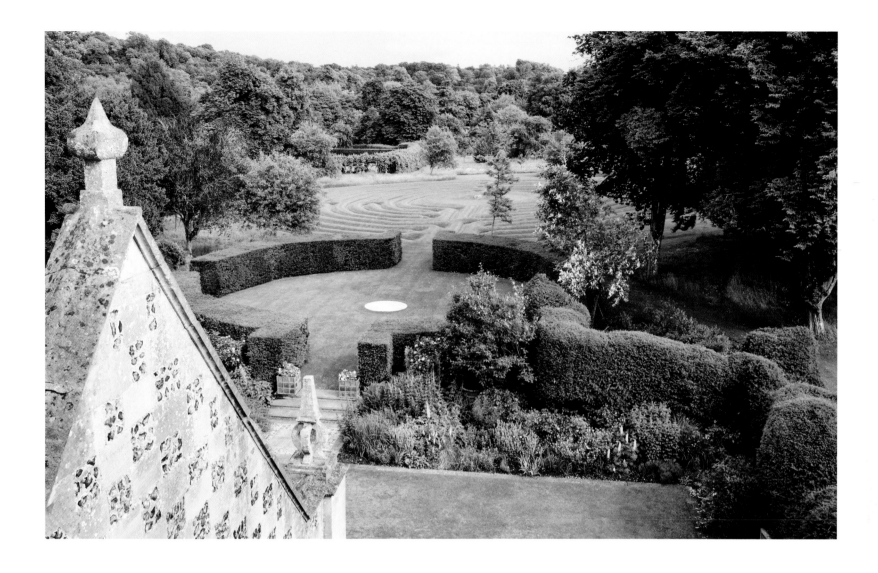

at the time, and leaping around like a little mountain goat, but at one point he went into the soil up to his knees. Dito felt he ought to rescue him, so he ran over, and went in up to his shoulders. By that time, Giacomo was safely back by my side, and we had to rescue Dito. It was like the children's nursery rhyme about pulling a radish out of the soil – one by one, everybody came and joined in the rescue operation."

The borders either side of the steps leading down from the house to the stone bridge feature foxgloves, hellebores and hardy geraniums, and provide a transition from the more formal planting scheme around the house to the semi-wild water garden. Originally, the borders were packed with 25,000 tulip bulbs, planted to create a display that ranged from deep red through to pale pink. "Unfortunately, we were rarely here in time for the tulips," said Trudie, "so Arabella and I decided it would be best

to make a garden that was at its peak in the summer." The planting in the water garden is naturalistic, with white-stemmed bramble (*Rubus thibetanus*), silver birches (originally used in a production at the Royal Opera House), dogwoods, narcissi and camassias.

They also created a rose garden, in memory of Trudie's mother. "When I was growing up, my dad grew veg, I had my own sweet william garden, and my mum had roses. She adored pink roses, and her favourite was 'Prima Ballerina' because it reminded her of Margot Fonteyn – she loved ballet."

Further to the east, beyond the second bridge, is a lake that Trudie designed herself. It has an island, and the lake margins are planted with the common reed, *Phragmites australis*, whose stems provide important habitats for wildlife. In 1995, while the lake was being dug out, the skeleton of a woman was discovered there. In his autobiography, *Broken Music*,

Above: A circular lawn, with yew hedges and a fountain at its centre, leads to the grass labyrinth beyond.
Opposite, clockwise from top: Trudie's own picture of the rose garden she planted in memory of her mother; the pollarded branches of the Lime Walk are hung with fairy lights for parties; the grass labyrinth; the serpentine-shaped crinkle-crankle walls provide a backdrop and template for the borders.

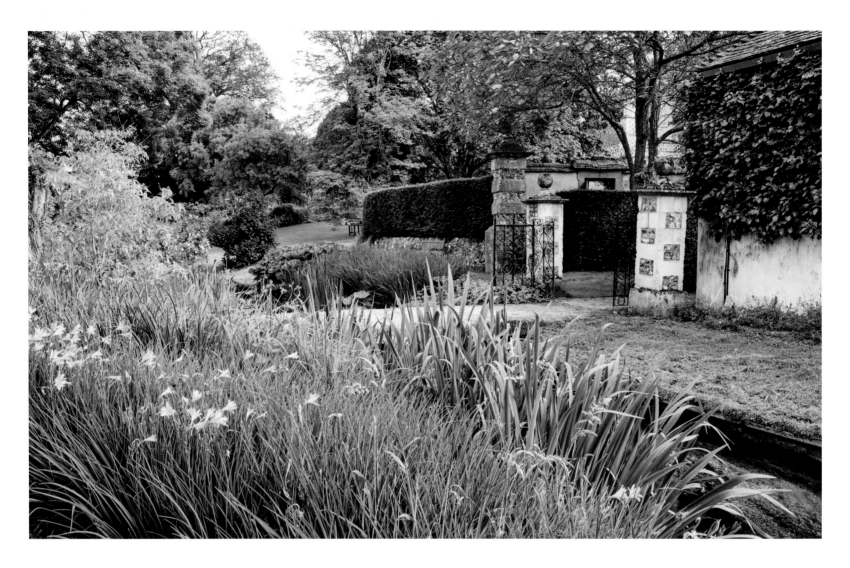

"In 1995, while the lake that Trudie designed was being dug out, the skeleton of a woman was discovered there."

Above: The water garden was created between 1922 and 1937, and comprises a series of channels and streams. Opposite, clockwise from top: The naturalistic planting includes moisture-lovers, such as Iris pseudacorus *and* Darmera peltata; *stepping stones provide a more adventurous alternative route to the bridge; sluices control the water flow; a Celtic cross near the listed stone bridge.*

Sting describes how his personal assistant rang him in America, where he was on tour, to tell him about the find. The woman had been ritually killed, his assistant said — buried face down, facing north, with her hands bound and her body weighed down by a huge piece of wood. Sting asked when the murder was thought to have taken place. It's not difficult to imagine his relief when she replied: "About 400 AD."

As Trudie points out, their land is close to Stonehenge and an archaeologically sensitive site. "The archaeologists told us that the woman was about 18 years old, and the fact that she was facing north, and face down, was an indication that she had died in disgrace. It's difficult to imagine what an 18-year-old could have done to deserve that sort of punishment.

"We asked the archaeologists if we could have her back, and I asked our local vicar, John Reynolds, who married Sting and I, if he would perform a service for her. When we made the lake, I'd designed it with an island, and this became her burial site."

A year or so later, Trudie was asked by a group of Buddhist monks if they could use the large dining room in her house to create a sand mandala, an intricate pattern made of coloured sands that represents the universe. On the final day, the mandala is ritualistically destroyed, and the monks asked if Sting and Trudie would like the sands to be scattered in the river. "Sting suggested that the monks choose the site and we took them to the lake. They stopped at a certain point, and said here was where the sand should go. It was the exact spot where the body had been disinterred."

Sting grew up in the Tyneside town of Wallsend, former home of shipbuilders Swan Hunter, while Trudie spent her youth in Worcestershire, historically one of the great centres of fruit farming in the UK.

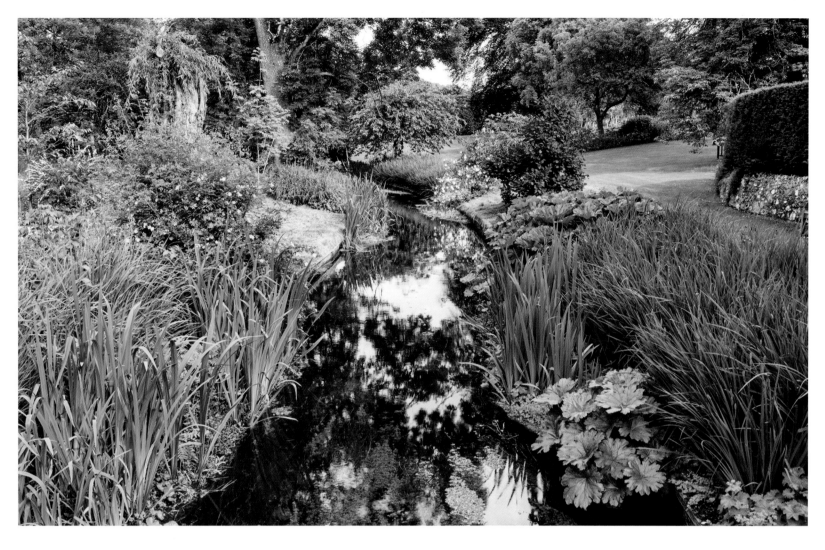

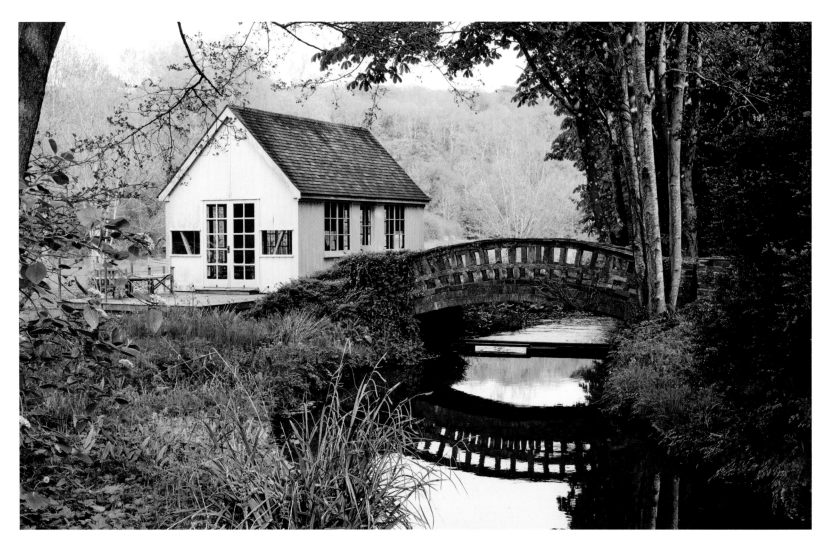

Her father worked on a farm, and she and Sting were determined not only to grow their own fruit and vegetables, but also to raise their own livestock and follow organic gardening methods.

Their four children went to local schools, and at home tucked into fresh vegetables from the kitchen garden and home-produced milk and meat. A barn was built to house a dairy herd, chickens ran free in the orchard, and there were stables, a goat-shed, and a pigsty. The kitchen garden, where pears grow against the crinkle-crankle wall, still boasts rows of kale, onions and leeks, but since the children — Mickey, Jake, Eliot, and Giacomo — have grown up and moved away, production has been scaled down.

On the other side of the wall, serpentine borders are planted with grasses and perennials in Arabella Lennox-Boyd's typically generous style. The term "crinkle-crankle", or "crinkum-crankum" as it is sometimes known, refers to a serpentine-shaped wall and is thought to come from an old English word meaning "zigzag". Slim and elegant, the wall is just one brick wide, the curved formation providing stability — a straight high wall of the same width would be in danger of toppling over.

There is a sense of continuity at the Lake House garden, where historical details are woven into new designs. It seems extraordinary that it has survived, given the history of English agriculture, particularly during the first half of the 20th century, when so many country houses and their estates disappeared.

When the house was sold to Sting and Trudie, one of the gardeners was asked by a local landowner how he liked the idea of working for "a bloody rock star". It is thanks to people like this particular "bloody rock star" that there are still gardens like the one at Lake House, and gardening jobs to go with them.

Above: The view of the house glimpsed through the trees from the bridge by the boathouse. Opposite, above: Sting uses the dining room of the house as a studio, and the boathouse to get away and think. Opposite, below: The lake designed by Trudie, who commented: "I said to Sting, the house is called Lake House, but where's the lake?"

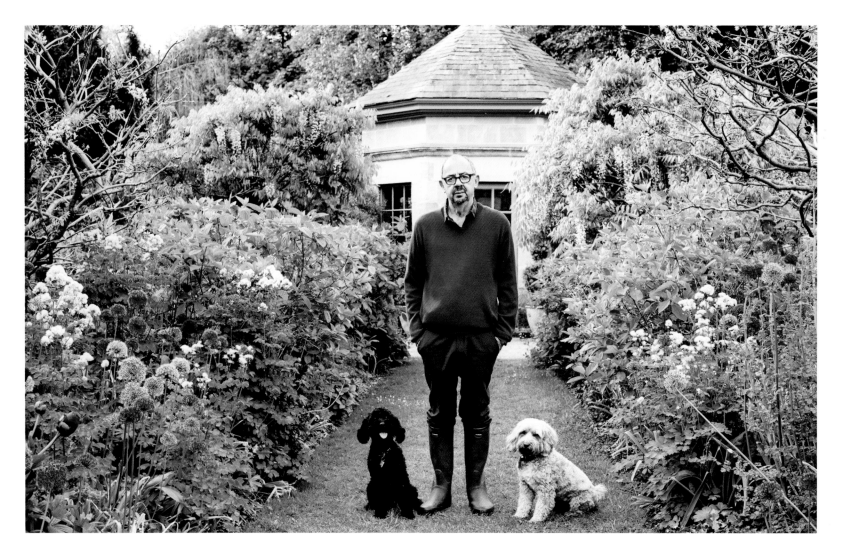

PAUL WEILAND

WILTSHIRE

People who are creative tend not to sit on the sofa and do nothing when they go home in the evening or at the weekend. A brain that is disciplined to come up with ideas and find solutions to problems will continue that process until sleep intervenes, and in the absence of work, that visionary energy may well be poured into the garden.

This is certainly the case with Paul Weiland OBE, owner of Belcombe Court in Bradford on Avon. He and his wife Caroline have lived here for 25 years and she says it is not uncommon for him to come home after a frustrating week and "relax" with a frenzy of horticultural activity. "He's never more anxious than when he is worrying about something in the garden, but he's never more relaxed than when he's here."

Paul and Caroline first became interested in the idea of creating a garden when they visited friends who lived in a mill house in Little Somerford, near

Malmesbury. The friends were film producer David Puttnam and his wife Patsy. David is an enthusiastic gardener, and the Weilands were impressed with his attention to horticultural detail. "I think it sowed a little seed," said Caroline. "We didn't have a garden at the time, only a window box, but we began to think it was something we would like."

Fast forward a few years, and the couple took possession of Belcombe Court, originally a 15th-century manor house, which had been remodelled by the Bath architect John Wood the Elder in 1734. The grounds surrounding the house were also redesigned as a landscape garden, with features such as a rotunda, a *cottage orné* – also known as a decorated cottage – and a grotto. What looks like a church on the east side of the house is actually a barn, built to look like a medieval chapel. Together, these features help to give the impression of a small village or

Paul Weiland

Born: 1953

Wife: Caroline

Film and television director, writer, producer, and hands-on horticulturist

Above: Paul Weiland in front of an 18th-century octagonal stone pavilion. The garden in front of the pavilion was designed by Rupert Golby. Opposite: The stone rotunda is part of the original 18th-century landscape design, and has nine columns.

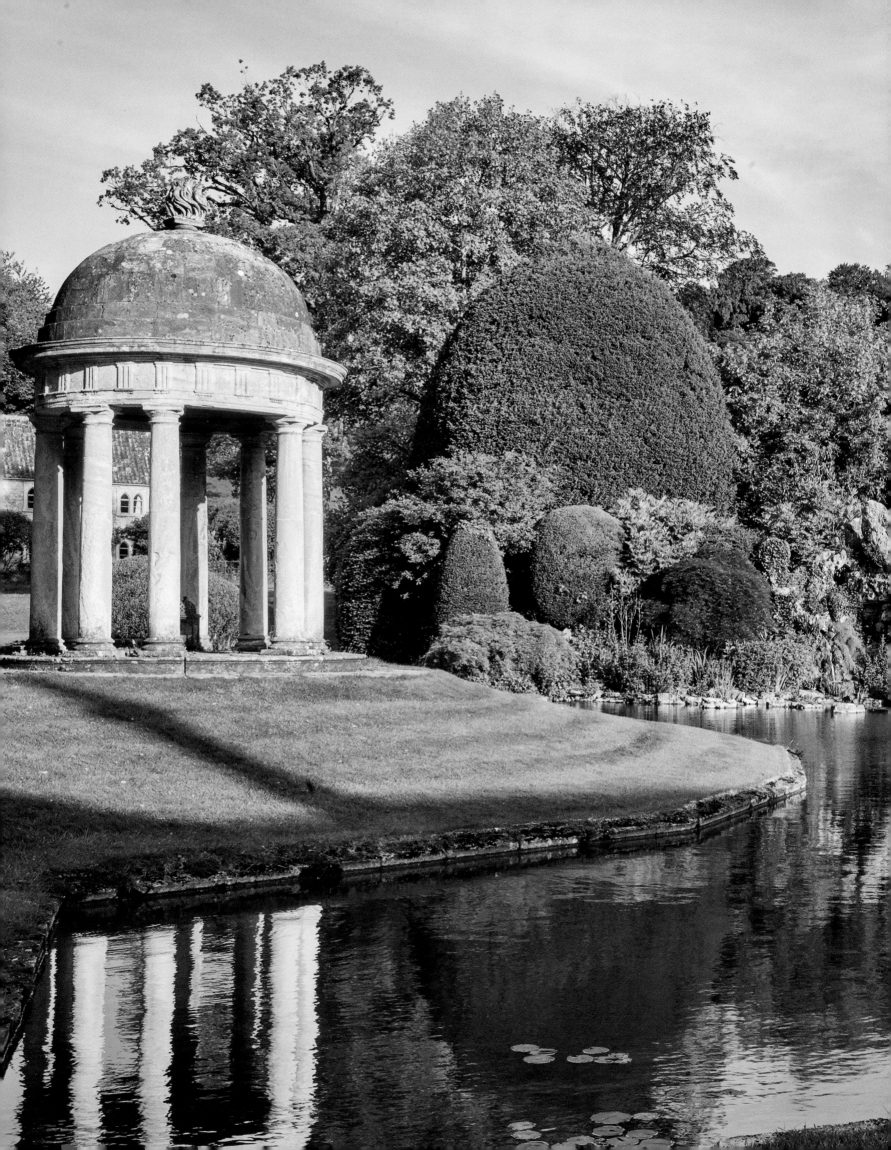

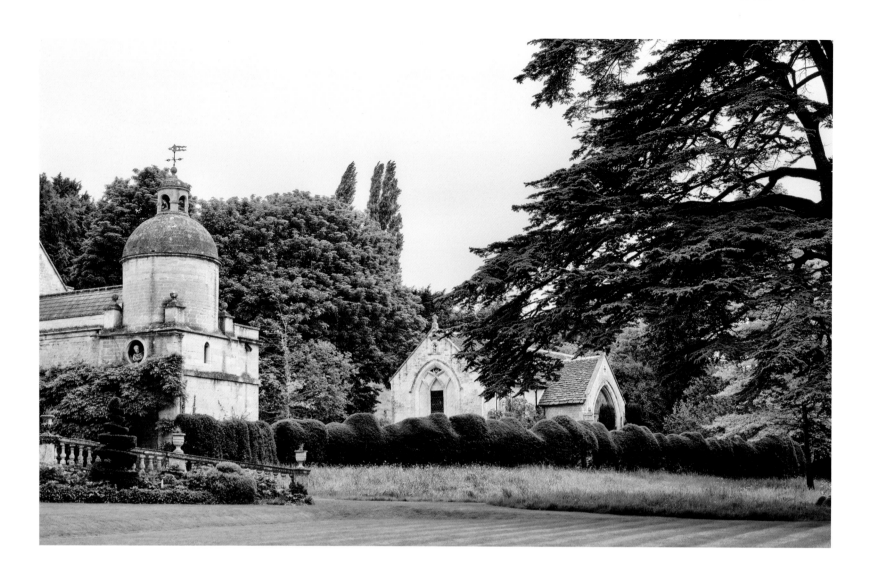

Above: What looks like a chapel is actually a 15th-century barn. It has never been a church, but was rebuilt in an ecclesiastical style in 1900 following a fire.
Opposite, above: The cloud-pruned hedges came from an RHS Chelsea Flower Show garden, designed by Arne Maynard and Piet Oudolf.
Opposite, below: The wooden serpentine bench is by sculptor Alison Crowther.

hamlet, particularly when you look down on the house from the sloping kitchen garden.

Paul Weiland is a film and television director, writer and producer. He began his career as an advertising copywriter, and made his directorial debut with a series of television advertisements for Heineken (the "refreshes the parts" campaign), Hamlet cigars, and later, the Walkers Crisps adverts starring footballer Gary Lineker.

Television commercials are mini-films in themselves, when you think about it, so it wasn't surprising that he then transferred these skills to television programmes, directing episodes of the Rowan Atkinson comedy *Mr Bean*, and the BAFTA Award-winning *The Storyteller* series, produced by Jim Henson and written by Anthony Minghella, as well as *Alas Smith and Jones*, starring Mel Smith and Griff Rhys Jones (*see pages 226-235*). His feature films

include *Roseanna's Grave*, starring Mercedes Ruehl and Jean Reno, and *Blackadder: Back and Forth*, for which he renewed his partnership with Rowan Atkinson. Another hugely successful movie was the romantic comedy *Made of Honor*, starring Patrick Dempsey.

Paul feels the secret to a successful garden design is in the editing: having the courage to remove plants if they have outgrown their space or don't fit the plan. He admits that he differs from his wife in this respect: "Caroline wants everything to stay as it is, whereas I want things to change."

Of course, he does not intend to make major changes to the historic landscape garden, but he is keen to make his own contribution. "The structure was here already, and we are very much guardians. We are readying the garden for our retirement, and I want to be less of a director and take a more hands-on role. I don't want to be the one saying plant this, plant

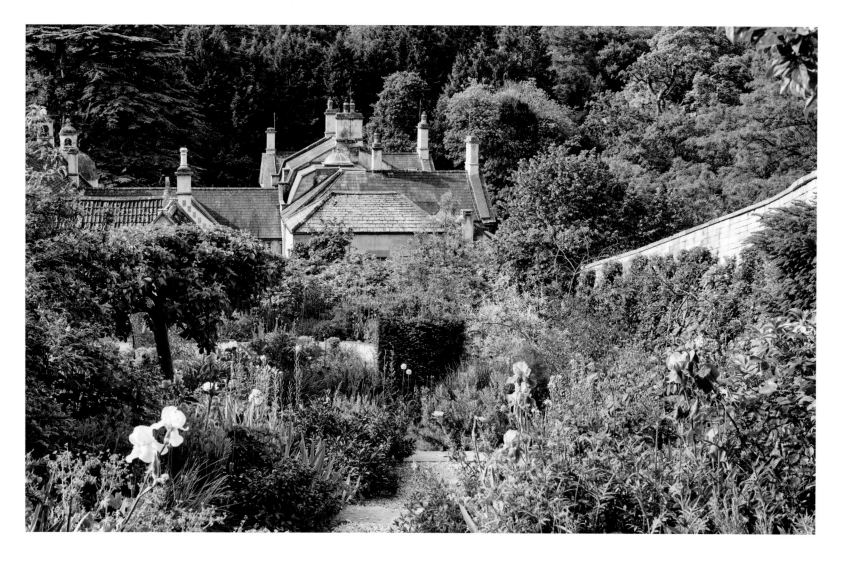

"Paul has always loved flowers and one of the things he enjoys most is the chance to learn how plants work with the seasons."

Above: From the top of the kitchen garden, the house and its outbuildings look like a small village.
Opposite, clockwise from top: Arne Maynard's design for the kitchen garden incorporates ornamental as well as edible crops; purple alliums add colour to a border in spring; chives decorate the edges of an old wellhead; a mirrored water feature by William Pye contrasts with the textures of a brick wall and yew topiary.

that, I want to be doing it." He feels that by being part of this process he will understand more about the plants and gardening methods.

The site slopes steeply behind the house, which could be why the neoclassical features, such as the rotunda and the cottage, are so close together – there simply wasn't enough level ground to spread them out. "I believe that the original owner, Francis Yerbury, was very critical of John Wood the Elder's design, which was based on Stourhead," explained Paul. "He thought it was all a bit too cramped." It is true that the cottage and the grotto are not very far apart, but the effect is rather endearing, like a scale model or doll's house version of how an archetypal 18th-century garden should look.

Paul has opened up the garden in recent years, sweeping away inappropriate 1960s bedding areas and the rose garden, so that the landscape looks less cluttered. Despite removing some of the blooms from the garden, Paul says he has always loved flowers and one of the things he enjoys most is the chance to learn about the seasons and the way plants work with them. "When I first started gardening, I didn't realise that you could have early alliums, then another few that come later. I thought they all flowered at the same time. It was the same with tulips and daffodils. Now we have something flowering most of the year – apart from July, that's always a tricky time," he explained. "That's when we go on holiday," joked Caroline.

Much of the planting around the house is evergreen, and most of it is box. There are two cloud-pruned box hedges, which came from the show garden that Arne Maynard and Piet Oudolf designed for *Gardens Illustrated* magazine at the RHS Chelsea Flower Show in 2000. They took a long time to settle in, says Paul, because the plants had been container-

grown and were root-bound, but once established they have been problem-free, with no signs of disease.

Arne Maynard was also commissioned to redesign the kitchen garden, which is on the most steeply sloping part of the garden. This means it gets lots of sun, but the slope was a design challenge, because conventional terracing would have meant looking up at a series of retaining walls. At one point, there was a central flight of steps, but this made the slope look even more precipitous, while the greenhouse Paul and Caroline installed "never looked right".

Arne decided to move the steps and make a feature of the slope, so there are now undulating grass banks punctuated by level vegetable beds, with steps on either side of the garden. The greenhouse was moved to the courtyard below, and replaced with a cutting garden, where all the flowers for the house are grown. Children visiting with their parents on open days

love rolling down the banks, but for adults the most attractive spot would probably be the swimming pool terrace at the top of the hill. This is a sun trap and, as a bonus, offers wonderful views of the house and the Avon Valley below.

You can walk from the kitchen garden past the back of the house via a little folly or grotto, which has been decorated with shells by the innovative shell artist, Blott Kerr-Wilson. The design includes the family's initials (Paul and Caroline have four children: Maxwell, Hannah, Bella and Joseph) and uses the different colours and reflective qualities of the shells to create designs that sparkle and shimmer.

As Paul walks round the garden, he is constantly assessing it, checking to see what looks good and what needs to be done. Two formal yew topiaries are going to be allowed to grow out into a natural shape, he says, which will be more in keeping with the cloud-

Above: The sloping kitchen garden was redesigned by Arne Maynard as a series of grassed terraces. It originally had central steps, which made it look even steeper. The swimming pool pavilion can just be seen at the top.
Opposite, above: An Antony Gormley figure stands in front of the Picturesque cottage, with its Gothic windows.
Opposite, below: The obelisk by David Nash forms a striking focal point in this meadow.

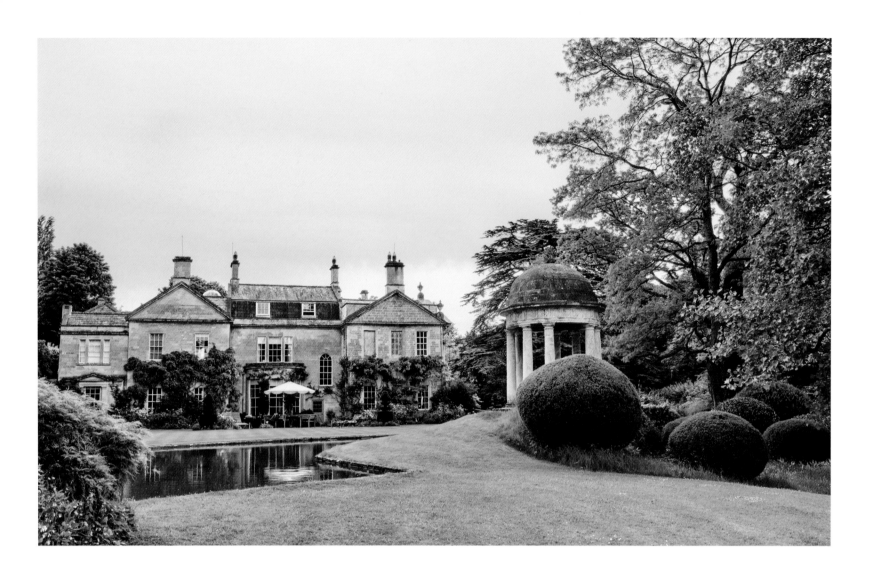

pruning elsewhere in the garden. He likes to feel that he is working hand in hand with nature, but also that nature is not getting the upper hand.

Paul and Caroline open the garden for charity once or twice a year, and Paul in particular enjoys talking to the visitors and hearing their stories. "A man aged 90 told me that he had nearly drowned in the pond as a very small child, and another elderly man told me he used to live in the cottage next door. I also remember a visitor showing me an old photograph of a man with a dog walking across the lawn, and it could have been taken yesterday."

That's the key to evolving a historic garden like the one at Belcombe Court: knowing what to change and what to leave alone. Today, when everything is listed or in a conservation area, it's difficult to conceive of an era when people made quite major alterations to buildings and landscapes without consulting anyone.

The 18th-century remodelling of the house was commissioned by the then owner, Francis Yerbury, and the Yerbury family continued to make changes to the property throughout the 19th century. The six-acre (2.4-hectare) piece of land known as The Grove, which is to the north of the garden and mainly woodland, was acquired around 1785 and transformed into a Picturesque-style walk, with stone steps and man-made arches and caves. (The Picturesque movement aimed to manipulate nature in order to achieve even more dramatic effects.)

The road that ran through the estate was moved south between 1825 and 1829, and then in 1836 the estate was bisected a second time by the arrival of the Great Western Railway. "Yes, we've got road, river, canal and railway. It's very easy to get out of here," commented Paul, but you sense that nothing could be further from his mind.

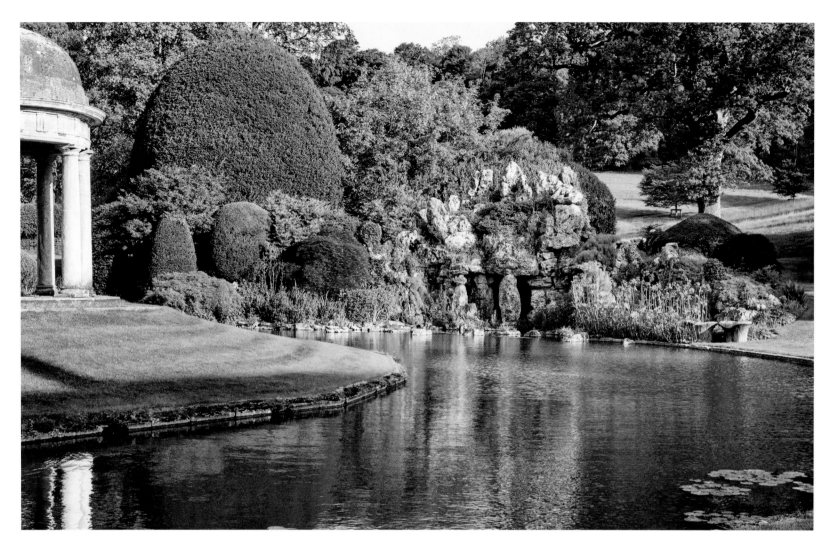

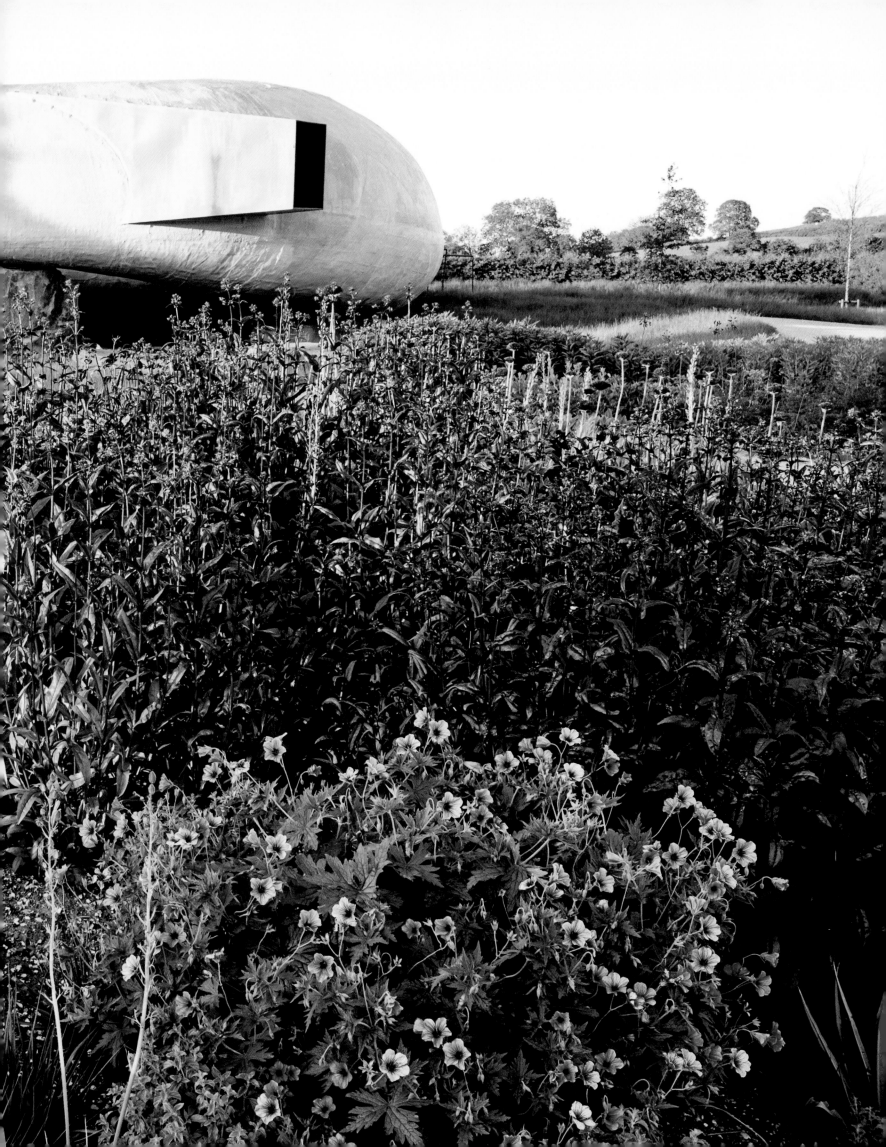

IWAN & MANUELA WIRTH

SOMERSET

The garden by the famous Dutch designer Piet Oudolf at the Hauser & Wirth gallery in Bruton, Somerset is worthy of a visit in its own right. However, combine it with the gallery space – converted from an old farmyard – and the restaurant, which features local produce, and you have a fascinating destination that is so much more than just an art gallery or a garden.

Bruton may not seem the obvious place for an international gallery of modern art (Hauser & Wirth also have branches in London, Zurich, New York and Los Angeles), but it is the home of Iwan and Manuela Wirth, who founded the company together with Manuela's mother, Ursula Hauser.

Iwan and Manuela are both Swiss. They met when Iwan approached Ursula, who is one of Switzerland's most prolific art collectors, about investing in a Picasso and a Chagall he was planning to buy. They agreed to go into business together, celebrating the deal over a

glass of champagne, at which point Ursula introduced Iwan to her daughter. The story goes that Iwan was so smitten that he drove his car into a fence on leaving, but initially Manuela was not so impressed, although she agreed to work for Iwan as his secretary when the Zurich gallery launched in 1992. Their relationship then blossomed and the couple were married four years later.

Their relationship with Somerset has also been a love affair, and the couple say that building the gallery there has been an extraordinary journey, not only for them, but for everyone involved in the project. They do not live on the gallery site itself, but have a house nearby. Their children attended local schools and they are also passionately committed to supporting the town's community. Their aim is to create a place that not only provides employment but also offers a venue for entertainment – the onsite Roth Bar & Grill hosts

Iwan Wirth

Born: 1970

Gallery owner, philanthropist, publisher, and sponsor of iconic Piet Oudolf garden

Manuela Wirth

Born: 1963

Gallery owner, and provider of contemporary art in a country garden setting

Above: Iwan and Manuela Wirth at their gallery in Somerset, where Piet Oudolf designed the garden.
Opposite: The Radić Pavilion.

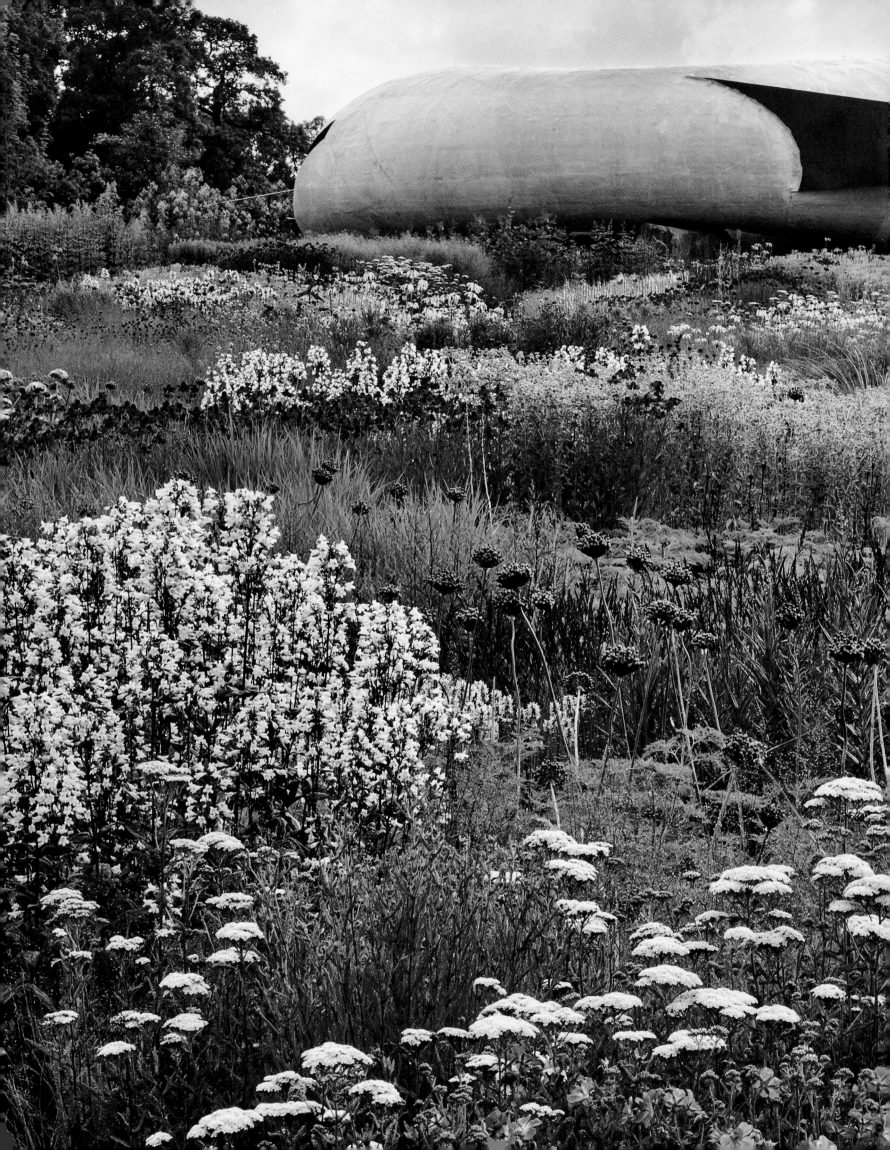

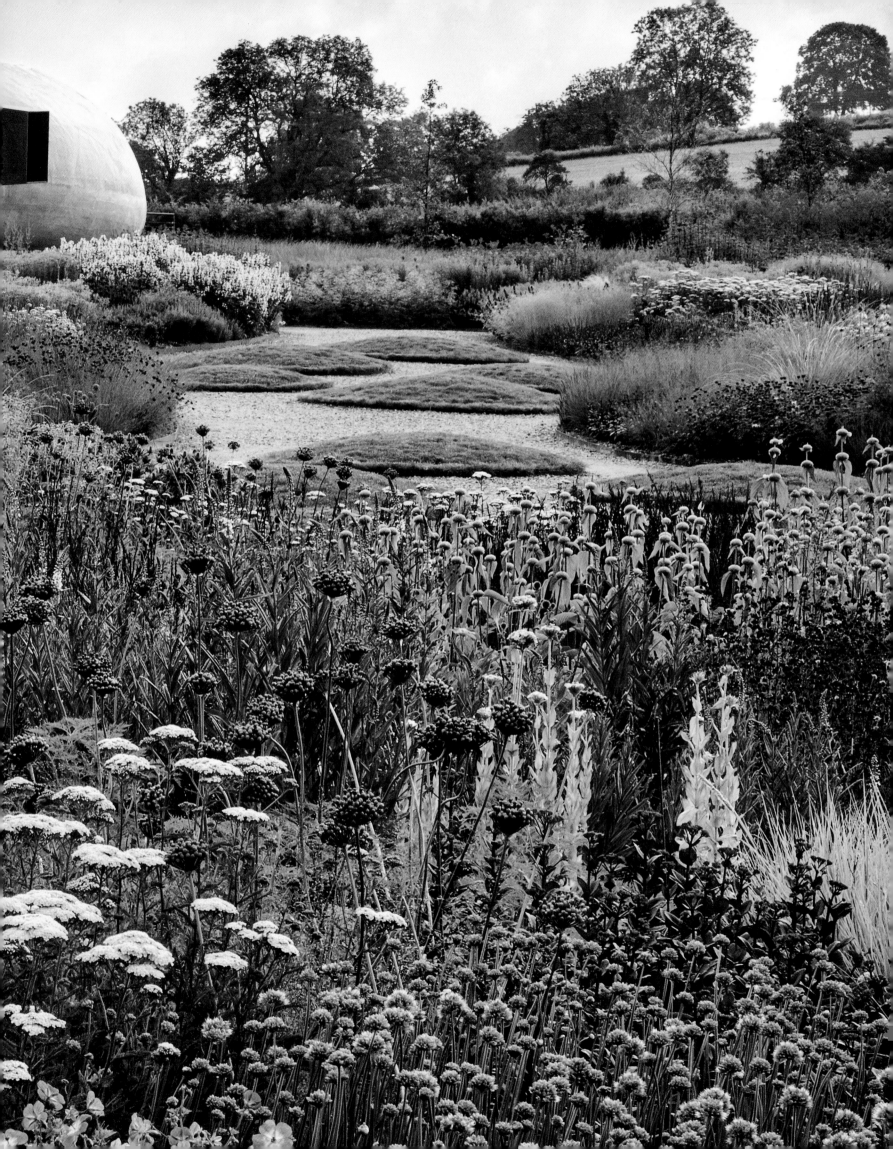

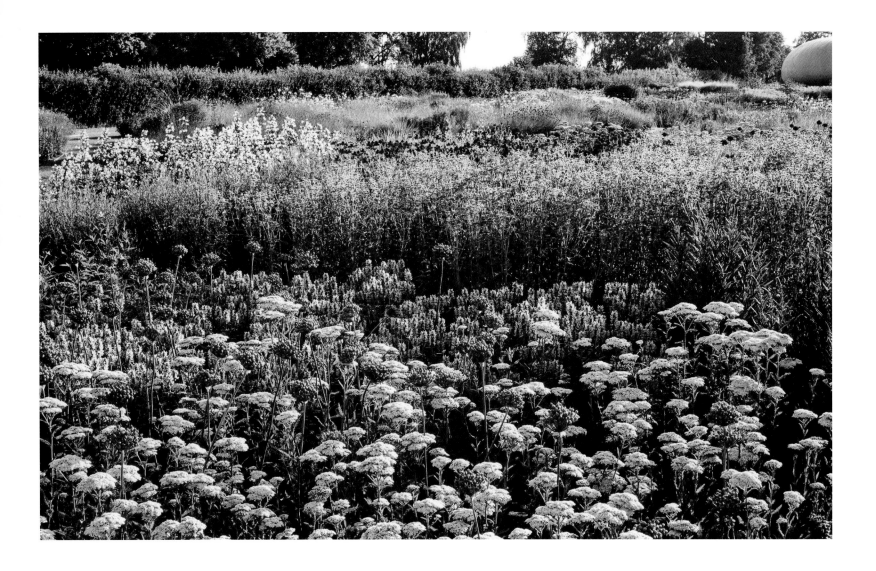

Previous page: Oudolf Field is a classic New Perennial design, where grasses and perennials are woven together in naturalistic swathes.
Above: The spires of stachys and Penstemon digitalis *'Husker Red', and the flat flower heads of* Achillea *'Credo', provide textural contrast as well as colour.*
Opposite, above: Helenium *'Moerheim Beauty' creates a focal point in the borders.*
Opposite, below: The blood grass, Imperata cylindrica *'Rubra', with the blue flowers of* Amsonia hubrichtii.

DJ and live music evenings, as well as catering for the gallery staff and garden visitors.

While the garden has been featured in glossy gardening magazines, and the gallery in glossy art magazines, to get a sense of how the whole thing works together, you really have to visit. It is not at all rarefied or exclusive, but an arts centre where the Wirths have been able to bring all their interests together: "Art, architecture, landscape, conservation, gardens, food, education, community ... and family."

Art lovers have the chance to appreciate what the Wirths describe as Piet Oudolf's "continually changing masterpiece", while those who have come to see the garden can also view works by artists such as Louise Bourgeois, Martin Creed and Elisabeth Frink. The atmosphere is both busy and relaxed, and the garden, created in 2013, is partly responsible for this. Piet was commissioned by the Wirths to design the garden

and the landscape for the entire site. The heritage of the site inspired the design, and as you enter the building, you pass two vegetable gardens, a reminder of the gallery's former life as a farm. The vegetables are grown using the no-dig method, championed by local resident and organic pioneer Charles Dowding.

The main garden, known as Oudolf Field, is at the rear of the building, and your first proper view of it is through a glass door that frames the space almost like a painting. At the far end of the garden is the Radić Pavilion, designed by Chilean artist Smiljan Radić for the Serpentine Gallery in 2014, and installed at Oudolf Field in 2015. Its rounded, mushroomy shape echoes the hummocks and mounds created by the perennials planted in the garden.

Despite the fact that this is former agricultural land (the address is still Durslade Farm), Oudolf Field was not the easiest place to make a garden. The soil hadn't

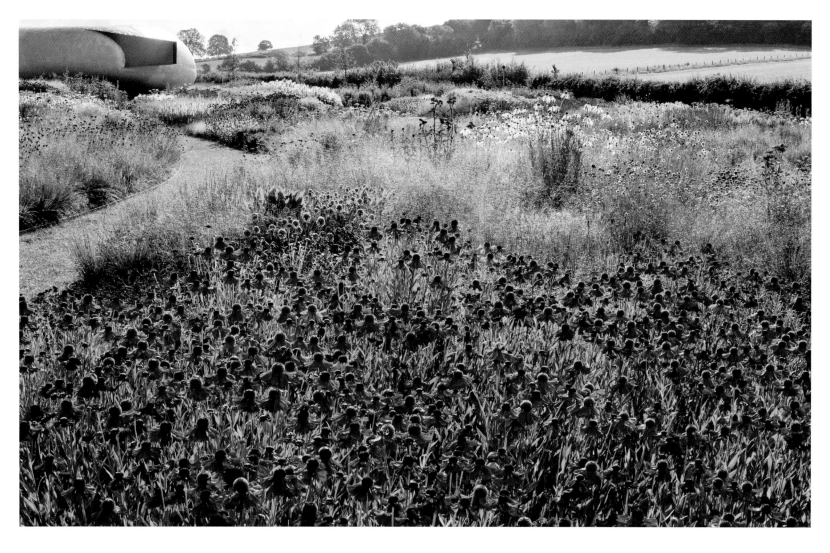

been cultivated for years, and the building work on the gallery had left it compacted. A thin layer of topsoil had done little to improve either the drainage or the fertility, and one of head gardener Mark Dumbleton's priorities is to add organic matter regularly to improve the heavy clay.

A problem common to many gardens of newly built properties, trying to break up compacted clay takes time and patience, as anyone who has ever tried will tell you. One traditional method is to plant it with potatoes, but that's not an option for Mark. By way of recompense, of course, he has an Oudolf garden to nurture and you can tell that he treasures the time spent planting it alongside the Dutch designer as one of the greatest experiences of his life.

Iwan and Manuela Wirth met Piet Oudolf when he designed the enclosed garden, *hortus conclusus*, at the centre of Swiss architect Peter Zumthor's 2011 pavilion

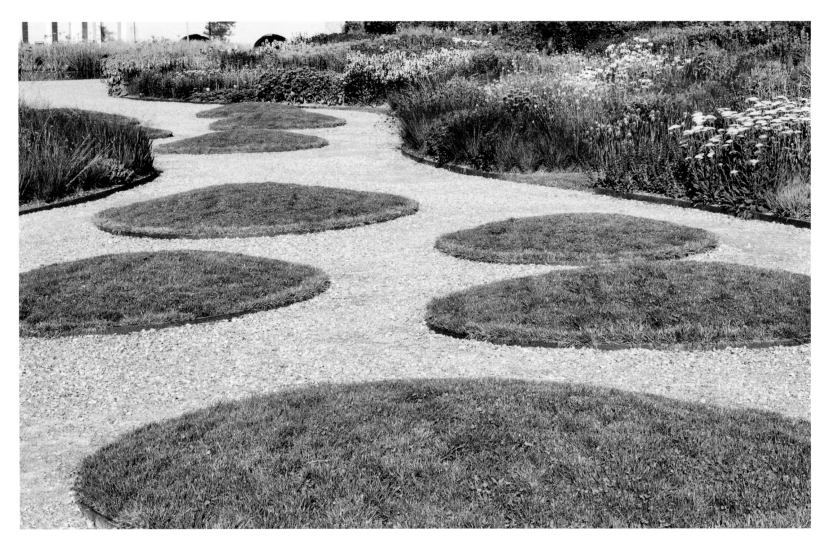

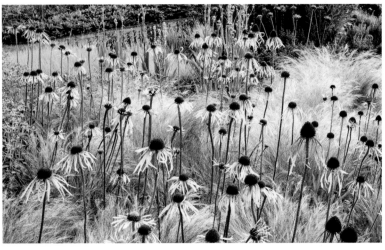

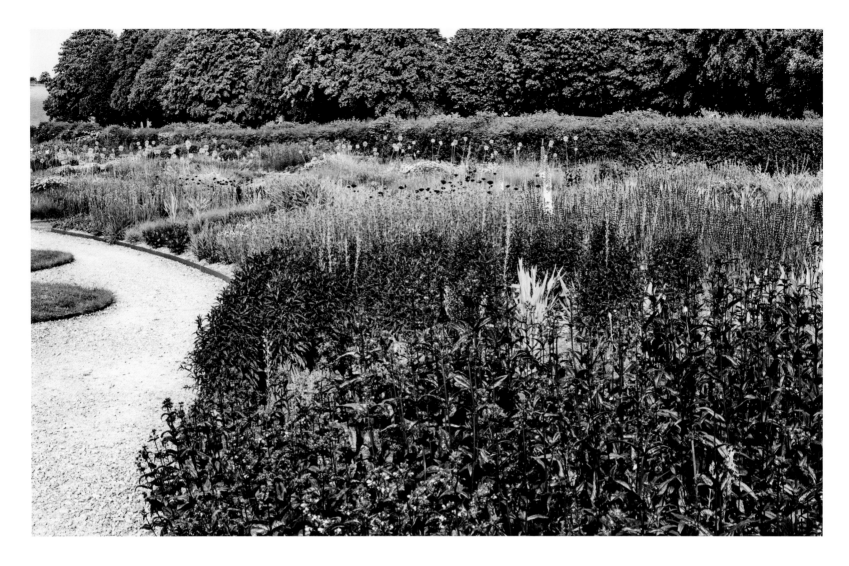

"Art lovers have the chance to appreciate what the Wirths describe as Piet Oudolf's continually changing masterpiece."

for the Serpentine Gallery in London's Kensington Gardens, which plays host to a new building each year.

The couple then asked him to design the garden at Bruton, treating him as they would any contemporary artist. They gave him complete freedom in terms of the design; a huge compliment, given that there were more than a dozen advisors, architects and contractors involved in the restoration of the farm and the building of the gallery. To put it in Piet's own words: "They gave me room."

The plan he created for Durslade has four main areas: a pond and wetland, a tall perennial section, a block planting area and a space in the middle of the garden featuring the North American grass, prairie dropseed (*Sporobolus heterolepis*), which gives the effect of walking through the long grass of a meadow.

A Piet Oudolf planting design looks like a work of art, carefully coloured and coded, and reminiscent of an intricate patchwork quilt or a textile design. The designer is often described as the father of the New Perennial movement, or "prairie planting", as it is also known. Sometimes erroneously regarded as a design solution or planting fashion, it is actually an ecologically driven method that works closely with nature. Although the final effect can be stunning in terms of colour, the perennial plants and grasses are chosen first for their structure and suitability to their particular site and soil, and then for their flowers, many of which also offer bee-friendly, nectar-rich blooms. This makes sense, because a plant's structure and form lasts a lot longer than the flowers, and it can also be used to create bold shapes within the landscape, without any clipping, pruning, or staking needed to achieve the desired result.

When designing a New Perennial planting scheme, you need to know your plants. Some demand

Above: The mahogany foliage of Penstemon digitalis *'Husker Red' contrasts with the misty blue flowers of* Scutellaria incana. *Opposite, clockwise from top: Grass circles lead the eye through the garden — originally the whole path was turfed, but this proved impractical; the flower spikes of* Veronicastrum virginicum *'Erica'; the bright red poppy* Papaver orientale *'Scarlett O'Hara';* Echinacea pallida *with* Stipa tenuissima.

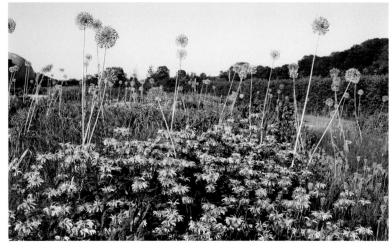

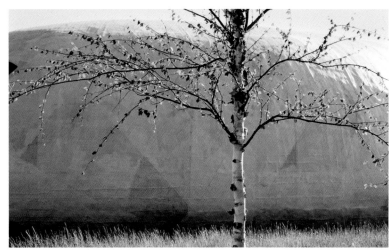

an open sunny site — the *Amsonia hubrichtii*, for example, will only put on its bright autumnal foliage in such conditions — while others, such as *Persicaria*, *Phlomis russeliana* and *Eupatorium purpureum*, spread fast and require periodic attention to keep them in check.

It is the grasses, however, that provide much of the impact in a New Perennial garden, and Oudolf Field is no exception. The elegant *Deschampsia cespitosa* 'Goldtau' look spectacular when clouds of silvery flowers appear in summer on tall stems over the evergreen lower leaves. In autumn, the stems of the purple moor grass, *Molinia caerulea* subsp. *arundinacea* 'Transparent' erupt like golden fountains above the fluffy flowers of the *Sporobolus* and drifts of *Panicum*.

There is also *Festuca mairei*, a taller version of *Festuca glauca*, which produces sage-coloured clumps topped by slender pale flower panicles, but the most unusual plant in the garden is probably *Bouteloua gracilis*,

a native of Mexico. Its flowering spikes stick out from the stems at a sharp angle, making it look as if a cloud of mosquitoes has settled on the plant.

The garden contains around 26,000 herbaceous perennials, and 115 different plant species. These may change over time, as the gardens continue to grow and develop, but one of the biggest problems facing Mark and Piet is the very people who come to admire their work: the visitors. Some of the original grass paths have had to be gravelled, and as Piet commented jokingly shortly after the garden opened: "Sometimes you need bodyguards to protect the garden from the public. They sneak through this, step on that, they take a picture with one foot in the planting, and children run around playing hide and seek. You have to keep all this in mind. If you garden like you do at home, it doesn't work; your plants have to be stronger and bolder, so, if you lose one, you won't be crying."

Above, clockwise from top left: The huge boulders that support the pavilion building; Allium 'Summer Beauty' *seed heads with* Monarda bradburyana, *a shorter form of the classic bee balm; a young silver birch in the field behind the pavilion.*

Opposite page, above and below: the pavilion, designed by Smiljan Radić, forms a boundary between Oudolf Field and the meadow behind.

INDEX

AUTHOR'S ACKNOWLEDGEMENTS

Huge thanks to my neighbour Neil Clegg for looking after my dog, Rufus, and to Cirencester beekeepers — Helen Moreton, Liz Gardner, Bill Mead and Denis Flavell — for taking care of my bees while I buzzed off round the country looking at gardens.

Thanks are also due to my commissioning editor Helen Griffin and copy editor Zia Allaway, whose patience and humour has made writing this book so enjoyable.

I owe Hugo Rittson Thomas a debt of gratitude for finding such inspiring gardens to explore, and designer Glenn Howard for making them look so beautiful on the page.

Thanks also to Sarah Zadoorian for doing such a great job of proofreading the words, and to Richard Rosenfeld for the index.

Finally, thanks to my children Rory and Nevada for being so supportive and wonderful in every way.

PHOTOGRAPHER'S ACKNOWLEDGEMENTS

I would like to thank the owners and head gardeners for allowing me to capture and reveal their enchanted sanctuaries.

My sincere gratitude to the wonderful writer, Victoria Summerley, for her dedication and beautiful way with words. It has been a pleasure, once again, to work with Frances Lincoln, and I am most grateful to Helen Griffin, Zia Allaway and Glenn Howard who have worked with astonishing efficiency and good humour.

I would also like to thank the studio team, Romain, Alex and Olivia, for all their input.

Finally, I would like to thank my wife, Silka, for her continual support and encouragement.

PICTURE CREDITS

All photographs by Hugo Rittson Thomas, except on the following pages:

11 (centre left), 22, Branson family photos; 73 Getty Images/Harry Borden; 82 Megan Edwards; 93 Neil Bridge; 102 Julian Fellowes; 125 (bottom right) Jamie Presland/Henley Standard; 194 Michael Le Poer Trench; 206 Adrian Sherratt; 209 Diane Vose/Wiltshire Gazette and Herald; 217 Getty Images/M J Kim; 242 (top) Trudie Styler.

The Secret Gardeners

© 2017 Quarto Publishing plc

Text © Victoria Summerley 2017
Photographs © Hugo Rittson Thomas 2017 except
those listed on page 271
Commissioning editor: Helen Griffin
Editor: Zia Allaway
Design: Glenn Howard

First Published in 2017 by Frances Lincoln,
an imprint of The Quarto Group.
The Old Brewery, 6 Blundell Street,
London N7 9BH, United Kingdom.
T (0)20 7700 6700; F (0)20 7700 8066
www.QuartoKnows.com

A catalogue record for this book is available from
the British Library.

ISBN 978 0 7112 3763 6

Printed and bound by GPS Group

1 2 3 4 5 6 7 8 9